Cold War Exiles in Mexico

Cold War Exiles in Mexico

U.S. Dissidents and the Culture of Critical Resistance

Rebecca M. Schreiber

University of Minnesota Press

Minneapolis

London

A version of chapter 2 was previously published as "Dislocations of Cold War Cultures: Exile, Transnationalism, and the Politics of Form," in *Imagining Our Americas: Toward a Transnational Frame,* ed. Sandhya Shukla and Heidi Tinsman (Durham: Duke University Press, 2007); copyright 2007 Duke University Press; reprinted with permission. A version of chapter 5 was previously published as "Resort to Exile: Willard Motley's Writings on Postwar U.S. Tourism," in *Adventures into Mexico: American Tourism beyond the Border,* ed. Nicholas Dagen Bloom (Lanham, Md.: Rowman and Littlefield, 2006); reprinted with permission.

Excerpts from Charles White's oral history are printed with permission from C. Ian White.

Passages from Willard Motley's unpublished and draft manuscripts, and from the letters of Willard Motley, are printed with permission from members of Willard Motley's family.

The letters of Dalton Trumbo are quoted with permission from Christopher Trumbo.

Robert Loomis's letters to Willard Motley are quoted with permission from Robert Loomis.

Excerpts from the letters of Max Shlafrock are printed with permission from Arthur Sheldon.

Rebecca M. Schreiber's interview with Elizabeth Catlett is printed with permission from Elizabeth Catlett.

Material from the unpublished memoir of Crawford Kilian is printed with his permission.

Excerpts from Margaret Taylor Goss Burroughs's oral history interview with Anna Tyler are printed with permission from Margaret Taylor Goss Burroughs.

Every effort has been made to obtain permission to reproduce previously copyrighted material in this book. If any proper acknowledgment has not been made, we encourage copyright holders to contact the publisher.

Published by the University of Minnesota Press
111 Third Avenue South, Suite 290
Minneapolis, MN 55401-2520
http://www.upress.umn.edu

Library of Congress Cataloging-in-Publication Data
Schreiber, Rebecca Mina.
Cold War exiles in Mexico : U.S. dissidents and the culture of critical resistance / Rebecca M. Schreiber.
 p. cm.
Includes bibliographical references and index.
ISBN 978-0-8166-4307-3 (hc : alk. paper) — ISBN 978-0-8166-4308-0 (pb : alk. paper)
1. Americans—Mexico—History—20th century. 2. Politics and culture—Mexico.
3. Political refugees—Mexico—History—20th century. 4. Politics and culture—
United States. 5. Political refugees—United States—History—20th century.
6. Cold War—Influence. I. Title.
F1392.A5S37 2008
305.9'0691408913072—dc22
2008028416

Printed in the United States of America on acid-free paper

The University of Minnesota is an equal-opportunity educator and employer.

15 14 13 12 11 10 09 08 10 9 8 7 6 5 4 3 2 1

For Alia and Alyosha,
and in memory of
my grandparents

Contents

Introduction

The onset of the Cold War precipitated a distinct and extensive forma-
tion of political exile comprising U.S. writers, artists, and filmmakers
who left the United States during the 1940s and 1950s for political rea-
sons.[1] Although many of these individuals relocated to Western Europe,
including England, France, and Italy, among the most crucial and least
studied of this exodus were the communities that developed in Mexico.[2]
The communities of U.S. artists, writers, and filmmakers in Mexico devel-
oped in stages after President Lázaro Cárdenas (1934–1940) welcomed
U.S. Spanish Civil War veterans to reside in the country during the late
1930s. The first group to arrive following World War II consisted of visual
artists, many of whom were African American, who went to Mexico City
to study art or to work alongside Mexican artists at the Taller de Gráfica
Popular (Popular Arts Workshop) in the late 1940s and early 1950s. These
artists included Elizabeth Catlett, Charles White, John Wilson, and Mar-
garet Taylor Goss Burroughs. The largest number of Cold War exiles, those
blacklisted from the Hollywood film industry, started relocating to Mexico
City and Cuernavaca during the early 1950s. Among the Hollywood exiles
were screenwriters Hugo Butler and his wife Jean Rouverol (Butler), Dalton
Trumbo, Gordon Kahn, Albert Maltz, and John Bright. They were joined
by poets, writers, and literary agents, including George Oppen, Howard
Fast, and Maxim Lieber, some of whom had been blacklisted from the pub-
lishing industry. This group also included African American writers who
were not "officially blacklisted," such as Willard Motley, who, according to
Jerome Klinkowitz, "found a more hospitable culture" in Mexico than he
had in the United States.[3] In the years between visual artist Elizabeth

Catlett's settlement in Mexico City in 1946 and the posthumous publication of Motley's novel *Let Noon Be Fair* in 1966, there came to be a critical mass of U.S. artists, writers, and filmmakers living in Mexico.[4]

Many of those who chose to live in Mexico during the late 1940s and early 1950s did so as a reaction to government harassment they experienced as "progressives," a term that artist Margaret Taylor Goss Burroughs and others used to describe people as anywhere on the political spectrum from "Left wing to Communist."[5] For African American artists and writers, the racial retrenchment following World War II left them disillusioned with the prospect of racial equality in the United States. The U.S. government's conflation of antiracist organizations with the Communist Party further compelled the exile of African American artists and writers from the United States.[6] After President Truman's Executive Order 9835 was established in 1947, the Internal Security Division of the Justice Department put together a formal list of "subversive" organizations, which included many liberal and left-wing institutions. With this list, government and private-sector employers obtained grounds to discriminate against and persecute members of groups whom they suspected were "disloyal."[7] By the late 1940s, individuals who left the United States were specifically concerned with being subpoenaed by congressional and state committees. The experiences of the Hollywood Ten at the 1947 House Un-American Activities Committee's (HUAC) hearings on "Communist infiltration" in the film industry had demonstrated that refusing to answer HUAC's questions about membership in the Communist Party could result in up to a year in federal prison for contempt of Congress. Further, the development of the Internal Security Act (McCarran Act) in 1950 authorized a Subversive Activities Control Board to require these organizations to register as "Communist-action," "Communist-front," or "subversive." These organizations would also be required "to file lists of their officers, maintain supervised records, and to label their mail."[8] The Internal Security Act also called for the detention of those included on the FBI's Security Index for "emergency situations."[9] This Act concerned some that if the attorney general used the definition of *disloyal* loosely, they might find themselves interned in a military prison.[10] These were a few of the repressive policies sanctioned by the federal government against left-wing Americans that contributed to their decisions to leave the United States for Mexico and elsewhere.[11]

The targeting of left-wing cultural producers by the U.S. government during this period underscores the extent to which the Cold War was fought not only by military and diplomatic strategy but on a cultural level as well. A significant number of artists, writers, and filmmakers chose to leave the United States during this period because they were denied the capacity to produce, exhibit, and/or distribute their work. The exile of these individuals thus calls attention to the democratic rhetoric of the United States and demonstrates the limits of inclusivity and the boundaries of permissible criticism within the United States during the early Cold War era. In a variety of ways, the cultural work of the U.S. exiles in Mexico continued not only to transgress those limits and boundaries but also to creatively interrogate them as well.

Americans who chose to live in Mexico during the early Cold War era did so for pragmatic as well as ideological reasons. Those who had been active in left-wing politics or the Communist Party could be assured that their applications to the U.S. Passport Division would be rejected for political reasons.[12] In the early 1950s, U.S. Secretary of State Dean Acheson stated that the Passport Office would deny passports to any applicants whom they deemed members of the Communist Party, reasoning that their travel abroad was "contrary to the best interest of the United States."[13] Choosing Mexico as a destination offered a means of getting around such restrictions because U.S. citizens did not need passports to go there.[14] Moreover, the cost of living in Mexico was less than in the United States, and many believed that they could survive on their savings until they could establish themselves there or return to the United States. Others chose Mexico on the basis of previous travels south of the Río Grande and/or an interest in some aspect of Mexican culture. While a significant percentage of these individuals lived in Mexico for a few years or less, others settled there for upward of ten years or more.

Life in Mexico presented difficulties for the exiles, whose problems were exacerbated by pressures brought upon the Mexican government by the U.S. government regarding "Communist subversion." The U.S. exiles who relocated to Mexico in the early 1950s did so following the creation of NSC 68, a top-secret report on national security policy created by the National Security Council in January 1950. According to Melani McAlister, the report "expanded the scope of the Cold War to include not just the Soviet

Union, but any Third World nation[s]" that in the eyes of the U.S. government "might be influenced by the Soviet Union's 'way of life.'"[15] Eric Zolov argues that "During this period of heightened Cold War tension, when the 'third world' was the disputed terrain of superpower rivalries, Mexico became a model nation in the U.S. imaginary and a valued strategic ally."[16] The U.S. exiles relocated to Mexico during a major political shift that began in the 1940s. The "counterreform" of the administration of Miguel Alemán (1946–1952) moved the Mexican government away from policies created by the more liberal administration of Cárdenas, leading to significant legal and institutional changes. These policy shifts, which contributed to both massive industrialization and a diminishing commitment to social welfare, were further promoted during the administrations of Adolfo Ruiz Cortines (1952–1958) and Adolfo López Mateos (1958–1964).[17] In response, Mexican workers organized numerous strikes in the mid-1950s to fight for improvements in wages as well as to democratize labor unions.[18] In retaliation, the Mexican government sought to undermine the labor movement while also deflecting responsibility for the strikes onto "outsiders," especially individuals whom they viewed as foreign and native-born Communists. As a result, some of the U.S. exiles were either arrested or deported from Mexico in the mid- to late 1950s.

In this book, I argue that the Cold War, as a political and cultural project that marginalized and pushed left-wing artists into exile, contributed to the formation of a culture of critical resistance. In its most significant manifestation, the Cold War culture of political exile made possible a space of critique for left-wing U.S. artists, writers, and filmmakers in Mexico. Cultural work by the U.S. exiles in Mexico during the early Cold War era was characterized by a distinctly transnational mode of cultural production. Although the extent to which and precisely how each of these artists, writers, and filmmakers articulated this transnational framework varied, I argue that the cross-border circumstances and the specific context of Mexico were decisive for the form and content of their work. Throughout this book, I use *transnational* to describe the circulation of individuals and ideas across national boundaries—the particular conditions of their physical, social, and political itinerary. I also employ *transnational* to describe how the formal and thematic structure of this work was the outcome of precisely these conditions—how this multiplicity of vantage points contributed to a deliberate aesthetic and political critique of U.S. racism, nationalism, and imperialism.

Thus, while I show at length how important the cultural and political milieu of Mexico was for this cultural production, my argument is not simply that this context was constitutive for their work. Instead, I argue that the form and content of this work, as well as its historical and political significance, cannot be understood in terms of any singular national context and is more than the sum of its locations of production and distribution. The juridical-political institutions of the nation-state (U.S. and Mexican) and the social significance of the nation as an imagined community profoundly shaped the lives of the artists, writers, and filmmakers who are the subject of this study, but I emphasize the term transnational to convey the sense in which a critical and conscious transgression of these boundaries came to be in various ways central to their work. As such, this study focuses on what George Lipsitz describes as "the ways in which culture functions as a social force" and how "aesthetic forms draw their affective and ideological power from their social location" in order to critically surpass the "hegemony of the nation-state as the ultimate horizon in American studies."[19]

The distance of the U.S. exiles from the United States, and from sources of financial support allotted for the culture industries by the U.S. and Mexican governments, enabled these individuals to develop a critical transnationalist perspective in contrast to dominant Cold War culture. In using the phrase *critical* transnationalist perspective, I am referring to the U.S. exiles' deliberate strategy of calling attention to political, economic, and cultural relations that do not take political borders as their ultimate horizon, as well as to their criticism of the normative and exclusionary functions of nationalism.[20] Their work challenged the U.S. government's evocation of American exceptionalist notions of culture in the battle for the "hearts and minds" of individuals in the so-called third world during the early Cold War era. The mode of address and formal strategies evident in the work of some of the U.S. exiles developed in critical opposition to the U.S. Cold War state's nationalist aesthetic parameters. This official aesthetic and ideological agenda was exemplified in the state's alliance with the Hollywood film industry and in its promotion and exhibition of abstract expressionism internationally, among other cultural projects.[21] Part of the cultural opposition by exiles was also directed toward the Mexican government (and Mexican film industry) that during the early Cold War years was aligned economically and (to some extent) politically with the United States. I demonstrate in this book how the artistic practices of the U.S. exiles were constituted by and directed to a

political moment in Mexico and how this work responded in sometimes oblique but significant ways to the U.S. context and the forces that contributed to their exile.

The work of the U.S. exiles deliberately countered the dominant ideology of "American nationalist globalism" championed by the United States during the early Cold War era.[22] In contrast to the nationalist subtext and global aspirations promoted in dominant U.S. cultural production during this period, the exiles' cultural production cut against the grain of nation-based paradigms by foregrounding the links between U.S. domestic and international racism as well as by critiquing U.S. nationalism and imperialism. Many of the African American visual artists, including Elizabeth Catlett and John Wilson, created pointed accounts of U.S. racism in their work in Mexico. Their representations of racial brutality, in the form of lynching and other instances of racial violence, challenged the ways that the United States portrayed itself as a beacon of freedom during the early Cold War era. Writers and screenwriters, including Gordon Kahn, Willard Motley, and Hugo Butler, also created work that represented U.S. racism directed toward Mexican Americans, African Americans, and Mexicans.[23]

For African American writers and artists, it was their perspective outside the United States looking in and, in the case of African American artists, the effect of Mexican artists that informed the specific themes of racism against African Americans in their work. These influences enabled them to articulate a solidarity with people struggling against the racialized imposition of colonialism worldwide. These associations are evident in their visual artwork as well as in their fictional and nonfictional writing, speeches, and essays. In his nonfictional manuscript about Mexico, "My House Is Your House," for example, novelist Willard Motley related U.S. domestic and international racism within the context of U.S. tourism in Mexico. However, his criticism of U.S. racism led to the censorship of his manuscript, which was never published. The work of the U.S. exiles also condemned the practices and relations of U.S. imperialism through their examination of economic inequities between the United States and Mexico. John Wilson saw Mexican muralist José Clemente Orozco's critical representation of Mexican life as a model, both in form and content, for his own representations of the lives of African Americans in the United States. In this sense, Wilson's work exemplifies a critical transnationalist perspective because he drew from Orozco's formal approach to his subject matter while por-

traying the specificity of African American life in the United States. While Catlett made connections between the experiences of Mexicans and African Americans in her visual artwork, her speeches and essays of the early 1960s explicitly directed her African American audience to see beyond the limitations of U.S. cultural discourse that had prioritized abstraction and persuaded them to envision the global dimensions of race and culture. In a speech she gave in 1961 at a meeting of the National Conference of Negro Artists, Catlett stressed the importance of African American artists' consciously considering their choice of a formal approach in their work as well as a mode of production and specific audiences, including African Americans in the South and people of color throughout the world.

Throughout this book, I use *exile* to describe a form of coerced migration.[24] Exile is significant to the particular historical moment examined here because U.S. national belonging during the early Cold War era was vigorously policed in both symbolic and administrative terms that essentially abrogated the citizenship rights of specified individuals. For instance, the U.S. government's decision to deny passports to applicants whom they viewed as members of the Communist Party withdrew one of their most basic rights as U.S. citizens—their right to travel. In the case of those who fled the United States to avoid government harassment or arrest during the early Cold War period, their relocation to Mexico was a response to the accelerated intolerance mandated by the U.S. state, which excluded those who did not meet the politically normative terms that policymakers established for national belonging. U.S. Cold War policy consolidated the legal category of citizenship through such legislation as the Immigration and Nationality Act (McCarran-Walter Act) of 1952, which enabled the government to deport immigrants or naturalized citizens who were accused of involvement in "subversive" activities.[25] (This law was also used to prevent former members of the Communist Party of the United States of America [CPUSA] and those suspected of Communist Party membership from entering the United States.) U.S. Cold War policy also narrowed acceptable cultural expression in the United States by its alliance with the Hollywood film industry and its promotion and exhibition of abstract expressionism, among other cultural forms. For the artists, writers, and filmmakers who went to Mexico during the early part of the Cold War, their migration was a direct consequence of these cultural and political proscriptions.[26]

Although exiled writers frequently worked in isolation—unlike many of the visual artists and filmmakers who worked collaboratively or were more directly engaged with broader artistic communities in Mexico—a comparable critical transnationalist perspective is evident in their work as well. Willard Motley used a range of formal techniques, including documentary and modernist techniques in point of view in his writings in Mexico. His experimentations with narrative perspective—which deliberately move across the lines of race, class, and nation—contribute to what I call a transnational mode of identification for the reader. This mode of narrative was explicitly anti-imperialist and served as a stylistic counter to the unilateral point of view underpinning the conventional travel narrative that Motley critically reworked. Gordon Kahn employed similar techniques in his novel *A Long Way from Home*, including multiple perspectives to destabilize a unified narrative point of view. Furthermore, Kahn's story takes the form of a bildungsroman, providing a context through which Gil, the main character, grows to recognize the ideological frame of U.S. Cold War nationalism.

In large part because these individuals were blacklisted or produced cultural work that was critical of the United States, they had difficulty exhibiting and distributing it to U.S. audiences. African American artists who had already confronted the rapid ascendance of abstract expressionism, as well as the demise of progressive, interracial arts galleries in cities such as New York and Chicago before they left the United States in the late 1940s and early 1950s, found that there were limited opportunities for exhibiting their work during the 1950s in the United States. The blacklist in the film and publishing industries kept some from producing cultural work at all. Screenwriters who were blacklisted from the Hollywood film industry were limited by the kinds of screenplays that could be sold on the "black market."[27] However, even writers who were not blacklisted by the mainstream publishing industry, such as Motley, found that they could not publish their work in the United States if they took on controversial subject matter, such as framing U.S. racism within an international political context.

In this book, I distinguish between the U.S. exiles who viewed their stay in Mexico as temporary and left Mexico within a few years and those who settled for longer periods, remaining in Mexico for five years or more. Although all the exiles left the United States, their specific reasons for departure influenced the degree to which Mexico became a surrogate home. For example, blacklisted Hollywood screenwriter Dalton Trumbo consid-

ered his leave voluntary. His expulsion was, in his words, "from a job, not a country" during a period of "political reaction."[28] His friend and fellow screenwriter John Bright disagreed, arguing that the blacklist deprived leftists in the film industry not from earning a living "but from making a lot of money" in Hollywood.[29] Instead, Bright believed that the United States had become fascist during the early Cold War era, and he saw little hope for change. While Trumbo wanted to return to the United States, Bright planned to remain in Mexico, although his residency was cut short in 1958 when he was deported from the country.[30] Many African American artists and writers shared a similar critical view of racism in the United States, which led to a decision for some, including Catlett and Motley, to make their move permanent.

Differences in how they perceived their circumstances in Mexico as well as in their ability to get their work produced, exhibited, or distributed in the United States and/or Mexico, contributed to whether the exiles directed their work to U.S. audiences, Mexican audiences, or both. Their address to different audiences also affected the kinds of representations that they created. Hugo Butler, who had written many screenplays in the Hollywood film industry before he left the United States, proceeded to write scripts for Mexican film productions when he arrived there in the early 1950s.[31] His first screenplay, *The Adventures of Robinson Crusoe* (1952), was a collaborative effort between himself and Spanish exile film director Luis Buñuel, who introduced Butler to alternative modes of filmmaking intended to disrupt conventional realist aspects of Hollywood film production. In his next film, *¡Torero!* (1956), Butler not only wrote the screenplay but also started directing. With this production, he worked with a group of independent filmmakers including Spanish exile documentary filmmaker Carlos Velo, Mexican producer Manuel Barbachano Ponce, and Dutch filmmaker Giovanni Korporaal, the latter of whom also worked on his production of *Los pequeños gigantes (How Tall Is a Giant?)* (1958), a film that Butler both wrote and directed. Although life in Mexico did influence the subject matter of screenwriter Dalton Trumbo's work, including his film about a boy and a bull, *The Brave One* (1956), his black market screenplays were written for U.S. producers and represented Mexico from a conventional Hollywood perspective. By focusing on U.S. audiences, the success of the screenplays that he wrote in Mexico and elsewhere provided him with an opportunity to expose the hypocrisies of the blacklist in Hollywood.

For U.S. exiles in Mexico still hoping to direct their cultural work to U.S. audiences, their political and geographical distance from the United States compounded difficulties that were already severe. Most were at least temporarily deprived of outlets for their work in the United States. Under these circumstances, some redirected their work toward Mexican audiences. This was particularly the case for those working in the visual arts, including artists and filmmakers. Addressing Mexican audiences enabled these cultural producers to influence perceptions of the United States in Mexico. For example, artwork by African Americans in Mexico—such as John Wilson's mural *The Incident* (1952) and the series *Against Discrimination in the United States* (1953–1954), which Elizabeth Catlett collaborated on with the other members of Taller de Gráfica Popular, a graphic arts collective—had a significant impact on political interpretations of the United States in Mexico. In the case of screenwriters who directed their work toward Mexican audiences, this address allowed them to create works that narrated a critique of dominant U.S. Cold War culture and ideology. These films also challenged representations produced within the Mexican film industry that were supported by the Mexican state.

Filmmakers who directed their work toward Mexican audiences, especially Hugo Butler and George Pepper, played a seminal role in Mexican independent film production. With *¡Torero!*, Butler collaborated with Carlos Velo to create a film that countered the romanticized representations of bullfighting produced in Hollywood and within the Mexican film industry. Furthermore, the manner in which this independent production mixed documentary and narrative elements defied the aesthetic conventions of Mexican and Hollywood film. In his next film, *Los pequeños gigantes* (1958), Butler also combined diverse generic elements but included a more overt and politically charged subtext that referenced, among other themes, economic inequalities between the United States and Mexico. Both of these films were influential in the emergence of Nuevo Cine (New Cinema) in the late 1950s, a movement of independent filmmakers in Mexico against the aesthetic and ideological conventions of both classical Hollywood and Mexican narrative cinema.

While the filmmakers' impact was greatest in Mexico, it was the African American artists who had the most significant influence on U.S. culture, most visibly on the Black Arts Movement of the 1960s and early 1970s. During the 1950s, individuals who returned to the United States, such as Margaret Taylor Goss Burroughs and Charles White, worked to establish

organizations that helped African American artists to exhibit and distribute their work. Artists such as Burroughs and White also brought with them their collaborative artmaking experiences in Mexico as a model for African American artists in the United States. While the mural as a widely used artistic form reappeared in the United States within the context of the Black Arts Movement, it survived in large part through the work of African American artists in Mexico as well as those who designed murals for black colleges in the South during the 1940s and 1950s.[32] One of the most influential artists in the Black Arts Movement, Elizabeth Catlett, never returned to live in the United States. However, Catlett did visit the United States to attend conferences and exhibitions through the early 1960s while still a U.S. citizen. After she became a Mexican citizen in 1962, she was not allowed to enter the United States until she was granted a visa in the early 1970s. Elizabeth Catlett's 1961 speech to the National Conference of Negro Artists, published in the first issue of *Freedomways,* was a "turning point for African American artists," according to Romare Bearden and Harry Henderson.[33] As I describe in the conclusion of this book, Catlett's speech contributed to the formation of African American art collectives and group exhibitions of the work of African Americans in the United States. Starting in the 1960s, as the Mexican art world became increasingly dominated by abstraction, Catlett primarily addressed her work to African Americans in the United States. As a result, she also became an important contributor to the development of the Black Arts Movement in the United States.

The Cold War culture of political exile in Mexico was an oppositional cultural formation, inflected by cultural forms developed within a community of left-wing artists forged in Mexico City and Cuernavaca, the significance of which has been minimized or omitted within scholarship on U.S. Cold War culture.[34] This book is part of the developing emphasis in the fields of American studies and U.S. history that examines what Melani McAlister describes as "alternative geographies," specifically in the Americas, the Black Atlantic, and the Pacific Rim.[35] McAlister argues that the work of scholars such as Paul Gilroy, José David Saldívar, Lisa Lowe, George Lipsitz, and others, makes clear that "we can not continue to assume that the histories we tell, or the cultural productions we analyze, or the people whose lives intersect with and produce both, are ever simply contained by the nation."[36] My work draws specifically from the scholarship of those who have focused on the alternative geographies of the Americas within American studies

and Latin American studies. Scholars such as José Limon, Claire F. Fox, Seth Fein, and Eric Zolov have examined how political and cultural ideas travel across national boundaries, challenging the binary, nation-based frames of seeing and analyzing post–World War II cultural work in the United States and Mexico.[37]

This study also contributes to a larger history that analyzes the continuation of the culture of the U.S. Popular Front outside the boundaries of the United States. It builds upon the work of recent scholarship in American studies and other fields that have critically rethought what scholars had previously identified as the "culture of the 1930s," such as Michael Denning's *The Cultural Front*.[38] Scholars, including Stacy Morgan, have analyzed the work of African American artists and writers aligned with the Cultural Front who continued to create politically engaged work into the 1950s.[39] In addition to Morgan, Bill Mullen and Alan Wald have also examined the work of Cultural Front artists, writers, and filmmakers, including some who left the United States for Mexico during the late 1940s and early 1950s.[40] While Morgan and Mullen credit Mexico as providing an important context for these individuals, this book focuses specifically on the transnational aspect of this work, analyzing the aesthetic and political influence of Mexican artists and filmmakers, as well as those within European exile communities, and of the Mexican context on the U.S. exiles.

Redressing some of the absences in the scholarship of the Hollywood blacklist, this study analyzes the impact of the mass exodus of left-wing filmmakers across national boundaries, specifically in Mexico.[41] By focusing on the context and consequences of cultural producers leaving the United States during the early Cold War era, this book complicates nation-based models of political and cultural opposition, revealing international communities of left-wing artists and filmmakers in Mexico City and Cuernavaca during the two decades following World War II.

My analysis is also engaged with the larger cultural and political history of the movement of left-wing African Americans outside the United States during the early Cold War era. It is influenced by scholars who have examined the transnational movement and oppositional politics of African American intellectuals and cultural producers during the post–World War II era, especially the work of Paul Gilroy, Tyler Stovall, and Kevin Gaines.[42] Gilroy and Stovall have examined the work of Richard Wright, Ollie Harrington, and others who fled the United States for France during the 1940s and

1950s, while Gaines has written about African Americans who went to Ghana during the late 1950s and 1960s because of their interest in participating in the development of this newly independent nation. Many of these individuals linked racial inequalities in the United States to racism globally, a perspective deemed politically subversive by U.S. policymakers throughout the early Cold War era.[43] Like African Americans who went to France and Ghana during this time, African American artists and writers in Mexico called attention to the insidious reach of the global color line and the consequences—from the United States to Africa to Asia—of white supremacist ideology. How particularly the realities of racism south of the Río Grande denigrated indigenous peoples and perpetuated racialized hierarchies despite official rhetoric that championed *mestizaje*, however, provided those in Mexico with a distinct perspective simultaneously addressed to global and idiosyncratic hemispheric manifestations of the color line. By focusing on African Americans in Mexico, this study provides an analysis both complementary to and distinct from scholarship concerned with analyzing the "Black Atlantic" (the triangle between the United States, Europe, and Africa).[44] As such, although I argue that African American artists and writers in Mexico articulated a critical transnationalist perspective on the global dimensions of national racist ideologies, I emphasize how the peculiar dynamics of racism in Mexico and the United States informed their perspective.

This book explores the ways in which the cultural production of the U.S. exiles developed in relation to their changing conditions in Mexico and proceeds chronologically and thematically. Chapter 1, "Routes Elsewhere: The Formation of U.S. Exile Communities in Mexico," focuses on the development of U.S. exile communities in Mexico during the late 1940s and early 1950s. This chapter examines why these individuals left the United States and what made Mexico a popular destination. The exiles' reasons for being in Mexico and their experiences settling into Mexico City and Cuernavaca shaped the aesthetic and political dimensions of their cultural work, as I discuss in the chapters that follow.

In chapter 2, "The Politics of Form: African American Artists and the Making of Transnational Aesthetics," I focus on the collaborations of African American artists with graphic artists in the Taller de Gráfica Popular and explore the influence of Mexican muralists, including José Clemente Orozco, on their visual artwork in Mexico. Unlike the other U.S. exiles, these artists chose to go to Mexico because of their interest in Mexican public art, in-

cluding printmaking and murals. These artists transposed representational strategies and formal techniques employed by artists in Mexico to address U.S. racism toward African Americans as well as to express their resistance to it. Elizabeth Catlett's *The Negro Woman* series (1946–1947), the Taller's *Against Discrimination in the United States* series, and John Wilson's mural *The Incident* are exemplary in this regard. I examine this work in detail to demonstrate precisely how African American artists in Mexico incorporated Mexican aesthetic practices and represented the conditions of U.S. white supremacist ideologies to audiences in the United States, Mexico, and internationally. I conclude with an analysis of how the experiences of African American artists in Mexico offered an example of a collaborative art practice that enabled them to create and distribute their work once they returned to the United States. Further, I explore how Elizabeth Catlett, who remained in Mexico, utilized her involvement in the Taller de Gráfica Popular as a model for African American artists to produce work and to address international audiences rather than to direct their artwork to the art establishment in the United States. Catlett's emphasis on the importance of African American and international audiences related to her understanding of the meanings of cultural production for African Americans and groups of people who had formally been colonized in Africa, Asia, and Latin America.

In chapter 3, "Allegories of Exile: Political Refugees and Resident Imperialists," I analyze two cultural works, *The Adventures of Robinson Crusoe*, adapted to the screen by Hugo Butler, and *A Long Way from Home*, a novel written by Gordon Kahn in the early 1950s and published in the late 1980s. These texts narrate the experiences of blacklisted Hollywood screenwriters in Mexico as political outcasts and relatively privileged Americans. Butler's collaboration with Buñuel on *The Adventures of Robinson Crusoe* developed from a classical literary adaptation to a film that explored the contradictory imperial impulses of Crusoe, a subtle reference to Butler's own position in Mexico. In addition, Buñuel's incorporation of surrealist elements within the film undermined cinematic languages developed within Hollywood and Mexican narrative cinema. This collaboration involved Butler in an independent film production less constrained by dominant filmic conventions, a mode that he continued to employ in future film projects in Mexico. In *A Long Way from Home*, Kahn focuses on the figure of a "political refugee," Gilberto, a Mexican American draft dodger who flees the United States for Mexico during the Korean War. Through the form of the bildungsroman,

Gil becomes aware of the rigid parameters that frame dominant Cold War ideology and the myth of American exceptionalism. In the conclusion, I argue that these texts contain significant oppositional strategies to the officially sanctioned cultural work produced in conjunction with or promoted by both the U.S. and Mexican governments during the early Cold War era.

In chapter 4, "Audience and Affect: Divergent Economies of Representation and Place," I examine the differences between representations of bullfighting in two films written by blacklisted Hollywood exiles: Hugo Butler's screenplay for ¡Torero!, a film created by Mexican and Spanish exile filmmakers for audiences in Mexico, and Dalton Trumbo's The Brave One (1956), which was produced in the United States. I argue that while the Hollywood exiles who directed their work toward Mexican audiences, including Butler, assimilated Mexican cultural idioms, those who addressed their work toward U.S. audiences, such as Trumbo, simply transposed Mexican subject matter onto conventional Hollywood scenarios. Although Butler's original script for ¡Torero! was directed toward U.S. audiences and slated as a documentary about bullfighting, I focus on how he changed the script into a film that mixed documentary and fictional modes, narrated by the "subject" of the film, famed Mexican bullfighter Luis Procuna. This film style, aided by Carlos Velo's footage of bullfights, enabled Butler to produce a film that ran counter to the romanticized and exoticized representation of the sport developed within both the Hollywood and Mexican film industries. While Trumbo used his black market screenwriting work as a means to expose the underground economy of the blacklist and precipitate its demise, Butler's independent production in Mexico, which continued with Los pequeños gigantes (1958), narrated a more explicit set of politics critical of both the United States and Mexico. The subtext of Los pequeños gigantes, written and directed by Butler, about the Mexican Little League baseball team that won the Little League World Series of 1957, references U.S. racism against Mexicans and Mexican Americans as well as repressive U.S.–Mexico border politics, challenging the image of America as a democratic nation that the U.S. government attempted to communicate globally during the early Cold War era. Furthermore, the subject of the film, the triumph of a disadvantaged Mexican Little League baseball team over an American team, conveyed an antiracist and anti-imperialist perspective.

Chapter 5, "Unpacking Leisure: Tourism, Racialization, and the Publishing Industry," explores representations of U.S. tourists in Mexico, focusing

on the work of writer Willard Motley. In Motley's nonfictional manuscript "My House Is Your House" and in his novel "Tourist Town," published posthumously as *Let Noon Be Fair* (1966), he used the trope of tourism in order to critique U.S. racism and imperialism in Mexico. While Motley's work in Mexico was explicitly critical of U.S. racism and imperialism, his aesthetic choices also opposed conventional U.S. travel narratives. Motley used a variety of different styles in "My House Is Your House" and "Tourist Town," including documentary and modernist techniques in point of view to contest the narrowly circumscribed perspective and exoticized realism of the conventional travel narrative. He did this in part by including indigenous perspectives, challenging the unilateral point of view that shapes travel narratives.

Chapter 6, "Exile and After Exile," examines the forces that contributed to the dispersion of the U.S. exiles from Mexico to the United States and Western Europe from the mid-1950s to the early 1960s. I argue that there were three waves of exiles who left Mexico. The first group left Mexico in the mid-1950s because of their difficulties in adapting to life there, including an inability to establish residency in Mexico. Their decisions were also related to an interest in returning to the United States after the censure of Joseph McCarthy and the *Brown v. Board of Education* Supreme Court decision in 1954. The second wave of U.S. exiles consisted of individuals who planned to remain in Mexico but left involuntarily after the Mexican government's charge that the U.S. exiles and other "outsiders" were responsible for a wave of national strikes in Mexico. This accusation resulted in the arrest and/or deportation of some of the U.S. exiles in 1958. The third wave of U.S. exiles left Mexico in the late 1950s and early 1960s, for a variety of reasons. While these individuals had been able to establish residence in Mexico, some returned to the United States because of the restoration of their passports after the 1958 *Kent v. Dulles* Supreme Court decision, symbolizing to many the return of their rights as citizens. Others left at this time because of negative publicity in U.S. newspaper articles, which accused them of sheltering spies from the United States and helping them reach Cuba or Soviet bloc nations. Still other U.S. exiles remained in Mexico and became Mexican citizens. However, their status as Mexican citizens made it more difficult for them to visit the United States in the 1960s and 1970s.

In the conclusion, I analyze the significance of the oppositional cultural work of the U.S. exiles in Mexico. I also examine the impact of their cultural

production in the United States and Mexico, focusing specifically on the influence of African American artists, including Elizabeth Catlett, on the Black Arts Movement in the United States and Hollywood exile filmmakers, such as Hugo Butler and George Pepper, on the Nuevo Cine movement in Mexico.

The Cold War was indeed a time of ideological retrenchment. The consequences of dissent were severe. The full force of the U.S. state mobilized against those cultural producers critical of U.S. policy. Yet, rather than decisively preempt cultural and political opposition, the force of exclusion and prohibition established the circumstances for the expression of newly resilient and innovative cultural forms of oppositionality. This book is an effort to understand the specific dimensions and aesthetic horizons of this oppositionality by focusing on the cultural work and political circumstances of U.S. exiles in Mexico between the mid-1940s and the mid-1960s.

1
Routes Elsewhere
The Formation of U.S. Exile Communities in Mexico

From the 1930s through the 1950s, Mexico served as a place of refuge for political dissidents from abroad. The liberal administration of Lázaro Cárdenas (1934–1940) welcomed individuals seeking sanctuary from fascist governments in Spain and Germany, political opponents of Stalinist Russia, and U.S. veterans of the Spanish Civil War. Beginning in the late 1940s, these exile communities were joined by left-wing artists, filmmakers, and writers from the United States. Julian Zimet, a blacklisted Hollywood screenwriter who relocated to Mexico in the early 1950s, also remembers meeting "school teachers, doctors, journalists, businessmen, college professors and government employees who had been dismissed for political reasons, in addition to Communist Party members."[1]

Focusing on the artists, writers, and filmmakers who were part of this significant political exodus, this chapter begins by examining the circumstances under which they chose to leave the United States beginning immediately following World War II. I then discuss their experiences crossing the border and establishing residency in Mexico. There were three groups of cultural producers who left the United States for Mexico starting in the mid- to late 1940s. The first group consisted primarily of African American artists who went to Mexico to escape racism as well as the harassment they suffered because of their political beliefs. They chose Mexico because they felt they could continue producing politically engaged artwork there, while also studying and collaborating with Mexican artists on printmaking and mural projects. The second group to leave the United States was the blacklisted Hollywood screenwriters and film industry professionals. Many of these individuals had been involved in antifascist and left-wing political or-

ganizations in Southern California; some had been members of the Communist Party. Most of these individuals left the United States after they had either appeared (and been jailed for contempt) or been subpoenaed to testify before the House Un-American Activities Committee (HUAC) during their hearings on "Communist infiltration" in the film industry. The third group consisted of left-wing and Communist writers and editors who left the United States because they had been blacklisted from the publishing industry and/or because they were concerned that they would be subpoenaed to appear before state and congressional committees. For some, such as writer Howard Fast, who had already served time in prison for contempt of Congress, Mexico offered a brief respite from continued government harassment. During the early 1950s, a number of African American writers left the United States as well, both because of the political environment and to evade U.S. racism.

Unlike the artists, the writers and screenwriters, with some exception, had little or no knowledge of Mexican culture before their move there. The writers chose to go to Mexico because they believed it to be beyond the reach of congressional committees and U.S. racism, and they knew they did not need a passport to enter the country. Some were aware that Lázaro Cárdenas had offered political asylum to antifascist refugees from Spain and Germany as well as to veterans of the Spanish Civil War. However, Cárdenas was no longer in office during the late 1940s and early 1950s when most of the U.S. exiles entered the country. As the U.S. exiles would discover, while Mexico had historically welcomed refugees from other countries, pressure from the United States on the Mexican government during the early Cold War era would weaken this commitment, as demonstrated by the "unofficial extraditions" of Communist Party of the United States of America (CPUSA) members from Mexico during the early 1950s. These actions as well as the alliance between the U.S. and Mexican governments had a significant effect on the lives of the U.S. exiles. It was in fact the deportations of CPUSA members that prompted the U.S. exiles to attempt to establish residency in Mexico soon after their arrival.

While those who settled in earlier aided newer arrivals with advice on subjects such as living accommodations, visa renewal, residency applications, schools for themselves and their children, employment, and other practical matters, some of the associations between the U.S. exiles were dis-

rupted by negative publicity in Mexican newspapers. For Willard Motley, a series of articles on "Reds in Cuernavaca" separated him from other artists and writers in Mexico, whereas these articles only temporarily split the Hollywood exile community. Meanwhile, Elizabeth Catlett established friendships with Mexican artists in the Taller de Gráfica Popular, providing a connection for other African American artists who joined the collective as guest members in the 1950s. The relations that the U.S. exiles established with other artists and filmmakers in Mexico influenced both the aesthetic and political aspects of their work.

POINTS OF DEPARTURE

"No Racist Laws in Mexico"

By the late 1940s and early 1950s, redbaiting in the United States contributed to an exodus of politically progressive artists, many of whom were African American. Anti-Communism only further compounded the everyday effects of racism toward left-wing African Americans following World War II and the decline in support for "socially conscious" representational art during the 1940s. Elizabeth Catlett recalled that she "never felt very patriotic in the States" because of its racist treatment of African Americans. She chose to go to Mexico in part because it was "the nearest place without racism and segregation."[2] During World War II, Catlett and other left-wing African Americans recognized the hypocrisy of African Americans fighting a war against race hatred abroad while they experienced discrimination in the United States. During the post–World War II period, African Americans grew increasingly frustrated with the persistence of racial violence and Jim Crow laws.[3] This sense of betrayal and outrage is evident in their artistic work, such as Charles White's painting *Freeport* (1946), which represented the murder of a black soldier and his brother in Freeport, Long Island.

The demise of the Works Progress Administration's (WPA) Federal Art Project in the late 1930s and early 1940s, which led to the elimination of federal funding for artists during the 1940s, had particularly significant consequences for African American artists.[4] Between 1935 and 1943, the WPA's Federal Art Project spent $85 million in support of the arts and provided 10,000 artists with weekly salaries.[5] One of the effects of the WPA's Federal Art Project was to substitute federal support in lieu of artists' reliance on wealthy patrons. Starting in the late 1930s, there was a concerted

backlash by the more conservative elements in Congress against the reformist programs of the New Deal. Spurred by an investigation by HUAC in 1938, led by Congressmen Martin Dies, Congress substantially cut the budget of the WPA in 1939.[6] Congress also passed a bill excluding Communists from participation in the WPA programs and instituted a loyalty oath.[7] Members of Congress linked the WPA's Federal Art Project to the Communist Party because of its connection to the American Artists Congress, which was affiliated with the Party. Artists and administrators who had been involved with the Project were accused of being "un-American," and by 1943, the federal government ended WPA funding altogether.[8]

Before the end of government support, African American artists were instrumental in establishing WPA-funded community arts centers in African American neighborhoods in large cities in the North. In New York, members of the Harlem Arts Guild helped establish the WPA-sponsored Harlem Community Arts Center. In Chicago, these efforts were spearheaded by the interracial Chicago Artists Union; the Arts and Crafts Guild, which was run entirely by African Americans; and the American Artists Congress.[9] Artist members of these organizations were involved in founding the WPA-funded South Side Community Arts Center. However, during the post–World War II era, the leadership of the South Side Community Arts Center became increasingly conservative, despite the involvement of progressive artists such as Margaret Taylor Goss Burroughs. Bill Mullen argues that the "center's postwar agenda included insuring its political and commercial credibility by repressing Left voices."[10]

After the federal government withdrew its funding from the Federal Art Project in 1943, artists again became largely reliant on support from the private sector. In an interview, artist Charles White, who helped establish the South Side Community Art Center, described the effects of the elimination of government funding for artists, arguing that "private patronage almost makes the artist completely dependent on taste."[11] He continued by suggesting that the artist "doesn't always shape the taste of his patrons. The patron sometimes exerts a kind of influence through his financial power."[12] Lisa Farrington mentions that while the WPA's Federal Art Project funded "social realist imagery that lionized the New Deal, American history, the working-class, [and] political activism," during the 1940s and 1950s, corporate and individual patrons tended to support artwork that did not demonstrate explicit political and social content.[13] Farrington notes further that

African American artists, whether or not they had actually been associated with the Communist Party or the WPA, were viewed with particular skepticism. So, too, was the social realism that dominated much of their artwork—despite the fact that the style had enjoyed more than a decade of approbation. The proletariat themes of WPA murals and prints became synonymous with Communist concepts of collective labor and social parity, and were subsequently scorned by the new, politically conservative art establishment.[14]

Following the demise of the WPA, African American artists sought and received support primarily from black organizations. While some African American artists worked on mural projects for black-owned businesses and black colleges in the South, most white patrons had less interest in collecting the work of African American artists, which, as Lizzetta LeFalle-Collins argues, "presented alternative voices that challenge[d] dominant cultural representation."[15]

This change in patronage had a significant effect on the artists who had been involved with the Federal Art Project as well as on the institutions that supported them. In the mid- to late 1940s, African American artists were marginalized within the mainstream art world, in part for reasons detailed by Farrington above. If their work was figural, representational, and political rather than abstract, they often had great difficulty securing gallery representation.[16] This was the case for many African American artists. However, a significant number of these artists continued to create work that was politically engaged into the 1940s and 1950s.[17] One option for these artists was to apply for fellowships to create work outside the United States. Artists, including Elizabeth Catlett and John Wilson, received funding from the Julius Rosenwald Foundation; Wilson also received a fellowship from the John Hay Whitney Foundation to study and create art outside the United States.[18] Most African American artists who received this funding traveled to Mexico or France.[19]

Among the African American artists who left the United States for Mexico during the late 1940s and early 1950s were Charles White, Elizabeth Catlett, John Wilson, and Margaret Taylor Goss Burroughs.[20] Bill Mullen asserts that by the early 1950s, Mexico City "had become a haven and refuge for African American artists seeking an alternative to the repressive political environment at home."[21] Most of these artists chose to go to Mexico because of difficulties they were experiencing in the political context of the United States during the early Cold War era. Catlett decided to

go to Mexico in 1946 after she found herself unable to focus on her artwork in New York while working as a promotion director and fundraiser at the George Washington Carver School. By that time, the Carver School, a community school in Harlem, was under attack as a "Communist front." Catlett recalled that difficulties ensued at the school during a power struggle between the white educators and African American leaders on the board of the Carver School, including Ben Davis and Adam Clayton Powell Sr. Eventually, the African American leaders took over. In response, a white member of the board contacted a journalist for a New York newspaper who wrote an article in which he referred to the Carver school as a "Red" institution. As a result of this negative publicity, the school lost support from the black middle-class and upper-middle-class communities in Harlem.[22] In 1952, Burroughs took a sabbatical leave from her position as an art teacher at a Chicago high school, in large part to escape the harassment she experienced because of her progressive politics. Burroughs described years later in an interview that "during the McCarthy period . . . there was a lot of pressure put on anybody who was the least bit militant. They'd claim you were a communist and would try to take your job away from you."[23]

The decision to go to Mexico was also based on these artists' interest in and familiarity with the work of Mexican muralists and printmakers. White and Catlett went to Mexico together in 1946 after Catlett's Rosenwald Fellowship was renewed. Both became guest members of the Taller de Gráfica Popular, an art workshop cofounded in 1937 by U.S. artist Pablo O'Higgins, who had settled in Mexico during the 1920s, and Mexican artists Luis Arenal and Leopoldo Méndez.[24] Wilson, who received a John Hay Whitney Fellowship in 1950 to study art in Mexico, knew Catlett and White and, like them, had met a number of Mexican artists in the United States, including José Gutiérrez, who encouraged Wilson to come to Mexico.[25] Wilson noted in an interview with Lizzetta LeFalle-Collins that he went to Mexico because "they were doing in Mexico what [Wilson] wanted to do in the United States."[26] In another interview, Wilson commented that Mexico was also appealing because, unlike in the United States, "There were no racist laws in Mexico."[27]

Exiled from Hollywood

The largest group of cultural producers who chose exile in Mexico during the 1950s consisted of blacklistees from the Hollywood film industry. Writer

Howard Fast commented in his memoirs that "because the witchhunt had taken such a devastating toll on the film industry, the mood of Communists and other left inclined people were desperate and despairing. Those punished, imprisoned, denied the right to work again . . . were part of a single industry, unlike in the East, where persecuted leftists were spread among a variety of industries and locations."[28] The move to Mexico was triggered by a political backlash in the mid-1940s against left-wing Hollywood screenwriters and others who were most active in the organization of studio guilds in Hollywood. John Howard Lawson and Lester Cole, two members of the Hollywood Ten, who were subpoenaed to appear before HUAC in 1947, had established the Screen Writers Guild in 1933. Although studio producers attempted to break up the Guild soon after its formation by creating a company union called the Screen Playwrights, they were unsuccessful. The Screen Writers Guild held an election authorized by the National Labor Relations Board and won by a wide margin in 1938. Within the next few years, the Screen Playwrights transformed into a new organization, the conservative Motion Picture Alliance for the Preservation of American Ideals.

In May 1947 the new Republican chairman of HUAC, John Parnell Thomas, was invited to Hollywood by the Motion Picture Alliance for the Preservation of American Ideals to investigate so-called Communist infiltration in Hollywood.[29] Thomas and his committee held private meetings with "friendly" witnesses, many of whom were members of this group. In September, Thomas scheduled hearings on Communist infiltration in the film industry for the following month and "pledged to expose 79 prominent members of the industry who were Communists or fellow travelers," according to Neal Gabler.[30] In actuality, only forty-three subpoenas were sent to individuals, twenty-four of which were mailed to those whom the committee regarded as friendly witnesses. The committee believed that the remaining nineteen witnesses would not cooperate, and they were thus labeled "unfriendly." Of the nineteen unfriendly witnesses, twelve were screenwriters. Interestingly enough, although the committee was meeting to investigate Communist infiltration in the film industry, the first question that the committee posed to these witnesses was whether they were members of the Screen Writers Guild, not whether they were members of the Communist Party.[31]

Most of the "Hollywood exiles" left the United States for Mexico between the 1947 and 1951 HUAC hearings. During the 1947 hearings, ten witnesses, later known as the Hollywood Ten, refused to respond to questions

directed at them about their past or present political affiliations and were charged with contempt of Congress. Not only did the Hollywood Ten receive prison sentences, but they were also purged or "blacklisted" from the Hollywood film industry. Thom Anderson, writing about HUAC, asserted that "there was no pretense that the Committee was conducting a reasoned inquiry into Communist influence on the movies. Its sole objective was collecting names for a blacklist."[32] While HUAC had plans to investigate Hollywood further, its focus was redirected to the Alger Hiss trial, and the committee did not return to Hollywood until 1951.

Many of the Hollywood exiles who left the United States for Mexico in the early 1950s were screenwriters, including Dalton Trumbo, Albert Maltz, Ring Lardner Jr., Ian Hunter, John Bright, Hugo Butler, Jean Rouvero, Julian Zimet, Leonardo Bercovici, John Collier, John Wexley, and Gordon Kahn. (Trumbo, Maltz, and Lardner were members of the Hollywood Ten.) Other Hollywood exiles included theatrical technician Asa Zatz, scenic artist Phil Stein, screen-story analyst Alice Hunter, scenarist Bernard Gordon, director Robert Rossen, scenario director Alan Lane Lewis, and cameraman Mike Kilian. A few who left had been active in political organizations in Hollywood, such as George Pepper, the executive director of the Hollywood Citizens Committee of the Arts, Sciences and Professions (HICCASP), which was included on the attorney general's list of subversive organizations.[33] Many of these individuals had been involved in left-wing political activity in Hollywood during the 1930s and 1940s, not only in the guilds but also in the Communist Party, in antifascist organizations such as the Hollywood Anti-Nazi League, the Hollywood Democratic Committee, and the Sleepy Lagoon Defense Committee.

The first group of Hollywood exiles to relocate to Mexico consisted of individuals who had left the United States to avoid receiving subpoenas from HUAC that required them to testify at the second set of hearings on Communist infiltration in the Hollywood film industry, held in 1951 in Los Angeles. Screenwriter John Bright was one of the first members of the Hollywood community to establish residence in Mexico City, in 1950.[34] Bright was followed shortly thereafter by screenwriters Leonardo Bercovici, John Wexley, and Gordon Kahn, and cameraman Mike Kilian.[35] John Wexley and his wife lived in Mexico City, as did Mike and Verne Kilian and their three sons, Crawford, Lincoln, and Starr. Gordon Kahn, author of *Hollywood on Trial* (1948), a book about the Hollywood Ten, settled in

Cuernavaca, where he was later joined by his wife, Barbara, their sons Tony and Jim, and Barbara's sister Janet.[36] Other Hollywood exiles who left the United States in 1950 included George Pepper, who relocated to Mexico after he received a subpoena from the Tenney Committee, California's version of HUAC.[37] He was also named as a Communist Party member in testimony before HUAC in 1951.[38]

Following Bright, Kahn, and others to Mexico were Albert Maltz, Ring Lardner Jr., and Dalton Trumbo, members of the Hollywood Ten who completed their jail sentences in the early 1950s. These left-wing screenwriters were anxious to leave the United States because they were concerned that they might be subpoenaed again to appear before HUAC, asked the same questions, and sent back to jail. In April 1951, screenwriter Albert Maltz, who had served ten months in prison, decided to relocate to Cuernavaca with his family, in part because he needed to rest and recover from an illness he developed during his incarceration. They were accompanied on their journey by Louise Stuart (Losey) Hyun, the ex-wife of blacklisted director Joseph Losey, who had a passport and had chosen to go to England. Ring Lardner Jr. left with his family for Mexico in December 1951, eight months after he was released from a federal prison in Connecticut.

Perhaps the best known of the Hollywood exiles to settle in Mexico was Dalton Trumbo. After he was released from prison, Trumbo and his family chose to relocate to Mexico when they traveled down to Ensenada in Baja California to visit screenwriter Hugo Butler. Butler left for Mexico after discovering that federal marshals were searching for him in order to serve him with a subpoena to testify at the 1951 HUAC hearings. He was driven over the border by friends, and then caught a flight to Mexico City, later relocating to Ensenada. After the school year ended, Butler's wife and collaborator Jean Rouverol drove their children to Ensenada, where they joined him.[39]

When the Trumbos and the Butlers gathered in Ensenada, they discussed in detail the idea of exile in Mexico. Their choice of location was limited, as Butler was "a wanted man" without a passport and Trumbo, like the other members of the Hollywood Ten, would not be able to acquire one.[40] Trumbo had considered going East but found that it would be too expensive to live there. However, he had reservations about relocating to Mexico and inquired about such diverse topics as "living costs, schools, rents, *mordito [mordida], inmigrantes* and the Virgin of Guadalupe" in a letter to Gordon Kahn, who had already settled there.[41] After corresponding with

those already established in Mexico, Trumbo became convinced that expenses in Mexico City would be only a fraction of what they were in California and that he could find work in Mexico "under the table," writing scripts for movies produced within the Mexican film industry.[42] He also learned that there was a good American school in Mexico City for his children, which for Trumbo made the idea of the "family" exile feasible.[43]

While Dalton and Cleo Trumbo's decision to relocate to Mexico was based on factors such as expenses, employment, and schools for their children, it was also related to the Butlers' interest in moving there. Although they had numerous friends who had already settled in Mexico, the connection between the two families was strong, and they believed their relationship would sustain them for the period that they remained in the country. In a letter to Hugo Butler, Dalton Trumbo wrote, "I would consider it most desirable for your family and mine to live in the same town and within a reasonable distance of each other. There are many reasons. . . . The fact that we can mutually spur each other on to work. The fact that, in movies and originals, two minds often strike sparks, provided both are hard enough, as I think is the case. The fact that we could provide for each other and broods a sort of mutual aid society in time of need or other harassment. And other reasons."[44] In another letter to Butler, Trumbo outlined a "prospectus" of their lives in Mexico, which included establishing "fronts" for their screenplays, living and working near each other, and becoming *inmigrantes,* either by finding employment in Mexico or by becoming *"capitalistos [capitalistas]."*[45]

The Trumbos and the Butlers decided to make the trip "over the border" and down to Mexico City together. They met in San Diego, spending a very short time there, as the local newspapers were filled with reports about HUAC hearings, and according to Rouverol, "Hugo's name had come up with uncomfortable frequency."[46] From San Diego they traveled across Arizona and New Mexico and crossed the border at El Paso, Texas, into Ciudad Juárez, Mexico. Although the journey was extremely difficult, Rouverol recalls in her memoirs that once they reached Mexico, the "air seemed to change, to be fresher, more free."[47]

Other Hollywood exiles joined the community in Mexico after having first gone to Europe, including screenwriter Julian Zimet and director Robert Rossen. Both Zimet and Rossen had been able to get passports in 1950 and subsequently fled to Europe to avoid being summoned to appear before

HUAC and risk going to prison. From Europe, Rossen went to Mexico to direct the film *Brave Bulls* (1951).[48] After spending 1950 and 1951 traveling around Europe, Zimet ended up in East Germany, where he wanted to develop a screenplay on the life of Martin Luther. He left after the East German film authority vetoed the project.[49] Zimet returned to the United States in the fall of 1951, bought a car, and drove it from New York City to Mexico. One of the many boxes in Zimet's car contained a collection of fifty records of African tribal music that he had been asked to bring to Spanish Civil War veteran and composer Conlon Nancarrow from the Musée de l'Homme in Paris.[50] Other late additions to the Hollywood exile community included Alice and Ian Hunter, who arrived in Mexico City in May 1952.[51]

Written Out

Similar to the film industry, the publishing industry also had a blacklist of those identified as Communists and "fellow travelers." The blacklist affected the careers of progressive editors and literary agents who worked with mainstream presses as well as the careers of authors who tried to publish with them.[52] In the early 1950s, some of these individuals found themselves unemployable. Max Lieber, whom novelist Howard Fast described as "one of the most important and best literary agents in New York," chose to leave the United States because many of his clients stopped working with him after he was named as a Communist by Whittaker Chambers during the Alger Hiss trial.[53] In Mexico, he joined one of his clients, Albert Maltz. A few years later, Howard Fast, another client, also traveled to Mexico.

Writers who had been active in the Communist Party, such as Howard Fast, the author of numerous historical novels, including *Citizen Tom Paine* (1943) and *Spartacus* (1953), were blacklisted from the publishing industry. In 1950, Fast was subpoenaed by HUAC because of his involvement with the Joint Anti-Fascist Refugee Committee, which HUAC considered to be a Communist front.[54] Citing the First Amendment, Fast refused to answer the committee's questions and was sentenced to three months in prison. While imprisoned he wrote a novel, *Spartacus*, about a slave revolt in ancient Rome. Later he sent the manuscript to numerous publishers, all of whom rejected it—a red flag that he had been blacklisted.[55] Since he could not find a publisher for *Spartacus*, Fast decided to establish his own publishing company, the Blue Heron Press.

Writers and poets like Howard Fast and George Oppen, who had been involved in the Communist Party, also suffered constant harassment by the FBI during the late 1940s and the 1950s. In Fast's autobiography, *Being Red,* he describes why his family decided to go to Mexico:

> At this point, we had lived through ten years of being Communist Party members in the United States. Our nerves were stretched thin; we lived in constant apprehension, and if the particular threat was not defined, it was still there. The main leaders of the Communist Party were in prison. The party was shrinking as the government's campaign against us took its toll, and aside from writing more or less regularly for *The Daily Worker,* my party efforts fell off. I tried to go on writing as my own publisher, but it was almost impossible. . . . I needed desperately to rest and to forget for awhile that my phone was tapped and across the street, some idiot FBI man was waiting to tail me.[56]

This type of redbaiting also contributed to poet George Oppen's decision to leave the United States for Mexico in 1950. He and his wife Mary, who had begun "an unaffiliated, short-lived protest and petition campaign against the Korean War in 1950," had reasons to fear a subpoena from HUAC and thus risked imprisonment.[57] A friend whom the U.S. government had charged with perjury decided to move to Mexico, an idea that also appealed to the Oppens at the time. Coincidentally, their friend Julian Zimet called them to ask what they thought about the idea of his self-exile in Europe, to which they replied, "We're going to Mexico next week."[58]

These individuals were joined by writers and editors employed by Communist Party publications who were told by the Communist Party of the United States of America (CPUSA) leadership to leave the country. For example, Charles Humboldt, whose real name was Clarence Weinstock, the editor of the CPUSA's art and literary journal *Masses and Mainstream,* and a poet and writer, left the United States for Mexico in 1952, as requested by the CPUSA.[59] Elizabeth Timberman, Humboldt's significant other, a photographer who had been active in the New York Photo League, went to Mexico as well after the demise of the organization in 1951, stemming from its inclusion on the Attorney General's list of "subversive organizations.[60]

Some African American writers left the United States in the early 1950s because they, like African American artists, were increasingly frustrated with U.S. racism in the postwar period and the repressive political atmosphere.[61] Willard Motley, the best-selling author of *Knock on Any Door* (1947), moved to Mexico after publishing his second novel, *We Fished All*

Night (1951). Motley had been part of what Bill Mullen describes as the "Negro People's Front" in Chicago. He was politically active in the Progressive Party in Chicago and spoke at events organized by the Chicago sector of the National Council for the Arts, Sciences and Professions, which was the successor of the Communist Party–led League of American Writers that mobilized support on behalf of the Progressive Party.[62] Years after his move, Motley stated in an interview with an *Ebony* magazine writer that he chose to live in Mexico "because there is a feeling of freedom there."[63]

The bleak view of the United States during the Cold War that Motley describes in the last novel he wrote in the United States, *We Fished All Night*, an antiwar novel, suggests why he decided to leave the United States for Mexico in 1951. Through Dave, a minor character in *We Fished All Night*, Motley demonstrated the irony of African American soldiers serving their country abroad during World War II while they were treated as second-class citizens at home. (Motley himself was a conscientious objector during World War II.) At the beginning of the last section of the novel, Motley inserts a brief account of current events in the United States during the early Cold War period: he describes America as "building a stock pile of atomic bombs," HUAC as "having a field day," and the Taft-Hartley bill as law.[64] When Motley departed for Mexico, he did not envision a permanent move there, although he remained in Mexico for the rest of his life.

The poet Audre Lorde left the United States for Mexico during the early 1950s for a number of reasons, both political and personal. Lorde had been active in progressive politics in New York, notably as a member of the Committee in Defense of the Rosenbergs. After the Rosenbergs were executed, Lorde became concerned about the political climate of the United States. She also felt marginalized by other African American writers involved in the Harlem Writers Guild, who told her that she spent too much time "downtown" with white women, as well as by her (mostly white) left-wing political friends, who became increasingly intolerant of her lesbianism.[65] In her "biomythography," *Zami: A New Spelling of My Name*, Lorde describes her experiences in New York before she left:

> In the evenings after work I . . . went to meetings with Rhea. Meetings where frightened people tried to keep some speck of hope alive, despite political disagreement, while all around us was the possible threat of dying like the Rosenbergs, or at least the threat of losing jobs or being fingered for life. Downtown at political meetings and uptown at the Harlem Writers Guild,

friends, acquaintances, and simple people were terrorized at the thought of having to answer, "Are you or have you ever been a member of the Communist Party?"

The Rosenbergs' struggle became synonymous for me with being able to live in this country at all, with being able to survive in hostile surroundings. But my feelings of connection with most of the people I met in progressive circles were as tenuous as those I had with my co-workers at the Health Center. I could imagine these comrades, Black and white, among whom color and racial differences could be openly examined and talked about, nonetheless one day asking me accusingly, "Are you or have you ever been a member of a homosexual relationship? For them, being gay was "bourgeois and reactionary," a reason for suspicion and shunning. Besides, it made you "more susceptible to the FBI."[66]

Around the same time, Lorde heard about the communities of U.S. writers and artists in Mexico from her friend Joan's fiancé, Al Sandler, an artist, who had gone to Mexico in the early 1950s. He told her how these individuals lived "unbridled by the fevered, anti-Communist hysteria of McCarthyism."[67] Sandler's description of life in Mexico appealed to Lorde, and in 1954, when she was twenty years old, she decided to move to Mexico City.

CROSSING BORDERS AND THE QUESTION OF ASYLUM

The ability of U.S. residents to seek refuge in Mexico was dependent in large part on the cooperation of the Mexican government, which had complex relations with the U.S. federal government as well as asylum seekers from the United States during the early Cold War era. While Lázaro Cárdenas had welcomed antifascist exiles from Spain and Germany as well as Spanish Civil War veterans to Mexico in the 1930s, the support of subsequent presidential administrations for left-wing Americans who attempted to gain asylum in Mexico in the late 1940s and early 1950s was complicated by the alliance between Mexico and the United States during these years. During the mid-1940s, when the U.S. exiles started to arrive in Mexico, President Miguel Alemán (1946–1952), whom historians of Mexico have designated the "architect of modern Mexico," increased industrialization and economic growth, which influenced Mexico's foreign policies.[68] While the Mexican government tried to hide its reliance on the United States, Mexico needed U.S. investment, which contributed to its support of U.S. Cold War foreign policy. Mexican presidents Manuel Avila Camacho (1940–1946), Miguel Alemán, and Adolfo Ruiz Cortines (1952–1958)

generally accepted U.S. Cold War policies, although they did not support U.S. intervention into the affairs of other countries, including their own.

While these Mexican presidents were critical of U.S. intervention into their country, agencies of the Mexican government did watch over Americans in Mexico. Alemán established the Dirección Federal de Seguridad (DFS), the Mexican secret police, which monitored left-wing Americans and Mexicans. According to historian Barry Carr, the DFS was modeled on the FBI and received telephone tapping equipment from the agency.[69] Marcelino Iñurreta, a Mexican general who had studied with the FBI, was the first director of the DFS.[70]

In the late 1940s, both the DFS and the U.S. Embassy monitored the activities of Mexicans active in the labor movement as well as individuals on the Left in general.[71] In addition to the surveillance of the Communist Party in Mexico, the U.S. Embassy watched other left-wing groups, such as the Sociedad de Amigos de Wallace (Friends of Wallace Society), whose members, according to an embassy memorandum, included artists David Alfaro Siqueiros, Diego Rivera, and Frida Kahlo, along with Narciso Bassols, active in the Partido Popular (Popular or People's Party) founded by labor leader Vicente Lombardo Toledano, and others on the Left.[72]

In addition to monitoring left-wing groups in Mexico, the U.S. Embassy and the FBI tracked the movement of alleged Communists from the United States into Mexico. In 1950, a letter from the State Department to U.S. diplomatic and consular offices in Mexico requested that they "cable any information about the whereabouts and travel plans" of Hollywood screenwriter Gordon Kahn and "refer any request for passport facilities to the State Department."[73] In a report written two months later, U.S. Embassy officials expressed their concern about the presence of "American Communists" in Mexico, including Gordon Kahn and George and Mary Oppen. This report was sent to the Secretary of State on December 28, 1950, but its contents remain classified.[74]

U.S. government officials, in conjunction with the DFS, were also involved in deporting U.S. Communists from Mexico back to the United States, apparently without the knowledge of other Mexican governmental agencies or the involvement of Mexican courts.[75] A collaboration between the FBI and the Mexican Secret Service against a member of the CPUSA occurred in the case of Morton Sobell, who was illegally deported from Mexico to the United States on August 18, 1950, and then arrested by U.S.

government agents in Texas. Sobell was accused of being a member of a "spy ring" that included Julius Rosenberg and Max Elitcher. After Sobell was deported to the United States and arrested, he was forced to stand trial. An analysis of the case by the *Columbia Law Review* noted that after the trial was concluded, Sobell "claimed that his return from Mexico to the United States had not been voluntary," stating that "he had been attacked, beaten unconscious and carried into the United States by several unknown assailants."[76] When Albert Maltz heard about Sobell's deportation, and the lack of protest against it in Mexico, he postulated that "the Mexican tradition of political asylum was somewhat like the United States tradition of free speech" in the sense that it "could arouse certain intellectuals on an abstract basis, but it would not put masses of people into motion unless it was tied up to their bread and butter."[77]

Communist leader Gus Hall was also illegally deported from Mexico to the United States. Hall, the former secretary of the CPUSA, had entered Mexico by swimming the Río Grande.[78] In Mexico he followed "secret escape routes planned by the CPUSA National Committee's underground apparatus," according to Barry Carr.[79] After Hall was tracked down and deported to the United States, he later related that "from the manner in which orders were given it was clear . . . that FBI men controlled the entire operation." He noted that when the FBI reached the border, "they faded out of the picture to make it appear as a purely Mexican immigration action."[80] While Sobell's deportation had been a complete surprise, some efforts had been made to prevent Hall's deportation. However, Hall's defenders were unsuccessful in part because the FBI and DFS moved more quickly than was expected. After Hall was deported, a demonstration of close to 10,000 people took place in Mexico City, according to Communist Gil Green.[81] In addition, the Mexican Communist Party established a permanent committee on the question of asylum. In mid-October 1951, the Comité de Defensa de Los Derechos Humanos (Committee for the Defense of Human Rights) published an advertisement that referred to the deportation as a "national shame" and a pamphlet defending Hall, condemning "Mexico's loss of national sovereignty."[82] The committee organized a public meeting that was well attended, according to Albert Maltz.[83]

The treatment of Sobell and Hall by the DFS and FBI concerned many of the U.S. exiles who chose to relocate to Mexico in the early 1950s, a fear

that manifested itself in their efforts to secure residency visas. This did not appear to be an issue for those who arrived before Sobell was deported in August 1950. In many ways, the Oppens' experience was typical of any white American tourist family who drove across the border into Mexico in 1950. The Oppens traveled by car with their daughter Linda and their pets, arriving in Mexico in June 1950. When they crossed the border, they were given three-month tourist visas, and after stopping in Chihuahua, they continued on to Mexico City. The Oppens were not concerned about the status of their visas, even with the knowledge that they would have to make somewhat frequent trips up to the border in order to declare themselves as tourists. They knew that they would be staying in Mexico for a prolonged period and that their visas could be extended more or less indefinitely.[84] By late 1950, however, U.S. exiles expressed concern about the status of their visas, stemming from the experience of Morton Sobell.[85] Those who relocated to Mexico after Sobell's "kidnapping," including Albert Maltz and Dalton Trumbo, were aware that since their tourist status meant they had only temporary residence in the country, there was a possibility they could be deported back to the United States. Maltz had become aware of illegal deportations from Mexico to the United States through individuals he met in prison while he was serving time for contempt of Congress. His fellow prisoners had told him that this was how the Mexican and U.S. governments dealt with fugitives from justice who crossed borders illegally. Maltz described these operations to fellow Hollywood Ten member Herbert Biberman in a letter he wrote from Mexico: "Since there is no formal extradition treaty between the U.S. and Mexico, the *modus operandi* has been one in which an FBI plane quietly landed at the Mexico City airport: the fugitive was then quietly arrested at gunpoint by the Mexican police in the middle of the night, hand-cuffed, taken to the airport and shoved aboard the plane. Six hours later he was in the United States in physical custody."[86] Although Maltz had also been informed by acquaintances in Mexico that "political asylum was a tradition of such depth that it united people from the far right to the far left," he was concerned because the Mexican government had not previously been subjected to as much pressure from the United States. Maltz wrote to Biberman that the Mexican people were "too complacent about the right of asylum and did not appreciate the dynamic that would be involved if and when actual political refugees from the U.S. attempted to

come here."[87] He felt that since these governments had handled criminals in such a way, the same practice could easily be applied to U.S. exiles. Thus, while the Maltz family entered Mexico with tourist visas in April 1951, they applied for *inmigrante* (immigrant, implying Mexican resident) status by the fall.[88]

Although Americans did not need passports to get into Mexico, they did need visas. All of the U.S. exiles received a tourist visa upon entering Mexico, and some, after a period of time, tried to establish primary residence there, campaigning the Mexican government for *inmigrante* status. They did this in part because Mexican law prohibited visitors from working or conducting business or even negotiations in Mexico while traveling on a tourist permit. According to the U.S. Spanish Civil War veteran James Norman (Schmidt), who authored the 1965 edition of the Mexican travel guide *Terry's Guide to Mexico*, if a noncitizen worked while on a tourist visa, he or she would be "liable to arrest, expulsion, heavy fines and/or imprisonment."[89] Thus, in order to engage in business, work, or retire in Mexico, a noncitizen had to apply for resident status.[90] The U.S. exiles' applications for *inmigrante* status required an explanation of why they had left the United States as well as their reasons for living in Mexico. In a sense, the U.S. exiles were requesting that the Mexican government provide them with asylum, since they left the United States for political reasons. *Inmigrante* status could be renewed for up to five years; after this five-year probationary period, foreigners were qualified to receive *inmigrado* status, which allowed them to work in Mexico and to own property.[91] There was also *capitalista* status, which involved transferring a significant amount of money (at least $40,000) to a Mexican bank upon entering Mexico. (Acquiring *capitalista* status made it easier to secure *inmigrante* status.) Most exiles campaigned for *inmigrante* or *inmigrado* status in part because they believed it would protect them from U.S. governmental agencies.[92]

In order to reside in Mexico, the exiles had to obey Mexican laws and could not participate in political activities of any kind, a rule that was difficult for individuals who had spent much of their adult lives involved in political activism.[93] However, they were aware that the punishment for their engagement in political activity was deportation.[94] Their letters and memoirs suggest that most did not risk their residency status by participating in clandestine political organizing in Mexico, although they would be accused

of such activity by the press and government agencies in both the United States and Mexico.

Generally, it took upwards of a year for a U.S. citizen to be granted *inmigrante* status. In the meantime, these individuals had to travel back across the U.S.–Mexico border every six months to renew their tourist visas. Leaving the country to renew visas created much anxiety for the Hollywood exiles who were concerned that they could be subpoenaed at the border and then driven to Los Angeles to appear before HUAC. Some found ways to insure that they would not encounter difficulties. George Pepper, for example, met an immigration official at the border who would distribute renewals for tourist visas in exchange for money, "a *mordida*."[95] Pepper informed others of this official, and they discovered for themselves that a little "greasing of the palms" could alleviate at least some of the stress of visa renewal.

African Americans in Mexico had a particularly difficult time with visa renewal because they crossed the U.S.–Mexican border into Texas, which meant exposing themselves to racism and segregation that was endemic in the South during the 1950s.[96] In an interview, John Wilson described how he had to cross the border into Texas every six months to get his student visa renewed. During one visit, he and his sister Eleanor went to a Texas border town (most likely Brownsville) together. Before returning to Mexico, his sister wanted to stop for a drink at a drugstore. He recalls:

> So we walk in the store, and of course Eleanor marches up to the counter and sits down. This is before Martin Luther King, before the Civil Rights. . . . And I say, "Eleanor, I don't know if this is going to go down. You're not in Boston, you know. . . ." And in any case Eleanor was indignant. So she sat down at this counter. So of course I had to sit down with her, and so we sat there, and no one of course paid any attention to us. Finally we got someone to come over and we talked to this young woman and she said, "I'm sorry, I can't serve you." And Eleanor got very indignant and said, "why not?" And started, you know, protesting in the top of her voice, and of course, in a very kind of tactful way, said, "You know, this is ridiculous. This is America. We are Americans. . . . We just fought a war about this crap, etc."[97]

Interviewed years later, Wilson remembers that they felt "angry and hostile" after this encounter, left the drug store, and "went across to the Mexican side, sat down and had a drink." He remarks further: "[H]ere I went, 'back to my native land' and had to go into this foreign country to feel like a human being. And I felt just like that. I felt like a foreigner in my own country."[98]

Willard Motley had a similar experience when he traveled with his mother and a friend to the border to renew their tourist cards, which he described in a chapter entitled "The States Again" of "My House Is Your House," a nonfictional (unpublished) manuscript that he wrote in the 1950s. Motley notes that their difficulties occurred after crossing the border into Texas. When the train pulled into Laredo, they went to town to get a hotel room for the evening. After hours of searching the town with a Mexican cab driver, they came upon a shabby hotel where they were allowed to stay. Once registered in the hotel, they went to look for a restaurant. After being denied service at a number of restaurants in town, they found a small Mexican restaurant along "skid row" where they could eat. The next day, they discovered that the Mexican restaurant where they had been served the day before was closed. Motley remarked:

> We had nowhere to eat, aliens in our own country and I could not but think with an ironic smile:
>
> > There is the church. The government buildings. The flag. How loud and in a world-wide voice they talk about American democracy— yet, once back in the States, once across the narrow little river, we had to search around corners and down alleys to find a place to sleep. The church. The government buildings. The flag. But there's no place here for a Negro to eat.[99]

Between descriptions of their stay in Laredo, Texas, Motley repeats two sentences over and over again: "This the land of my birth. This my native land," conveying his shock regarding the treatment of African Americans in the United States, as compared with Mexico.[100]

FROM THE IMPERIAL HOTEL TO CALLE DE INSURGENTES

The settlement of the U.S. exiles in Mexico occurred in stages. Most began their Mexican habitation in Mexico City in *pensiones,* or hotels, gradually settling into residential areas. Some relocated to Cuernavaca, where communities of Spanish Civil War refugees had already been established. When Audre Lorde arrived in Mexico, she lived in hotels in Mexico City, starting with the Formos, which she described in her journal as "a third-rate hotel in the heart of the Districto Federal."[101] She soon switched to the Hotel Fortín, which had been recommended by Al Sandler. Before starting classes at the National University of Mexico, she traveled to Cuernavaca, about forty-

five miles south of Mexico City, where a group of U.S. Spanish Civil War veterans and nurses who had been granted citizenship in the early 1940s had established a community. Lorde described the town of Cuernavaca years later as having "earned a name as a haven for political and spiritual refugees from the north, a place where American middle class non-conformists could live more simply, cheaply, and quietly than in Acapulco or Taxco, where all the movie stars went. A small beautiful town, largely supported by the expatriates from many different countries who live there."[102] In Cuernavaca she met up with Frieda Matthews, an American nurse who had served in the Spanish Civil War and who was an acquaintance of Lorde's friend Ruth Bahras. After visiting Cuernavaca, Lorde decided to move there.

Those who came from California, from Hollywood and elsewhere, settled in different sections of Mexico City, including San Angel and Lomas de Chapultepec, as well as in Cuernavaca. John Bright, one of the first Hollywood exiles to reach Mexico City, remembers the procession of arrivals in the early 1950s, "I registered in the Imperial Hotel down there, and one by one, they all came, and everybody on the blacklist . . . passed through the Imperial Hotel. Why at one time, 14 of the 16 apartments in the place were occupied by blacklistees." Bright remembers that soon after their arrival, "the *Mexico City News* got wind that we were there and ran a story on us, who we were, and so on. So when the news broke, the clerk at the Imperial found out all his tenants, who he thought were Hollywood big shots, were just lepers in disguise."[103] After leaving the hotel, the filmmakers scattered throughout Mexico City and Cuernavaca. Their decisions about where to live were largely dependent on their income. The Oppens were one of the first exiled families to settle in San Angel, originally a small village south of Mexico City that eventually became incorporated into the larger city. Mexicans considered it to be an upper-middle-class neighborhood, although it was viewed as inexpensive by American middle-class standards.[104] However, it was less expensive than upper-class neighborhoods like Lomas de Chapultepec, where Hollywood exiles such as the Trumbos, the Butlers, and the Lardners resided. Within a year after their arrival in Mexico, the Butlers moved into a house in San Angel previously occupied by television producer Bob Heller and his wife Jeanne.[105] This house was owned by artist Juan O'Gorman; their next-door neighbor was Diego Rivera.

Some of the Hollywood exiles moved directly to Cuernavaca. Although he did not settle there, Dalton Trumbo had been informed, presumably by a Hollywood colleague, that Cuernavaca was "a little cheaper than Mexico City," which could be part of the reason why some chose to reside there.[106] A highway linked Cuernavaca to Mexico City, making the urban center accessible to those who lived there. Albert Maltz, who settled in Cuernavaca in 1951, described the city in a letter to Herbert Biberman: "Just as Paris remains very wholly the city of its French inhabitants no matter the number of tourists, so this town is Mexican, and the percentage of Americans is still quite small. There are more Mexican *turistas* here, or sojourners from Mexico City, than Americans."[107] The fact that the town had a life of its own, other than tourism, was important for the U.S. exiles who settled there. However, they found that their friends who came to visit from the United States acted as if their hosts were on a kind of extended vacation. "*Turista* fatigue" is noted by Albert Maltz in a letter he wrote to friends and associates in the United States asking that they not give his address "to any prospective visitors unless you know them to be our old friends, or unless they are friends of yours and you feel certain we'll be especially anxious to meet." He also warned them not to "tell casual friends that they should look us up in Cuernavaca."[108]

The adjustment of the U.S. exiles to life in Mexico was enabled by those already living there who helped the more recent members of the exile communities establish themselves in their new environment. Elizabeth Catlett was an anchor for many African American artists who went to Mexico in the 1940s and 1950s. Catlett herself had settled in Mexico in 1947 after divorcing Charles White and moving in with Taller member Francisco (Pancho) Mora, whom she married. In 1950, when John and Julie Wilson arrived in Mexico City, Catlett introduced John Wilson to artists at the Taller de Gráfica Popular, including Nacho Aguirre, Pablo O'Higgins, and others.[109] The Wilsons stayed at a *pensión* that was at that time primarily inhabited by Spanish refugees. John Wilson remembers discussing politics with the refugees, who shared many of his political interests. Margaret Taylor Goss Burroughs, who had lived with Catlett during the early 1940s in Chicago, contacted Catlett in 1952 to help her family establish themselves in Mexico. Catlett located an apartment for Burroughs in the same building where John and Julie Wilson had moved. Burroughs noted in an interview that "we found an apartment in a building with practically all Mexicans . . .

living there really helped us develop our ability to understand and speak the Spanish language."[110] Burroughs enrolled at Escuela de Pintura y Escultura de la Secretaría de Educación Pública (National School of Painting and Sculpture), known as La Esmeralda, when she arrived. Catlett helped Burroughs to become a guest member of the Taller de Gráfica Popular, where Burroughs befriended artists in the collective who helped her develop her work in lithography and linoleum printing.

Those relocating from California had their own network. When the Oppens arrived in Mexico City, they called the Allens, whose address had been given to them by their friend Julian Zimet.[111] As Mary Oppen describes in her memoirs, "We were received cordially, and with all the information and attention we needed, we began to find our way to Mexico City's United States émigré and refugee circle."[112] Similar to the Oppens' experience, many of those who arrived in Mexico City in 1951 had contacts there who could aid them as they settled in. Years later, Jean Rouverol wrote, "At first, until we learned our way around, our *cicerones* [tour guides] were George and Jeanette Pepper, a bright, knowledgeable couple down from Hollywood long enough to have picked up a certain amount of expertise in Mexico."[113] Later, once these individuals had established themselves, they assisted others. In order to accommodate newly arriving political refugees from the United States, the Oppens moved into a thirteen-room apartment over the San Angel post office. Almost as soon as they had settled in, screenwriter Bernard Gordon and his family arrived and moved in with them.[114] When Spanish Civil War veteran and former opera singer Bart van der Schelling relocated to Mexico with his wife Edna Moore, they moved in with fellow veteran and composer Conlon Nancarrow. Similarly, artist Phil Stein and his wife Gertrude lived for awhile with artist José Gutierrez and his wife Ruth. The Steins, van der Shelling, and Moore eventually moved to an apartment building on Calle de Insurgentes (Insurgents Street). At least twelve families from the United States lived in two apartment buildings on the street.[115]

THE EXILE COMMUNITIES

While some of these individuals socialized solely with one another, others met and befriended exiles from Spain, Germany, and elsewhere, in addition to Mexicans. The U.S. exiles chose their friendships with much consideration. Some avoided certain individuals socially, such as members of various left-wing political parties in Mexico, because they were concerned that they

would be accused of involvement in political activity. Many of these individuals had been harassed by U.S. governmental agencies while living in the United States, a situation that continued in Mexico, taking the form of their being "named" as Communist Party members in local newspaper articles, which they feared would affect their applications for residency. For example, Willard Motley met numerous U.S. artists and writers at a party he hosted early on during his habitation in Cuernavaca. However, he learned that socializing with other Cold War exiles could bring unwanted attention in the form of exposés about "Reds in Cuernavaca" published in Mexican newspapers such as *Excélsior*.[116]

Although the exiles could not prevent these articles from appearing in local newspapers, some were cautious about their associations. Motley did not spend time with other U.S. artists and writers following the articles that appeared in *Excélsior*. Albert Maltz initially avoided Communist artist David Alfaro Siqueiros because he was concerned that he would be targeted as an active Communist in Mexico. Maltz's wariness was perceptive, as the FBI monitored Mexican labor leaders, members of the Mexican Communist parties, and the U.S. exiles with whom they associated. When Mexican American union organizer and political activist Bert Corona went to Mexico City in 1951 to attend an international conference of mineworkers, he stayed with Diego Rivera, who was being watched by the FBI. As Corona remembers, "agents had rented the house across the street and had cameras in the window, photographing anyone who visited Rivera, especially those who looked American."[117]

Some friendships that had existed in the United States disintegrated when they were transplanted to a different political context. When Julian Zimet arrived in Mexico City in October 1951, he stayed with his friend Bob Allen, who worked for the Associated Press. Allen had specifically warned Zimet not to join the community of Hollywood exiles because of the "Red" taint that local newspapers had associated with individuals such as Albert Maltz and Gordon Kahn.[118] Thus, Zimet socialized solely with individuals outside the Hollywood community; since Zimet lived in Mexico City, and Kahn and Maltz lived in Cuernavaca, he could easily avoid them. Because of Zimet's distance, Maltz and Kahn grew suspicious of him, and so when Zimet had tried to visit them in Cuernavaca months later, they would not speak with him because they assumed that he was an in-

former hired by the U.S. Embassy. According to Zimet, their suspicions "spread through the Hollywood community."[119] This affected his interactions with all members of this community for a long time.

Zimet's distance from the Hollywood faction encouraged him to meet and befriend other exiles during his early years in Mexico. He regularly played poker with a group that included the Allens and the Oppens, as well as Conlon Nancarrow, Bart van der Schelling, and German émigré Luis Lindau. Allen's warning to Zimet about associating with "Reds" in Mexico did not significantly affect his relationship with the Oppens, friends from his Southern California days, with whom he had been corresponding while traveling around Europe in the early 1950s. Although the Oppens were being watched by both U.S. government agencies and the Mexican Secret Service while living in Mexico, they had not been associated with the "Hollywood Reds" and thus had stayed out of the "limelight" of the Mexican press.[120] However, Zimet remained cautious as to whom he appeared with in public and would only meet the Oppens outside of Mexico City at designated points in the countryside.[121]

In addition to the "poker group," the U.S. exiles formed numerous social groups. One group centered around the Hollywood exiles, including the Maltzes and the Kahns, who resided in Cuernavaca, and the Butlers, the Trumbos, and the Peppers, who lived in the residential areas surrounding Mexico City. Jean Rouverol remembers that the first drive they took on the Old Cuernavaca Highway "was to visit the refugees who had chosen to settle there, including the Kahns and the Maltzes."[122] Those in the Mexico City area played baseball together on Saturday mornings. After the games, the adults would sing folk songs and socialize.[123]

The Hollywood exiles also met individuals outside the U.S. refugee community through work collaborations or mutual artistic and political interests. Through their work on the film *The Adventures of Robinson Crusoe*, Hugo Butler and George Pepper became friends with Spanish exile filmmaker Luis Buñuel and collaborated with him on other film projects. Due to his interest in pre-Columbian artifacts, George Pepper befriended artist Miguel Covarrubias, who was an expert in the field. While he had initially avoided interacting with Mexicans involved in left-wing political parties, over time Albert Maltz met Mexican artists involved in Taller de Gráfica Popular, as well as cinematographer Gabriel Figueroa.

As I argued at the outset of this chapter, the reasons the U.S. exiles went to Mexico, as well as their experiences settling in Mexico City and Cuernavaca, affected their relations with individuals both within and outside the exile communities. In the chapters that follow, I examine how some of the U.S. exiles' collaborations with artists and filmmakers in Mexico influenced their cultural work. In chapter 2, I analyze the visual artwork of U.S. artists, including Elizabeth Catlett, Charles White, John Wilson, and Margaret Taylor Goss Burroughs, all of whom either became guests or full members of the Taller de Gráfica Popular working alongside U.S. and Mexican artists.

2
The Politics of Form
African American Artists and the Making of Transnational Aesthetics

Many of the African American visual artists who moved to Mexico did so because of a passionate attraction to Mexican art. Most had encountered the work of Mexican muralists and printmakers in the United States and chose to move south of the Río Grande because of their knowledge and interest in Mexican art. Their already established familiarity with an aspect of Mexican culture distinguished them from most U.S. exiles who relocated because it seemed the course of least resistance and a matter of practical choice. This difference significantly affected the particular way in which Mexican culture would subsequently contribute to changes in the work of the exiled African American artists. And yet, these ensuing changes would not have been the substantial transformation that they were had their encounter with Mexican art been a casual interest or even an avid inclination from afar. The context of artistic production—most notably the collaborative working environment of the graphic arts collective the Taller de Gráfica Popular (Popular Arts Workshop)—and the African American artists' interactions with Mexican artists helped them to make creative sense of their exile and profoundly impacted the themes and aesthetics of their artwork.

The art of Elizabeth Catlett and John Wilson provide especially remarkable examples of the transformation of African American cultural production in Mexico. Their efforts to depict the experiences of African Americans in the United States through Mexican-derived cultural forms and techniques produced a deliberately transnational artistic practice in opposition to the style of art promoted abroad by the U.S. State Department as quintessentially American. Although both Catlett and Wilson represented African

American experiences using aesthetic conventions and methods they learned in Mexico, they drew upon different sources for inspiration. Catlett's collaborations with artist members of the Taller de Gráfica Popular influenced her approach to the process of production as well as the form and content of her work. Artmaking as a collective endeavor, as well as printmaking for popular distribution, had a decisive effect on her art. Wilson also worked for many years with the Taller de Gráfica Popular, but it was his interest in and exposure to the murals of José Clemente Orozco that most significantly influenced changes in his work. Catlett and Wilson, along with Charles White and Margaret Taylor Goss Burroughs, spent time in Mexico making explicitly politically engaged art. Their work provided an influential model for other African American artists who remained in the United States during the 1950s and 1960s. Moreover, this work articulated a decidedly critical transnational aesthetic through its fusion of representational techniques, multiple audiences, and thematic transpositions.

The connections forged between African American and Mexican artists after World War II was influenced by the previous association between African American and Mexican artists during the two decades following the Mexican Revolution. Leading artists of the Mexican school, such as José Clemente Orozco, David Alfaro Siqueiros, Diego Rivera, and Miguel Covarrubias, went to the United States during the 1920s and 1930s either to create or to exhibit their work.[1] During this same period, U.S. artists also traveled to Mexico. According to Mauricio Tenorio-Trillo, it was during the 1920s and 1930s that "Mexico . . . represented a season of revolutionary fascination, primitivism, and social hope to modernist and radical activists, artists, and writers."[2] Although James Oles declared this season to have passed by the post–World War II period, a significant number of artists, many of whom were African American, went to Mexico during the 1940s and 1950s.[3]

In order to understand the effect of Mexican artists on African American artists in Mexico in the 1940s and 1950s, it is necessary to highlight connections forged between African American and Mexican artists in the United States after the Mexican Revolution. In this chapter, I explore these associations by examining the role of the John Reed clubs in the 1920s, the Works Progress Administration's (WPA) Federal Art Project of the 1930s, as well as the influences of Mexican artists on African American artists in

New York and Chicago during the 1940s. I then describe how the visual artwork of African American artists developed in Mexico and how this context impacted their artistic practices as well as their production process. I begin with an account of how Catlett in particular was drawn to the work of Mexican artists in order to provide, through her example, a detailed sense of the dynamics of this appeal and development of this interaction in the United States. I then focus on the work of Catlett and John Wilson in Mexico, looking specifically at the influences of the Mexican muralists, as well as of artists at the Taller de Gráfica Popular, on the content and the aesthetic qualities of their work. Finally, I analyze the effect of the Mexican context on African American artists in Mexico and how it enabled them to imagine ways both to distribute their work to African Americans and to aid other African American artists once they returned (either temporarily or permanently) to the United States. Their experiences demonstrate how working in Mexico contributed to a transnational perspective that was in opposition to dominant Cold War culture.

REVOLUTIONARY ASSOCIATIONS

In *The Cultural Front,* Michael Denning argues that the culture of the Popular Front "transformed the ways people imagine the globe." Artists affiliated with the Popular Front in the United States drew inspiration from "international stories" as well as from artists in other parts of the world. As Denning describes it, "the romance of the Revolution was manifested not only in the popularity of the Soviet films of Eisenstein and Pudovkin, but also in the romance of the Mexican Revolution, embodied in the grand murals of Diego Rivera and José Clemente Orozco."[4] Numerous U.S. artists were influenced by the Soviet's Prolecult movement and by the work of Mexican artists creating public art, such as making murals or working in a collective context on printmaking projects.

The John Reed clubs, developed by artists and writers in the late 1920s and early 1930s, were an early forum for this "left internationalism" within the United States. In forming the clubs, these artists and writers attempted to implement the Soviet model of workers' collectives, the Prolecult program, in the United States.[5] The John Reed clubs organized exhibitions comprising the work of artists from around the world; invited filmmakers such as Sergei Eisenstein and artists such as David Alfaro Siqueiros and Diego

Rivera to present their work on occasion to club members, and brought these individuals and others to speak at conferences they organized, including the American Artists Congress in 1936.[6]

The Mexican muralists and graphic artists were some of the most significant "international" influences on left-wing U.S. artists during the 1930s. By this time, the works of *los tres grandes,* Orozco, Rivera, and Siqueiros, were well known within (proletarian) avant-garde art circles in the United States. The Mexican muralists were also influenced by the proletarian cultural movement that emerged within the Soviet Union following the Russian Revolution. While "the big three" held distinct ideological viewpoints, all took up the call for the establishment of art from the point of view of the working class. As a member of Sindicato de Obreros Técnicos, Pintores y Escultores (Union of Technical Workers, Painters and Sculptors), Siqueiros edited a manifesto for Mexican artists, which was signed by Rivera, Orozco, and others, and published in the union's paper *El Machete* in June 1924. In it, Siqueiros stated that "the art of the Mexican people . . . is great because it surges from the people; it is collective, and our own aesthetic aim is to socialize artistic expression, to destroy bourgeois individualism."[7] Not only was it important for these Mexican artists to think about producing work collectively; they were also interested in the relation of their artwork to their audiences, whom they imagined as the impoverished, working-class, and indigenous populations of Mexico. They wanted to create public art that would be located in the environment of these groups rather than easel painting, which was only available to the elite classes who attended museums and galleries.

However, as is evident from the manifesto, Siqueiros and others believed that their art should take up not only a *working-class* perspective but a specifically *Mexican* perspective as well. Siqueiros's viewpoint emerged in part from the context of the Mexican Revolution. He had been part of a congress of "soldier-artists" who decided in 1919 to send him abroad. In 1921, Siqueiros wrote a manifesto in Barcelona in which he argued for a new revolutionary art, which Miguel Covarrubias described as "based on the constructive vitality of Indian art and decrying outworn European ideals."[8] During the same year, Rivera painted his first mural in Mexico. According to Shifra Goldman, Rivera was primarily concerned with two issues in his work: "the need to offset the contempt with which the *conquistadores* had viewed the ancient Indian civilizations, and the need to offset the anti-

mestizo and anti-Indian attitudes of the European-oriented ruling classes during the *porfiriato* (the dictatorship of Porfirio Díaz)."[9] Goldman further explains that "the role of the arts was to restore understanding of and pride in the heritage and cultures that the concept of Spanish superiority had subverted. Postrevolutionary *indigenista* philosophy appeared in the work of writers, musicians, filmmakers, sculptors, and painters as a facet of Mexican nationalism."[10]

During the early 1920s, Mexico was beginning to experience an "artistic renaissance" underwritten in part by José Vasconcelos, the Secretary of Education from 1921 to 1924. Vasconcelos believed that the government should fund public art—and specifically public murals "characterized by an emphasis on indigenism, folk characters, and historical epics; solidarity with the dispossessed; dramatization of class conflicts, mockery of egotism and hypocrisy of those in power; and a celebration of traditional rites and myths," according to Raquel Tibol.[11] It was Vasconcelos who, in the wake of the Revolution, called on artists to "remake" Mexico by creating and reconstructing forms of popular art, drawing from the pre-Hispanic and colonial periods to Mexican independence and later the Revolution.[12]

While the work of the muralists was influenced by notions about art and art production that were developing in the Soviet Union, social realism in Mexico can be differentiated from Socialist realism. David Shapiro provides a useful differentiation between the two genres: "Social realism, opposed to the ruling class and its mores, predominantly selects as its subject matter the negative aspects of life under capitalism: labor conflicts, poverty, the greediness of capitalists, the nobility of long-suffering workers." However, he asserts that "Socialist Realism, as it has developed in the Soviet Union, supports the ruling class in the form of government. It selects as its subject matter the positive aspects of life under socialism: happy, cooperating workers, the beauty of factory and countryside, well-fed, healthy children, and so on."[13] Shapiro describes Mexican social realism as demonstrating "both the struggle of the people to gain control of the means of production and some of the fruits of that power."[14] Furthermore, Mexican artists drew from numerous aesthetic traditions, which included Renaissance classicism, expressionism, fauvism, and cubism.[15] Shifra Goldman argues that "the language the Mexicans introduced . . . was the pictorial dialect of social realism, which they raised to the highest level of artistic development—in contrast to the visual clichés of Soviet Socialist realism."[16]

By the mid-1930s, the influence of the Mexican muralists had gone beyond avant-garde circles into broader U.S. culture, the outcome of the federal government's relief projects developed during the first New Deal. Simultaneously, as the Communist Party of the United States of America (CPUSA) launched the Popular Front in 1935, many of the John Reed clubs disbanded. This had a two-pronged effect. First, members of John Reed clubs became involved in Federal Art Projects. Many in fact viewed their participation in these projects as an opportunity to create "art for the people." Second, members of the John Reed clubs channeled their energies into Popular Front organizations, such as the American Artists' Congress, which was established in the fall of 1935. The congress featured the first exhibition of the Taller de Gráfica Popular in the United States and was attended by Orozco and Siqueiros, as well as by the African American artist Hale Woodruff who had worked in Mexico with muralists during the early 1930s.[17]

The Federal Art Projects sponsored in the early 1930s drew inspiration from the relationship between Mexican muralists and the Mexican government. Painter George Biddle, a friend of Franklin Delano Roosevelt, advised the President that the government should sponsor public works of art. Biddle based this suggestion on his observation of Mexican muralists during a visit to Mexico in 1928.[18] As a response to protests led by unemployed artists in 1932, Roosevelt decided to implement a public art program. In 1933, the FDR administration established the Public Works of Art Project (PWAP).[19] The PWAP, which ran through the U.S. Treasury Department with support from the Civil Works Administration, hired artists to create murals throughout the country. While the PWAP lasted for little more than six months, it employed close to four thousand artists during that time, most of whom were of European descent.[20] Two years later, with word from Roosevelt that supervisors not discriminate in their hiring of artists, the WPA's Federal Art Project was set up under Harry Hopkins as Federal Project Number One. The Art division of the Federal Art Project was split into eight sections: murals, easel painting, photographs, sculptures, graphics, posters, motion pictures, and the Index of American Design.[21] The WPA's Federal Art Project ran for eight years, between 1935 and 1943, although it was constantly under attack by politicians and citizens who did not believe that the government should be running relief programs for artists.[22]

Some African American artists were introduced to the work of Mexican artists through their involvement in the Federal Art Project. Through the WPA's Federal Art Program–sponsored community arts centers, the U.S. government provided support for working-class Americans, many of whom were immigrants, children of immigrants, or African American.[23] In total, sixty-seven WPA-funded community arts centers were erected throughout the United States. Some of the most successful WPA-funded community arts centers were those established in large cities in the North, particularly in African American neighborhoods, including the South Side Community Arts Center in Chicago and the Harlem Community Arts Center in New York City. Members of the Harlem Arts Guild—including Vertis Hayes, a student of Jean Charlot; Augusta Savage; and Charles Alston—helped develop the WPA-sponsored Harlem Community Arts Center, which was founded in 1937.[24] (Partial funding for materials came from the Harlem Arts Committee, which was led by A. Philip Randolph.) The Harlem Community Arts Center was one of four centers in New York and eventually became the largest WPA-sponsored community arts center in the United States, enrolling fifteen hundred students.[25] It was in a WPA-funded art class taught at the "306" arts center established by Charles Alston and sculptor Henry Bannarn at a former stable at 306 West 141 Street in New York that the young artist Jacob Lawrence learned about the work of the Mexican muralists and the Chinese woodcut artists, as well as that of Käthe Kollwitz and George Grosz.

Romare Bearden contends that there were three groups of artists whose work interested African American artists during the 1930s and 1940s. The first group consisted of "regionalist" artists, including Grant Wood and Thomas Hart Benton, whose art can be characterized by its "realism" and attention to American subject matter. The second group consisted of "socially conscious" representational artists, such as Ben Shahn and Philip Evergood. The third group was composed of Mexican muralists and printmakers. Bearden suggests that African American artists were drawn specifically to the work of Mexican muralists because of the "Mexican concept of aiding uneducated, impoverished peasants by depicting their revolutionary past." He further remarks that "this approach seems applicable to their own relationship to their own poor, oppressed people" and to the artists' interest in representing African American history.[26] In addition, Mexican muralists

created murals that focused on racial discrimination in the United States. Of course, other artists, such as Käthe Kollwitz and George Grosz, appealed to African American artists because of their social commentary, but as was the case with artists like Jacob Lawrence, it was the content of the Mexican artists' work that "most excited and influenced" them.[27]

Some African American artists, including Hale Woodruff, had visited Mexico in the 1930s to study with Mexican muralists. However, during the 1930s, most of these artists encountered the muralists and their work in the United States through assisting or studying with (or working with, as in the case of the PWAP or WPA murals) individuals who had collaborated with the Mexican muralists.[28] For example, Charles Alston, who was one of the first African American supervisors hired by the WPA, met Diego Rivera while he was painting *Man at the Crossroads* at Rockefeller Center.[29] Alston, who painted murals at Harlem Hospital in 1936, noted in an interview that he was "very much influenced" by Rivera's mural work.[30] Charles White had been introduced to the work of the Mexican muralists in art school as well as while working on the Mural Division of the Illinois Federal Art Project.[31] African American artists were also aware of the work of Mexican artists in the Taller de Gráfica Popular. Artists from the Harlem Arts Guild exhibited their work alongside that of artists in the Taller de Gráfica Popular during the New York World's Fair of 1939.[32]

The work of the Mexican muralists appealed to African American artists, Bearden noted, for the manner in which they "used historical subjects to educate their illiterate and impoverished people on social issues."[33] What was also similar between the work of these Mexican and African American artists was that although they were influenced by the themes, content, and style of artists in the Soviet Union, they did not privilege class over racial issues in their work. In their WPA artwork, African American artists reinterpreted U.S. history, exploring the significant contributions that African Americans have made within the United States in much the way Mexican muralists explored the contributions of indigenous people to the Mexican state. Some of Charles White's most well-known WPA murals, including *Five Great American Negroes* (1939) at the Chicago Public Library, are concerned with aspects of African American history. Representations of African American resistance can also be seen in other WPA murals, such as Hale Woodruff's *Mutiny Aboard the Amistad, 1839* (1939).

As described in chapter 1, the decline in government support for artists began in the late 1930s and significantly affected African American artists. With the demise of government support for artists, African American artists continued to create murals but with funding from private institutions, including black colleges and black-owned businesses in the 1940s. Stacy Morgan notes that Charles White's work at Hampton University on politically engaged themes following the decline of government sponsorship provided him with "a relative safe haven from the red baiting of the Dies committee, and later the House Un-American Activities Committee."[34] However, with a turn in the art world from "socially conscious" representational artwork to abstraction in the 1940s, African American artists became increasingly marginalized. At this point, African American artists looked for opportunities abroad, with most choosing to go to Paris or Mexico City.

TRANSNATIONAL COLLABORATIONS

Elizabeth Catlett's relocation to Mexico in the mid-1940s had a profound impact on her art practice. Her artwork changed significantly through her collaborations with Mexican artists at the Taller de Gráfica Popular and by her training at the Escuela de Pintura y Escultura de la Secretaría de Educación Pública, known as La Esmeralda, in Mexico City where she studied with sculptor Francisco Zúñiga.[35] Not only did Catlett incorporate techniques employed by artists at the Taller de Gráfica Popular into her work, but their art also strengthened her interest in portraying both the history and contemporary life of African Americans in the United States.

Like many African American artists of the 1930s and 1940s, Catlett's interest in the work of Mexican artists had begun many years before her decision to establish permanent residence in Mexico in 1947. Catlett was first introduced to the work of Mexican artists while a student at Howard University in the 1930s, when her teacher, James Porter, arranged for her and another student to paint a mural as part of the PWAP in Washington, D.C. In doing research for that project, Catlett familiarized herself with the work of Mexican muralists. As Melanie Herzog writes, Catlett was attracted to the work of the muralists because of "their social commitment, direct engagement with the experiences of ordinary people, deliberately accessible style, and choice of medium."[36]

It was in Chicago that Catlett first became involved in a community of socially engaged African American artists for whom the work of Mexican muralists suggested an inspiring model of politically committed art practice. This contact with African American artists influenced Catlett's artwork as well. Bill Mullen notes that between 1941 and 1945, "Mexican lithographic and muralist technique was beginning to inform a revision of her classical art school training."[37] After her graduate work in Iowa, Catlett taught at Dillard University, a new WPA-funded black college in New Orleans. During the summer, she went to live in Chicago, rooming with Margaret Taylor Goss Burroughs, who was instrumental to the founding of the South Side Community Arts Center, in the early 1940s. The South Side Community Arts Center was sponsored by the WPA-funded Illinois Art Project, the successor to the Federal Art Project.[38]

Scholars have referred to the period from the mid-1930s to the late 1940s as both a Chicago "renaissance" in the literary and visual arts and, as Mullen has argued, a Negro People's Front.[39] Many of the artists and writers involved in the South Side Community Arts Center were members of the Communist Party, including Margaret Taylor Goss Burroughs and Charles White, who later became Elizabeth Catlett's husband. Although Catlett was not directly affiliated with the Center, she became part of a lively community of African American artists who had been involved with it.[40] In addition, Catlett socialized with other African American writers, poets, dancers, and intellectuals who met frequently to discuss their work.[41]

Catlett moved to New York with White in 1942 to study printmaking at the Art Students League and there became increasingly drawn to social realist graphic design. In New York, they joined a community of African American artists, including Jacob Lawrence, Gwendolyn Bennett, and Charles Alston, who had been involved in WPA-sponsored community art centers such as the Harlem Community Arts Center and the 306 arts center.[42] While studying lithography at the Art Students League with Raúl Anguiano of the Taller de Gráfica Popular, Catlett also met other Taller members, including José Chávez Morado and Ignacio Aguirre, who had traveled to New York to exhibit the work of the collective.[43]

Catlett's work in the early to mid-1940s at the George Washington Carver School, a community school for working people in Harlem, was the culmination of her engagement with politically active and artistic African

American communities in Chicago and New York.[44] Bearden and Henderson write that the art classes held at the Carver School were an effort to continue the prewar WPA-sponsored Harlem Community Arts Center.[45] The Carver School, directed by Gwendolyn Bennett, a writer and painter, had the support of prominent figures in the arts and in progressive politics in Harlem.[46] It was, in the words of Catlett biographer Samella Lewis,

> a community school—certainly one of the earliest of its kind—that addressed the needs of the neighborhood working class, those whose lives were unfulfilled economically, politically, socially and culturally. The curriculum was an experimental hybrid of continuing and alternative offerings—popular and classical music, practical economics, literature, photography... that went beyond the studies to build pride and confidence in those whom the rigid, traditional school system had failed.[47]

While working at the school as a promotion director and fundraiser as well as teaching sculpture and dressmaking, Catlett decided to create a print series about the contributions of African American women. In an essay she wrote years later, Catlett describes how her concept of *The Negro Woman* series (1946–1947) was shaped by her experiences at the Carver School, where she interacted with women who were of a class background different from her own. Her conversations with working-class women inspired Catlett not only to include well-known African American female figures in her series but also to show the contributions of average working-class African American women.[48]

Catlett applied for a grant from the Julius Rosenwald Foundation in 1945 to create a series of prints on the "role of Negro women in the fight for democratic rights in the history of America," which she planned to show to African American audiences throughout the United States.[49] When her grant was renewed for another year, Arna Bontemps, a committee member, told Catlett to leave New York so she could complete the work.[50] Catlett left in part because she believed that "the New York art scene offered no opportunities for a black woman."[51] She chose to go to Mexico after meeting some artists from the Taller de Gráfica Popular while they were in New York exhibiting their work. These artists, including José Chávez Morado, encouraged Catlett to come to Mexico and join their collective. Chávez Morado had in fact given Catlett contact information for David Alfaro Siqueiros's mother-in-law, who ran a rooming house in Mexico City.

After hearing that there was a room available, Catlett made plans to go to Mexico. She and White arrived in Mexico City in 1946, where they both became guest members of the Taller de Gráfica Popular.[52]

Catlett's decision to go to Mexico was related to her interest in and knowledge of the work of Mexican artists, including the muralists and those involved with the Taller de Gráfica Popular. She knew, for example, that the Taller de Gráfica Popular produced inexpensive, reproducible art for the people of Mexico, and she was intrigued by the idea of being part of a collective. Catlett also wanted to work in a context where she could create public art. The immediacy and accessibility of printmaking allowed the Taller artists to address current events in their work, and thus they took on more specific subject matter than did the Mexican muralists. They had also been more independent from government funding than were the muralists.[53]

The Taller de Gráfica Popular developed out of the split between artists and writers who made up the Liga de Escritores y Artistas Revolucionarios (League of Revolutionary Writers and Artists, or LEAR).[54] LEAR was founded in the 1930s at the beginning of the administration of Lázaro Cárdenas as an activist organization that included politically engaged artists, writers, and intellectuals in Mexico City. While the leadership of LEAR had ties to the Mexican Communist Party, it was not a requirement that those who joined be members. However, as Deborah Caplow notes, when the organization was established in the early 1930s, members "followed the directives of the Sixth Congress of the Communist International of 1928, which emphasized the class struggle and encouraged working classes in all countries to rise against the ruling classes, with the slogan 'Class against class.'"[55] The organization developed ties with groups of artists, writers, and intellectuals in different countries, including the John Reed clubs in the United States, making LEAR an international organization. By the mid-1930s, tensions developed in LEAR as a result of a decrease in government support for the League and because of conflicts between LEAR members. Luis Arenal, Pablo O'Higgins, and Leopoldo Méndez left the organization to found the Taller de Gráfica Popular in 1937.

The LEAR artists who established the Taller de Gráfica Popular brought a new model of artistic practice to the group, creating prints primarily for the poor and working-class communities of Mexico. In their turn to printmaking, the Taller artists drew on a tradition of Mexican printmaking that dated back to the nineteenth century, specifically to the work of printmaker

José Guadalupe Posada (1851–1913). Posada's work consisted in part of illustrated *corridos*, epic ballads that were sold all over Mexico. The sheets, printed on cheap paper, were the primary way that the working classes became exposed to current events.[56] Posada was known for his *calavera* (skeleton) prints, a uniquely Mexican form of popular art. Through his *calavera* images, Posada satirized both politicians and other prominent figures in Mexican society.

While the cofounders of the Taller de Gráfica Popular were all influenced by Posada, it was Taller member Leopoldo Méndez whose work most emulated his politically engaged printmaking style.[57] Méndez started publishing satirical prints in *Frente a Frente* (Head to Head), the newspaper published by LEAR, in the 1930s. These images referenced and reworked Posada's style and imagery in response to contemporary political concerns, which, as Caplow argues, contributed to "a new genre in Mexican art"— the "Mexican political print."[58] Caplow suggests that like the work of Leopoldo Méndez, the prints that the Taller de Gráfica Popular produced drew on both Mexican and international sources, which included the work of Posada as well as German expressionism and Russian constructivism.[59] However, the Taller artists agreed to limit their work to realistic portraits of the themes that concerned them. Their work was also largely figurative, with a focus on social issues.

Arenal, O'Higgins, and Méndez organized the Taller de Gráfica Popular as an artists' collective, with a central membership of about twelve to fifteen artists. In addition, twenty-five to thirty artists were affiliated with the collective at any given time.[60] Members met every Friday to discuss new projects as well as those in progress. In an interview, Elizabeth Catlett described the process by which artists created work:

> People would come to the workshop if they had problems: if students were on strike; or trade unions had labor disputes, or if peasants had problems with their land, they would come into the workshop and ask for something to express their concerns. We would then have collective discussion about what symbolism would be effective in expressing those concerns. The artists at the Taller would volunteer to do the work together or individually; after the preliminary sketches were made they were put up for more collective discussion.[61]

Taller members created art that engaged issues concerning the working-class population of Mexico, as the collective produced much of its work for

trade unions, student organizations, and the government's anti-illiteracy campaign.[62]

Catlett joined the collective during a period of intense productivity. Between the late 1930s and the late 1940s, when Catlett became a full member, Taller artists created a number of portfolios as well as countless prints that addressed both national and international issues. Mexican subject matter included historical events such as the Mexican Revolution, the expropriation of petroleum in Mexico in 1938, and holidays such as the Day of the Dead. The main international issue that the Taller artists represented in their work was fascism in Europe—both in Germany and in Franco's Spain.[63] During the 1930s and 1940s, the Taller artists exhibited their work internationally and published numerous portfolios and books, including *T.G.P. México: El Taller de Gráfica Popular: Doce años de obra artística colectiva/ The Workshop for Popular Graphic Art: A Record of Twelve Years of Collective Work,* which was edited by Hannes Meyer and published in 1949. As a result of circulating these works, the influence of the Taller de Gráfica Popular grew significantly throughout the world, including the United States, Czechoslovakia, Italy, Brazil, Ecuador, and Guatemala.[64]

However, during the 1940s, there was a significant shift in the work of the Taller collective. This was due in large part to the political environment of Mexico that moved dramatically to the right following the administration of Lázaro Cárdenas as well as to changes within the Taller de Gráfica Popular itself. While the Taller de Gráfica Popular had been politically aligned with the Mexican Communist Party, by the mid- to late 1940s some members had joined the Partido Popular (Popular or People's Party), established by labor leader Vicente Lombardo Toledano. The Partido Popular was a left-wing party that hoped to build a large popular base in Mexico and whose goals were aligned with those of the Mexican Revolution. As a result, Susan Richards suggests that the Taller de Gráfica Popular shifted from "artistic production that addressed smoldering Mexican social issues" in the 1930s to "a graphic art that celebrated Mexican history and society" in the 1940s.[65]

When Catlett started at the Taller de Gráfica Popular in 1946, members were at work on *Estampas de la Revolución Mexicana* (Prints of the Mexican Revolution), a portfolio of eighty-five linocuts focused on the Mexican Revolution. In creating this portfolio, the collective worked to represent the specific experiences of the Mexican people during the Revolution.[66] In part due

to the high illiteracy rate in Mexico and the interest of these artists in addressing their art to a working-class audience, their graphic work tended to be based on photographs and other reproductions that would be familiar to most Mexicans. The portfolio included numerous portraits of leaders of the Mexican Revolution, drawn from well-known photographs by Agustín Casasola. In addition to the portraits of "heroes," the portfolio also contained images that acknowledged the contribution of "ordinary" Mexicans, such as Fernando Castro Pacheco's *La huelga de Rio Blanco: Los obreros textiles se lanzan a la lucha. 7 de Enero de 1907* (The Strike of Rio Blanco: The Textile Workers launch the Struggle. January 7, 1907) and Leopoldo Méndez and Alfredo Zalce's *México en la guerra: Los braceros se van a Estados Unidos* (Mexico in the War: The Braceros go to the United States).[67]

On the one hand, the Taller de Gráfica Popular's decision to create a series about the Mexican Revolution during the mid- to late 1940s was a critical response to what these artists saw as the "imperialistic pressure on Mexico," mainly from the United States, during the immediate post–World War II era.[68] James Wechsler has argued that while the series "celebrates the revolution's original reforms and decries the theft of peasant land and capitalist exploitation in Mexico's initial push toward modernization under Díaz, by ending with Alemán's industrialization campaign, the portfolio links *porfiriato*-style imperialism to Mexico's new Cold War–era strategies."[69] On the other hand, this project was less critical of the Mexican state than was much of the collective's work of the late 1930s.

As members of the collective were working on the portfolio, Catlett developed her own series of linocuts on the subject of African American women in the United States. Melanie Herzog suggests that the Taller de Gráfica Popular's *Estampas de la Revolución Mexicana* conveyed to Catlett "the means to envision her epic celebration of the historic opposition, resistance, and survival of African American women."[70] Similar to the Taller de Gráfica Popular portfolio that included images of heroes of the Mexican Revolution and of Mexico's rural and urban working people, Catlett's *The Negro Woman* series included images not only of well-known African American women but also of ordinary individuals, such as union organizers, musicians, and domestic workers, based on the women she met at the Carver School. While scholars such as Richards have criticized the work of the Taller de Gráfica Popular in the late 1940s, including *Estampas de la Revolución Mexicana*, for portraying an "official" history of the

Mexican Revolution, Catlett viewed the series as a model for convey-
ing the histoical importance of "The Negro Woman." Catlett's series
challenged dominant accounts of U.S. history that had diminished or
erased entirely the contributions of African American women within the
United States.

The aesthetic style of Catlett's *The Negro Woman* series reflected her
exposure to new artistic techniques that she learned while making linocuts
(prints made on linoleum) for the *Estampas de la Revolucíon Mexicana* port-
folio. According to Catlett, collaborating with members of the Taller de
Gráfica Popular not only affected her general way of working but intro-
duced her to new techniques, such as linoleum printing.[71] The prints Catlett
produced soon after she came to Mexico for *The Negro Woman* series, such
as *In Phyllis Wheatley I proved intellectual equality in the midst of slavery* and
In Sojourner Truth I fought for the rights of women as well as Negroes, reflect
the aesthetic influences of Mexican artists on Catlett's work, in part by her
choice of linocuts as her medium but also, as Melanie Herzog suggests, in
Catlett's use of line and composition.[72]

In looking at the project as a whole (images and text), one can also see
how the explicit narrative content demonstrated in the work of the Taller de
Gráfica Popular's portfolio on the Mexican Revolution influenced Catlett's
series. The accompanying text reads as follows:

> I am the Negro woman. I have always worked hard in America . . . In the
> fields . . . In other folks' homes . . . I have given the world my songs. In
> Sojourner Truth I fought for the rights of women as well as Negroes. In
> Harriet Tubman I helped hundreds to freedom. In Phyllis Wheatley I proved
> intellectual equality in the midst of slavery. My role has been important in
> the struggle to organize the unorganized. I have studied in ever increasing
> numbers. My reward has been bars between me and the rest of the land. I
> have special reservations . . . Special houses . . . And a special fear for my loved
> ones. My right is a future of equality with other Americans.[73]

Each of the images is accompanied by one of these statements. For ex-
ample, "I have always worked hard in America" is written beneath an image
of domestic workers. As in the Taller de Gráfica Popular's portfolio on the
Mexican Revolution, Catlett also used narrative to link these images in
service of the larger project, which is a history of African American women's
contributions.

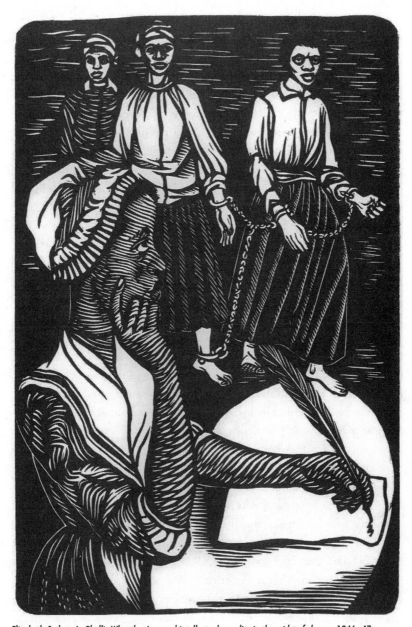

Elizabeth Catlett, *In Phyllis Wheatley I proved intellectual equality in the midst of slavery*, 1946–47.

In *The Negro Woman* series, Catlett moved from portraying domestic workers and fieldworkers to a woman blues singer to the historical figures Sojourner Truth, Phillis Wheatley, and Harriet Tubman. Like artists at the Taller de Gráfica Popular who based their work on familiar images of their subjects, Catlett drew her portrait of Phillis Wheatley from an engraving of the poet created by the artist Scipio Moorhead in the eighteenth century. Similar to Taller artists who visually related their heroes to "ordinary" Mexicans by situating them within crowds, Catlett, in her portrait of Wheatley, reworked Moorhead's version by positioning three female African American figures in chains behind the image of Wheatley. In so doing, she not only references the institution of slavery but also situates Wheatley, a former slave, within that historical context.

Catlett exhibited the work that she completed in Mexico in a show entitled "Paintings, Sculpture and Prints of the Negro Woman" at the Barnett-Aden Gallery in Washington, D.C., from December 1947 to January 1948.[74] While Catlett had initially intended for the show to travel throughout the United States to "alternative" gallery spaces, such as schools and churches in African American communities, it was shown only at the Barnett-Aden Gallery. When Catlett returned to the United States in 1947 for the show, she realized that remaining in the United States might cause difficulties for her because of her political affiliations. Specifically, she was concerned that she could be subpoenaed by HUAC and questioned about her political activity as well as that of her friends, some of whom had been members of the Communist Party.[75] Around the time of the exhibition, Catlett decided to relocate permanently to Mexico.

In addition to being shown in Washington, D.C., some of the prints from the series were published in *T.G.P. México* in 1949, which included the work of both guests and members of the Taller de Gráfica Popular.[76] The images from *The Negro Woman* series that were selected for the book included that of Sojourner Truth, "And a special fear for my loved ones" of a lynched African American man, and "My role has been important in the struggle to organize the unorganized." These images demonstrate Catlett's interest in portraying repressive actions directed toward African Americans in the United States as well as those who actively resisted.

During the early 1950s, other African American artists, such as John Wilson, went to Mexico to study and to participate in the Taller de Gráfica

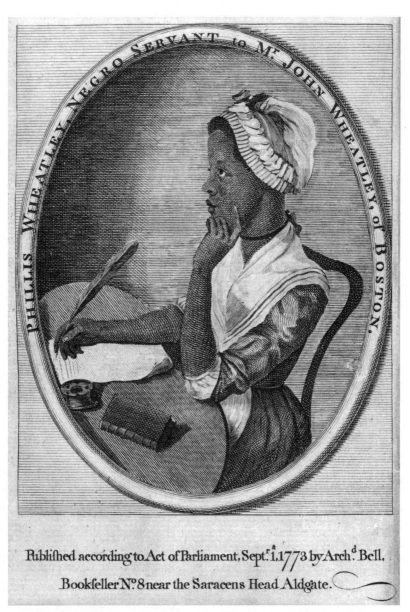

Scipio Moorhead, "Phillis Wheatley, Negro Servant to Mr. John Wheatley, of Boston," 1773, from *Poems on Various Subjects*, by Phillis Wheatley. Courtesy of the Library of Congress Rare Book Division, Washington, D.C.

Popular. John Wilson chose to go to Mexico in large part because of his interest in public art—both in murals and in printmaking. While Wilson was drawn to printmaking, he was more inspired to develop his skills in mural painting while in Mexico. As he noted in an interview, he "wanted to emulate the Mexicans and paint murals . . . to change people through the . . . environment of the community."[77] Of *los tres grandes*, Wilson most admired José Clemente Orozco, with whom he hoped to study after receiving the John Hay Whitney Fellowship that brought him to Mexico. Unfortunately, Orozco passed away before Wilson arrived in Mexico City in September 1950. However, Wilson met and befriended other Mexican and U.S. artists in Mexico, including the muralists David Alfaro Siqueiros and Diego Rivera as well as printmakers associated with the Taller de Gráfica Popular Pablo O'Higgins, Francisco Dosamantes, and Ignacio Aguirre. Even though Wilson did not get to study with Orozco, he did have the opportunity to view a significant amount of his work. Since Orozco primarily painted murals, it was necessary to travel around Mexico City and to other cities and towns to view them. Wilson visited many of the sites of Orozco's work and purchased dozens of photographs taken by an individual who had documented Orozco's drawings and studies for his murals.[78]

Both the style and content of Orozco's artwork appealed to Wilson. While he learned something about new materials from Siqueiros and met Rivera, for Wilson, neither matched his engagement with Orozco's murals.[79] What Wilson found especially significant about Orozco's work was his political iconoclasm and, as Wilson noted in an interview years later, "not taking into account whether it's going to be fashionable, whether it's going to come across, whether it's becoming recognized."[80] Dawn Ades asserts that Orozco's artwork "sets up an internal dialectic between the power and the dangers of the traditional icons and political myths of the revolution."[81] While Rivera's murals were celebratory and idealistic in their portrayal of Mexican life, it seems fitting that Wilson, who found the United States to be profoundly undemocratic especially in its treatment of its African American citizens, would be drawn to the more critical perspective of Orozco.[82] Through the model of Orozco, Wilson, as he put it, found a "form through which I could use my art skills to create convincing images of black people."[83]

In Mexico, Wilson also started to think about ways to visualize the specificities of the experiences of his subjects. Years later, he commented

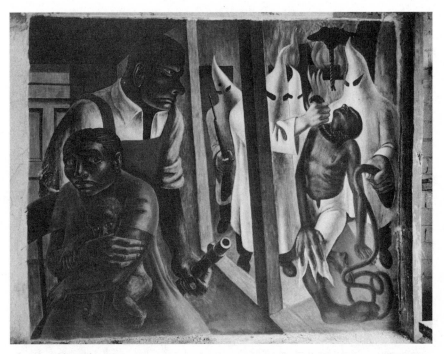

John Wilson, *The Incident*, 1952. Art copyright John Wilson. Licensed by VAGA, New York, N.Y. Image courtesy Sragow Gallery, New York.

that "I went to Mexico and painted Mexicans, but...I didn't just paint Mexican landscapes. I didn't paint 'the colorful Mexican peon with his big hats.'" Wilson recalled that he "identified with the kinds of reality that Orozco found...but I was identifying with it through my own experience in the United States as a black person."[84] As Wilson notes about his work at the time, he tried to be "much more specific" in his attempt to find "a way to make...a meaningful visual statement, about the reality of life for blacks in the United States."[85]

One of the most important works that Wilson produced in Mexico, and one that demonstrates the influence of Orozco, was a fresco mural entitled *The Incident* (1952), which portrays an African American family inside a house watching members of the Ku Klux Klan (KKK) lynch an African American man.[86] In 1951, with letters of recommendation from Pablo O'Higgins and Diego Rivera, Wilson applied for and received a grant from the Institute of International Education in 1951, which enabled him to remain in Mexico. With this funding, Wilson took classes at La Esmeralda,

including a class on techniques of fresco painting with Ignacio Aguirre. While he was enrolled in Aguirre's class, Wilson painted *The Incident.* In this mural, Wilson positions the African American father figure as actively and defiantly taking up arms against the KKK to protect his family. Orozco's influence on Wilson's mural is exhibited both formally and thematically. Wilson distorts the figure of the lynched man, in part by elongating his fingers and feet, suggesting the violence to and violation of his body. The exaggeration of the menacing hands of the KKK member holding a whip and the enlarged hands of the African American father holding his gun underscores the brutality and visceral tension of the confrontation. In this image, Wilson draws on Orozco's work as well as more broadly on what Michael Denning refers to as the "proletarian grotesque."[87] Denning argues in *The Cultural Front* that the proletarian grotesque is "an attempt to wrench us out of the repose and distance of the 'aesthetic.'"[88] While the original plan was to paint over the mural as soon as it was completed to allow another student the space for his or her work, Aguirre let Wilson's mural remain, after Siqueiros, who had heard about the mural and was then head of the Department for the Protection and Restoration of Murals, requested that it be preserved.[89]

Siqueiros's response to Wilson's mural was just one example of the interest of Mexican artists in the work of African American artists. Mexican artists in the Taller de Gráfica Popular were also enthusiastic about participating in the production of a print series on well-known figures in African American history entitled *Against Discrimination in the United States* (1953–1954), conceived of by Elizabeth Catlett in the early 1950s. This series was a means for Catlett, Margaret Taylor Goss Burroughs, and other Taller artists to interpret the experiences of African Americans in the United States using techniques drawn from Mexican art traditions and to direct this work to an African American audience. This project included images of Crispus Attucks, Blanche K. Bruce, George Washington Carver, Frederick Douglass, W. E. B. Du Bois, Paul Robeson, Sojourner Truth, Harriet Tubman, Nat Turner, and Ida B. Wells. Unlike her vision for *The Negro Woman* series, Catlett saw this series as a collective project. Although she picked the figures she wanted to include, she let other Taller members choose which individuals they wanted to portray. Drawing on the process used by Taller artists in their series on the Mexican Revolution, Catlett provided the group with images on which to base their portraits and information about the

Elizabeth Catlett, "Harriet Tubman," 1953–54. From the series *Against Discrimination in the United States/Contra la discriminación en los Estados Unidos* by El Taller de Gráfica Popular. Art copyright Elizabeth Catlett. Licensed by VAGA, New York, N.Y. Image courtesy Taller de Gráfica Popular collection, Center for Southwest Research, University Libraries, University of New Mexico.

important contributions that each individual had made. Of the African American artists involved in the series, Catlett created a linocut of Harriet Tubman, while Margaret Taylor Goss Burroughs produced a portrait of Sojourner Truth.[90] Catlett's image of Harriet Tubman was loosely based on a print that she had created for *The Negro Woman* series.

Catlett's hope for the project, drawing on the example of the exten-
sive distribution of the Taller de Gráfica Popular's work, was that it would
challenge dominant accounts of U.S. history that had diminished or erased
the key contributions of African Americans. The series was addressed to
African Americans, as Catlett had intended for these images to be printed
in *Freedom,* a newspaper published by Paul Robeson in Harlem. Catlett's
inclusion of Robeson and Du Bois in the series was an important interven-
tion during the early Cold War era, as agencies of the U.S. government at-
tempted to silence these African American activists and others who spoke out
against the global color line.[91] However, after the series was completed and
the prints mailed to New York, editors from *Freedom* informed the Taller de
Gráfica Popular that they would have to change the image of Frederick
Douglass in order for it to be included in their publication. True to the rules
set by the Taller, members refused to submit another print, as the work had
already been approved by the collective. As a result of these decisions, the
series remained unpublished in the United States. While this must have
disappointed Catlett, four of the images were reproduced for Mexican audi-
ences and included in an issue of *Artes de México* published in 1957 that cele-
brated the twentieth anniversary of the Taller de Gráfica Popular.[92]

Catlett had originally intended that her series would inform an African
American public about important historical figures in African American
history, yet the end result of decisions made by the editors of *Freedom* and
the Taller de Gráfica Popular meant that it was in fact audiences outside the
United States who were educated about the contributions of these African
American heroes and heroines. Although Catlett regarded audiences out-
side the United States as secondary in the distribution of the *Against Dis-
crimination in the United States* series, during the late 1950s and early 1960s,
she increasingly became interested in directing her work not only toward
audiences in the United States but also to those in Latin America, Africa,
and Asia.

"AN ART ABOUT AND FOR THE PEOPLE"

In 1961, Elizabeth Catlett gave the keynote speech at a meeting of the Na-
tional Conference of Negro Artists (NCNA), held that year at Howard
University. In her talk, which was later published under the title "The Negro
People and American Art," Catlett asked her audience to consider the fol-
lowing questions:

What is this great goal of being an accepted artist in the årt movement of the United States? Of the hundreds of millions of human beings in our world, who reaps the cultural benefits of United States art in 1961? We all know who reaps the economic benefits. But what is the great United States contribution in the graphic and plastic arts to world culture? This question must be investigated and answered before the Negro artist can make his decision. I say that if not, he is doomed to a minor position in a minor contribution that is of little importance to our changing world.[93]

Catlett cautioned her audience of African American artists not to be swayed by the pressure exerted upon them by the art establishment in the United States. Instead, she encouraged them to think more broadly about the significance of their artistic production and its relevance not just within the confines of the United States but also within the context of the entire world.

In her speech, Catlett implicitly questioned the significance of abstract expressionism as the dominant aesthetic style of art production during the early Cold War era. David and Cecile Shapiro argue that at the time of Catlett's speech, abstract expressionist artists "were so strongly promoted and dispersed by the art establishment that to an unprecedented degree... they effectively routed other stylistic and philosophical expressions in American painting."[94] The Shapiros note that "large numbers of artists swung over to Abstract Expressionism during the 1950s, thus contributing to the force of the movement they were joining because they could not beat it."[95] In addressing her audience of African American artists, Catlett directly challenged the production and circulation of abstract expressionism, which agencies of the U.S. government promoted during the early Cold War era in order to associate the United States with the concept of "artistic freedom."[96] Francis Stonor Saunders asserts that abstract expressionism "spoke to a specifically anti-Communist ideology, the ideology of freedom, of free enterprise. Non-figurative and politically silent, it was the very antithesis to socialist realism."[97]

As Eva Cockcroft and other scholars argue, during the 1940s and 1950s, "art became a weapon in the battle of the Cold War."[98] Cockcroft, Saunders, and the Shapiros have written extensively about the connections between the U.S. state and the rise of abstract expressionism both in the United States and abroad during the early Cold War era. The arm of the U.S. government that, as the Shapiros suggest, "lifted Abstract Expressionism to the peak it achieved as the quasi-official art of the decade, suppressing other kinds of painting to a degree not heretofore conceivable in our society,"

was in fact the CIA, which worked furtively behind the back of the U.S. Congress and the American people by promoting abstract expressionism abroad in art exhibitions.[99] Cockcroft asserts that the CIA "sought to influence the foreign intellectual community and to present a strong propaganda image of the United States as a 'free' society as opposed to 'the regimented' communist bloc." She furthermore contends that in the world of art, "Abstract Expressionism constituted the ideal style for these propaganda activities. It was the perfect contrast to 'the regimented, traditional, and narrow' nature of 'socialist realism.'"[100] Thus, some agencies of the U.S. government associated abstract expressionism with the "freedom" of the United States and the "social realist" style with Soviet "totalitarianism."[101]

African American artists who returned to the United States from Mexico during the late 1940s and 1950s entered an environment that was both dismissive of and hostile to the work of politically engaged representational artists. Their marginalization was further compounded by institutionalized racism within the gallery system, and most were largely ignored by leading art critics. The content of their work as much as their aesthetic style appeared in stark contrast to the otherworldly metaphysics of abstract expressionism. As Romare Bearden and Harry Henderson write in the case of Charles White, this work "ran directly counter to Abstract Expressionism."[102] Stacy Morgan notes that White in particular "held steadfastly to his chosen mode of politicized figurative art during the 1950s, in spite of the heightened cold war assault on progressive cultural expression and the commercial ascendance of abstract expressionism."[103]

The work of African American artists who lived in Mexico during the late 1940s and early 1950s, including that of Elizabeth Catlett, Charles White, John Wilson, and Margaret Taylor Goss Burroughs, was distinct from that of African American artists who resided in the United States during these years. Morgan argues that African American artists who remained in the United States, including Charles Alston and Hale Woodruff, were at this time "gravitating in a qualitatively new direction ... stemming from a heightened engagement with American high modernism and 'universalist impulses.'"[104] The differences between the work of African American artists who went to Mexico and those who remained in the United States was largely related to the connections that African American artists had established in Mexico with Mexican artists and in Mexican art institu-

tions such as the Taller de Gráfica Popular and La Esmeralda in the post–World War II era.

Because of racial discrimination, their left-wing politics, and the fact that their work diverged from the aesthetic style dominant in the United States during the 1940s and 1950s, Charles White, John Wilson, Elizabeth Catlett, and other African American artists found that they had limited opportunities for exhibiting their work in the United States.[105] Interracial arts organizations that had supported African American artists in the 1930s and 1940s, such as the Chicago Artist's Union and the American Artists Congress, no longer existed. During the early 1950s, White exhibited his artwork at the ACA (American Contemporary Art) Gallery in New York, one of the few venues that still featured the work of figurative artists.[106] While Wilson had been represented by a gallery in Boston before he left for Mexico, he could not find gallery representation in the 1950s.[107] At that time, his work was included only in group exhibitions. Following her show at the Barnett-Aden Gallery in 1947, Elizabeth Catlett did not have another solo exhibition in the United States until 1971.

One of the places where Catlett and these other artists could exhibit their artwork consistently was the Atlanta University Annual, which was established during World War II by the artist Hale Woodruff, who taught at Atlanta University during the early 1940s. Margaret Taylor Goss Burroughs recollects what it was like for an African American artist to exhibit there:

> For most of us, the Atlanta show provided the first memory, the first mention, and the first knowledge of the black arts presence. In those catalogs from Atlanta we first read the names of people like Hale Woodruff, Jacob Lawrence, John Wilson, Elizabeth Catlett, Charles White, Aaron Douglas, William Artis, and many, many others. Many were unknown, but through this cultural vehicle . . . Atlanta University became an oasis in the Southern desert, not only for the black artist of the South but for those also in the East and West as well.[108]

The Atlanta University Annual remained one of the few outlets for these artists, especially for their painting and sculpture throughout the 1950s. Printmaking proved to be a slightly different matter, perhaps because once removed from the original gesture of painterly "genius" and tainted by its association with mechanical reproduction, it was already relegated to a lower artistic status in the art market.

It was in fact with printmaking that these artists were able to find a limited but still receptive market for their work. While abstraction dominated in painting and sculpture, Eva Cockcroft argues that "social content was more acceptable in the graphic arts than it was in painting."[109] Confronted with the limitations of the U.S. art market, White, Wilson, and Burroughs drew on their printmaking experiences working at the Taller de Gráfica Popular as a model for the kind of art production process that they wanted to continue in the United States. They did this by working collectively with other artists, in groups such as the Printmaking Workshop in New York, by producing print portfolios to exhibit and distribute the work of African American artists to African American audiences, and by creating organizations that fought against racial discrimination and segregation in the arts.

Charles White retrospectively observed that in Mexico he "saw artists working to create an art about and for the people. This has been the strongest influence in my whole approach. It clarified the direction in which I wanted to move."[110] Upon his return, White became involved with the Printmaking Workshop, which was founded by artist Bob Blackburn, who purchased a lithographic press and opened his own studio in New York in 1948. In many ways, the Workshop was a continuation of the WPA art programs, but without government funding. Blackburn himself had been involved in the Harlem Community Arts Center, where he learned lithography, and also in the 306 art workshop, the Harlem Workshop, and the Uptown Arts Laboratory. The Printmaking Workshop fostered the artwork of African American artists in particular, including White, Wilson, Jacob Lawrence, and John Biggers.[111] Alison Cameron notes that the Workshop took on "the Taller's collective organizational structure and its ethos of producing socially useful art."[112] The collective art projects taken up by the Workshop soon after White arrived in New York were two print portfolios: *Yes, the People* (1948), and *Negro U.S.A.* (1949). While the emphasis of the first portfolio was everyday "people," the second portfolio, *Negro U.S.A*, focused specifically on the contributions of African Americans. The Workshop included two prints, *Mexican Boy* and *Mexican Woman*, that White had produced at the Taller de Gráfica Popular in 1946 in its first print portfolio. For the Printmaking Workshop's next portfolio, White produced a print entitled *Our War* in which he portrayed the bravery of an African American soldier.

In addition to producing artwork, White became involved in the Committee for the Negro in the Arts (CNA), which offered support to African American artists similar to that of the John Reed clubs of the 1930s. One of the main goals of the organization was to aid younger artists in gaining entry into various art industries—film, television, publishing, music, and art. Other members of the committee included African American cultural leaders, such as Harry Belafonte, Sidney Poitier, Lorraine Hansberry, Ruby Dee, Ossie Davis, and Paul Robeson.[113] White, who headed the Plastic Arts section, arranged a show of the work of African Americans at a major gallery in New York, with help from Edith Halpert, the owner of the Downtown Gallery.[114] The CNA also supported well-established artists— for example, they aided Charles White with his first solo exhibition (after his return from Mexico) at the ACA Gallery in 1951. In many ways, it was the community of artists involved in the CNA who, as Richard J. Powell argues, enabled White to survive the "1950s atmosphere of action painting and 'red baiting.'"[115]

For Margaret Taylor Goss Burroughs, her year in Mexico served as a respite from the increasingly politically hostile atmosphere of the United States during the early Cold War years and also provided her with renewed energy to overcome the impasses that she would encounter when she returned to Chicago. (For example, upon her return, Burroughs found that her membership to the South Side Community Art Center, an organization that she had helped found, had been terminated due to her radicalism.)[116] Residence in Mexico helped inspire her to create other institutions and organizations whose goals were to build a sense of community for African American artists nationally as well as to provide a forum for them to exhibit and sell their work.[117]

One of the most significant of these organizations was established by Burroughs and two other artists, Burroughs's ex-husband Bernard Goss and Marian Perkins. In 1959, after receiving an invitation from Atlanta University to attend its annual exhibition of African American art, Burroughs, Goss, and Perkins decided to use it as a platform to launch an organization tentatively called the National Conference of Artists. The group who assembled at this first meeting decided to change the organization's name to the National Conference of Negro Artists (NCNA) and established that their mission was "to encourage black artists in every way—to exhibit and

sell their work."[118] Similar to Charles White's portfolios with the Print-making Workshop in New York, artist members of the NCNA also created print portfolios. Unlike the work of the Taller de Gráfica Popular or the Printmaking Workshop, the production of these portfolios was a means for the organization to support the work of its members, which it helped to distribute and sell.[119]

It was during a keynote address that she gave at the NCNA in 1961 that Catlett recommended ways for African American artists to take up the methods of the Taller de Gráfica Popular, both technically and in terms of a collective production process, as a means to circumvent the gallery system that excluded them.[120] Early in her address, Catlett asked her audience to redefine what it meant to be a "successful" African American artist. She encouraged them to reevaluate their sense of what an "ideal" audience was for their work and to redirect this focus from white gallery owners to blacks in the United States (especially in the South). She suggested that African American artists address the concerns of African Americans in their work and that they exhibit their work in alternative spaces, such as schools, churches, and community centers, where African Americans congregated. Using the example of the Taller de Gráfica Popular, Catlett encouraged these artists to take up printmaking, which could be easily reproduced and was transportable, in order to exhibit their work to the largest number of people.[121]

In addition to directing their work to African Americans in the South and elsewhere, Catlett encouraged her audience to exhibit their work outside the United States—in Latin America, Africa, and Asia. In her speech, she emphasized the interest of citizens of these nations in the work of African American artists. Describing a 1960 visit by her husband Francisco Mora, on behalf of the Taller de Gráfica Popular, to the Third International Educators Conference in the New Republic of Guinea, Catlett mentioned that of the large collection of Taller de Gráfica Popular prints that Mora brought to give to the Teachers Federation of Black Africa, the work that most interested them was the series *Against Discrimination in United States*. She described why this work appealed to the teachers:

> The African teachers explained that their national culture had deteriorated under French colonialism for when a people must be dominated, first there is an attempt to destroy their culture. They spoke of their magnificent African sculpture that now enrich the museums and cultures of other countries, and

[have] even served as an inspirational source for modern art, but are lost to them, and that they were beginning again in these countries that had achieved national independence, to develop their artists and establish their own museums.[122]

Here Catlett highlighted the importance of the series for the African teachers, who articulated the significance of culture for groups of people who had previously been colonized.

African American artists who returned to the United States from Mexico, including White and Burroughs, drew on their experiences in Mexico as a means not only to survive the Cold War years but, more importantly, to create art, as White once noted, "about and for the people," in this case African Americans.[123] The artwork of these artists referenced the history of slavery in the United States and the history of violence against African Americans as well as those who resisted. The inclusion of individuals like Paul Robeson and W. E. B. Du Bois in the *Against Discrimination in the United States* series was an important intervention during the Cold War, when U.S. government agencies attempted to silence African American activists and others who advocated for the independence of colonized peoples in Africa while simultaneously sending African American performers on tour as, in Saunders's words, a "living demonstration of the American Negro as part of America's cultural life."[124] These artists produced work that was counter to how U.S. government agencies promoted other artistic and musical forms as indicative of the "freedom" allowed artists in United States. Their representation of the experiences of African Americans in the United States cut against the tenets of American exceptionalist ideology while also articulating a politically informed transnational and antiracist aesthetic. Catlett, who eventually became a Mexican citizen, increasingly directed her work to African Americans in the United States during the 1960s, drawing on her extensive work with the Taller de Gráfica Popular to envision links between the experiences of African Americans in the United States and people of color throughout the world.

3
Allegories of Exile
Political Refugees and Resident Imperialists

The Cold War exiles left the United States as political outcasts. Once in Mexico, however, they were often confronted with the relative privilege they personified as U.S. citizens. In this regard, important differences existed between African American and white exiles that were further complicated by class and U.S. citizenship status. Dalton Trumbo's son Chris Trumbo later implied that the Hollywood refugees were "resident imperialists."[1] For some of the most privileged U.S. exiles in Mexico, this dual and contradictory position—as both resident imperialists and political refugees—became an important subtext of their cultural work. This particular tension was especially evident in work that allegorized their experiences of exile. In this chapter, I focus on two representative texts that narrate themes of exile: Hugo Butler's screenplay of *The Adventures of Robinson Crusoe* (1952; director, Luis Buñuel) and screenwriter Gordon Kahn's novel *A Long Way from Home*, written during the 1950s and published posthumously in 1989. I examine how these allegories of exile critically targeted the relations of U.S. imperialism and the normative and chauvinistic posture of U.S. nationalism and national identity during the early Cold War. I argue that the narrative trope of exile, as specifically shaped by the paradoxical conditions of exile in Mexico, was a means to conceive of a critical transnationalist perspective opposed to the reductive polarities of Cold War grand strategy.

It was primarily white authors whose work expressed the contradictions of this dual refugee/imperialist position and made the theme of exile central to their work. De jure and de facto U.S. racism complicated and to an extent counteracted the imperial status of African American exiles. Mexicans were often aware of racial discrimination in the United States and, as such, dis-

tinguished between African Americans and white exiles. Moreover, African American artists and writers in Mexico were less likely than whites to recall their life in the United States nostalgically. White writers, especially some of the Hollywood screenwriters, had been relatively affluent and lived quite comfortably before the blacklist. The sense that a great deal had been taken away from them, combined with their own critical understanding of U.S. imperialism, helps to explain why the theme of exile was principally the purview of white authors.

Two of the most thoroughly developed allegories of exile were written by Hollywood screenwriters Hugo Butler and Gordon Kahn. Both Butler's screenplay of *The Adventures of Robinson Crusoe* and Kahn's novel *A Long Way from Home* allegorize the authors' experiences of exile and address aspects of their dual identity as political refugees and resident imperialists. While Butler reworked the classic literary figure Crusoe in order to explore these themes, Kahn depicted exile through the experiences of Gilberto, a young Mexican American draft dodger and political refugee in Mexico during the Korean War.

Butler's independently produced screenplay and Kahn's decision to write a novel were also the result of the limited career options open to blacklisted U.S. screenwriters in Mexico. The Mexican film industry had become increasingly protectionist after World War II and discouraged the participation of foreigners in Mexican-based film production. As such, *The Adventures of Robinson Crusoe* was produced without the financial support of the Mexican state. The film was made in conjunction with a number of political refugees who had fled European fascism for Mexico during the 1930s and 1940s, including Spanish director Luis Buñuel and Russian producer Oscar Dancigers. This context directly affected the content of Butler's adaptation of Daniel Defoe's classic. Butler's treatment of the Crusoe character differed significantly from Defoe's portrait of a self-made man. Instead, Butler and Buñuel recast Crusoe as a vehicle to critically interrogate the norms of colonialism and imperialism, all the while staging a subtle attack on the conventions of classical Hollywood cinema and, by extension, Mexican cinema that had been influenced by it. As I discuss in greater detail in chapter 4, Butler's collaboration with Buñuel had a major impact on his later work, which strayed even farther from the constraints of Hollywood narrative cinema.

Gordon Kahn, also blacklisted in Hollywood, faced similarly limited prospects for selling his screenplays. In Mexico, Kahn decided to forego

efforts to develop alternative venues for his film work and to instead devote his time to writing a novel. Butler's choice to work with Mexican-based independent producers exposed him to new aesthetic possibilities and led him to be actively engaged with an exile community that extended beyond his fellow Americans. Kahn's novel, in contrast, shows little connection to the work of other novelists in Mexico at the time. Instead, *A Long Way from Home* maintains a definitive association with the work of Cultural Front and proletarian novelists in the United States. The book's narrative trajectory remains similar to proletarian novels that, as literary scholar Barbara Foley argues, depict "working-class protagonists in the process of acquiring militant or revolutionary class consciousness."[2]

The political circumstances for U.S. exiles in Mexico during the early 1950s contributed to the particularities of exile as a theme in their writing. The screenwriters had evaded subpoenas in the United States and tried to establish themselves as political refugees upon arrival in Mexico. Their attempts to acquire residency status were actively opposed by U.S. governmental agencies. During this period, U.S. agencies mounted a concerted anti-Communist campaign in Mexico with the collaboration of Mexican governmental agencies, such as Gobernación (Ministry of Interior). As a means to exaggerate the threat posed by a growing number of U.S. citizens seeking sanctuary in Mexico, the U.S. Embassy in Mexico City linked the U.S. exiles to Communist Party of the United States of America (CPUSA) leaders who had gone underground in Mexico and pressured Associated Press correspondents and other journalists to publish incriminating articles about them in local newspapers. The FBI and other U.S. agencies also orchestrated a number of actions to impede the U.S. exiles—from withholding their mail to harassment by the Dirección Federal de Seguridad (DFS). Under these circumstances, the U.S. exiles found it difficult to renew their residency visas, which they needed in order to remain in Mexico.

For Butler and Kahn, this situation was further compounded by their having been immigrants to the United States before choosing exile in Mexico. As "naturalized aliens" in the United States, securing residency visas was even more essential for them than it was for the other exiles. If either were deported back to the United States, the Immigration and Naturalization Service (INS) could "denaturalize" them.[3] In fact, according to Hugo Butler's FBI files, the INS began denaturalization proceedings against him

in 1951, with follow-up investigations into the mid-1950s. The INS was authorized to initiate these proceedings following the passage of the Internal Security Act of 1950, which enabled U.S. agencies to retract citizenship from "naturalized aliens."[4] U.S. agencies energetically interfered with efforts by Butler and Kahn to acquire residency papers. A letter from the U.S. Embassy in Mexico City to the Secretaría de Relaciones Exteriores (SRE, Ministry of Foreign Relations) reveals that the Embassy had contacted the SRE to inform them that Kahn's U.S. citizenship was "under consideration."[5] Other U.S. exiles, such as Ben Barzman, a Canadian-born Hollywood screenwriter who left the United States for France during the same period, not only had their status as naturalized aliens revoked but also were denied residency visas and refused citizenship in their country of birth.[6] Neither Butler nor Kahn wanted to be officially "stateless."

The significance of Butler's and Kahn's immigrant histories was not limited to the insecurities of political inclusion; their naturalized alien status also profoundly shaped their political and creative outlooks. While Butler grew up in a lower-middle-class family in British Columbia, Kahn's family was working class, and he grew up in Hungary and later in New York City's Lower East Side. Kahn was part of what Michael Denning described as "the proletarian globe-hopping [that] had created the multi-racial, multi-ethnic metropolises of modernism."[7] Denning argues that individuals like Kahn, who were part of the Cultural Front, articulated a working-class ideology that synthesized ethnic nationalisms and internationalism, producing a panethnic Americanism that reconfigured "the contours of official U.S. nationalism."[8] This global perspective continued to inform their work in the context of the Cold War and became further inflected by the conditions of exile. Official U.S. nationalism, however, foreclosed possible reorientation through such critical internationalism, instead projecting what historian John Fousek calls "American nationalist globalism" as the dominant ideology of the early Cold War.[9]

This chapter begins with a discussion of the circumstances of the U.S. exiles, differentiating between the relations of whites and African Americans with Mexicans. Taking into account the relative privilege of white exiles in Mexico, I elaborate on their position as refugees targeted by the punitive efforts of U.S. Cold War domestic and international policies. Having established the dynamics of these social and political circumstances, I

examine in detail *The Adventures of Robinson Crusoe* and *A Long Way Home* in order to consider how the experiences of exile were narrated and theorized in the work of the Hollywood exiles. I argue that Butler's film cast exile as a means to critique the norms and forms of colonialism and imperialism. This critique is evident both in how Butler, in collaboration with Buñuel, reinterpreted Defoe's story and in their specific use of aesthetic strategies to challenge the conventions of realism central to both classical Hollywood and Mexican narrative cinema. In my analysis of *A Long Way from Home,* I focus on how Kahn uses the theme of exile to expose the processes and practices of U.S. nationalism and imperialism. The thematics of exile are reinforced by two aesthetic features of the novel. First, Kahn's inclusion of multiple perspectives in the novel destabilize a unified narrative point of view and allegorize the decentered position of the exile. Second, Kahn's story is cast within the bildungsroman form, with the main character Gil's growing consciousness of U.S. nationalism as an ideological boundary paralleled by narrative mechanisms that convey to the reader an increasing awareness of the contingency of perspective. In the conclusion, I compare the work of Butler and Kahn to film projects produced in association with the U.S. government during the same period. These films were made for distribution to U.S. or Latin American audiences and espouse anti-Communism as a particularly patriotic form of nationalism. Juxtaposing Butler's and Kahn's works with these official representations underscores the specific political stakes narrated in their allegories of exile.

RED REFUGEES AND THE PERSISTENCE OF PRIVILEGE

In Mexico, the white U.S. exiles were equally political refugees and resident imperialists. These exiles were refugees, as they had been driven outside U.S. borders to avoid congressional subpoenas and possible prison terms. Nevertheless, their class, race, and national identity positioned them alongside the elite in Mexican society. Indeed, one problem for the exiles was maintaining the accoutrements of their class privilege as their previous sources of income in the United States became increasingly precarious. Although some of the exiles were not middle or upper-middle class upon arrival, even those who had been more well-off financially found their coffers drained during their years in Mexico. Furthermore, while the administration of Lázaro Cárdenas (1934–1940) had welcomed Spanish Civil War veterans, including those from the United States, a new administration was running

the country by the time many of the U.S. exiles arrived in Mexico during the late 1940s and 1950s. The emphasis of the administration of Miguel Alemán (1946–1952) was that of modernization. One of Alemán's major goals, according to Seth Fein, was to expand the corporatist controls of the Mexican state, and as a result, the domestic policies of the Alemán administration were distinctively antilabor and anti-Communist.[10]

Although some of the white exiles had wanted to acclimate to Mexican society upon their arrival, they found themselves unable to do so in part because of the discrepancy between their class and racial status as Anglos and those of most Mexicans. When they arrived, Mary and George Oppen believed that they would be in Mexico for an extended time and had decided that they did not want to live only among other U.S. exiles. Rather, they hoped to "enter into the life of Mexico as it is offered."[11] However, once they settled in, they found that their lives "were occupied with earning extra money in order to live a bourgeois life in Mexico" because, as Mary Oppen wrote, "to live as the lower classes live in Mexico is a life fraught with danger due to the lack of hygiene in such a poverty-stricken, undeveloped country."[12] George Oppen, whom his wife described as the "proletariat of the Hollywood exiles," actually maintained a "high bourgeois social class" in Mexico, according to Rachel Blau DuPlessis.[13]

The primary interactions between most white exiles and Mexicans that were not social or business related were those that revolved around the home. These exchanges usually took place between the "manager" of the home, usually a woman, and a maid, cook, and/or laundress. While hired help was common among some groups of exiles, the arrangements in Mexico were dissimilar from those in the United States. Screenwriter Ian Hunter described their discomfort with the privileged position they occupied in Mexico and how he and his wife Alice unsuccessfully attempted to rectify it: "I guess we all had live-in maids—well, because all the houses had provisions for them, a room and what-not. You just had to pay her a hundred pesos and give her every other Sunday off, though with our turn of mind we all offered a little more money. And then, before you knew it, you had added a cook and a laundress, and a gardener because from the Mexican point of view you represented some kind of rich character."[14]

Most of the Hollywood exiles were financially successful before leaving the United States, yet many were uncomfortable with their status in Mexico. However, some still enjoyed aspects of the privileged life they encountered

in Mexico. In a letter to Herbert Biberman, Albert Maltz remarked caustically that their house, "like all such houses here is surrounded by a wall to show the peons that quality resides." However, he also mentioned that his house had a pool and noted that "after living a decade in Hollywood without one, I never thought to find one in Mexico, but it found us, and we enjoy it."[15]

While many of the white exiles lived a kind of privileged existence in Mexico, most of them had trouble finding enough work to support themselves in their chosen profession. Dalton Trumbo, who had been a very successful screenwriter when employed in Hollywood, was forced to sell many of his family's personal belongings to the National Pawn Shop, known as the Monte de Piedad (Mountain of Pity), in order to support his upper-middle-class lifestyle.[16] In a letter to Hollywood screenwriter Michael Wilson, who was living in exile in Paris, Trumbo wrote, "We are living out an old truism: 'The first time you see Mexico you are struck by the horrible poverty; within a year you discover it's infectious.'"[17]

Not all of the white exiles started out in Mexico as middle class or upper-middle class. The lower-middle-class exiles, including Mike and Verne Kilian, lived alongside Mexicans in poorer neighborhoods in Mexico City, such as Tacubaya. Over the wall from the Kilians' house was a ditch that the neighborhood used as a toilet. Crawford Kilian describes in his unpublished memoirs that "The homes around us were shacks of cardboard and sheet metal, sometimes built in a day." While the Kilians lived near a poverty-stricken slum, Crawford and his brothers still had many more advantages than their neighbors, as they attended school, whereas, as Crawford wrote, "the children who swarmed the dirt streets would never see the inside of the classroom."[18]

The white exiles, regardless of class, were perceived differently than were African American exiles in Mexico. The experiences of African Americans in Mexico indicate that there was a significant dissimilarity in their relationships with Mexicans as compared to those of most white exiles and Mexicans. John Wilson remembers being more accepted by Mexicans than were white Americans. As he noted in an interview, "I was an American but I wasn't a *gringo*."[19] (Willard Motley wrote in his nonfictional manuscript "My House Is Your House" that in Mexico *gringos* referred to all Americans, not just white Americans. However, as Motley explained, the term can be used "descriptively, insultingly or in a friendly manner.")[20] These distinctions were evident from their familial affiliations to their casual inter-

actions on the street. Both Elizabeth Catlett and novelist Willard Motley settled in Mexico and raised families there. Catlett married a Mexican citizen, Francisco Mora, with whom she had three sons. Motley adopted two Mexican boys, Raúl and Sergio, whom he raised on his own. Motley also socialized primarily with working-class Mexicans rather than with American or European exiles. Nor did he interact with Mexican writers or artists. Instead, Motley befriended working-class Mexicans whom he met in bars, restaurants, and elsewhere.[21]

While the relationships between African Americans and Mexicans could be more intimate, even brief exchanges with people on the street could take on a significant meaning for the African American exiles. Audre Lorde described her experiences in Mexico City years later in *Zami: A New Spelling of My Name:*

> It was in Mexico City those first few weeks that I started to break my life-long habit of looking down at my feet as I walked along the street. There was always so much to see, and so many interesting and open faces to read, that I practiced holding my head up as I walked, and the sun felt hot and good on my face. Wherever I went, there were brown faces of every hue meeting mine, and seeing my own color reflected upon the streets in such great numbers was an affirmation for me that was brand new and very exciting. I had never felt visible before, nor even known I lacked it.[22]

Catlett recalled that she felt "like an ordinary human being in Mexico."[23] Motley noted in "My House Is Your House" how pleasant it was "to live in a country where you can live anywhere, go to any hotel or restaurant."[24] John Wilson commented in an interview that "I certainly felt the Mexicans I knew I felt identified with, I felt at home with."[25]

African Americans found that while they were better able to integrate themselves into Mexican culture than white Americans, they were still privileged as U.S. citizens in Mexico. This was because Mexico was not free of its own kind of racism. While there was little if any prejudice expressed toward African Americans by Mexicans, Motley discovered that there was racialized prejudice against indigenous Mexicans, who were frequently positioned on the lowest rungs of Mexican society.[26] In fact, Motley wrote a chapter of "My House Is Your House" on the "Indian problem."[27]

While all of the U.S. exiles were privileged inhabitants of Mexico, many of them were also refugees seeking political asylum in Mexico. The multiple initiatives against U.S. exiles in Mexico during the 1950s were part of a

larger effort conceptualized by the U.S. Embassy in Mexico City to establish an anti-Communist campaign in Mexico.[28] The U.S. ambassador to Mexico, William O'Dwyer, wrote a letter in 1951 to the Department of State in which he outlined the campaign. According to O'Dwyer, "the campaign would have two phases . . . the first phase would be a personal campaign to convince Latin American officials of all levels of the very personal danger to each should Communism take over in any country of this hemisphere; the second phase would be a mass media approach."[29]

One of the main vehicles for the mass media component of the anti-Communist campaign were Mexican newspapers. As U.S. Embassy officials were developing this campaign during the early 1950s, they focused their attention on U.S. Communists who were seeking asylum in Mexico. Perhaps the first attack on U.S. Communists in the Mexican press took place around the time of CPUSA leader Gus Hall's deportation from Mexico in 1951, when a series of articles on "Reds in Cuernavaca" appeared in *Excélsior,* the largest circulating newspaper in Mexico. In one of these articles, authorities accused Gordon Kahn and Albert Maltz of organizing "fugitive writers" into a company in Cuernavaca to make "Red films."[30] The similarity between this series and one on "Red espionage," written by Ogden Reid, published in the *New York Herald Tribune,* was noted at the time by Albert Maltz, who speculated in a letter to film director Herbert Biberman that this was "because the clipping was given to them [editors at *Excélsior*] by the American Embassy."[31] According to Diana Anhalt, the U.S. Embassy used the Mexican press, including *Excélsior,* as a means of disseminating information about the U.S. exile communities in Mexico City.[32]

The appearance of these articles in *Excélsior* coincided with a party given by Willard Motley and his friends soon after they arrived in Cuernavaca. When Motley moved to town, one of the first Americans he met was Eudora Garrett, a Texan woman who wrote a weekly column about Cuernavaca for the English-language newspaper. Garrett, who knew many people in Cuernavaca, introduced Motley to a number of Europeans and Americans living there, including Gordon Kahn, Martha Gellhorn, Leonard Bernstein, Ross Evans (Dorothy Parker's secretary), and Spanish Civil War refugees Dr. and Mrs. Amann, among others. Motley invited these newly made acquaintances, along with a list of others that Garrett had given him, to the party. Motley enjoyed the party, writing, "I met more writers this one evening in Cuernavaca than I had met in New York and Chicago combined;

everyone in Cuernavaca seemed to be a published author or was working on a book."[33] However, the following day, an article appeared in *Excélsior* that included an extended section on Motley's party. Motley translated the article from Spanish to English and included parts of it in "My House Is Your House":

> Last Saturday, there was a party at the home of Willard Motley, a Negro who has written some works in English and who took refuge in Mexico upon being processed by North American authorities. This colored man came in the company of three other Negroes who live in Cuernavaca with him and who are Communists.
>
> The party at the home of Motley joined together the cream of the reds and pinks, not only foreign refugees but also some Mexican sympathizers, some of whom came from the capital to attend the reception. There was music, poems were read and bits of books in preparation, since most of those who attended were authors or screenwriters. Motley was congratulated by his "comrades" upon the publication of his new novel *We Fished All Night*. Formerly Motley had published in the United States the novel *Knock on Any Door*, of a radical theme.[34]

When a list of "attendees" appeared in the newspaper, Motley commented that some of them, including Albert Maltz, had not actually been present at his party. At the time, Motley believed that the U.S. Embassy had provided information, including a list of Americans in Cuernavaca, to *Excélsior*. In "My House Is Your House," Motley speculated on the influence of the U.S. Embassy: "In amazement I wondered if the United States was so powerful here, if the American Embassy could bring pressure on the Mexican government to have 'undesirable Americans' sent home."[35]

This series of articles in *Excélsior* linked the so-called red refugees in Mexico with active Communist Party leaders in the United States, such as Gus Hall, who escaped to Mexico during the same time period. U.S. Embassy staff were aware of the proximity of the articles' publication to Hall's deportation, as noted in a letter written by Franklin C. Gowen, the counselor of the U.S. Embassy, to the Department of State:

> In a well timed "scoop," *Excélsior* on October 8, 1951, came out with banner headlines on page one proclaiming, "Cuernavaca Converted into a Nest of Red Refugees from the United States, Branch of the Kremlin 75 km from Mexico City." About 12 hours later Gus Hall, former Secretary General of the Communist Party of the United States, was detained by the Mexican police and sent back to the United States to the custody of the FBI.[36]

In his letter, Gowen linked the publicity attributed to the impact of the red refugees in Cuernavaca with Hall's capture. He noted that the article mentioned the activities of these "fugitives from justice," which included "display of red colors, singing of the International, Red Army marches and other Communist songs, demonstrations against the United States and in favor of Russia and the like," which he wrote "had created an atmosphere of antagonism and division in Cuernavaca, offending both local residents and tourists."[37] Much of this reportage was exaggerated, according to both Willard Motley and Albert Maltz.[38]

In his report, Gowen listed the names of the alleged "Communists in Cuernavaca" with no distinction between those who had been involved in left-wing politics in the United States and those who were living in Mexico as expatriates.[39] Contrary to what was stated in the article, very few of these individuals were fugitives from justice. The only individual mentioned in the article who had been sentenced to a jail term was Albert Maltz, who served six months in prison for contempt of Congress.[40] However, it was not as important for the newspapers to be accurate as it was to discredit the U.S. exiles in Mexico.

The appearance of these articles suited the cause of the U.S. Embassy's anti-Communist campaign because it helped to publicize the presence of "foreign Communists" in Mexico. In a letter to the Department of State, Gowen noted that the Mexican Ministry of Interior had been unaware whether these individuals were in Mexico as tourists or in some other capacity. The response to the *Excélsior* articles by the press, Mexican governmental officials, and both left- and right-wing political groups in Mexico was duly noted in Gowen's letter in which he described how the Ministry of Foreign Relations reported tightened controls over immigration and that all major Mexican papers had publicized Hall's deportation.[41]

However, U.S. Embassy officials believed that their anti-Communist campaign was only partially effective in convincing Mexican government officials of the dangers of Communism or of foreign Communists in Mexico. A few months following the publication of the articles in *Excélsior*, U.S. Embassy officials issued a report to the Department of State on "Communists in Mexico," in which they stated that "Communist activists in Mexico will continue to warrant careful and sustained attention." In this report, embassy officials expressed their concern about the lack of interest demonstrated by agencies of the Mexican government in "controlling" Commu-

nism.[42] They remarked that "the Mexican government and people were passive generally with regard to world Communism," as they "expressed disapproval of Communist aggression" but did not display "an inclination to assume an active role in halting this aggression."[43]

The publication of these articles in *Excélsior* was troubling to the U.S. exiles; they worried especially about how the articles might influence public opinion and affect their asylum in Mexico. Albert Maltz wrote in a letter to Herbert Biberman that the purpose of the articles was to "create such public thinking in Mexico as will destroy the right of asylum for North Americans."[44] Of all the Hollywood screenwriters, Gordon Kahn was most often attacked in Mexican newspapers as a "red refugee" from the United States. The articles in *Excélsior* made a number of accusations about Kahn, who was singled out for the founding of an "American Communist colony" in Cuernavaca and for transporting Albert Maltz to Mexico.[45] However, the articles listed only one activity of the so-called American Communist colony, involving an altercation between Willard Motley and a white Texan tourist. Although the U.S. exiles were not able to effectively respond to the negative publicity they received in Mexican or U.S. newspapers and magazines, there were numerous ways in which they dealt with the harassment initiated by agencies of the U.S. government.[46] In addition to their own attempts to counter these efforts, they hired lawyers who helped them negotiate the bureaucracy of Gobernación among other Mexican governmental agencies.[47]

The publication of the series in *Excélsior* occurred just as U.S. exiles such as Albert Maltz were applying for *inmigrante* visa status, which would enable them to remain in Mexico. Like Kahn, Maltz was concerned that the articles would affect his ability to stay in Mexico and could possibly lead to his deportation from the country. At that time, he wrote a letter to Herbert Biberman in which he speculated on the different possibilities that awaited the U.S. exiles who remained in Mexico: "We might get deported in the middle of the night; we might get our papers of above permission and remain here unmolested for quite some time; or we might get our papers and three weeks later a reversal of policy would see us deported; or we might be refused our papers, go to the border and also be refused a return tourist card; or we might get another tourist card."[48]

Although the U.S. Embassy launched a negative campaign against U.S. Communists in Mexico, agencies of the Mexican government did not respond as if they believed that the U.S. exiles were a threat. When Maltz

went to the U.S. Embassy to get a certificate of citizenship needed for his application, he was denied because, as he was informed by an embassy official, "the State Department is not interested in facilitating your residence in a foreign country."[49] Maltz, with the help of his attorney, received *inmigrante* status from Gobernación after he wrote a statement in which he explained the position that he had taken against the House Un-American Activities Committee (HUAC) as well as the reasons he chose exile in Mexico. Gobernación granted Maltz an *inmigrante* visa that could be renewed for up to five years.[50] Securing an *inmigrante* visa would enable U.S. exiles to live in Mexico, but this visa did not allow them to work in Mexico.

TO "ESCAPE THIS TOMB": REMAKING *ROBINSON CRUSOE*

While some of the blacklisted screenwriters living in Mexico found employment working on films produced in Mexico and the United States, this was not an easy task. The blacklist in the Hollywood film industry limited the options of blacklisted screenwriters by creating a two-tiered system of employment, with the blacklisted working the lower paying "black market" jobs. Furthermore, the situation changed dramatically for blacklisted screenwriters after 1951; Larry Ceplair and Steven Englund contend that "the majors ceased trafficking in the black market altogether, and there were few independents willing to risk opprobrium for the benefit of cut rate talent."[51] According to Ceplair and Englund, "there was almost no film work available until the mid-1950s, and even then assignments hardly flowed."[52] Those who did find employment discovered that their working conditions were even more deplorable than had been the case in Hollywood. John Howard Lawson, a member of the Hollywood Ten, told interviewer Victor Navasky that "he found life on the blacklist corrupting because you worked on scripts you didn't believe in, had no communication with director or producer, and in general labored under conditions that guaranteed an inferior product."[53]

Screenwriters also had difficulty securing film work in Mexico where they were rarely granted working permits. Non-Mexican residents needed work permits in order to obtain employment in Mexico, and as Jean Rouverol notes in her memoirs, "*inmigrado* papers—resident alien status with a working permit—were hard to come by."[54] In the face of an increasingly protectionist Mexican film industry, the Hollywood exiles had difficulty finding work. One of the most significant developments within the Mexi-

can film industry during the post–World War II period was the formation of the Asociación de Productores y Distribuidores de Películas Mexicanas (Association of Producers and Distributors of Mexican Films), whose mission it was to protect the Mexican film industry from competition with the United States.[55] Furthermore, at this time, all film distribution in Mexico became centralized under the Banco Nacional Cinematográfico.[56] This meant that state financing contributed to investment in the work of film producers who were committed to making profitable commercial films over other producers.[57] Individuals working outside that network, who did not receive state funds, such as Spanish director Luis Buñuel, Russian producer Oscar Dancigers, and Mexican producer Manuel Barbachano Ponce, were, on the other hand, central to the development of a "cinematic crosscurrent" in Mexico.[58]

During their early years in Mexico, Hollywood exiles Hugo Butler and George Pepper became part of this unofficial film movement, consisting largely of foreigners who had been unable to gain a foothold in the Mexican film industry. Hugo Butler's first screenwriting project in Mexico was *The Adventures of Robinson Crusoe* (1952), a "collaboration between exiles," including Buñuel and Dancigers, who was Jewish and had fled Europe during World War II. Butler was significantly influenced by his work with Buñuel on *The Adventures of Robinson Crusoe*. While Butler had written the first draft of the script, Buñuel, who always worked closely with screenwriters on his films, collaborated with Butler in rewriting it.[59] Working with Buñuel exposed Butler not only to independent film production but also to avant-garde film practices that ran counter to the conventions of classical Hollywood narrative cinema.

Butler wrote the screenplay of *The Adventures of Robinson Crusoe* in Ensenada, Baja California, at the beginning of his almost decade-long exile in Mexico. The story told in *The Adventures of Robinson Crusoe* narrates his initial experience as an exile in Mexico, which contributed to his choice of literary vehicle. In choosing to represent his exile through the figure of Crusoe, Butler implicitly casts himself as a "resident imperialist," an interloper who imagines the site of exile as relatively empty. However, Butler's collaboration with Buñuel resulted in a complete reconceptualization of the character of Robinson Crusoe portrayed in Defoe's novel. Butler and Buñuel used Defoe's classic not only to critique the history of European colonialism but also as a means of foregrounding the colonial encounter as a precursor to

the contemporary imperialism of Hollywood narrative cinema. Furthermore, Defoe's story provided them with a narrative through which to allegorize their own position as exiles in Mexico.

Buñuel, who is best known for his early surrealist works *Un chien andalou* (An Andalusian Dog) (1929) and *L'Age D'or* (The Golden Age) (1930), directed over twenty films in Mexico between the mid-1940s and the mid-1960s. Although he had left the movement many years earlier, his aesthetic and political ties were most closely linked to surrealism. Buñuel's early films are anarchic, challenging prohibitions dictated by a given society, the Church, the State, as well as the organization of bourgeois society more generally. According to Buñuel, surrealism "was a coherent moral system that, as far as I could tell, had no flaws. It was an aggressive morality based on the complete rejection of all existing values."[60] Joanne Hersfield argues that "surrealism was also a political statement, a reaction against social repression characterized by conservative values of propriety and restraint."[61] Buñuel's visual approach defied film languages constructed in Hollywood, which he referred to as "conventional capitalist cinema."[62] His surrealist aesthetic was apparent in the last film he directed in Spain before the outbreak of the Civil War, *Las hurdes (Land Without Bread)*, (1932), a parody of the social and ethnographic documentary tradition established by Robert Flaherty and John Grierson.[63]

During the Spanish Civil War, Buñuel traveled to New York after he was hired by the Museum of Modern Art (MoMA) in 1938 to work for the Office of the Coordinator of Inter-American Affairs (OCIAA) as part of the production team that would gather, review, and edit films intended as antifascist propaganda to be distributed in Latin America. While at MoMA, Buñuel was attacked for his "anti-Catholic" and "Marxist" inclinations that his former friend Salvador Dali had mentioned in his autobiography, *The Secret Life of Salvador Dali* (1942).[64] Buñuel resigned from his job because of the scandal and spent the following year largely underemployed. Furthermore, because he had been charged with being a Communist, his visa was threatened.[65] Buñuel did eventually get work in Hollywood through screenwriter Vladimir Pozner recording commentaries for training films made by MGM for the Army Corps of Engineers.[66] Following his work for MGM, Buñuel was employed as a Spanish dubbing producer in Hollywood.[67] When Buñuel's contract with MGM expired in 1945, he decided not to

renew it.[68] Instead, he accepted the offer of producer Denise Tual to direct a film titled *The House of Bernarda Alba*, based on García Lorca's 1936 play. They traveled to Mexico to meet with refugee Oscar Dancigers, who had been living in Mexico City during World War II, about producing the film. Dancigers, a Communist, had established an independent film production company in Mexico that assisted U.S. film companies with on-location production in Mexico. Following World War II, this work was no longer available for Dancigers, both because of the demise of the Good Neighbor Policy and because he was blacklisted by Hollywood studios.[69] Although Dancigers decided against coproducing Tual's film, he was interested in working with Buñuel, who during this visit decided to relocate to Mexico.[70]

During World War II, the Mexican film industry had grown substantially, partially as a result of the increase in the U.S. government's exportation of raw film stock to Mexico during the years of the Good Neighbor Policy. In response to this tremendous growth, the Producers Union established a new structure for film production in Mexico. According to the new rules, producers who made high- and mid-range-budget films received most of the government funding. Producers who made low-budget films, on the other hand, had to depend entirely on their box office returns to finance their films, a plan that ultimately marginalized independent producers.[71]

Faced with these restrictions, Dancigers's strategy was to produce low-budget films with the potential to be commercially viable either within Mexico or on the international market. In working with Dancigers, Buñuel would direct films that were not (on the surface) avant-garde, addressed (at least in part) to a Mexican audience. The first collaboration between Buñuel and Dancigers was *Gran casino* (Grand Casino) (1946), a musical set in Tampico about the oil industry before petroleum was nationalized in 1938. Buñuel went against the rules of conventional film language by "crossing the axis" in that he did not abide by the U.S. and Mexican film industries' standard 180-degree camera angles, disrupting spatial relations in the film. The film was not a commercial success, and Buñuel was again without work, this time for a period of two years. During his hiatus from film directing, Buñuel developed a technique for making films cheaply and quickly by limiting them to 125 shots.[72] Dancigers gave him another chance to direct with *El gran calavera (The Great Madcap)* in 1949, which was well received in Mexico. After the success of this film, Dancigers suggested that Buñuel

and Spanish exile Luis Alcoriza devise a screenplay about street children, which resulted in *Los olvidados (The Young and the Damned)* (1950).

Buñuel's experience with *Los olvidados* points to the gap between his filmmaking style and that of conventional Mexican narrative film of the post–World War II era. Film scholar Ernesto Acevedo-Muñoz convincingly argues that *Los olvidados* "directly addresses and attacks the official idea of Mexican culture, the official shape of Mexican cinema that was part of the postrevolutionary cultural project."[73] Buñuel's experience directing the film was an uphill battle, from his conflicts with cinematographer Gabriel Figueroa and producer Oscar Dancigers to the response to the film in Mexico. Figueroa's work was influenced by Eduardo Tissé, the cinematographer on Sergei Eisenstein's *¡Qué viva México!* (Long Live Mexico!) (1933), by photographer-filmmaker Paul Strand (*Redes*, 1934) and by Hollywood cinematographer Gregg Toland (*Citizen Kane*, 1941), who was known for his dramatic shots of clouds across wide landscapes.[74] During production, Buñuel and Figueroa fought incessantly over the framing and composition of shots. While Figueroa had a more classical approach to cinematography, stemming from the influence of Toland, Buñuel was interested in challenging the constructedness of "realism" within classical Hollywood (and Mexican) narrative cinema. Buñuel's approach to this film irritated Dancigers, who tried to limit the ways that Buñuel attempted to disrupt the conventional realist aspect of the film.[75]

Initial reactions to the film, even those of intellectuals and artists in Mexico, including painter David Alfaro Siqueiros, Spanish poet León Felipe, and Lupe Marín, the wife of Diego Rivera, were mixed. Mexicans, with the exception of Siqueiros, took offense to the film, interpreting it as a "negative" portrayal of Mexico. In an interview, Buñuel recalled that the overall reaction to the film in Mexico was so contested that he was told he deserved "Article 33 (which expels 'undesirable foreigners' from the country)" because he was accused of insulting Mexico.[76] However, after Buñuel received the award for Best Director at the Cannes Film Festival, the film had a successful run when it was re-released in Mexico City. (Buñuel won the Ariel award, Mexico's version of the Oscar, for direction.) Following *Los olvidados*, Dancigers settled on an agreement with Buñuel whereby he could direct a "personal" project for every two or three commercial productions made through the company.[77] Buñuel made *Susana (The Devil and the Flesh)* (1950); *Una mujer sin*

amor (A Woman without Love) (1951); *Subida al cielo (The Mexican Bus Ride)* (1951); and *El bruto (The Brute)*, (1952) before Hugo Butler and George Pepper offered Buñuel the opportunity to direct *The Adventures of Robinson Crusoe.*

As mentioned earlier, Hugo Butler wrote the screenplay adaptation of Daniel Defoe's *Robinson Crusoe* soon after he left Hollywood, while living in Ensenada in Baja California. He had made a name for himself in Hollywood in the late 1930s and early 1940s writing screenplays for children's dramatic films, including *The Adventures of Huckleberry Finn* (1938), *A Christmas Carol* (1938), *Young Tom Edison* (1939), and *Lassie Come Home* (1943). Butler was not one of the original Hollywood Nineteen and in fact "fronted" for Dalton Trumbo on *The Prowler* (1951; director, Joseph Losey) before leaving the United States in 1951 to avoid a subpoena from HUAC that would require him to testify during the second set of hearings on Communist infiltration in Hollywood. As mentioned in chapter 1, it was at this time that he fled to Ensenada, where he lived for a few months before his family joined him. His experience living alone in this coastal town may have influenced his decision to adapt this novel set on an island apart from "civilization."

Once in Mexico, Butler contacted George Pepper, who had set up a production company in Mexico City, about producing his screenplay adaptation of *Robinson Crusoe*. Financing was the responsibility of George's brother Jack Pepper, who raised money for the film primarily from blacklisted musicians.[78] In part, Butler chose to adapt *Robinson Crusoe* to the screen because it could be made inexpensively for both Spanish- and English-speaking audiences. While other films would have to be shot twice, once in Spanish, and once in English, the filmmakers would only have to shoot the first two-thirds of the film once, since Crusoe appears alone and thus there is no dialogue during these sequences. Pepper took the script to Buñuel, who was not initially enthusiastic about directing the film, writing in his autobiography years later that over time he "became interested in the story, adding some real and some imaginary elements to Crusoe's sex life as well as a delirium scene where he sees his father's spirit."[79] Buñuel's surrealist vision was evident in this literary adaptation, notably in the sequences mentioned. Securing Buñuel as the director helped Pepper and Butler entice Dancigers to coproduce the film. This film fit the type that Dancigers was looking to produce—a low-budget film with export potential.

Butler and Buñuel's version of the story of Robinson Crusoe narrates their coming to terms with their exile.[80] The film also thoroughly overhauls Defoe's narrative, a novel that Martin Green describes as "the prototype of literary imperialism."[81] The influence of Buñuel on Butler was significant: Butler began to rethink aspects of Hollywood narrative cinema and to develop new approaches to filmmaking during the production of the film. While Butler originally chose to adapt the novel within the generic codes of Hollywood narrative cinema that focused on the colonial civilizing mission and imperialist settlement, he developed a critique of this position, paralleling his own reorientation in Mexico.

The film depicts the story of an eighteenth-century British explorer, Robinson Crusoe, whose boat becomes shipwrecked on an island. Crusoe, the lone survivor, lands on the island after having lost his way on a trip to Africa where he was to purchase slaves. The film is largely focused on the activities of Crusoe's daily life—building a home, hunting, finding food and water, raising goats, and growing wheat—which contrast with the inner torment he experiences living in isolation. While he leads a mundane, task-oriented existence, his desire for companionship erupts in dreams, hallucinations, and fantasies. In the last third of the film, Crusoe meets another maroon, a native islander whom he names Friday. Friday at first becomes his servant and later his friend. This last section of the film is largely a study of social relationships in isolation, specifically that between Crusoe and Friday.

While in the novel Defoe focuses on Robinson Crusoe's "mastering" of himself and his environment, Butler and Buñuel instead highlight the psychological effects symptomatic of Crusoe being deprived of human contact. Both the film's form and its content throw his solitude into sharp relief. The novel commences with Defoe's description of Crusoe's family life in England, yet the film opens as Crusoe is shipwrecked on the island. Literary scholar Brett McInelly argues that in the novel, Crusoe's sense of self assurance increases the further away he is from England.[82] However, in the film, Crusoe becomes markedly distraught by his solitude. Crusoe's ability to "perfect all tasks" contrasts with the inconsolable loneliness he experiences. He desperately wants to "escape this tomb," his term for his exile, and refers to himself as "a prisoner, locked up by the eternal bars and bolts of the ocean." In a particularly desperate moment, Crusoe runs to the ocean with a lit torch screaming for help. However, he soon realizes that his efforts are fruitless, and he extinguishes his torch in the body of water that separates

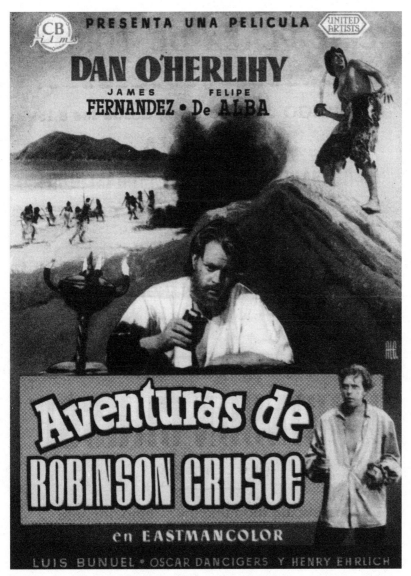

Film poster of *Aventuras de Robinson Crusoe* (1952). Courtesy of the Agrasánchez Film Archive, Harlingen, Texas.

him from human companionship. Following this sequence of events, Crusoe turns around and faces the shore, eventually walking into the camera, thus directly confronting the viewer. His entrapment on the island is represented here visually by his inability to walk off screen. As opposed to Crusoe's anxiety over the presence of cannibals on the island, which contributes to his

psychological instability in the novel, his descent into insanity in the film is ushered in by his lack of contact with other people.[83]

The filmmakers' revisions to the story of *Robinson Crusoe* accent Crusoe's loss of companionship. In the film, Crusoe's feelings of psychic alienation cause him to destroy the center of his island life that he has spent so long creating. The destruction of his "compound" occurs through a progression of events in which Crusoe slowly descends into madness. This sequence begins with a scene that does not appear in the novel, on the day that marks his fifth year anniversary on the island. In this scene, Crusoe, who gets drunk, imagines himself surrounded by his friends in England. During this hallucinatory sequence, which is constructed through a close-up shot of Crusoe paired with an additional soundtrack of people singing and talking, Crusoe "hears" the voices of his friends, as if they were in the room. He speaks to them, waves to them, and drinks to them. This imagined homecoming ends abruptly as the camera pulls back, revealing Crusoe's isolation in a wide-angle shot. In this scene, where the soundtrack does not correspond to the image, the voices of Crusoe's friends heighten his isolation. Butler and Buñuel accent the way Crusoe's isolation causes a psychological breakdown during which he realizes that elements of his former life in the "civilized" world have little meaning on the island. His world spirals from desperation into insanity as the convictions that have kept him connected to his life in the civilized world, such as his belief in the Bible, gradually lose all meaning.

The filmmakers' emphasis on Crusoe's loss of companionship is echoed in the conclusion of the film. Crusoe and Friday are joined on their island by another group, consisting of mutineers and their prisoners. After Crusoe and Friday team up with the prisoners, they successfully capture the mutineers, whom they then imprison. Here again the film differs in significant ways from the novel. In the novel, Crusoe tricks the mutineers into believing that if they return to England they will be hanged; thus when he allows them to stay on the island, they are thankful. In the film, however, exile on the island is a form of punishment, as Crusoe tells them that they may not be able to survive. His speech to them highlights how exile has affected him: he informs them that they at least "have something which I for years did not have, something for which I wept, for which my soul shriveled and starved. You have others of your own kind—you have companions—you have man." This emphasis on Crusoe's exile is also demonstrated in the ending of the film. While the novel begins and ends in Europe, the film

concludes with Crusoe leaving the island. Thus, the entire narrative of this film version of *Robinson Crusoe* centers on his life on the island, whereas in the novel his exile is framed and thus recuperated by Europe.

The focus of the film on Crusoe's isolation from civilization had broader significance for Buñuel and Butler. While literary scholars have described the ways Defoe accented the advantages of colonialism in the novel, these filmmakers actually reverse aspects of this story. One of the ways that they do this is by substantially rewriting the relationship between Robinson Crusoe and Friday that Defoe had established in his novel. Peter Hulme writes that Defoe's *Robinson Crusoe* makes absent the similarity between "civilized" and "savage" cultures, as he instead establishes a hierarchy between "master" and "slave."[84] However, the filmmakers destabilize Defoe's master–slave hierarchy as Friday "saves" Crusoe from his isolation and loneliness. Buñuel once commented on the relationship between Crusoe and Friday in an interview, "Two people on an island must survive and help each other—it isn't natural to maintain our social conventions. Conventions would cease."[85] In the film, Crusoe's life has little purpose before he "encounters" Friday. He in fact rediscovers a sense of identity as Friday's master. Crusoe's efforts to establish social hierarchies on the island allow him to regain civility. However, the filmmakers depict this relationship ironically as Crusoe forces Friday to use the table manners that he had long ago abandoned and teaches Friday to read the Bible in which Crusoe had previously lost faith.

While in the novel Defoe represents Friday as an extension of Robinson Crusoe, the filmmakers give Friday a voice and a position apart from Crusoe from which to challenge him.[86] For example, the filmmakers wrote a scene into the film (instigated by Buñuel and cowritten with Butler) in which Crusoe and Friday discuss God and the devil. In their conversation, Friday raises questions that expose inconsistencies in Crusoe's explanations as well as in the Bible more generally. Crusoe explains to Friday that "the devil is God's enemy in the hearts of men." Friday, who is confused by Crusoe's explanations, asks him quizzically: "If God [is] the most strong, why he not kill devil?" Crusoe responds that without the devil, man would not have the option of sinning or resisting. Friday points out the contradictions of Crusoe's argument—if God wants man to be good, why does God have the devil tempt man? Crusoe cannot respond to this last question, which exposes the limitations of himself both as a master and as the embodiment of the ideas of the civilized (Christian) world.

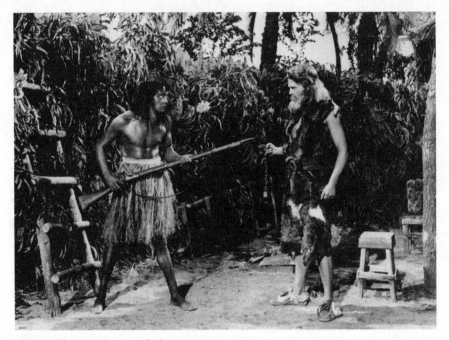

Publicity still from *The Adventures of Robinson Crusoe* (1952). Courtesy of the Academy of Motion Picture Arts and Sciences, Beverly Hills, California.

Numerous film scholars have noted that *The Adventures of Robinson Crusoe* narrates a critique of the "first world" through the filmmakers' representation of the relationship between Friday and Crusoe, who must rely on each other to survive. Victor Fuentes argues that this film (and Buñuel and Butler's other collaboration, *The Young One*) offered "a critique of colonialism and racism" that was so much a part of U.S. cinema. In contrast to Hollywood's stereotyping of people from the so-called third world, Fuentes contends: "From Mexico, Buñuel and his North American–Mexican team give a practical example of the urgent necessity of the interrelationship with the others (the so-called third world cultures), negated and humiliated by the colonialism of Western civilization."[87] These filmmakers sought to undermine the Manichean worldview of imperialism, obliquely referencing both Hollywood film production and U.S. foreign policies during the early Cold War era.

Another level of commentary, specifically directed at Mexican narrative cinema's representation of indigenous characters, is evident in the choice of casting Jaime Fernández, the brother of famed Mexican director Emilio

"El Indio" Fernández, as Friday. Marvin D'Lugo argues that "this Friday serves as much as a refutation of the condescending European myth of the noble savage as a reminder of Emilio 'Indio' Fernández's marketing of exotic pseudo-indigenous characters like Dolores Del Río and María Félix as cinematic representations of Mexico to the world."[88]

Buñuel's and Butler's rewrites to Butler's original script of *The Adventure of Robinson Crusoe* enabled them to comment on what Buñuel termed "conventional capitalist cinema" through surrealistic approaches. The overall style and content of the film differs from that of classical Hollywood (and Mexican) narrative cinematic productions, yet it registers a negotiation between Butler's background working in Hollywood film and Buñuel's experience directing European avant-garde film. While Buñuel's filmmaking style was aligned with a political and aesthetic perspective based in surrealism, Butler's training was in the Hollywood film industry, with its own formal codes and conventions. Although Butler's original screenplay corresponded to the generic conventions of Hollywood's novel-to-film adaptation, Buñuel inserted filmic elements that disrupted these conventions. For example, in the conclusion of the film, we see the influence of Buñuel's film practices as Crusoe leaves the island on a boat. One of the qualities of classical Hollywood narrative cinema, according to David Bordwell and Kristin Thompson, is that it "displays a strong degree of closure at the end of a film."[89] Instead of choosing a more conventional approach to narrative closure, Buñuel inserts the barking sound (presumably) of Crusoe's dog Rex, who had died many years before. Here Buñuel's addition of nonsynchronous sound calls attention to the tenets of Hollywood narrative cinema, contesting the constructed realism within the film. It also highlights one of the main themes of the film, which is Crusoe's isolation, triggered by the loss of companionship.

From a position at the periphery of the U.S. and Mexican film industries, these filmmakers launched an alternative to the capitalist and industrial mode of production found in classical Hollywood and Mexican narrative film. David James argues that "a given stylistic vocabulary is never merely itself, rather it is the trace of the social process, that constitutes a practice."[90] Bordwell and Thompson define the industrial mode of production taken up within the classic studio system in Hollywood as a kind of mass-produced filmmaking whereby "skilled specialists collaborate to create a unique product while still adhering to a blueprint prepared by management."[91] This mode of production was familiar to Buñuel who, while working in Hollywood in

the early 1930s, devised a game to show that "American cinema was composed along such precise and standardized lines that anyone could predict the basic plot of a film simply by lining up a given setting within a particular era, ambience, and character."[92] During the time that these filmmakers were in Mexico, Mexican film had developed a similar structure to that of Hollywood film. Many Mexican filmmakers had been trained in Hollywood, and as Ana López argues, went back to Mexico to produce the "national" cinema.[93] In contrast, the mode of production in which Buñuel and Butler worked was independent of that characterized by the Hollywood studio system and the Mexican film industry of the early 1950s.

In this filmic collaboration between Buñuel and Butler, they also position Crusoe and Friday as men without countries. Both Crusoe and Friday have been exiled—Crusoe by the shipwreck and Friday by his fellow countrymen who had attempted to sacrifice him. Near the conclusion of the film, Friday points out his island to Crusoe, to which Crusoe comments, "your nation, your people." Friday responds by repeating what Crusoe said ("my nation, my people") and indicates that he would like to see his people. Yet, when Crusoe later encourages Friday to return to his country, Friday resists, pleading with Crusoe to kill him rather than send him back. However much each man longs to return to his native land, he cannot. In this sense, they are both men "without nations."

The figure of Robinson Crusoe in particular allegorizes the dual positions of these filmmakers in Mexico as political refugees (and as noncitizens marginalized within the Mexican film industry) and as "resident imperialists" producing a film in Mexico largely intended for foreign distribution. However, in *The Adventures of Robinson Crusoe,* one can also find the exiles' nascent form of critique of their position in Mexico as the filmmakers reconceptualize Defoe's representation of Crusoe.

The Adventures of Robinson Crusoe cannot be located within either classical Hollywood or Mexican narrative cinema; in a sense this collaboration between exile filmmakers should be understood as interstitial.[94] Hamid Naficy argues that to be interstitial is "to operate both within and astride the cracks and fissures of the system, benefiting from its contradictions, anomalies and heterogeneity."[95] The film's reception was largely "international." It won prizes through international film festivals and was screened in large cities throughout the world. Marsha Kinder writes that the work of Buñuel "problematizes the nationality of the émigré artist and his films,

particularly amid the growing complexities of international co-productions and multinational capitalism," and notes further that "it makes us question what factors determine the film's nationality—the country where the production company is based or the film is shot; the nationality of the director, producer, writer, cinematographer, stars, or other key personnel; the source of its funding; the cultural source of its subject matter and thematics; or unpredictable events in its reception."[96] As some scholars have suggested about Buñuel, one can see an allegory of the positions of both Buñuel and Butler in this film "at the interstices of cultures, aesthetic ideologies and film industries."[97] While the film utilizes some conventions of classical Hollywood narrative film, Buñuel's use of nonsynchronous sound and other techniques simultaneously disrupt aspects of these conventions to expose the ideological and formal terms of their construction.

This meditation of exile, scripted by Butler with the input of Buñuel, critiqued conventional Hollywood narrative cinema and by extension the Hollywood film industry that had allied itself with the U.S. government during the early Cold War era. It was this association that forced both left-wing and "alien" filmmakers out of the industry and out of the country. Víctor Fuentes asserts that *The Adventures of Robinson Crusoe* is indicative of "the Buñuelian response to the inquisitorial climate of the United States that had forced his second exile, and to the commercial and arch-conservativism of Hollywood which had closed its doors to him."[98] It could also be argued that the film leveled a critique of the Mexican film industry and its alliance with Hollywood, the Mexican state, and by extension the U.S. Cold War state during a time in which the Mexican government became increasingly aligned with the United States economically. Through his work on *The Adventures of Robinson Crusoe,* Hugo Butler became acquainted with film practices that provided an alternative to conventional Hollywood narrative film. This collaboration with Buñuel marked the beginning of Butler's career in independent film production in Mexico.

RESIGNING FROM COUNTRIES: *A LONG WAY FROM HOME*

Like Hugo Butler, Gordon Kahn left the United States in 1950 to avoid a subpoena from HUAC.[99] However, unlike Butler, Kahn could not get work writing screenplays in Mexico and thus sought other forms of employment in order to make a living. In addition to the articles he wrote for U.S. magazines under pseudonyms, Kahn authored what he believed to be his "great

American novel," *A Long Way from Home,* during the 1950s. The main character in *A Long Way from Home* is Gilberto (Gil) Reyes, a Mexican American teenager living in Los Angeles, who is drafted to fight in the Korean War. Gil opts out of serving in the Army by fleeing to Mexico. The novel's trajectory is guided by Gil's journey across the border, from the United States into Mexico, and his eventual settlement in Mexico. In choosing to narrate his story of exile through a Mexican American draft dodger, Kahn allegorizes the U.S. exiles' position as political refugees rather than as resident imperialists.[100] I argue that the thematics of exile are reinforced by two aesthetic features of the novel. First, the cinematic quality of Kahn's writing counters traditional notions of point of view and narrative voice in conventional realist literature, producing a sense of disorientation and estrangement for the reader that echoes the social, political, and psychic dislocations of exile that the novel takes as its subject. Second, Kahn translates his perspectives on the Cold War culture and politics of the United States and Mexico into fiction by adopting the literary form of the bildungsroman. In particular, Kahn uses the bildungsroman's narrative of personal development—its movement from innocence to experience—to build a critique of the processes, practices, and relations of U.S. imperialism, a profit-driven war, and U.S. Cold War nationalism.

Kahn had no prior experience as a novelist when he wrote *A Long Way from Home.* Before he was blacklisted in the late 1940s, following the 1947 HUAC hearings on the film industry, Kahn had cowritten or written over forty screenplays for gangster and crime films in Hollywood during the Depression, moving onto scripts for Roy Rogers Westerns and film noir in the 1940s. During the late 1940s, Kahn wrote and published his account and analysis of the HUAC hearings in *Hollywood on Trial* (1948). He started to write *A Long Way from Home* soon after moving to Mexico in the early 1950s. When Kahn finished his novel in the 1950s, he submitted it to numerous publishers. All of them rejected the novel, arguing that it was "too political."[101] As a result, the novel gathered dust for twenty-seven years after Gordon Kahn's death until his brother Joseph succeeded in getting it published by Bilingual Press/Editorial Bilingüe.[102] The novel was included in its literary series of Chicano Classics.

A Long Way from Home has interested Chicano studies scholars in part because it is one of the few novels written during the 1950s that deals with

Mexican American issues from the perspective of a Mexican American. *A Long Way from Home* can be contrasted with another bildungsroman of the same era featuring a Mexican American protagonist, José Antonio Villa-rreal's novel *Pocho* (1959). Gil's beliefs and actions differ dramatically from those of Richard Rubio, the protagonist in *Pocho,* as Gil sees beyond U.S. Cold War ideology, whereas Richard does not. In *A Long Way from Home,* Gil decides not to serve in the U.S. Army in part because he comes to be-lieve that the Army uses people of color to fight their wars, while the U.S. government and other institutions discriminate against these same individ-uals at home. In *Pocho,* Richard decides to enlist in the U.S. Navy in order to prove his loyalty to the U.S. government. *Pocho* is in many ways a "reflec-tion of Mexican American life during what is termed the 'assimilationist' period in Chicano history," as Carl Shirley argues.[103] Nonetheless, other Chicano studies scholars, including Ramón Ruiz, who wrote the introduc-tion to the 1970 edition of *Pocho,* criticize Villarreal for not highlighting racial prejudice against Mexican Americans in the novel.[104] In his introduc-tion to the 1989 edition of *A Long Way from Home,* Santiago Daydí-Tolson describes Kahn's beliefs as a precursor to the Chicano civil rights movement of 1960s and thus "advanced" as compared with those of Mexican Ameri-cans in the United States in the 1950s.[105] However, Kahn's views were signifi-cantly influenced by Mexican American activists, including those involved in El Congreso de Pueblos de Hablan Español (Congress of Spanish-Speaking People) who campaigned for the rights of Mexican Americans in the United States during the 1930s and 1940s.[106]

Kahn's decision to write a novel about the experiences of a Mexican American draft dodger can be linked to his involvement in the Screen Writers Guild, which along with the activities of El Congreso and the Mexican Defense Committee (MDC), brought his attention to the condi-tions of Mexican Americans living in Southern California during the 1930s and 1940s.[107] The cofounders of El Congreso, Josefina Fierro and Luisa Moreno, frequently met with members of the Hollywood Guilds to educate them about discrimination against Mexicans and Mexican Americans.[108] While she was involved in the MDC, Fierro organized a committee with numerous Hollywood screenwriters, in response to the Sleepy Lagoon case, to protest police brutality against Mexican Americans.[109] This group, which became known as the Sleepy Lagoon Defense Committee, brought together

Mexican American activists and progressives in Hollywood, including Fierro's husband, screenwriter John Bright, as well as Orson Welles, Dalton Trumbo, Ring Lardner Jr., and John Howard Lawson.[110]

In addition to his political past, I situate my analysis of *A Long Way from Home* within the context of the political conditions that influenced Kahn to leave the United States as well as those of Mexico where he lived during the early to mid-1950s. In the novel, Kahn represents the United States as dominated by racism and anti-Communism with a government that persecutes individuals whose belief systems are counter to dominant U.S. Cold War ideology. While Kahn portrays Mexico as a nation that resists aspects of the U.S. Cold War agenda, he also underscores the significant problems facing poor and indigenous peoples in Mexico following the administration of Miguel Alemán, who moved the country toward modernization and industrialization.

In the novel, Kahn critiques the political conventions of nationalism and national identity that had been naturalized within the context of the Cold War. As an immigrant from Eastern Europe who had journeyed to the United States at the turn of the twentieth century, Kahn had already been part of a diaspora. In the United States, he became part of a new working class, which, according to Michael Denning, consisted of the "migration of millions from an agricultural periphery" to an industrial core.[111] Kahn's ideological outlook, like others whom Denning identifies as part of the Cultural Front, could be described as a "pan-ethnic Americanism."[112] This manner of pluralism was challenged during the early Cold War years by a U.S. patriotism that criminalized foreigners, left-wing and liberal thinkers, as well as racial minorities. As a person derided as "Un-American," Kahn was further compelled to question the nation-centered biases of the U.S. Cold War state.

A Long Way from Home, which remains unedited in its posthumous publication, can be divided into three sections. The six opening chapters focus on Elvira Reyes, Gil's mother, before and after her death. Sections of these chapters are portrayed through Elvira's point of view as she recollects (in dreams) her life before her hospitalization, including her years as a singer. After Elvira dies, Gil is informed that he's been drafted to fight in the Korean War. However, after conferring with Elvira's doctor, Dr. Samuel Eisen, Gil decides not to serve in the U.S. Army and instead flees to Mexico. The second part of the novel tracks Gil's journey to Mexico and his relationship with Fred Bishop, a World War II veteran with whom he travels across the

U.S.–Mexico border. The final section of the novel centers on Gil's new life in Mexico and his relationships with Russian-Polish exile Don Solomón as well as with his extended family members. At the end of the novel, Gil decides to join the Mexican Army and to become a Mexican citizen.

Aesthetic decisions in *A Long Way from Home* register the effects of Kahn's own experience of exile. Deprived of creative and professional access to the Hollywood film industry, Kahn nonetheless conceived of his novel cinematically. The first six chapters of the novel read like a screenplay, with frequent movement between different characters' points of view and temporal location. These chapters alternate between the perspectives of Gil, Elvira, and Dr. Eisen and contain literary versions of a technique called *internal diegetic sound* in film. According to Bordwell and Thompson, internal diegetic sound is when "sound is represented as coming from the mind of the character within the story space."[113] This literary version of internal diegetic sound is used to convey information about the characters, their backgrounds, and what motivates them. While in the novel these segments appear as internal thoughts of individual characters, this mode of narration partially disorients the reader, who must continually try to locate whose point of view is guiding the narrative.

This sense of dislocation, of searching for a coherent vantage point, begins at the outset of the novel, as it appears at first that the novel is about Elvira. Although Gil later becomes established as the protagonist, the first three chapters are largely composed of Elvira's dreams about the past as she lies in a hospital bed being treated for an occupational disease she acquired while working in a factory during World War II. These chapters alternate between Elvira's dreams about events in the past and the present where nurses tend to her. (When the narrative returns to the present, these sections of the story are told from the perspective of Belle, one of the nurses on the ward.) In her dreams, Elvira thinks back to her life before Gil was born, when her husband went to jail, as well as the news about his death after Gil's birth. She also reflects on her career as a waitress and later as a performer in nightclubs. It was at the Trocadero, where she fainted during a performance, that she met Dr. Eisen, a spectator in the club. After this incident, Eisen became her doctor and pays her medical expenses.

Within the next three chapters, the point of view shifts again. Chapters 4 and 5 alternate between Gil's remembrances of the past, including his being expelled from high school and appearing before a judge for a crime he

did not commit, and the present. In chapter 5, Gil discovers that his mother has died and talks to Dr. Eisen about plans for the future. Chapter 6 is written from the perspective of Dr. Eisen, after Gil leaves his office. Eisen recalls his own recent past, specifically his interview with a State Department official regarding his application for a passport. The official tries to press Eisen to talk about his decision to volunteer during the Spanish Civil War and then accuses him of having "conspired to violate" the National Selective Service Act by counseling his brother-in-law to become a conscientious objector during the Korean War. With one exception, the remainder of the 455-page novel follows Gil's perspective.[114]

Similar to the function of flashbacks in films, the switching back and forth between different characters and moments is employed as a time-saving device in the novel: it provides a means to present information about a character's past without extended digression. It is also used as a way to condense the past and present in order to create more space for the story of Gil's journey. However, what differentiates the use of temporal movements in a novel from those in a film are the visual cues that prompt the viewer to these changes. Such cues are followed by sequences that can be visually distinguished from the film's representation of "real time." There are no such cues in Kahn's novel, and thus it is left up to the reader to differentiate between these temporal moments. The novel highlights this disjuncture of aesthetic languages, and the formal awkwardness of the translation from a screenplay to a novel persists. That the novel was published still unedited leaves intact to an even greater degree the restructuring of Kahn's cultural production through his experience of exile, which is visible in the uncomfortable reworking of the book's aesthetic form. Alternatively, if the text had been edited, these temporal movements might have been differentiated, eliminated, or at least minimized by an editor.

What is striking in the early chapters of the novel from an aesthetic standpoint is the sense of disorientation caused by the unorthodox use of perspective that shifts unexpectedly among characters. This structure speaks to two issues. The first is the cinematic experience of the work of a screenwriter who has authored his first novel, translating his own experience into fiction. The second is the way that this disorientation serves as a device to formally reiterate the theme of displacement that is at the heart of the novel. In this sense, the circumstances of Kahn's own political dislocation reverberate within the aesthetic qualities of his novel. In particular, the

shifting point of view provides an ungrounded feeling, confounding clear lines of identification and narrative vantage point, conveying the sensation of not being at home, the subject of Kahn's book. Here, of course, Kahn is also borrowing the techniques of modernism, experimenting in point of view, which writers use to fragment perspective and to capture a multitude of experiences.[115]

These multiple perspectives also destabilize the hierarchy of perception that is created by a single narrator's voice. This undermining of a single, coherent narrative point of view similarly forces into relief, in the context of Kahn's story, the artificially unified master narrative of the nation-state itself. It also provides a formal allegory for the experience of exile. Forced beyond the national borders of the United States, the condition of exile compels a reassessment of one's location. This is tied to the form of the bildungsroman, as Gil, through coming-of-age during his journey from the United States into Mexico, becomes conscious of the rigidly policed parameters that frame dominant Cold War ideology. He gradually becomes aware of U.S. nationalism as an ideological limit, paralleling the way in which the reader is made aware of the contingency of point of view.

In addition to the way that exile is central to the aesthetic form of the novel, Kahn allegorizes his own experience of blacklisting and exile through the experiences of Gil.[116] This is most apparent in chapters 4 and 5, where Kahn describes Gil's encounters as a target of U.S. racism. In these sections, Kahn draws connections between the persecution of racial minorities and those with left-wing views during the early Cold War era. One scene in particular evokes aspects of the 1947 HUAC hearings on the Hollywood film industry, which Kahn had detailed in *Hollywood on Trial* (1948). In a passage set in the past, Gil is expelled from his high school because he dates Carolyn, who is white. When her mother discovers three condoms in Carolyn's purse, she badgers her to "name names" of the boys she is dating. Carolyn's parents contact the principal of the high school, who brings Gil in for questioning. The principal, whom Gil refers to as "The Dutchman," is both a racist and anti-Communist who fired a teacher at his school because of her progressive politics. The Dutchman hurls accusation after accusation at Gil, leaving him little opportunity to defend himself:

> The first thing The Dutchman said was, "There's no sense in your denying anything, Reyes. I have the girl's statement in writing. She says you forced her into this relationship. . . ."

> "Did you induce her to smoke marihuana?"
> ". . . No, sir."
> "But you know what it is."
> "Yes, sir."
> "Of course you do. It's in common use among you Mexicans. . . ."
> "It's a good thing for you that the girl's father didn't go straight to the po-
> lice," Van Kliek said. "They would have handled this matter differently. None-
> theless, I'm going to clean house here at McVeigh. Root out every single one of
> you. . . . And, Reyes—if you're thinking of transferring to any other high school
> in this county, you'll find that your record has gotten there ahead of you."[117]

Here Kahn links the anti-Communist assault of HUAC hearings of 1947
to the position of a racist principal who both expels and blacklists Gilberto
for dating a white girl.

Although Kahn conveys his own experience of blacklisting and exile
through that of Gil's, it is also the literary vehicle of the bildungsroman that
provides him with a context in which to compare and contrast aspects of
U.S. and Mexican politics and culture. Gil's story resembles many aspects of
the bildungsroman. As in a traditional bildungsroman, this is a story of an
individual's personal growth from innocence to maturity, overseen by men-
tor characters. However, *A Long Way from Home* can specifically be charac-
terized by what Barbara Foley refers to as a "proletarian bildungsroman," as
Kahn "operates from behind a screen," communicating political ideas
through Gil's mentors (and Kahn's stand-ins), two older Jewish men—Dr.
Eisen in the United States and the appropriately named exilic figure Don
Solomón in Mexico.[118] In some of the early chapters of the novel, Kahn's cri-
tique of U.S. Cold War militarism is expressed by Dr. Eisen, who converses
with Gil about leaving the country after he receives his draft notice. In the
final section, it is Solomón, a former soldier who went AWOL after fight-
ing in World War I, who discusses the idea of not returning to the United
States with Gil. While Foley characterizes the proletarian bildungsroman as
a form in which a working-class protagonist acquires a militant or revolu-
tionary class consciousness, in this novel Gil develops not only a class con-
sciousness but an ethnic and antinationalist consciousness as well.[119]

Early on in Gil's journey to Mexico, World War II veteran Fred Bishop
presents him with a class-based analysis of the Korean War. Bishop tells Gil
that the Korean War is being fought by the poor, critically describing the
arguments he was given to fight:

The same ones you get on every side, wherever you go. It baffles me. Pick up
a magazine—anything—the *Post, Colliers*. They advertise a four thousand-
buck television and it says "Don't Let Them Take This Away From You!" . . .
You haven't got it yet and already they want you to protect it. . . .
 You see an ad for a washing machine. It used to be, don't let your poor
old mother break her back; get her one of these. Now it says something about
how many man-hours a Commie has to put in to buy a shirt. (117, 118)

In this passage, Bishop articulates a critical perspective on the "selling" of
the Cold War by the U.S. government. His statement raises the issue of who
the Korean War, and by extension the Cold War, will benefit, indicating
that it is those who can buy expensive consumer goods, rather than the work-
ing classes, who are drafted to fight in the war. These comments influence
Gil's perception of the aims of the U.S. Army.

In part because of his conversations with Eisen in the United States
and with Bishop crossing the U.S.–Mexico border, Gil develops an increas-
ingly critical perspective of the U.S. government's motives for involvement
in the Korean War, as well as discrimination in the United States against
people of color and the working classes. Some of the earliest conversations
Gil has with Solomón, a Russian-Polish exile whom he meets in Zaragoza,
are focused on the Korean War. When asked by Solomón about the support
of the American people for the Korean War, Gil responds that compared
with World War II, few Americans enlisted during the Korean War. He
states that "they [the U.S. Army] can't even sell the idea. They have to de-
pend on the draft—about thirty thousand fellows every month." Gil also
comments that those drafted were most often Mexican or white ethnics,
with names such as "López, Gómez, Chávez, Cohen, Rodríguez, Kelly"
(299). After their discussion, Gil reflects that the U.S. government consid-
ered him a second-class citizen, or in his words a "half assed American," yet
with a war on, the government recruited him to fight anyway. Gil notes that
with a name like Reyes, "you're a Yankee Doodle Boy, No. 23328–37, when
they want something from you—like your life, for instance" (306). Here
Gil has the opportunity to reflect on the reasons that influenced him to
avoid serving in the Korean War. On the one hand, he knows that this war
is unpopular, thus forcing the U.S. Army to institute a draft. On the other
hand, he views those who are drafted as "second-class citizens" who will be
used as cannon fodder.

Gil's discussions with Solomón further his own position against the Korean War to a broader critique of nationalism and required military service. Originally from Poland, Solomón explains to Gil that he'd been drafted to fight in the czar's army as a Russian in 1915. He was then sent to fight alongside the French as a Russian-Pole, and in 1918 was declared Polish. After the armistice, he was not discharged and became a legionnaire under the French and British, fighting against "the Bolsheviki," his former countrymen. He remarks to Gil that a "Marshall Pilsudski changed my nationality as it suited him. I changed it to suit myself," referencing his decision to desert and settle in Mexico. As Solomón is speaking, Gil's mind drifts off as he imagines himself fighting "those North Korean and Chinese with their ridiculous tennis sneakers, some of them women" (303). Gil relates the idea of his own fighting against the North Koreans to Solomón's having fought against his former countrymen because it suited the ruling powers to change his nationality.

Solomón's experience of military desertion provides a model for Gil, as does his decision to seek exile in Mexico. In choosing between returning to the United States and remaining in Mexico, Gil compares the two countries for the different ways that they treat immigrants and exiles. Gil views Mexico as a place that shelters political exiles from Russia, Poland, Spain, Germany, and the United States; he sees the United States as discriminating against Mexicans and Mexican Americans. In a conversation with a Spanish exile in Mexico, Gil asks whether he would return to Spain, to which the exile replies, "My countrymen have made their own Spain here." Following his conversation, Gil thinks to himself: "The guy had it right. . . . When the day comes it doesn't matter whether they plant you in Spain, Mexico, Jerusalem, or the Forest Lawn Burial Park, where he didn't think they sold space to Mexicans anyhow" (398). Gil critically assesses the myth of the United States as a "melting pot" that openly accepts foreigners and exposes how the "color line" operates in the United States, even in death. Referencing racially segregated cemeteries, Gil's statement speaks to U.S. racism toward Mexican Americans, but the further implication is that it doesn't matter in what country you die—or where you live—you can make your home anywhere.

While Gil develops a critical perspective toward U.S. foreign policy during the Korean War, he also learns that Mexican foreign policy does not follow that of the United States. By reading Mexican newspapers, Gil dis-

covers that the majority of Mexicans do not support U.S. action in Korea. In the antiwar publication *Paz* (Peace), Gil studies articles about Mexican politicians and army personnel who are against the U.S. government's role in the Korean War.[120] In one article, a Mexican general asserts that *"¡Nuestros hijos no irán a Corea!"* ("Our boys will not go to Korea!") (427). Gil also reads a statement by former President Lázaro Cárdenas, who declares, "Millions of men and women of all faiths and nations must carry on the moral aim to enforce peaceful convictions among the responsible leaders of the nations now in conflict, and to eliminate violence as a solution to international problems" (427). While reading *Paz*, Gil reflects that Mexicans would not contribute to the Korean War, as they would only be willing to fight in a war if it was "something more than a whine on the radio from some distant chancellery. It would have to come from the watch towers on their own soil to find its echo in the hearts of the people." Reflecting back on a conversation with Bishop regarding the purpose of the Korean War, Gil comments, "The Mexican lucky enough to own a wind-up phonograph is not going across wide seas to preserve his *yanqui* brothers' fine 21-inch television" (431). In the novel, the goals of the U.S. Army during the Korean War are represented in part as protecting the rights of consumers. The Mexican army, on the other hand, does not send soldiers to Korea. Rather it works to combat underdevelopment in Mexico through reforestation and other civic projects.

While learning about political perspectives in Mexico, Gil discovers an anti-imperialist strain in the writing of Mexican journalists who are disparaging of U.S. intervention not only in Korea but also in Mexico during the early Cold War era. In most of the articles that Gil reads, Mexican journalists assert a critical stance on the Korean War and the Cold War, specifically challenging U.S. global hegemony from an anti-imperialist standpoint. After reading an article, Gil comments to himself that he often sees the phrase *imperialismo yanqui* (Yankee imperialism), noting that it came up as frequently as the word "Communism" in the American periodicals. In one article, a journalist appears to be referencing the 1951 Military Defense Assistance Act, which the U.S. government developed after the beginning of the Korean War. As part of the Act, the United States provided counterinsurgency funding to governments in Latin America to suppress local left-wing organizing.[121] In this article, the writer asks, "Will the colossus of the North which offered México an outright gift of 8 billion pesos for

the establishment of an élite military corps in this country lend us that sum now so that we may buy more cotton mills, more shirt factories? More employment for our working people?" (426). Here the writer emphasizes how the U.S. government, rather than offering economic aid to Mexico and Latin America, provides funds solely to support their military forces. Furthermore, these publications include anti-imperialistic cultural work, including a poem by the Cuban intellectual José Martí, in which a mother tells her baby which he should choose between a "yoke" and a "star" (426, 427). By quoting Martí, a writer who challenged U.S. dominance in the Americas, Kahn references an extended anti-imperialist history.

It is through his exile in Mexico that Gil begins to see the parameters that frame dominant U.S. Cold War ideology, contributing to his decision to renounce his U.S. citizenship. His choice to remain in Mexico is forced by a particularly conservative priest who discovers Gil's status as a draft evader and accuses him of being a traitor who should return to his "own" country. After this conversation, Gil suggests to Solomón that perhaps he *should* return to his "own" country. Solomón reminds Gil of a previous comment he had made regarding the constructedness of national identity: "Your *country*, my son? You yourself, didn't you say a country—yours, mine—was not earth or trees; neither mountains nor valleys" (302). Drawing on an earlier conversation with Fred Bishop, Gil asserts that identity is not linked to a geopolitical space (a country) and that one cannot define identity by national borders. However, thinking back to his experience at the border, where people had to declare themselves either "Mexican or American— *mexicano* or *norteamericano,*" he realizes that he must make a choice, eventually deciding to revoke his U.S. citizenship. Gil reflects on the long history of immigration to the United States and elsewhere: "People have been resigning from countries as well as firms ever since [Plymouth Rock, 1620]— All over the world there are bronze monuments, scratches on rocks, plaques and shrines with the dates when these resignations went into effect. For different reasons; shortages in some places, and too much of something else in others. Not enough potatoes in Ireland or spaghetti in Sicily. Too much misery in Poland and too little rye bread" (383). Here Gil envisions a connection between his own exile and the history of people who have "resigned from countries." Like those from Ireland, Italy, or Poland, Gil's migration was driven by a historical event, the Korean War, and his avoidance of fighting in this war, the purpose of which has little meaning for him.

Gil's decision not to serve in the U.S. Army is in part based on his lack of belief in the purpose of the Korean War, but it is the problems within Mexico that inspire him to stay in the country to fight against poverty and underdevelopment. Although Gil negatively compares the United States to Mexico, he gradually becomes aware of the hypocrisy of the Mexican state, particularly of politicians who espouse revolutionary rhetoric while discriminating against the poor and indigenous, as well as the church and its priests, some of whom identify themselves as *"Porfiristas"* (supporters of Porfirio Díaz) (148). Through conversations with Lorenzo, a man who works for Don Solomón, Gil learns that while the Mexican government had established *ejidos* (communal farms) after the Mexican Revolution, politicians (and military officers) divided some of them up, turning them into *latifundios* (privately owned landholdings) (276). This happened to the *ejido* where Gil's father's family lived, which was taken over by a military officer named Coronel Carrasco. On Carrasco's ranch ("Rancho Corona"), he employs residents of the town who work for low wages. Through Lorenzo, Gil thus becomes aware of the problem of *caciquismo,* a system whereby a local boss exerts power over the rural poor, a contemporary form of feudalism in rural Mexico. Over time, Gil comes to believe that by joining the Mexican army and working on a reforestation project he can help to combat underdevelopment in Mexico.

The exile of the Mexican American draft dodger from the United States presents an interesting juxtaposition with the opposite geographical trajectory of the *bracero* from Mexico. Kahn wrote this novel at a time when most of the movement across the U.S.–Mexico border began in Mexico. During the years that the Bracero Program was in operation (1942–1964), thousands of Mexican workers crossed the border every year to labor in the fields of the U.S. Southwest. Their movement was guided in part by the potential for increased earnings in the United States, but it was also related to the lack of economic opportunities for many in Mexico, especially for those who lived in rural areas. During this time, many unauthorized Mexican workers also crossed the border in order to find work during a period of modernization in Mexico, when the country shifted from a predominantly agricultural to an industrial-based economy.[122]

Kahn's decision to focus his story on a Mexican American draft dodger who becomes a Mexican citizen provides a kind of resolution regarding Kahn's own lack of a home. Kahn describes that after Gil "becomes" a

Mexican citizen, he walks to the plaza "feeling relieved physically and every other way." The importance of this walk was "to be seen, to be looked upon as a stranger no more." As opposed to hiding his identity, now "He wanted to be asked his name and to give it" (410). In the last paragraph of the book, Gil is crying with joy at the decision he made to remain in Mexico. In the last line of the book, he notes that "the Finding was better than the cold tearlessness of the Seeking. It was the best"(455). As Gil had hoped for earlier in the novel, he successfully closed the gap between the "getting *away* and getting *to*" (153). However, the decision to renounce his U.S. citizenship and to become "Mexican" was not an option for Kahn. As mentioned earlier, during the 1950s, U.S. governmental agencies attempted to keep Kahn from acquiring residency papers that would allow him to remain in Mexico, thus putting him at risk of being deported from the country and then "denaturalized" by the INS.

Kahn's experiences of exile, from Hungary to the United States and from the United States to Mexico, contributed to his notion of "resigning from countries." This position informed his understanding of his exile as a reaction to the explicitly nationalistic project of U.S. Cold War policy, which involved expunging those not tolerated by the political terms that national policymakers and law enforcement officials established for the nation. This perspective contrasted with the dominant ideology of the early Cold War era, which consisted of a trenchant U.S. nationalism and an American exceptionalist vision of the world at large.

CULTURE IN THE BATTLE OF IDEAS

During the early Cold War era, the U.S. State Department used various forms of cultural work, such as abstract expressionist painting and jazz music, as strategic weapons of the Cold War.[123] In cultivating the artwork of abstract expressionists and by sending jazz musicians on "Goodwill" tours across the Middle East, India, Africa, South America, and elsewhere, the State Department attempted to promote artistic and musical forms that appeared as both "universal" and uniquely American. As ambassadors to the world, these artists and musicians were to convey the exceptionalism of American achievement, that such freedom was uniquely American, and to suggest that U.S. capitalist democracy still stood as a "city on a hill," a beacon for the rest of the world to emulate. The U.S. State Department's presentation of U.S.

culture was predicated upon two erasures. The first erasure involved promoting one specific interpretation of abstract expressionism and jazz as aesthetic and musical forms. The second erasure was accomplished by silencing or expelling voices of political dissent.

In the late 1940s and 1950s, other cultural forms, including film, also became important ideological weapons in the battle for hearts and minds. Starting in the late 1940s, U.S. governmental agencies, including the State Department, were involved in the production of anti-Communist films intended for audiences in Latin America and elsewhere. While the State Department did not attempt to change any aspect of abstract expressionism or jazz music, focusing instead on the exhibition and distribution of this work, it did successfully intervene in the content of film productions. These films, some of which were produced or coproduced in conjunction with Hollywood studios, developed plots that contained distinctly anti-Communist "messages."[124] In his analysis of the U.S.–Mexico coproduction *Dicen que soy comunista* (They Say That I Am Communist), (1951), directed by Alejandro Galindo, produced at Estudios Churubuso in Mexico, and distributed by RKO Pictures for Latin American audiences, Seth Fein describes how the filmmakers used discourses of nationalism as a form of anticommunism.[125] In *Dicen que soy comunista*, the leftist characters are portrayed as criminals and as distinctly antinationalist.[126] Fein suggests that the "message" of the film suited both the administration of Miguel Alemán in suppressing dissent within Mexico and the U.S. State Department's early Cold War efforts in Latin America to "contain external Soviet and curtail internal radically nationalist movements, especially independent labor currents."[127]

A Long Way from Home and *The Adventures of Robinson Crusoe* ran counter to this agenda for containment and suppression. *A Long Way from Home* can be differentiated not only from novels like *Pocho* but also from screenplays written about Mexican Americans and Mexicans for State Department or Hollywood film productions during the early Cold War era. Specifically, Kahn's novel contrasts with the State Department's film portrayal of a young Mexican American man being drafted to fight in the Korean War in *And Now, Miguel* (1953). The film was directed by Joseph Krumgold, who would later turn the story into a novel addressed to a U.S. audience.[128] *And Now, Miguel,* like Kahn's novel, is a coming-of-age story centered on a young male Mexican American protagonist, in this case

Miguel Chávez from Las Córdovas in northern New Mexico.[129] The film focuses on Miguel's hope to accompany other male family members to the Sangre de Cristo Mountains to take the sheep for their summer pasture. His wish is granted after his older brother Gabriel is drafted to serve in the U.S. Army. (The film displayed an assimilationist ideology along the lines of that espoused by the League of United Latin American Citizens and the GI Forum, whose goals were to "Americanize" their constituents.)[130] Just as the State Department sent jazz musicians and other African American performers on tour as a "living demonstration of the American Negro as part of America's cultural life," so too were Mexican Americans incorporated into the project of exporting American culture abroad, as this film was screened throughout Latin America.[131]

The differences between the USIS-produced film *And Now, Miguel* and the novel written by Krumgold attests to the ideological agenda of the U.S. State Department. In 1953 the State Department's International Motion Picture Service, which produced films distributed through USIS posts, developed a new approach to film production. Instead of focusing entire films on anti-Communist messages, they began to insert messages within so-called normal films.[132] These messages are evident within *And Now, Miguel*. For example, in one sequence that takes place near the Río Grande, Miguel explains (in his voiceover) that his older brother Gabriel will report for duty, because in Gabriel's words, "beyond the oceans into which this river flowed there was now a danger, not only to the sheep but to our whole family and to all the families like us who lived with the freedom to make the wish that was in their hearts. . . ." In an unmistakable reference to Soviet totalitarianism, Gabriel speaks about the threat of "those who would put an end to such a freedom and destroy everyone's wish but their own." In the film, it is the oceans, where the rivers lead, that bring "danger" to the family, whereas in the novel, Gabriel explains that he also made a wish to leave Las Córdovas—not to join the Army, which is just "something you have to do," but to see new places, to follow the river, down to the Río Grande, through Texas, to the Gulf of Mexico.[133] In contrast to the novel, the film implies that if this danger is not stopped in far-off oceans, it will travel to nearby rivers to squelch their (and by implication, "our") freedom. John Fousek described this conceit as American nationalist globalism, whereby "a threat to 'freedom' anywhere in the world was deemed a threat to the American

way of life."[134] This narration conveys what Fousek argues was the central tenet of the struggle against international communism, which "was believed to threaten fundamental American values, most notably freedom of enterprise and freedom of religion and the possibility of spreading those values, which were deemed universal, to the rest of the world."[135]

Within the context of producing a film that romanticizes pastoral life (in actuality, a reenactment of the sheepherding practices of the Chávez family of Las Córdovas, New Mexico),[136] narrated by a young Mexican American boy, the State Department chose to emphasize a message regarding the duty to serve in the Army while attempting to demonstrate that what "we" were fighting for was a "universal" concept—freedom—that affected everyone. In contrast, in *A Long Way from Home*, Gilberto refuses "his duty" to serve in the U.S. Army during the Korean War because he sees no point in fighting "foreigners on foreign soil" in order to defend Americans' "freedom" to buy consumer goods. Leaving the United States, Gil is increasingly aware of the circumscribed vision of U.S. Cold War ideology and its relentless promotion of U.S. nationalism and "benevolent" imperialism.

One of the goals of the U.S. Cold War state's cultural battles was to attempt to silence or expel voices of political dissent. Many progressive Hollywood screenwriters were blacklisted from the film industry because of their political beliefs and silenced through the censorship of their work. It is significant that *And Now, Miguel* was both produced and distributed by the U.S. State Department, while Kahn's "Great American Novel," as he referred to it, was rejected from every publisher to whom he submitted it in the 1950s. Kahn's challenge to U.S. Cold War ideology as well as his specific critique of nationalism clearly went beyond the permissible bounds of U.S. cultural production during the early Cold War era.

These allegories of exile, which narrate aspects of the filmmakers' dual positions as resident imperialists and political refugees, critique the relations of U.S. imperialism. While in *A Long Way from Home*, Kahn condemns U.S. imperialism and a profit-driven war, in the case of *The Adventures of Robinson Crusoe*, Butler and Buñuel combine a rewriting of Defoe's classic story of colonial mastery with a formal affront to the hegemony of Hollywood's mode of production and aesthetics that had so significantly influenced Mexican cinema of the post–World War II era. The filmmakers narrated a critique not only of conventional Hollywood cinema but also of

the Hollywood film industry that had, through its alliance with the U.S. Cold War state, forced these filmmakers out of the country. The allegorized tension between U.S. exiles as resident imperialists and political refugees made visible precisely the erasures upon which state-promoted representations were predicated. Not only did Butler and Kahn continue to produce work despite the proscriptive efforts of the U.S. state, but their work performed a vital condemnation of the emphatically delimited and chauvinistic perspective of officially acceptable U.S. culture.

4

Audience and Affect

Divergent Economies of Representation and Place

Hugo Butler and Dalton Trumbo were good friends with similar political perspectives, but they parted ways when it came to bullfighting. Jean Rouverol describes the disagreement between her husband and Trumbo in her memoirs. As she recalls, her husband felt that there was "little difference between slaughtering an animal for beef and killing it in the bullring." Trumbo, who had owned a cow as well as a few horses on his ranch in Southern California, disagreed. While Rouverol represents their discussions as jovial, one of their conversations ended up in Walter Winchell's gossip column in the *Hollywood Reporter,* "transmogrified by gossip into a shouting match, expulsion from the restaurant, and a public fistfight." The Butlers were so upset by the article that they contacted a U.S. attorney about suing for libel. According to Rouverol, the attorney stated that "it might be rather difficult, considering our current situation, to prove that our careers had been substantially damaged by the story."[1]

Whether U.S. exiles were fans or critics of the sport, bullfighting proved to be one of their most popular subjects. It is not surprising that once in Mexico, many U.S. writers, including screenwriters, turned to Mexican culture as a subject for their writing. Their understanding of Mexican culture, history, and politics, however, varied significantly. Moreover, the extent to which they viewed their exile in Mexico as a long-term relocation or as a temporary condition contributed to identifying the audiences they imagined for their work. For those intent on making Mexico their new home, Mexican audiences and narratives that assumed familiarity with Mexican cultural idioms took precedence. Others, who looked upon Mexico as an interim staging ground for their efforts to reenter the U.S. mainstream, often

appropriated Mexican subject matter as a thematic conceit superimposed onto conventional Hollywood genres targeted at U.S. audiences. Overtly political subjects for writers of either tendency were severely constrained by the circumstances of their residence in 1950s Mexico. As such, politics were partially articulated through aesthetic form and mode of address. The marginalization of foreigners by the state-sponsored Mexican film industry further propelled U.S. screenwriters in Mexico toward either the U.S. black market or independent production in Mexico.

Bullfighting turns up in screenplays by John Bright (*Brave Bulls*, 1951), Hugo Butler (*¡Torero!*, 1956), and Dalton Trumbo (*The Brave One*, 1956), as well as in Willard Motley's unpublished novel "Moment of Truth," written during the 1950s.[2] While the choice of bullfighting was related to their own newly acquired exposure to the sport as spectators, it was also a subject that could appeal to audiences in the United States, Mexico, and the international market. However, these individuals produced their work in distinct contexts, which affected the kinds of narratives they created. The differences between producing films in the United States and Mexico can be found in the two most significant films about bullfighting written by Hollywood screenwriters in Mexico, Butler's *¡Torero!*, made in Mexico, and Trumbo's *The Brave One*, produced in the United States.

While both *The Brave One* and *¡Torero!* focus on bullfighting, their approach to their subject is significantly dissimilar.[3] Dalton Trumbo's story is set in the Mexican countryside on a ranch and portrays the relationship of a young boy and a bull. Hugo Butler, on the other hand, locates his film in the urban world of Mexico City, on the streets and in the bullring, and the story is told by the professional bullfighter Luis Procuna. Trumbo's screenplay of *The Brave One* was shaped in part by the constraints of the blacklist as well as by the intended audience for his work, as it was addressed to a U.S. rather than a Mexican public. While Trumbo used his black market screenwriting work as a means to break the blacklist, his approach to his topic had political implications within the Mexican context of which he was likely unaware. As mentioned above, *The Brave One* was produced in the United States, and its mise-en-scène is established through pastoral tropes that frame and interpret Mexican culture for a U.S. audience. Trumbo's work stands in contrast to that of Hugo Butler. Butler's collaboration with Mexican independent film producer Manuel Barbachano Ponce and Spanish exile filmmaker Carlos Velo influenced his filmic practices; as a result he

opted for a less romanticized approach to his subject matter. Juxtaposing these two films provides an opportunity to elaborate on the contrasting political and aesthetic trajectories of the U.S. exiles in Mexico.

Dalton Trumbo's *The Brave One* was directed toward a U.S. audience, yet the film drew upon the aesthetics of other foreigners who produced films about Mexico in the 1930s and 1940s, including Sergei Eisenstein, Paul Strand, and Orson Welles. During the 1940s, this work had a formative impact on Mexican filmmakers such as Emilio "El Indio" Fernández as well as on cinematographer Gabriel Figueroa, whose collaborations came to represent "Mexican film" both within Mexico and internationally during the "Golden Age" of Mexican cinema after World War II. As such, their work was influential in the production of Hollywood films set in Mexico, including *The Brave One.*

¡Torero!, which was directed primarily to Mexican audiences, runs counter to the aesthetics of conventional Hollywood cinema as well as that of films produced during the "Golden Age" of Mexican cinema. As I mention in chapter 3, Buñuel introduced Butler to alternative filmmaking practices that deconstructed conventional Hollywood narrative cinema. In his collaborations with independent filmmakers Manuel Barbachano Ponce and Carlos Velo on *¡Torero!*, Butler developed a new mode of production within his filmmaking practice as well as an aesthetic form that combined dramatic reenactment with stock footage. While *¡Torero!* reflects Butler's newfound approach to the politics of aesthetics, the political issues, especially inequalities between U.S. and Mexican citizens, narrated within his next film, *Los pequeños gigantes (How Tall Is a Giant?)* (1958), are more pointed. *Los pequeños gigantes* had much in common with the work of other independent filmmakers in Mexico that narrated critical perspectives on class and racial divisions within Mexico. The greatest impact of these films was on the development of the Nuevo Cine (New Cinema) movement in Mexico during the late 1950s and early 1960s.

This chapter examines different representations of bullfighting in the films of Trumbo and Butler as related to their intended audiences for their work. I start by examining the views of the Hollywood exiles toward Mexico during the 1950s, which guided their representations of Mexican culture. In particular, their different experiences of bullfighting led to distinct perceptions of the sport. In my analysis of the films, I examine not only the screenwriters' views of bullfighting but also their address to distinct audiences (in

the United States and Mexico) as well as other influences on the films' productions. In addition, I analyze the political meanings of the films within both the U.S. and Mexican contexts. While Trumbo used his Oscar win as a means to launch an offensive against the blacklist, Butler's films had a significant impact on Mexican film production. In the conclusion, I describe how Butler's film productions, as well as those of other independent filmmakers in Mexico, contributed to the rise of Nuevo Cine during the late 1950s and early 1960s.

BLACKLISTED SCREENWRITERS AND MEXICAN CULTURE

The differences between the U.S. exiles' knowledge of Mexican culture corresponded not only to their interest in it but also to the varying relationships they made in Mexico. Those who settled in Mexico developed more of a commitment to living in the country than those who left after a few years. This distinction can be observed in their engagement in aspects of Mexican cultural life. Language posed one of the most serious barriers to the U.S. exiles' acclimatization to their new home. Most of the adults entered Mexico with little knowledge of Spanish. However, once they settled in, some, like Hugo Butler, Jean Rouverol, and Cleo Trumbo, took lessons to learn the language, while Julian Zimet studied Spanish from books and spoke with the children of his American host who were learning Spanish in school.[4] Others, including George Oppen, did not learn Spanish during the entire period they lived in Mexico.[5] Dalton Trumbo wrote in a letter to Hollywood exile Hy Kraft, who was living in London, that "I insist my tongue is English; and as long as I can indicate hunger and express thanks for its satisfaction, I am sufficiently fluent to get by here." However, this was, in Trumbo's words, "an attitude that is generally frowned upon by my compatriots. They feel a positive obligation to learn the language which, I presume, is justified."[6]

Many of the U.S. exiles were interested in learning about Mexican history and culture even though their ability to understand it was to varying degrees constrained. While there were exceptions, most of them learned about Mexico's history and culture through tourist activities and attendance at national festivals, such as those occurring on the Day of the Dead and Mexican Independence Day. The U.S. exiles were in fact the beneficiaries of government-financed improvements made to Mexico's infrastructure to accommodate tourism in the postwar period. The Butlers, among others,

would take Sunday drives and explore the countryside around Mexico City and various historical sites in the area. Shortly after arriving in Mexico, the Trumbos and the Butlers drove to a national agricultural school in Chapingo that contained historical murals of the Mexican Revolution painted by Diego Rivera. The two families also visited Teotihuacán, the Pyramid of the Sun and Moon, about an hour outside Mexico City. In 1953 and 1954, the Butlers took trips to Oaxaca to see Monte Albán. They also started vacationing in Acapulco, frequently with the Oppens, during their children's school holidays.[7]

In numerous ways, the collection of pre-Columbian artifacts was the logical extension of the kind of tourist activities in which the U.S. exiles engaged themselves. George and Jeanette Pepper, who had an interest in pre-Columbian art, were the first of the group to study books on the topic and to collect artifacts in Mexico. Their hobby spread through the Hollywood exile community, drawing in Cleo and Dalton Trumbo as well as Hugo Butler.[8] During one of their Sunday drives, Trumbo and Butler ran across a man selling *cabecitas,* ancient stone heads that were dug from the ground and sold illegally to tourists. After this experience, Trumbo and Butler accompanied George Pepper on Sundays to the brick pits at Tlatilco, a pre-Columbian burial ground where workmen who were digging clay for bricks would find ancient figures and sell them for 50 centavos each. Trumbo and Butler started to study pre-Columbian art and purchased artifacts from dealers.[9]

The U.S. exiles were also exposed to Mexican culture through their spectatorship of certain sports, such as bullfighting. Although many had witnessed a bullfight at least once during their stay in Mexico, none was as enthusiastic about the sport as Hugo Butler. Both Jean Rouverol and Hugo Butler read books on bullfighting, and every Sunday afternoon during the season, Hugo went to the Plaza de México to watch a fight, sometimes accompanied by Jean or other family members. His love of bullfighting was not shared by many U.S. exiles, including Dalton Trumbo, who had witnessed an inept kill during his first trip to the bullring.[10]

WORKING THE BLACK MARKET

Dalton Trumbo, who had written a number of screenplays after being blacklisted from the Hollywood film industry following the 1947 HUAC hearings, decided while living in Mexico in the early 1950s to write an original

screenplay about a relationship between a boy and a bull set in Mexico, which he hoped would be produced by the King Brothers, an independent production company.[11] Trumbo was inspired to write the screenplay following a bullfight in which he witnessed an *indulto* (a pardon granted the bull as a reward for a brave fight). While Hugo Butler thoroughly enjoyed watching the sport, Trumbo was disturbed by his first exposure to bullfighting. According to Jean Rouverol, her husband and Trumbo argued about the subject, Butler taking the pro-bullfighter position, Trumbo sympathizing with the bull. Rouverol noted that her husband believed that "in the bullring it [the bull] had the chance to revenge itself on its attacker, and even a chance, however infrequent, of winning the *indulto*."[12]

Trumbo had firmly established connections with independent producers in the United States before his relocation to Mexico in the early 1950s. These connections dated back to 1947. The day after he returned to California following the 1947 HUAC hearings, Trumbo was contacted by Frank King, one of three brothers who comprised King Brothers Productions. King asked Trumbo if he was interested in writing a screenplay for their production company. Although Trumbo had not yet been blacklisted, the King Brothers were interested in hiring him in large part because they knew that he was a talented screenwriter who might work for less money due to his circumstances. Trumbo started writing the screenplay for *Gun Crazy* (1950) the following day. Once the screenplay was finished, the King Brothers decided to use a different name on the script because Trumbo was under contract with MGM at the time.[13] In 1948, Trumbo returned to Washington, D.C., where he had to stand trial for contempt of Congress. He was convicted and sentenced to one year in jail. Before serving time in a federal prison in Ashland, Kentucky, Trumbo wrote a number of other scripts for independent producers, including *The Prowler* (1951), directed by Joseph Losey and produced by Sam Spiegel, and *He Ran All the Way* (1951), directed by John Berry.[14]

Following his release from prison in 1951, Trumbo immediately sought work on the black market. First he contacted the King Brothers, indicating to them that he was available to work on screenplays.[15] The King Brothers sent him a number of original stories as well as a novel to consider for a screenplay. At this time, Trumbo was also approached by Herbert Biberman, another member of the Hollywood Ten, to write a screenplay for *Salt of the Earth*. Trumbo turned down the script largely for financial reasons.

He noted in a letter to Biberman that he was "not interested in pamphlets, speeches or progressive motion pictures" as he felt that his priority should be finding more lucrative work on the black market to support his family.[16] During this time, Trumbo wrote the screenplay for *Roman Holiday* (1953), a hugely successful film produced by Paramount Pictures, which starred Gregory Peck and Audrey Hepburn. Trumbo's friend and soon-to-be black-listed screenwriter Ian McLellan Hunter agreed to serve as his "front" and received an Oscar for best writing in a motion picture story in 1953.

Trumbo proposed the idea of *The Brave One* to the King Brothers because, having worked with them before, he thought they might be interested in producing such a film. Trumbo described the steps he took to "sell" the script on the black market in a letter he wrote to the King Brothers in the late 1950s. In May 1952, Trumbo visited Los Angeles to see if the King Brothers would be interested in buying a script on the black market. During their meeting, Trumbo gave them an outline of a story that he proposed to call "The Boy and the Bull." Trumbo noted that the conditions of the blacklist "made speculative work extremely difficult" and told them that he was willing to "speculate in writing a screenplay" based on what he had communicated to them, but only if they demonstrated serious interest in the project. "Otherwise," he later wrote, "I would simply forget the whole project." Apparently, they were interested enough to encourage Trumbo to continue with the project but not enough to pay him up front. Trumbo and the King Brothers made a verbal agreement for compensation, based on "his willingness to do the script without advance payment," but they would cut him a check only if they liked the finished product.[17] After visiting the King Brothers, Trumbo returned to Mexico City and over the course of the next month wrote the script for what became *The Brave One*. Trumbo conducted research for this script about a relationship between a boy and a bull by reading books written in English on bullfighting.[18]

Trumbo's screenplay of *The Brave One* highlights the relationship between Leonardo, a Mexican boy, and a young bull named Gitano (Gypsy), who is being raised to fight by Leonardo's father. Although Gitano belongs to the owner of the ranch, Leonardo convinces the owner to keep him as a "seed bull." After the death of the bull's owner, however, the estate gets divided and Gitano is auctioned off. Desperate not to lose his companion, Leonardo steals Gitano but is eventually forced to return him. Soon after, Leonardo runs away from his rural town to Mexico City so that he can ask

the president of Mexico to pardon Gitano, who had been sent there to fight in the bullring. In what first appears to signal tragedy, he does not get to the bullring with the President's letter in time, and Gitano is put in the ring. However, Gitano is so brave that the audience requests an *indulto*, and the bull's life is spared.

This film draws both ideologically and aesthetically from films produced by foreigners in Mexico during the 1930s and 1940s, such as Sergei Eisenstein's *¡Qué viva México! (Long Live Mexico!)*, (1932), and *Redes (The Wave)* (1934), co-directed by Fred Zinnemann and Emilio Gómez Muriel and shot by Paul Strand; and the collaborations between Mexican director Emilio Fernández and cinematographer Gabriel Figueroa.[19] While Seth Fein argues that the Mexican film industry "adapted various domestic and foreign influences to produce the nexus of narratives and images promoted internationally as *lo mexicano* ('the Mexican way')" in the post–World War II period, foreign influences on Mexican film can be charted back to the beginning of sound cinema in Mexico.[20] Carlos Monsiváis asserts that since the early 1930s, the Mexican film industry "assumed the programmatic duty of making local colour and folkloricism its ideological axis (in this instance, it was faithful to the chauvinistic Hollywood model)."[21] These influences were most evident in the work of Mexican filmmakers who were trained in Hollywood, such as Figueroa who worked with cinematographer Gregg Toland (*Citizen Kane*, 1941), contributing to the "international style" of Mexican cinema.[22] The films of Figueroa and Fernández, which are viewed as examples of Mexican nationalist filmmaking, are not, as Seth Fein describes, "ideologically, industrially or aesthetically opposed to Hollywood's hegemony."[23] On the contrary, the work of these filmmakers demonstrates the connections between Hollywood studios and the Mexican film industry.

One of the most influential foreign filmmakers in the production of Mexican cinema was Sergei Eisenstein. Eisenstein made many films in the Soviet Union before he journeyed to Hollywood in the early 1930s to learn filmmaking techniques. While he was in Hollywood, Upton Sinclair enlisted him and cinematographer Eduard Tissé to make a film about Mexico. Eisenstein traveled around Mexico, working with nonprofessional actors, eventually creating six episodes for a film entitled *¡Qué viva México!*[24] In her research on *¡Qué viva México!*, Laura Podalsky analyzes the specific ways that Eisenstein imagined Mexican culture as primitive, a view that

was shared by Mexican artists and intellectuals who drew connections be-
tween indigenous cultures and the Mexican nation as part of the search for
national identity following the Mexican Revolution. Podalsky explains that
Eisenstein, like other foreigners who journeyed to Mexico during this
period, was concerned about "the effects of the 'machine age' on man and
saw the primitive as a source of renewal."[25] Eisenstein's influence on Mexi-
can film has been well established by film scholars. John King argues that
"the legacy for Mexican cinema was to be an assimilation of the 'painterly'
aspects of Eisenstein's work . . . the architecture of the landscape, the maguey
plants, the extraordinary skies, the noble hieratic people."[26] Mexican film
critics have had different opinions on the effects of Eisenstein's work on
Mexican film. According to Eduardo de la Vega Alfaro, some believe that
his influence was negative—that his "folkloric" aesthetic had "markedly
touristic overtones," while others view Eisenstein as the "'father' of Mexi-
can cinematic art, the artist who enabled the development of the national
aesthetic."[27]

Another foreigner whose work was influential in the development of
the nationalist aesthetics of Mexican cinema was photographer-filmmaker
Paul Strand, the cinematographer of *Redes*.[28] Although the film was not a
documentary, it was based on real events in the lives of Mexican fishermen
who decide to strike in protest of the low prices they receive for their catch.
The film was co-directed by Hollywood filmmaker Fred Zinnemann and
Emilio Gómez Muriel, as mentioned above, and was paid for by an agency
of the Mexican government, the Secretaria de Educacíon Pública, run by
leftist Narciso Bassols. *Redes,* like other films produced by the Mexican
state in the 1930s, was made in order to promote social programs proposed
by President Lázaro Cárdenas, yet this film draws upon filmic techniques
developed in Hollywood, U.S. documentary production, as well as the work
of Eisenstein. Like Tissé, Strand frames the fishermen from low camera
angles against the clouds and sky, casting them as heroic and firmly situat-
ing them within the natural landscape. While the film was addressed to a
Mexican audience, these techniques have the effect of aestheticizing the
fishermen. To artists like Strand, who was part of what Michael Denning
calls the Cultural Front, pastoralism was "a strategy of elevating and en-
nobling the simple."[29] Yet Strand's address to his (primarily Mexican) audi-
ence was also didactic and patronizing. In an article for *New Theater,* Strand
was quoted as saying that the film was directed "at a great majority of rather

simple people to whom elementary facts should be presented in a direct and unequivocal way."[30] Carl Mora suggests that *Redes* "served to initiate an 'Eisensteinian' current of 'Indianist' films that were to be a distinguishing feature of Mexican cinema for the next 20 years. Romanticized, and often melodramatic, such films, along with those dealing with the theme of the Revolution . . . were to constitute a 'national style of cinema.'"[31]

The work of Mexican filmmakers also drew links between indigenous cultures and the Mexican nation. The collaborations between Emilio "El Indio" Fernández and cinematographer Gabriel Figueroa became emblematic of the Mexican film industry during the "Golden Age" of Mexican film in the immediate post–World War II era.[32] While Figueroa and Fernández produced key examples of Mexican nationalist filmmaking, such as *Río Escondido (Hidden River)* (1947), Seth Fein argues that referring to their films as nationalist is inaccurate if understood as anti-imperialist.[33] Instead, Fein argues, this style of filmmaking "served the cultural project of the Mexican state, supporting ideologically an authoritarian regime (whose patronage was crucial to national film producers) committed to alliance with U.S. foreign policy and transnational capital." Fein notes further that the nationalism of Mexican cinema supported these connections by "producing a cinematic idiom that concealed both the depth of the Mexican industry's transnationalization and the broader structures that linked the government's project to its Northern neighbor."[34]

In addition to the work of Eisenstein, Strand, and Fernández, *The Brave One* bears a striking resemblance to the "My Friend Bonito" segment of Orson Welles's unfinished film *It's All True*, especially in its representation of the relationship between a young boy and a bull.[35] As in "My Friend Bonito," representations of the actual conditions of bullraising are made peripheral in *The Brave One*. Mexican film scholar Emilio García Riera argued in his critique of *The Brave One* that "in the love of the Mexican boy toward a bull one saw an extreme and definitive demonstration of the profound connection of the 'primitive' south to nature."[36] This is demonstrated through the "friendship" between Leonardo and Gitano, which is developed to the exclusion of other relationships, such as that between the bull trainer and Gitano. While Trumbo's screenplay originally contained story lines that drew attention to the relations between other characters in the film, he decided to "ruthlessly cut all extraneous material and scenes" and instead keep "rigidly to the simple story of the boy and the bull." As a

result, Trumbo felt, the film gained "simplicity, directness and hence in dramatic forcefulness."[37] Shaping the screenplay in this way made the film more dramatic and sentimental. The film ends on a particularly fantastic note, as Leonardo runs into the middle of the ring to hug Gitano, who instantaneously transforms from a fighting bull into a friendly one.

Furthermore, the didactic approach to representing aspects of Mexican culture for a U.S. audience in *The Brave One* is similar to that of the "My Friend Bonito" segment of Welles's film *It's All True*, which was sponsored by the Office of the Coordinator for Inter-American Affairs.[38] This is notably apparent in the film's explanation of the meaning of bullfighting that is demonstrated in one scene in *The Brave One* in which arguments for and against the sport are explicitly counterposed. In this sequence, which occurs at a bullfight, an American actress who is visiting Mexico discusses the sport with Gitano's owner. Representing a broader U.S. viewpoint, she condemns bullfighting as an essentially cruel spectacle. In the debate that ensues, the owner draws equivalencies between bullfighting and sports practiced in the United States, such as boxing and hunting. The degree to which the conversation serves as an explanation of bullfighting, detailing the social purpose and technicalities of the contest, clearly identifies the film as produced for a non-Mexican audience.

While this exchange is presumably included to familiarize the (U.S.) audience with an aspect of Mexican culture, the film's depictions of the sport depend in large part on generic representations of Mexican culture and specific recourses to primitivism. For example, the owner's analysis of bullfighting portrays the sport as a kind of "primitive" ritual. He insists that while Americans are shocked at the pain inflicted on the bull, Mexicans are an "older race" who understand that bullfighting is a metaphor for the pain they experience in life as well as a reminder that death is never far away. As such, his explanation remains safely within the parameters of archetypal generalism. Furthermore, Trumbo's script omits the broader social context in which bullfighting serves as an imagined escape from poverty. While bullfighting in this scene is presented as a legitimate sport, rather than as cruelty to animals, the entire narrative of the film works against this perspective. The audience identifies with the boy, who throughout the film struggles to prevent "his bull" from entering the bullring, and in the film's "happy ending," the bull, through its bravery, is granted immunity from fighting in the ring.

That the film contained a superficial and sentimentalized view of Mexican culture was evident to both U.S. and European reviewers. One reviewer characterized the cast as "stock Mexican types" who spoke "stock dialogue."[39] Both U.S. and European film reviewers found the story of a relationship between a boy and bull, as one of them put it, "unashamedly sentimental." However, another reviewer wrote that because of the "touches of human comedy" and the "exciting bullring finale," viewers would not find the "tendency to over-sentimentality objectionable."[40] Still other reviewers praised the "realism" of the culminating bullring sequence; contrasting it with the "sentimentalized" story of the relationship between the boy and bull.[41]

The pastoral representations were duly noted by U.S. reviewers who described the film's aesthetics specifically the "wide views of the open Mexican countryside." In fact, reviewers praised the formal qualities of the film, such as the cinematography, more frequently than its content. As one British reviewer wrote, "The film's strength is in its technical superiority. Jack Cardiff's superb colour photography makes the film constantly exciting visually; the scene of the child running through a stormy night, the stormy rain-clouds over him, startlingly lit by twin forks of jagged silver lightning, for example, is a remarkably beautiful shot."[42] The film was complimented by one reviewer for its "magnificent CinemaScope photography of the below-the-border setting" and was described by another as "handsome in its CinemaScope and Technicolor."[43]

As mentioned previously, the aesthetics of *The Brave One* drew upon the works of Eisenstein, Strand, Welles, and Fernández in representing the Mexican countryside, which dominates visually throughout the film. The images of the landscape and surrounding mountains set against cloud-filled skies provide the backdrop for scenes where Gitano is either being taken away from Leonardo, as in the opening scene, or when the two are being reunited, such as in the scene where Leonardo rescues Gitano soon after he is born. Panoramic shots, representing the "idyllic" qualities of the Mexican countryside, frame the scene when Leonardo's father is informed that Gitano belongs to the ranch (not Leonardo) and thus must be branded, as well as when Leonardo receives a letter from Gitano's owner giving him full ownership of the bull. In both cases, Leonardo and Gitano are shot from a low camera angle against the sky, which ties them both narratively and visually to this pastoral space through their association with the landscape.

Trumbo's vision of pastoralism coincided with a period of industrialization in Mexico as well as the growth of Mexico's urban population in the 1940s and 1950s, through increased migration from the countryside to the cities. The visual coding in the film establishes the tension and conflict over the rightful "home" for Gitano—in the fields (rural) or the ring (urban). The representation of urban space contrasts visually with that of rural space in the film. When Leonardo goes to Mexico City to see if the president will pardon Gitano, he appears to be dwarfed by the buildings. This change of scale suggests a kind of diminished value of living beings in the city, which further accentuates the film's idealized pastoralism.[44]

Similar to Mexican films of the 1940s, including those of Emilio Fernández, *The Brave One* creates a key role for the Mexican state, which is to resolve the young boy's conflict about his bull. As mentioned earlier, in *The Brave One,* the young boy journeys from the countryside to Mexico City to talk to the President of Mexico about "pardoning" his bull. In the scene where he first tries to meet with the President, Leonardo walks through the National Palace, past the Diego Rivera murals to the office of the President, which he discovers is closed on Sundays. However, this sequence has the effect of appropriating revolutionary ideas and aesthetics (in the work of Rivera) and tying them to the Mexican state, which during the late 1940s and 1950s was becoming increasingly conservative following the administration of Lázaro Cárdenas. As Roger Bartra argues, after the Revolution, the Mexican state tried to gain legitimacy by manipulating forms of popular culture through "an explosion of myths," which included "the idea of a fusion between the masses and the state, between the *Mexican* people and the *revolutionary* government."[45] While the government's support of Rivera's murals was one result of this attempt, in *The Brave One,* this scene serves the purpose of linking the boy with the state. This trope is evident in other Mexican films, as Seth Fein contends, such as *Río Escondido,* in which a teacher, Rosaura Salazar (played by María Félix), walks through the National Palace (past Rivera's murals) to meet with President Miguel Alemán, as a narrator describes Mexico's history.[46]

The Brave One received the Academy Award for best original story in 1956, and when there was no writer to receive the Oscar at the Academy Awards ceremony (since Trumbo had used the pseudonym Robert Rich and no such writer existed), individuals representing Robert Flaherty and Orson Welles sued the producers for plagiarism.[47] As Charles Higham

Publicity still from *The Brave One* **(1956).** Courtesy of the Academy of Motion Picture Arts and Sciences, Beverly Hills, California.

describes, Fred Zinnemann told the Academy of Motion Picture Arts and Sciences that the story of *The Brave One* was the same as one that Robert Flaherty showed him in 1931. The King Brothers, who produced *The Brave One,* responded that the story was "a legend in the public domain."[48] The lawsuit against the King Brothers surprised Mexican film critic Emilio García Riera, who wrote that "for me (and for many Mexicans I believe), the interest awakened by such a conventional story in prestigious men like Flaherty, Zinnemann, Welles and Trumbo, and the success of *The Brave One* is mysterious."[49] García Riera's quote indicates a gulf between Mexicans' view of this generic story and those of foreign filmmakers who situated their narratives in Mexico.

Dalton Trumbo was likely unaware of the political implications of his screenplay within the Mexican context, specifically the way that the film could serve the cultural project of the increasingly conservative Mexican state. Placing the Mexican state in a position to resolve the boy's plight emphasized the positive role of the state as it aligned itself further with the United States. Furthermore, by focusing his story on a relationship between

a boy and a bull and by setting his film in a rural area, Trumbo presented a romanticized view of his topic. This approach was appropriate for his intended audience of U.S. moviegoers, who were unknowledgeable about bullfighting and would view the film's subject as entertaining and its location in Mexico as "exotic."

THE VISUAL ECONOMY OF MARGINALITY

While Trumbo chose to represent his subject in a manner that would appeal to a U.S. audience, Butler addressed his screenplay of *¡Torero!* primarily to a Mexican audience. This difference in the direction of their work contributed to distinct narratives about bullfighting. Butler chose to focus his narrative on the life experience of a real bullfighter, Luis Procuna, rather than on a bull, one of the main protagonists of Trumbo's film. Trumbo's representation of bullraising and bullfighting relied on an insistent use of pastoral tropes in the mise-en-scène of *The Brave One*. On the other hand, Butler's *¡Torero!* is a distinctively "urban" film, set in Mexico City, a location that more directly evokes the social and economic conditions of modern bullfighting.[50] Furthermore, while Trumbo's film was produced within an industrial mode of production in the context of a Hollywood film industry, Butler's film employed an artisanal mode of production and was produced at the margins of the Mexican film industry. *¡Torero!*, as well as the work of other independent filmmakers in 1950s Mexico, contributed to the creation of the Nuevo Cine movement, members of which in their 1960 manifesto "criticized the sad state of the Mexican film industry and called for its renewal."[51]

With *¡Torero!*, Butler and George Pepper were introduced to independent film production in Mexico through their collaboration with Manuel Barbachano Ponce, who had a significant role in helping produce the work of filmmakers who were unable to gain entry into the Mexican film industry during the 1950s. Ponce, who owned Teleproducciones, a newsreel company, produced the newsreel *Tele-Revista* and in 1953 started *Cine-Verdad*, a monthly newsreel about cultural events. In 1953, he also began to produce independent features, the first of which was Benito Alazraki's *Raíces (Roots)* (1953), which received the International Critics prize at the Cannes Film Festival in 1955. As Nelson Carro notes, Ponce produced *Raíces* "outside the established industry and achieved surprising international notoriety."[52]

Mexican film scholars, including Emilio García Riera and Manuel Michel, consider *¡Torero!* and *Raíces* to be two of the key films that emerged

from Mexico's cinematic crosscurrent during the 1950s.[53] The filmmakers who were involved in *Raíces*, including director Alazraki, Carlos Velo, and Ponce, wrote the screenplay based on four short stories by Francisco Rojas Gonzalez. While these stories are set primarily in rural locations, the narrator's introduction to the film establishes the relationship between modern Mexico City and what he refers to as the indigenous "roots of growing Mexico." In Mexico, the move toward industrialization in the 1940s created a bigger gulf between rich and poor, which extended into the 1950s. One outcome was an increase in unemployment. Peter Smith notes that the "industrial sector was more capital intensive than labor intensive," leading to an uneven distribution of income.[54] During the 1940s, the distribution of land slowed, and the lowering of agricultural prices contributed to an increase in poverty for the rural poor, and especially for indigenous communities. In contrast to the work of Emilio Fernández, who created romantic and stereotyped images of abstract "Indians" during the 1940s, in *Raíces*, the filmmakers portray indigenous peoples both as struggling and resisting their exploitation. Further, the filmmakers level a critique against foreigners who believe that they are superior to indigenous peoples, who view them as savages and/or treat them abusively.[55]

Following *Raíces*, Ponce agreed to produce ¡*Torero!* from a screenplay written by Hugo Butler about the life of famed Mexican bullfighter Luis Procuna and assigned Carlos Velo to direct the film. Velo, who had been involved in documentary film production in Spain, left the country during the Civil War, arriving in Mexico in 1939. As Jorge Ayala Blanco describes, although Velo had directed "classical documentaries in the Spanish republic," the "doors of Mexican cinema remained closed for him, in spite of excellent scripts."[56] Velo directed the newsreel *España-Méxicana-Argentina* (EMA) from 1941 to 1951, and in 1953 started working with Ponce at Teleproducciones as a director and editor for various newsreel series, including *Tele-Revista*.[57] (In Mexico, Velo became part of the Spanish exile community, socializing with Luis Buñuel and others.)[58] In an interview with Francisco Pina in the *Novedades* supplement *Mexico en la cultura*, Velo noted that while directing newsreels in Mexico, he had to "film and edit the bullfights every Sunday for ten years." On one of the Sundays, Velo saw Procuna perform a particularly spectacular fight.[59] While Velo was credited as the director of the film, Jean Rouverol notes in her memoirs that her husband did much of the directing of reenacted material.[60] Other collabo-

rators included filmmaker Giovanni Korporaal, originally from Holland, who did special effects, and Spanish exile composer Rodolfo Halffter.[61]

Butler's decision to focus his narrative on the life of Luis Procuna reveals some aspect of the "laborist sensibility" that Michael Denning argues was one of the qualities in the work of cultural producers within the U.S. Popular Front. The "star" has an important role, as Denning notes that "stardom is part of the struggle for hegemony, part of the way social institutions and movements win consent." He also asserts that "the star," which in the context of Mexico would include the famous bullfighter, "wins the loyalty and allegiance of audiences through an implicit or explicit claim to represent them," which "derives from the symbolic weight of the star's social origin."[62] The "stars" of the Popular Front were working-class young men and women, including the "star musician, dancer, singer, comedian, boxer or bullfighter," according to Eric Hobsbawm, who were "not merely a success among this sporting or artist public, but the potential first citizen of his community or his people." The bullfighter, like the movie star, as Hobsbawm asserts, is the "artist sprung from the unskilled poor and playing for the poor."[63]

¡Torero! presents a "day in the life" of bullfighter Luis Procuna as he returns to the bullring after an extended hiatus. The film has a three-part structure. The first section reenacts Procuna's preparation for the fight. The second, shot entirely in flashback, examines the reasons Procuna became a matador and reconstructs his life and career up to the day of the fight. The third section, combining newsreel footage and dramatic reenactments, presents Procuna's return to the bullring. Procuna, after being fined for a bad performance, pleads with the judge for another bull. In this final match, he fights heroically to the enthusiastic cheers of the crowd.

Both formally and thematically, *¡Torero!* represents a less exteriorized perspective on bullfighting than other films produced by U.S. filmmakers, which is related in large part to the telling of this story through Procuna's own voiceover narration. The film changed dramatically between Butler's original outline, which was written to entice a U.S. producer, and his final screenplay, which was instead produced in Mexico.[64] In the preliminary version, the film was scripted as a "documentary" about bullfighting, aimed at a U.S. audience. The final screenplay, which focused solely on Procuna and was directed to both Spanish- and English-speaking audiences, can be situated between the genres of documentary and dramatic feature. In Butler's original outline, the American narrator, who functions as the stand-in

for the audience, is led through the Plaza de México, the well-known bull-ring in Mexico City, by a guide who informs him of the rules and regulations of the sport. However, in the final version of the screenplay, Butler has Procuna narrate his own experiences on the day he returns to the bullring. That Butler chose Procuna to narrate, as opposed to using a detached narrator, avoids the didacticism of a film like *The Brave One*, which has to translate the meaning of bullfighting to a U.S. audience.

Furthermore, the production of *¡Torero!* was more characteristic of an artisanal, low-budget cinema rather than an industrial approach typical of conventional Hollywood (and Mexican) narrative cinema. Butler conducted research on bullfighting, and specifically on Procuna's life and career, before he wrote the script. He structured the narrative of the film so that it could be shot once, adding voiceover narration in English and Spanish later (as he had done with *The Adventures of Robinson Crusoe*). The filmmakers shot the film on location, using available light and nonprofessional actors, including many of Procuna's family members and friends.[65] In addition, instead of re-creating Procuna's last bullfight, the filmmakers edited stock footage of the event into the film.

Drawing on the backgrounds of Velo and Butler, *¡Torero!* contains elements of both documentary and fictional film. While *¡Torero!* sustains elements of the documentary film through its use of newsreel footage of bullfights and voiceover narration, it consistently exceeds the parameters of the documentary genre. Butler "refictionalizes" the film through dramatic reenactments and frames the narrative through an extended flashback. Even as Procuna performs his own identity, he speaks words scripted by Butler. In addition, Butler utilized filmic techniques drawn from conventional Hollywood narrative cinema. The flashback, for example, was a common device employed within specific genres in the Hollywood film industry during the 1940s, including film noir and the melodrama. However, the narrative framework of the flashback does not conform with the required standards of linear chronology employed in documentary filmmaking during the 1950s. The presence of these fictional conventions within *¡Torero!* challenges the clearly defined divisions between genres and disrupts the formal elements that construct them.

The artisanal mode of production utilized in *¡Torero!* is similar to the work of independent filmmakers in the United States who were involved in

the New American Cinema Group. One of the main goals of filmmakers in "The Group," as they referred to themselves, was to create films that countered the conventions of Hollywood narrative cinema.[66] The connection between Butler's work and that of filmmakers involved in The Group can be demonstrated by the resemblance between *¡Torero!* and *Bullfight* (1955), an experimental film by dancer turned filmmaker Shirley Clarke, who was a founding member. While the subject matter of their work was similar, both films also drew from different film genres. In *Bullfight,* Clarke combined a dance performance with footage of a bullfight. In the film, Clarke employs crosscutting between dancer Anna Sokolow's "performance" as a bullfighter with footage of an actual bullfight, which includes Sokolow as a spectator in a crowd.[67]

The mode of production used in *¡Torero!* and its narrative structure are distinct from those of bullfighting films produced in Hollywood as well as from the equally hegemonic representations of the sport developed in mainstream Mexican film. While the formal qualities of *¡Torero!* differentiate it from Hollywood-produced films, the film's content can also be distinguished from bullfighting films produced in the United States. *¡Torero!* can be contrasted with Hollywood studio efforts of the 1940s and 1950s, such as the John Wayne vehicle *Bullfighter and the Lady* (1951) and *Magnificent Matador* (1955) with Anthony Quinn, as well as the work of Cultural Front filmmakers, including *Brave Bulls* (1951), written by John Bright and directed by Robert Rossen; *The Brave One;* and the "My Friend Bonito" segment of *It's All True. ¡Torero!* distinguishes itself from the "exoticizing" gaze of standard Hollywood films whose main characters are Americans fascinated by bullfighting. Nor is the film didactic, unlike films that explicate the "meaning" of bullfighting to American audiences or that carry "messages" about the dangers of sports like bullfighting and boxing.[68]

Yet Butler's film is also distinct from portrayals of bullfighting found within mainstream Mexican films, as bullfighting is not represented uncritically as a form of upward mobility for the working classes.[69] In *¡Torero!* Butler narrates the theme of class inequality in Mexico, which persisted into the 1950s despite the Revolution. The film tells the story of a young man born into poverty who chooses from limited options in his efforts toward upward mobility, eventually risking his life in order to escape from his impoverishment. In Butler's script for *¡Torero!,* Procuna explains in detail

how he sacrificed to train to be a bullfighter, how he saw and later experienced what "bulls' horns could do to men's flesh." In a voiceover he states that "sure they say the bull's horns hurt, but hunger hurts worse . . . a rich man's son never becomes a bullfighter."[70] In flashback sequences in the film, Procuna is seen watching the deaths of other famous bullfighters, suggesting that although he has become a successful bullfighter, he could still die while performing his job.

The structuring of the narrative from the point of view of Procuna had different effects on audiences in Mexico, the United States, and at film festivals throughout the world. ¡Torero! was intended primarily for a local Mexican audience, and there were different ways in which film reviewers and critics in Mexico understood the film, as compared with the reception of the film outside the country. Film critic Francisco Pina, who wrote a review of ¡Torero! that included an interview with Carlos Velo, contrasted the film with others about bullfighting that were produced more for their entertainment value. Pina notes that the purpose of ¡Torero! was distinct from "those found in a more clichéd movie that is simply entertaining" and that the filmmakers portrayed the life of a bullfighter in a humanitarian way. Furthermore, Pina describes ¡Torero! as "blending the documentary with imagined fiction," indicating that this critic did not view the film as a documentary.[71]

However, film critics in the United States viewed the film differently, interpreting Procuna's narration as representing "the real" rather than a conscious re-creation. Teshome Gabriel writes that the challenge for "First World" interpretations of "Third World" films is related to "the films' resistance to the dominant conventions of cinema" and "the consequence of the Western viewers' loss of being the privileged decoders and ultimate interpreters of meaning."[72] U.S. film critics identified ¡Torero! as "authentic," praising it for its "close-up realism."[73] Furthermore, some reviewers equated an "insider's perspective" of bullfighting with a "racial" identity, such as that demonstrated in a review written by Robert Hatch for *The Nation:*

> It is my firm, if narrow, conviction that the world of bullfighting is no place for Anglo Saxons. Non-Latin aficionados are corrupted; they go about talking of "the moment of truth," telling you of the sacred brotherhood between matador and bull and asserting that death in the afternoon is somehow a purification. Feverish talk, this, and I've always suspected that the northern zealots were making it up out of a misty romanticism unknown in the Spanish-speaking countries. . . . There is nothing romantic or high-flown about *Torero!*, incomparably the most lucid and revealing account of the sport I have seen.[74]

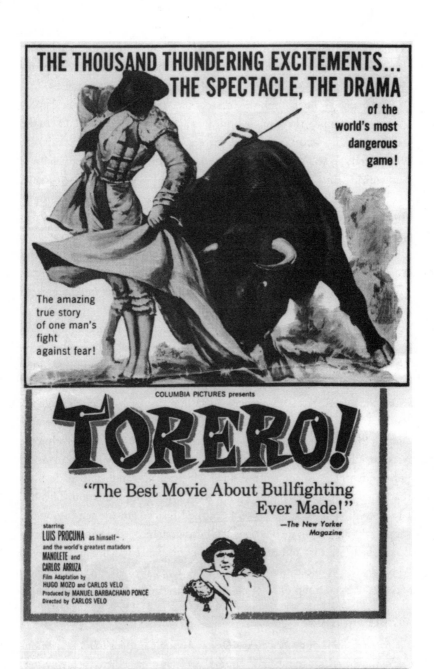

Film poster of *Torero!* (1956). Courtesy of the Academy of Motion Picture Arts and Sciences, Beverly Hills, California.

While Hatch implicitly distinguishes *¡Torero!* from "non-Latin" representations of the sport, his quote is ironic, for what he sees as "authentic" or indigenous was in fact written by one of the Anglo-Saxons he criticizes.[75]

The entry of *¡Torero!* into the international market points to the impossibility of sustaining the film's hybridity as a production positioned between the documentary and the dramatic feature. International film festivals also categorized the film as a documentary, drawing on the filmmakers' claim of "authenticity" through their use of newsreel footage, as well as the "voyeuristic" sensibility of the international market. That *¡Torero!* was nominated for an Oscar in the documentary category and won the Robert Flaherty Award at the Venice Biennale in 1955 revealed a fundamental misrecognition of the film, as it was positioned within an established generic category.[76] In this sense, it was both the film's structure and its distinction from mainstream Mexican film production of the 1950s that led to its being miscategorized as a documentary within international film festivals.

¡Torero! was produced during the development of an independent film movement in Mexico during the 1950s. García Riera described *¡Torero!* years later as contributing to the "renewed style" that was "contrary to the industrial routine" in Mexico during the mid-1950s.[77] The work of filmmakers involved in this movement, including that of Manuel Barbachano Ponce, Carlos Velo, and Luis Buñuel, led to a cinematic crosscurrent in Mexico that challenged the formulas of mainstream films produced within the Mexican film industry.[78] Butler and these other filmmakers, who worked independently from the state-funded Mexican film industry, made films that could be characterized by their artisanal mode of production. This had largely to do with their exclusion from the Mexican government's financial support through the Banco Nacional Cinematográfico, which instead funded established directors and producers. Although Ponce was one of the few in Mexico who produced this work in the 1950s, by the end of the decade, he was joined by a group of filmmakers and critics who formed Nuevo Cine.

VISIBLE FRICTIONS

Dalton Trumbo's film *The Brave One* and Hugo Butler's *¡Torero!* demonstrate the differing political and cultural projects of blacklisted screenwriters in Mexico. In analyzing the work of Trumbo and Butler, it is necessary to place their aesthetic practices within the historical context of both the United States and Mexico during the early Cold War era. These film projects

are representative of the different directions taken up by U.S. screenwriters in Mexico. The first approach, evident in the work of Trumbo, Julian Zimet, and others, was to prioritize U.S. audiences and to focus on selling screenplays to Hollywood.[79] The second tendency, as demonstrated in the work of Butler, John Bright, and others, was to write screenplays for Mexican films and to reconceive of their work through the context and culture of Mexico.[80] While Trumbo used his film work, including *The Brave One*, as leverage to challenge the conditions that contributed to the blacklist in Hollywood, Butler focused his filmic productions on the social and cultural framework of his new residence. In part due to the limitations of his residency in Mexico, in *¡Torero!* Butler redirected his commitment from politics proper to the less overt sphere of cultural politics and the politics of aesthetic form. In his subsequent film *Los pequeños gigantes*, Butler included a more politically charged subtext about U.S.–Mexico relations into this seemingly innocuous screenplay about the Mexican Little League team that won the 1957 World Series. Butler's films *¡Torero!* and *Los pequeños gigantes* contributed to the emergence of Nuevo Cine, which challenged the conventions of both Hollywood and Mexican narrative cinema in the 1950s. This movement, as Seth Fein argues, "would call for not only radically nationalist industrial practices but also aesthetic and ideological ones."[81]

These divergent political investments are evident in the work that these screenwriters produced in Mexico during the early to mid-1950s. Trumbo focused on breaking the blacklist, not the particularities of the Mexican context or the politics of aesthetic and narrative form. His writing was limited by the types of screenplays that were acceptable within the Hollywood film industry and was additionally circumscribed by the conditions of the blacklist that prohibited his direct participation in the production process. As a result, *The Brave One* envisioned Mexico with pastoral sentimentality and primitivist motifs. Such tropes were evident in mainstream Mexican cinema as well, however, and Trumbo's screenplay can still be differentiated from the work of Hollywood filmmakers during the 1950s whose representations of Mexico offended the Mexican government.

For example, Trumbo's screenplay can be distinguished from Hollywood films about Mexico that contained anti-Communist "messages" produced in the early 1950s. One particularly egregious example is *Viva Zapata!* (1952), written by John Steinbeck and directed by Elia Kazan. The film, released in the United States around the time that Kazan "named names" to HUAC

during the 1951 hearings, rewrote not only aspects of Zapata's life but also of Mexican history. Hollywood Ten member John Howard Lawson analyzed the meanings of Kazan's representation of Zapata and the circumstances of his retreat from Mexico City in his book *Film in the Battle of Ideas* (1953).[82] In the film, Lawson argued, Kazan depicted this retreat as Zapata's decision to turn "his back on power" rather than as a direct consequence of the U.S. military forces positioned against him.[83] Lawson criticized Kazan's fictionalization of Zapata and the Mexican Revolution in the context of the early Cold War, observing that "at a time when colonial peoples are throwing off the yoke of poverty and oppression, it is not possible to deny that these great popular movements exist." Kazan's adaptation suggested a perhaps more sinister approach, which was "to deal sympathetically with the 'futility' of revolt, to lament the 'inevitable betrayal' of the revolution by those leaders who demand fundamental changes in the system of exploitation." Lawson identified Kazan's film as a prime example of this exculpatory strategy that by necessity allows for the reality of popular revolt but insists on revolution as quixotic and impracticable. As an example of what Lawson referred to as "White chauvinism [and] contempt for the darker peoples of the world," *Viva Zapata!* also completely expunged any and all traces of U.S. culpability. Kazan removed all evidence that might suggest that the peasant movement led by Zapata was a calculated affront to U.S. imperialism in the hemisphere. Moreover, as Lawson noted, "The film presents Mexico as a land of corrupt generals and politicians, apparently acknowledging no obligation to a foreign power." But from the perspective of the film, even this fraudulent government cannot warrant revolt, and the multiple uprisings across the country do not represent a common will. Lawson observes that in the film, "The demand for land on the part of the poverty-stricken Indians and *Mestizos* of *Morelos* is treated as a separate and isolated struggle, humanly justified, but doomed from the start because the peasants are too 'ignorant' or 'innocent' to seize and hold state power."[84] The screenplay represents Emiliano Zapata as an illiterate, a portrayal so offensive to the Mexican government that it denied Kazan's production crew entry into Mexico to make the film. Instead, Kazan shot the film on the Texas side of the U.S.–Mexico border.[85] Trumbo's pastoral clichés did their own representational work, but in a manner peculiarly consistent with the standpoint of the Mexican state.

It was films like *Viva Zapata!* that were being produced in the United States at the time that Trumbo wrote the script for *The Brave One* in Mexico. When Trumbo returned to the United States in 1954, he remained blacklisted and could not write screenplays under his own name for films produced in the Hollywood film industry. Instead, he continued his black market work, writing under pseudonyms primarily for independent producers. Trumbo accepted all black market work that was directed his way. When he was too busy to do a job, he would farm out work to other blacklisted screenwriters, "guaranteeing" their screenplays to the film's producers. Thus, if the producers were unhappy with the screenplay, Trumbo, in the role of script doctor, would rewrite the script, making far less money than he would have if he had written the original screenplay.[86] This undermined the intent of the blacklist, which was, according to Helen Manfull, "to starve out leftists until they yielded to the committee."[87] Trumbo's success in working on the black market was related in part to the development of television, which had a devastating financial effect on the Hollywood film industry. The beneficiaries of this situation were not only blacklisted screenwriters but also independent producers working on low-budget films. Following Trumbo's return to the United States, he wrote screenplays for *The Boss* (1956), *Bullwhip* (1958), *Terror in a Texas Town* (1958), *Wild Is the Wind* (1957), and *From the Earth to the Moon* (1958), among others.

However, Trumbo's "big break" occurred in 1956 when his pseudonym, Robert Rich, was awarded an Oscar for best original story for *The Brave One*. This situation provided Trumbo an opportunity to expose and criticize the enforcement of the blacklist. After Jesse Lasky Jr., a screenwriter and vice president of the Screen Writers Guild, accepted the Oscar on behalf of Robert Rich, he discovered that no such person was listed in the Guild's files. Following this realization, journalists who interviewed Lasky started reporting the story in various newspapers and magazines. Apparently, there were rumors in Hollywood that Robert Rich was really a pseudonym employed by Dalton Trumbo. Trumbo used this to his advantage:

> [I]t was that Robert Rich thing that gave me the key. You see, all the press came to me, I dealt with them in such a way that they knew bloody well that I had written it. But I would suggest that maybe it was Mike Wilson, and they would call Mike and ask him, and he would say no, it wasn't him. And they would come back to me, and I'd suggest they try someone else—

another blacklisted writer like myself who was working on the black market. I had a whole list of them because we kept in close touch. It went on and on and on. I just wanted the press to understand what an extensive thing this movie black market was.[88]

In effect, Trumbo sent these journalists on a wild goose chase, contacting blacklisted screenwriters throughout the United States, Mexico, and Western Europe, which was one way of publicizing the extent of the blacklist.[89]

Trumbo's attempts to break the blacklist did not end with the Robert Rich episode. Much of his energy throughout the 1950s was focused on this pursuit. Trumbo carried on a vigorous campaign against the blacklist, writing letters to Hollywood producers, politicians, and writers whose work appeared on the screen, in addition to giving lectures and authoring articles on the topic for almost anyone who asked him to do so. In his letters, Trumbo gave each of these groups a different pitch. In a letter he wrote to writer William Faulkner in 1957, Trumbo described the oppressive qualities of the blacklist for film workers by asserting, "Those who remain in motion pictures work under the surveillance of private pressure groups, a permanent Hollywood representative of the committee, and a system of clearances which certified them to be patriotic American artists. The blacklist, once thought to be a temporary reflection of troubled times, has become institutionalized. Motion pictures, policed and censored by Federal authority, have become official art."[90] Trumbo hoped that writers like Faulkner and others whose novels had been adapted to the screen would respond to his letters by protesting the circumstances that transformed these productions into "official art." However, none of the writers whom he contacted wrote back to him.[91]

In his letters to those who worked in Hollywood, Trumbo described how the institutionalization of the blacklist served particular financial interests outside the United States, in Mexico and elsewhere. In one letter to Hollywood producer Edward Lewis, the executive vice president of Bryna Productions (the production company that made the film *Spartacus* in 1960), Trumbo described the "open" context in which Hollywood screenwriters worked in the Mexican film industry:

> Blacklisted American talent has now become integrated into the Mexican film industry. . . . Two Mexican films involving blacklisted American talent

won high honors for Mexico in various European film festivals. Mexican film circles openly deride the United States for its blacklist of film personalities, and the derision fortifies Mexican nationalism at the expense of Mexican-American friendship.[92]

In this letter, which Trumbo wrote while working on the screenplay of *Spartacus* in 1958, he conveyed the different circumstances of blacklisted screenwriters outside the United States who had continued to write scripts for which they had been acknowledged within their host country. Trumbo strategically emphasized the success of these films internationally but also inserted more politically pointed arguments about the effect of the blacklist on U.S. relations with other countries.

In his letter to Lewis, as well as to politicians, including President Eisenhower, Trumbo wrote about the larger political impact of the blacklist on U.S. cultural relations abroad.[93] With Eisenhower, he used the threat of writing a series in "non-Communist and anti-Communist publications" in England and France in which he would explain "how hundreds of American artists have been driven from their professions and deprived of their civil rights by the legislative, judicial and executive branches of the federal government."[94] He received a response a few weeks later from the Special Counsel to the President, Gerald D. Morgan, who indicated that the president had "no comment" in response to the letter. Trumbo sent a letter to Morgan directly in which he replied that he would therefore "proceed in good conscience to warn the intellectuals and artists of Western Europe to resist with all their strength that policy of inquisition, imprisonment, blacklist, and denial of passport which in America has destroyed hundreds of artists and intimidates all of them."[95] Threatening to describe the repressive atmosphere of the United States to residents of England and France, Trumbo's letters to Eisenhower emphasized the hypocrisy of U.S. Cold War domestic policies that curbed the freedoms of progressive artists and writers while U.S. government agencies touted the freedoms of U.S. culture abroad.

Trumbo's early attempts to break the blacklist with *The Brave One* jump-started that process, but it was not until 1959 that he announced his authorship of the screenplay.[96] As such, Trumbo became one of the first screenwriters to "officially" break the blacklist. Previous to Trumbo's announcement however, fellow blacklistee Nedrick Young informed the Academy of Motion Picture Arts and Sciences that he had written the Os-

car-winning script for *The Defiant Ones* (1958) under the pseudonym Nathan E. Douglas.[97] Following these events, director Otto Preminger gave Trumbo an onscreen credit for *Exodus* (1960). By 1960, the political legitimacy of the blacklist was waning. After he was elected, President John F. Kennedy crossed the picket lines set up by the Catholic War Veterans (in protest against Trumbo's role as screenwriter) to see *Spartacus* at a movie theater in Washington with his brother Robert Kennedy, who was soon to be Attorney General.[98] These actions opened the door for other blacklisted screenwriters to both gain employment in the United States and receive credit for their work.

While scholars have discussed Trumbo's strategies to break the blacklist as explicitly political, this has not been the case for Butler's film work in Mexico. Butler's film projects, specifically *¡Torero!* and *Los pequeños gigantes*, in which he collaborated with Ponce, Velo, and others, challenged the conventions of both Hollywood and Mexican narrative cinema. Not only did the context of independent production allow for a greater degree of formal experimentation, as opposed to mainstream Mexican cinema, but because the funding of these films was autonomous from the state, these filmmakers were less directly at the mercy of state censors. This distance from the Mexican state enabled these filmmakers to create a space for critique. While these films did not exist "outside" of state censorship, their context of production allowed for a more explicit set of politics that critiqued both the U.S. and Mexican state.

In *Los pequeños gigantes*, about the Mexican Little League team that won the World Series in 1957, Butler accented this triumph of Mexico over the United States.[99] While Mexicans view bullfighting as a nationalist sport, it is telling that this story focuses on a sport (baseball) that has served as the "national pastime" in the United States.[100] Butler started writing the screenplay for *Los pequeños gigantes* soon after the Little League team from Monterrey, Nuevo León, won the World Series in 1957, the first year that the Mexican team was allowed to participate. He spoke to George Pepper about the idea, who agreed to produce the film. Butler and Pepper went to Monterrey to explore the areas where the children lived and to interview their coach, César Faz, and manager, Harold "Lucky" Haskins, in an effort to find out how this team had become so successful. Unlike the case of *¡Torero!*, there was little newsreel footage that could be integrated into the film, so most of the film was reenacted. Butler directed the film and chose a

Hugo Butler and César Faz talking to members of the Monterrey Little League team regarding *Los pequeños gigantes* (1958). Courtesy of Jean Rouverol.

crew consisting of individuals who had been involved in the making of *¡Torero!*, including Giovanni Korporaal as editor and Spanish exile musician Rodolfo Halffter as composer of the soundtrack. Luis Buñuel's son Juan Luis Buñuel served as assistant director.

Butler chose to tell the story of the Monterrey team's hard road to success through the perspective of César Faz, who started the team with World War II veteran Lucky Haskins, both of whom had been born in the United States and later moved to Mexico.[101] Impressed with Faz, Butler decided to have the Mexican American coach narrate the story. The film begins with the first "call for players" that Faz posts around Mexico City and proceeds to tryouts and player selection. From there, the film covers the team's history from their first games in Mexico to their trip to the United States to play baseball in McAllen, Texas. Their victory in McAllen eventually leads to their participation in the World Series in Williamsport, Pennsylvania. The last section of the film contains restaged footage of the semifinal and final games of the Little League World Series of 1957. The final scene of the film, following their win, consists of newsreel footage intermixed with a reenactment of the players' return to Mexico. The newsreel footage includes the players meeting with Eisenhower at the White House as well as their

reception in Mexico, where they are photographed with President Ruiz Cortines and honored at a huge parade.

Butler's film and screenplay of *Los pequeños gigantes* both reference repressive U.S.–Mexico border politics, poverty in Mexico, economic inequality between U.S. and Mexican citizens, U.S. racism against Mexicans and Mexican Americans, and Mexico's resistance to U.S. imperialism.[102] While poverty in Mexico was an especially taboo topic for Mexican films during the 1940s and 1950s, the other themes challenged the image of American society as "democratic" that the U.S. government was trying to convey globally during the early Cold War era.

In an early sequence of the film, when the team travels across the International Bridge from Reynosa, Mexico, to McAllen, Texas, Butler highlights the inconsistencies between the U.S. government's propagandistic claim of the United States as a "democratic" nation and U.S. immigration policies toward undocumented migrants from Mexico, which during this time resulted in the largest deportation drive in U.S. history.[103] Although the team's journey across the U.S.–Mexico border is uneventful, the film and screenplay allude to the difficulties that Mexicans experienced crossing the border into the United States during the years leading up to and following Operation Wetback, the U.S. government's massive deportation drive of Mexicans that occurred in the mid-1950s.[104] As the team walks across the International Bridge, Coach Faz remarks in his voiceover that "we crossed the Río Grande—without even getting our feet wet," a direct reference to undocumented Mexicans who wade through river to enter the United States.[105] In another segment of his voiceover that was cut from the script, Faz commented that they had no trouble entering the United States, "as we only requested visas for three days."[106] Notably, it is not Faz but Lucky, the Anglo manager, who secures their visas at the U.S.–Mexico border. In a dialogue between the two, Faz states, "When I was a kid up here, it was pretty rough on Mexicans who crossed the border. I guess things've changed," to which Lucky replies, "Well, changing anyway."[107] Although there is a special exception made for the team to enter the United States, both Faz's and Lucky's comments are critical of the difficulties that Mexicans experienced crossing the U.S.–Mexico border in the 1950s.

Mexican film censors considered U.S.–Mexico border policies contentious subject matter for films produced in Mexico during the 1950s. Director Alejandro Galindo's *Espaldas mojadas (Wetbacks)* (1953), a film about Mexi-

The reenactment of the crossing of the International Bridge for *Los pequeños gigantes* (1958). Courtesy of Jean Rouverol.

cans who cross the U.S.–Mexico border in order to work in the United States, had been withheld from distribution for two years by the Dirección General de Cinematografía. According to Seth Fein, the U.S. State Department and the USIA had pressured the Secretaría de Relaciones Exteriores to ban the film because of the way it addressed the mistreatment of Mexican workers in the United States.[108] Aspects of *Espaldas mojadas* had to be modified in significant ways before it was released. Although Galindo had made the film to "convince Mexicans not to go to the U.S.," according to Carl Mora, this message was framed and qualified by an introductory sequence with voiceover narration that cautioned Mexicans from *illegally* entering the United States.[109] The introduction included a specific word of warning about the predicament of undocumented Mexican workers "who place themselves at the margin of the law." While the film accents the difficulties that Mexican workers face in the United States, the introduction differentiates between the treatment of *braceros* and "illegals" in the United States, portraying only the former as protected by both the U.S. and Mexican

governments. Seth Fein argues that the Dirección General de Cinematografía decided to delay rather than ban the film because the "Mexican state had a stake in suppressing criticism of Mexican working conditions in the United States, considering its own need to find an outlet for its labor surplus through undocumented emigrant workers."[110] The Dirección General de Cinematografía thus tempered Galindo's original message to Mexicans not to go to the United States by differentiating between legal and "illegal" means to cross the border.

Mexican censors at the Dirección General de Cinematografía had also removed Butler's direct references to the poverty of most of the players in *Los pequeños gigantes*, yet the film still drew attention to the economic inequities between the Mexican and the U.S. players. Although the Mexican film censors deemed it acceptable to show the Monterrey team's success, they were insistent on removing references to poverty and inequality within Mexico itself. For example, the Mexican film censors excised a shot of the boys' shoeless feet during the early tryouts.[111] What remained in the version of *Los pequeños gigantes* that was released was the team's lack of adequate means, including food and clothing, in contrast with those of the American boys during their first game. The American boys appear well fed and are notably bigger than the Mexican boys. Thus, the Mexican team refers to the U.S. team as "giants," while the U.S. team refers to them as "midgets."

Even though the Americans are favored to win, some "concerned citizens" attempt to derail the Mexican team's chance of winning in what some members of the team interpret as a racist act. While the Mexican players are practicing for a game in their uniforms because their only other clothes are being washed, a couple of white Texan men who are observing inform Faz that it is against the rules for the players to practice in their uniforms on Sundays. Not only does the team stop practicing, but since the men have reported their infraction, there is also the possibility that the team could be disqualified from competing. In the original script, there was a sequence in which Faz tries to understand why these men contacted the Little League authorities, but this section of the narrative was cut from the script. Faz noted that he had "feared" this kind of racist incident happening "since we left Monterrey."[112] In another voiceover, Faz thinks that Fidel, the second pitcher, "said it was *more* than rules—those guys at the field had it in for us because we were Mexican." This segment was originally followed

by a scene in which Faz recounts his experience sleeping in a locker room, rather than in a hotel, while working as a bat-boy for the San Antonio Missions, but it was deleted from the final script.[113] Even without the scene, it remains implicit in the film that Faz is a Mexican American who "returns" to Mexico because of the racism he experienced in the United States.

The screenwriters used the success of the "midgets" over the "giants" as an allegory for Mexican resistance to U.S. imperialism. During their game in McAllen, the Texas team bets "the cost of a fiesta" to whichever team loses the championship. One of the more outspoken members of the Monterrey team, Fidel, says that it's their chance "to take Texas back from the Americans."[114] Once the team advances to the semifinals, a Mexican businessman and others advise Faz to use his best pitcher, Angel, in this game, because winning second place is better than nothing. (The rules dictate that the same pitcher can't play in the semifinals and finals of the World Series.) Fidel disagrees, telling Faz that it's "always second-place, always with us," referencing Mexico's history of losing to invading armies, and encourages him to go all out for victory.[115] Although the Mexican team is disadvantaged, they win this series, conveying what Emilio García Riera argues is "a clear antiracist message" in the film and "a vindication of the so-called Third World."[116] In her memoirs, Rouverol described the occasion of the Monterrey's team win for Mexico: "[F]or a country that had lived so long in the shadows of the colossus of the North, it was a glorious moment."[117]

This event was also a kind of "glorious moment" for the USIA, which decided to send footage of the World Series win to the producers of the "Mexican" newsreel *Noticiario clasa*. *Noticiario clasa*, owned by the USIA, was part of "Project Pedro," which Seth Fein describes as "its [the USIA's] attempt to take control of the Mexican newsreel."[118] According to Fein, the USIA viewed newsreel production as a "way to wage the Cold War in the Americas."[119] The USIA deemed the 1957 Little League World Series appropriate for the kind of "international" news stories it wanted to include in the newsreel. Motion picture coverage of the game, as well as that of a visit between President Eisenhower and the team, could (potentially) demonstrate "international cooperation" between the United States and Mexico.[120] However, resituated in the context of Butler's film, the Little League games instead foregrounded economic inequality between the two countries, repressive U.S. immigration policies, and U.S. racism against Mexicans. The film also highlighted the Mexican team's victory against the "giant" to the North.[121]

As Seth Fein argues, during the 1940s and 1950s, film in Mexico was "closely integrated into the structures of power controlled by the authoritarian state-party, through the Secretaría de Gobernación's evolving mass-communication bureaucracy, which administered cinema censorship as well as industrial promotion."[122] Just as Fein describes the limitations of *Noticiario clasa* to produce "effective propaganda" in the eyes of the USIA, due in part to the role of Mexican censors who didn't want the newsreels to appear to be too "pro-American,"[123] Butler also had to contend with state censorship for his representation of the Mexican team's players as economically disadvantaged. As García Riera notes about the filmmakers, "[T]heir serious difficulties before the censors of that time . . . were in that they presented the reality of their characters, very poor boys of the industrious regional mountain capital [Monterrey] that, as with all cities of the world, has not been able to nor can eliminate the needs . . . of their inhabitants."[124] The reason for the absence of the poor and marginalized within Mexican film was echoed in an article written in 1965 by filmmaker and critic Manuel Michel:

> In Mexico, or rather, in Mexican cinema, they [marginalized classes] do not exist. . . . Remedies for poverty and illness, land and food distribution . . . do exist. . . . But the poor and the sick, that is, the permanent crisis, do not exist. . . . But their filmic nonexistence stems from excuses such as the following: the problems are being fought and solved; the poor are a demagogical issue, they must be hidden because they are depressing and they harm the morale of the country which is on the road to progress; they damage the image of our country abroad.[125]

Michel, an important figure within the development of Nuevo Cine, emphasizes the relationship between the Mexican government and the film industry, which had been cultivated starting in the 1940s. It was these connections that filmmakers and critics who developed the Nuevo Cine movement specifically challenged.

Butler's *Los pequeños gigantes* had much in common with films such as Buñuel's *Los olvidados,* Korporaal's *El brazo fuerte (The Strong Arm)* (1958), and Alazraki's *Raíces,* which narrated themes of government corruption and/or class and racial divisions in Mexican society in the 1950s.[126] These films emerged as the administrations of Miguel Alemán (1946–1952) and Adolfo Ruiz Cortines (1952–1958) reversed many of the reforms enacted during the Cárdenas administration, as they tried to assuage rather than to

address the problems of the poor, working-class, and indigenous peoples of Mexico.[127] Oppositional intellectuals in Mexico, including Daniel Cosío Villegas, identified this period as a "*neoporfiriato*," which according to Claire F. Fox referred to the era's drive for "modernization and its authoritarianism."[128] In his essays of the late 1940s and 1950s, Cosío commented on the similarities between Mexico in the 1940s and the administration of Porfirio Díaz (1876–1911) before the Revolution. In his book *American Extremes/ Extremes de América,* Cosío argued that the crisis within Mexico that started in the 1940s was related to "the fact that the goals of the Revolution have been exhausted, to such a degree that the term *revolution* itself has lost its meaning."[129] In his review of Cosío's nine-volume *Historia moderna de México* (1955–1972), Charles Hale wrote that Cosío saw the goals of the Revolution "as political democracy, economic and social justice, and the defense of national against foreign interests, goals which had become distorted, confused or laid aside in the fever for economic development" in the 1940s and after.[130]

Alejandro Galindo, the director of *Espaldas mojadas,* viewed Mexican film of the 1950s as part of a "*neoporfirista*" era of filmmaking, as he believed that filmmakers could not make social and political films during this time.[131] In *The Fence and the River,* Claire Fox notes that Galindo did not relate this situation to the crisis in Mexico, as did Cosío, but rather to the effect of McCarthyism in Mexico.[132] The irony is that it was HUAC hearings on the film industry in 1947 and 1951 that led to the diaspora of left-wing Hollywood screenwriters to Mexico, some of whom, including Butler and Pepper, contributed to the development of a cinematic crosscurrent in Mexico. This movement began in the 1950s at a time when, Galindo argues, the days of social and political filmmaking were over in Mexico.

In order to address the politics of Butler's aesthetic practices, it is necessary to situate his film work within the context of Mexico and Mexican cinema during the early Cold War era. This enables us to understand how his work, along with that of his collaborators, was positioned against the Mexican film industry and its alignment with the Mexican government and by extension the U.S. Cold War state. Filmmakers like Emilio Fernández had received financial support from the Mexican government to create films that represented an "idealized, romanticized and imaginary Mexico," which circulated both within and outside Mexico during the 1940s and 1950s.[133] This work had been supported not only by the government but also by

the elite classes in Mexico.[134] By the mid- to late 1950s, Fernández's reputation had begun to wane both in Mexico and internationally. The decline of mainstream Mexican cinema within the international marketplace created a "crisis" within the Mexican film industry that gave way to a cinematic crosscurrent.

Representations of Mexican culture in the work of blacklisted Hollywood screenwriters in Mexico resulted in the two principal responses exemplified by Trumbo and Butler. Trumbo remained focused on the U.S. context as well as on U.S. audiences, which led him to create images of Mexico framed through a U.S. perspective for an American public. After he returned to the United States, Trumbo used the success of his black market work, including his screenplay of *The Brave One,* as part of a broader strategy to expose and dismantle the Hollywood blacklist. In his campaign against the blacklist, Trumbo railed against the repressive atmosphere of the Hollywood film industry, overseen by government officials that had forced out talented individuals whose scripts enhanced the film industries of other nations. Perhaps most pointedly, Trumbo wrote about the effects of the blacklist on U.S. relations with other countries, in parts of Latin America and Western Europe, whose artists supported the blacklisted against that of the U.S. government. This position challenged the cultural projects of the USIA, the State Department, and other U.S. agencies that promoted "official art" abroad during the early Cold War era.

By contrast, Butler's film practice in Mexico addressed the cultural politics of filmmaking in a way that challenged the logic undergirding dominant U.S. and Mexican film production of the early Cold War era. Butler's work was shaped by his knowledge of Mexican history and culture, collaboration with an international community of politically progressive filmmakers, and an interest in addressing his films primarily to a local Mexican audience. These influences led Butler to create films that portrayed Mexican culture from a less exteriorized viewpoint as well as to employ experimental film practices and narrative forms that challenged the conventions of Hollywood narrative film. As a result of his engagement in a "cinematic countercurrent" in Mexico, Butler's work grew further away from U.S. models of film production, specifically those developed in Hollywood. His formal choices were conceived with regard to particular historical and political relations in the United States and in Mexico, and the work he produced both responded to and rearticulated the cultural and political terms of that context.

5

Unpacking Leisure

Tourism, Racialization, and the Publishing Industry

During the twenty years following World War II, the Mexican tourist industry modernized and grew exponentially. Propelled by foreign speculative investment and Mexican state–sponsored promotion of "national culture," tourism played a significant role in remaking the Mexican landscape, especially in coastal areas prime for resort development.[1] Vacationing tourists from the United States provided a stark counterpoint to the U.S. exiles residing in Mexico. Perhaps unsurprisingly, between the mid-1950s and mid-1960s American tourists were frequent subjects in U.S. exile writing.[2] They were the sanctioned double of the fugitive exile and a garish symbol of U.S. hemispheric preponderance. Of all the U.S. exiles, it was Willard Motley who wrote most incisively and extensively about U.S. tourism in Mexico. In his writing and correspondence with his editors, his critique of U.S. tourists and the consequences of the tourist industry on Mexicans confronted publishing industry pressure to align his characters with the titillating perspective of U.S. tourists.

This chapter examines two manuscripts written by Motley after his move to Mexico: the unpublished "My House Is Your House," a non-fictional manuscript comprising Motley's writings about Mexico, and a novel "Tourist Town," which was posthumously published as *Let Noon Be Fair* (1966). Motley's writings in Mexico are significant in that they convey a vivid analysis of the reciprocities between U.S. domestic and international racism within the context of U.S. tourism in Mexico. Tourism in Motley's nonfictional and fictional writings in Mexico functioned as a literary trope for discussing U.S. racism and imperialism. In particular, Motley explored how U.S. racial ideologies were transposed to the Mexican context through

tourism. In "My House Is Your House" and "Tourist Town," Motley contrasts U.S. and Mexican racial ideologies and excoriates U.S. imperialism, in the form of tourism, in Mexico. In both of these manuscripts, Motley also describes the effect of the presence of U.S. tourists within the broader context of the tourist industry in Mexico during the immediate post–World War II era.

While Motley makes explicit his critique of U.S. racism and imperialism within the content of his writings, his aesthetic choices also challenge conventional U.S. travel narratives about Mexico written during the post–World War II era. Both "My House Is Your House" and "Tourist Town" draw from documentary as well as modernist techniques in point of view. Motley's use of different formal approaches within his writings in Mexico serves to disassemble the narrowly circumscribed perspective and exoticized realism of the conventional travel narrative. Motley foregrounds Mexicans looking back, returning the gaze of the tourist, and disrupting the omniscient imperial gaze that constructs the world as a spectacle to be consumed. Motley's experimentations in point of view, specifically refracted across lines of race, class, and nation, contributed to what I call a transnational mode of identification in his reader. By this I mean an expressly anti-imperialist mode of representation that, by staging indigenous perspectives that frame and challenge tourism, undermines the unilateral point of view that shapes traditional travel narratives, in which "native" viewpoints are not considered. Furthermore, by positioning himself as the narrator of his nonfictional "My House Is Your House," he centrally locates his experience as an African American man within the context of U.S. racism in Mexico.

Motley's attention to the racial and economic dimensions of Americanization and scathing critique of U.S. tourism in Mexico led to his work being censored or significantly altered by editors at commercial publishing houses in the United States. The perceived inflammatory nature of his work and his protracted negotiations with the publishing industry provide an opportunity to examine the complexity of Cold War cultural and racial politics in the expanded frame of U.S. ascendance. Furthermore, considering Motley's writings in Mexico enables an examination of the conditions in which cultural work that linked U.S. racism and imperialism persisted during the early Cold War era.

In Mexico, Motley grew increasingly critical of the United States, specifically its treatment of African Americans. Motley's analysis of race prejudice in his writings about Mexico contrasts with the work he produced in the United States. Motley, the best-selling author of *Knock on Any Door* (1947), moved to Mexico after publishing his second novel, *We Fished All Night* (1951). In both of these novels, the main protagonists were white. In fact, Motley had not included African Americans as characters in his writings before his relocation to Mexico in the early 1950s. Motley wrote three book-length manuscripts in Mexico, which include *Let No Man Write My Epitaph* (1958), "My House Is Your House," and "Tourist Town." These works, unlike the books Motley wrote in the United States, more directly examined race relations. In the introduction to Willard Motley's published diary, Jerome Klinkowitz comments: "Race, a subject of little concern to the early Motley, became by the end of his life a major personal issue."[3]

Motley gained new insight on race relations while living outside the United States. In a chapter of "My House Is Your House" titled "An American Negro in Cuernavaca," Motley explains his new understanding of U.S. racism, while using the rhetoric around contamination and disease that was dominant during the early Cold War era:

> Richard Wright once made a statement, briefly criticized in the U.S., that there was more freedom in a block of France than in all of the U.S. There are overtones of truth in the statement, economically, socially speaking, surely psychologically speaking. I'd say that there is more thought about a person's race or color in every individual family in the U.S. than there is in all of Mexico. This deadly self-consciousness about race and color in the U.S. has actually numbed an entire country. This skin disease is something everyone born there has to suffer from the day of his birth. And you never realize how psychologically sick the U.S. is from this point of view until you live in a foreign country.[4]

As opposed to using the rhetoric of contamination to fan anti-Communist fears, here Motley uses the tropes of this rhetoric against U.S. racism.

This new perspective is also evident in "Tourist Town," the novel Motley wrote following "My House Is Your House," in which he fictionalizes his observations of U.S. racism and imperialism through an examination of the social and material effects of U.S. tourism on "Las Casas," a small Mexican fishing village. Motley's representation of economic inequalities within Mexico developed between his writing "My House Is Your House" and

"Tourist Town." In the latter, he described a more complex world whereby tourists from the United States are presented as working in conjunction with other forces, such as the upper classes, the Catholic Church, and the Mexican government, to exploit the poorest segments of Mexican society. In "Tourist Town," Motley explores the effects of these forces on the town as well as on its residents. Specifically, he examines the unequal relations of power among U.S. tourists and expatriates, Mexican elites, and the Mexican residents of Las Casas, and it is the dynamics of these relations that propel his narrative. However, it was Motley's frank statements about U.S. racism within the United States and Mexico that made it difficult for him to publish his work. "My House Is Your House" was never published, and "Tourist Town," which included pirated sections of "My House Is Your House," was significantly edited after Motley's death and published as *Let Noon Be Fair*.

In this chapter, I start by briefly examining Motley's U.S. writings as a way to both draw continuities and explore differences between this work and his writings in Mexico. I then analyze "My House Is Your House" within the context of the developments in the Mexican tourist industry in the post–World War II era. In this section, I explore how Motley's placement of U.S. racism within an international context—so vigorously excised by his editors—challenged dominant U.S. representations of race relations during the early Cold War era. I also consider Motley's political and formal strategies in "My House Is Your House," arguing that they reveal an effort to de-exoticize the representational approach evident in conventional travel narratives. I contend that Motley brought a similar aesthetic approach to his writing of the novel "Tourist Town." However, the subsequent revision of "Tourist Town" by Motley's editor after his death dismantled much of Motley's critique of U.S. tourists and the tourist industry in Mexico. In the last section of the chapter, I contrast the ways in which Motley implicates even sympathetic U.S. visitors (including one of his fictional stand-ins) in the negative transformation to Las Casas with the less critical perspective of other U.S. writers who traveled to Mexico during the 1950s. In concluding, I argue that editorial changes to Motley's work indicate not only the limitations of the commercial publishing industry in the United States during the early Cold War era but also scholarly interpretations of Motley's literary contributions while in Mexico. Analyzing Motley's original manuscripts brings to light the way in which his work narrated the global dimensions of

U.S. racism, a perspective that he attempted to convey to U.S. audiences during the post–World War II era.

AN AMERICAN NEGRO IN CUERNAVACA

Before Willard Motley's *Knock on Any Door* became a best seller and brought him broad recognition, he had established himself professionally as a writer in the 1930s in Chicago.[5] During the 1930s, Motley traveled extensively throughout the country, especially in the West, where he encountered the struggling lives of the working classes in the wake of the Depression. When he returned to Chicago, he became part of a group of politically progressive novelists who worked on the Illinois Writers' Project, some of whom were affiliated with the South Side Community Arts Center established by African American artists. Not a participant in the South Side Writers Group, Motley cofounded *Hull-House Magazine* in 1939 along with two white radicals, Alexander Saxton and William Schenk. Motley contributed some of his own writing to this little magazine, which included both fictional and nonfictional pieces. Many of the articles Motley published in the magazine developed out of his research and writing for the Illinois Writers' Project, where he started working in 1940.[6]

Motley's involvement in the Illinois Writers' Project had a significant impact on his future work. While he was employed by the Project, he immersed himself in the cultural milieu in which he was writing, an approach that he believed enabled him to most accurately describe those contexts.[7] Many of Motley's early works, including *Knock on Any Door*, contain sections of writing from the material he researched on an Italian American neighborhood of Chicago for the Illinois Writers' Project.[8] Stacy Morgan argues that during the 1940s and 1950s, African American writers, including Motley, "often examined a given issue in more than one expressive mode." Further, Morgan comments that these writers "saw the potential limits of the novel" and that they "dabbled in documentary as a way of authenticating to readers the experiences presented in their novels."[9] This hybrid aesthetic characterizes much of Motley's writings in Mexico.

The first manuscript Motley authored in Mexico, "My House Is Your House," was written in a documentary mode. Soon after Motley arrived in Mexico, he began to write brief descriptions of his impressions of life there as a way to familiarize himself with his new surroundings. Although he had

not initially intended to write a book, a number of years later he decided that this material could be compiled into a manuscript. In the mid-1950s, he ceased writing "My House Is Your House" to work on a novel, *Let No Man Write My Epitaph*, which was published in 1958, but he later picked up the project again. Motley finished the first section of the manuscript in 1960, at which time he submitted it to his agent and his editor at Random House.

"My House Is Your House" is about Motley's earliest experiences in Mexico and his insights on Mexican customs, traditions, food, and language. In the book, Motley also describes his hostile interactions with white Americans at hotels geared toward the tourist trade as well as his difficulties at the Texas border where he travels to renew his tourist visa. Motley analyzes aspects of Mexican culture such as religious holidays; the idea of "macho"; the poverty of working-class and indigenous peoples, which includes debunking stereotypes held by Americans about Mexicans; and bullfights. His descriptions of Mexican food and drink are not geared toward the average American tourist. In one chapter, "A Kilo of Tortillas, a Güaje of Pulque," which was published later in *Rogue*, a men's magazine, Motley describes Mexicans eating fried grasshoppers, not to exoticize Mexican food but—as in his descriptions of the significance of *pulque*, a beerlike drink, and *pulquerías*, the bars where Mexican men drink it—to make reference to the poverty endured by many Mexicans.[10]

Motley wrote "My House Is Your House" as the Mexican state's involvement in the development of tourism reached its peak following World War II through the 1960s. Between 1950 and 1960, the number of tourists who entered Mexico increased from 384,000 to 681,000.[11] It was the administration of Miguel Alemán (1946–1952) that allocated substantial resources into building the infrastructure of the tourism industry. According to scholar Eric Zolov, tourism promotion in the postwar era was "repackaged" so as to change how foreigners viewed Mexico.[12] While most Americans perceived Mexico as underdeveloped before World War II, it was to the benefit of the Mexican government to represent the country as safe for both foreign capital and foreign travelers. Alex Saragoza argues that "Alemán was instrumental in the move to promote Mexico vigorously to foreign travelers, and in the construction of a more modern, highly commercialized approach to Mexican tourism."[13] Alemán's efforts continued after he left office in 1952, when he was hired to run the Mexican government's agency for tourism.

The rise in the number of U.S. tourists visiting Mexico was also related to a heightened demand for vacation experiences abroad by Americans both during and after World War II. This interest was fueled in part by the changing position of the United States as *the* world power following the war, as well as by the boom in the postwar U.S. economy. Christina Klein argues that during this period, "Tourism functioned as a discourse through which Americans could enact and imagine the transition from what William Harlan Hale of the *Saturday Review* saw as their prewar 'total isolation,' to their postwar 'total immersion' in world affairs."[14] While in 1947 only 200,000 Americans had passports, by 1959, 7 million Americans traveled outside the United States. Of the 7 million, over 5 million Americans took trips within North America, to Canada or Mexico.[15]

·"My House Is Your House," like other works of travel writing, is auto-biographical; there is no distance between the author and the first-person narrator.[16] As mentioned previously, all of the manuscript reflects situations that Motley had observed, including the way in which white American tourists treat Mexicans, as well as his own experience as an African American living in Cuernavaca. Motley starts "My House Is Your House" by describing the activities of American tourists in Cuernavaca that he studied as a guest at the Bella Vista Hotel. In a chapter entitled "The American Verandah," Motley sets the scene where he first starts to write about the inequities between the U.S. tourists and the Mexicans who serve them. On the verandah of the Bella Vista Hotel, the Americans "order drinks from the waiters who made 11 little pennies an hour," while they "complain about the dirt, how dirty the Mexicans are, how poorly their country is run."[17] Among other issues, Motley overhears discussions between the Americans about how they treat their Mexican servants. In their conversations, the U.S. tourists tell one another not to "spoil" the servants, which Motley translates as "don't pay them more than $18 a month" (111). Motley also contrasts his characterizations of the U.S. tourists with the Mexicans he meets, including those who are employed at the hotel, who warmly embrace him. The title of the book is taken from the Mexican saying, "*Mi casa es su casa*," ("My house is your house"), suggesting the openness and generosity of Mexicans toward visitors to their country.

Motley comments on the racism exhibited by white Americans toward African Americans (including himself) in Mexico in chapters entitled "Little Texas, Cuernavaca" and "An American Negro in Cuernavaca." In Cuer-

navaca, he discovers that there are some white Americans who can live next to African Americans and others who cannot. The "Texas contingent," as Motley refers to the latter group, "don't like it that Negroes have now come to Cuernavaca—and consorting with whites! That Negroes can sit on the same verandah with them in Mexico. It isn't an old Southern custom. They would like to bring their customs here" (137). Motley, who believed that he was leaving racial prejudice behind when he entered Mexico, writes that while "we have long gone beyond thinking of color, it was to become evident that it was much on the minds of American white residents and tourists" (131). He continues, "[I]n a dark-skinned country we ironically find ourselves in a strange little microscopic world revolving around color. Had we flown across the Mason-Dixon line, across the Río Grande and into Mexico?" (137). While Motley left the United States in part to escape racial discrimination, he found himself confronting U.S. racism through his contact with white Americans who came to Mexico not to evade persecution but as tourists. It is his experience as a U.S. citizen in Mexico, frequenting a hotel that caters to U.S. tourists, that exposes him to racial prejudice.

Motley's critical analysis of the behavior of U.S. tourists in Mexico demonstrates that the U.S. State Department was not altogether successful in its attempt to "manage" Americans who traveled abroad. During the 1950s, all U.S. citizens whose applications for passports were granted received a letter from President Eisenhower advising them to carefully consider their interactions with individuals outside the United States. Although it was not directly stated as such, racial prejudice in particular was viewed by government officials as a type of behavior that would work against the efforts of the United States to win the "hearts and minds" of citizens within so-called third-world countries.[18]

At the same time that Motley critically observes the contingent of U.S. tourists who inhabit that "strange little microscopic world," he befriends another segment of Mexican society: the Mexicans who are employed by the tourism trade in various occupations such as bellhop, bartender, and cook. In fact, for most of the time that Motley lived in Mexico, he socialized with working-class Mexicans rather than with Americans. In an article about Motley, Robert Cromie mentions that Motley knows "no Mexican writers or artists," as he prefers "to find his friends among the lower middle-class."[19] In "My House Is Your House," Motley includes the perspective of the Mexican hotel employees as a means to demonstrate how citizens of

Mexico, a strategic ally of the United States during the Cold War, were disturbed by American racism both within and outside the United States. In the chapter "An American Negro in Cuernavaca," Motley writes that while Mexicans didn't care what color he was, they were aware that white Americans discriminated against him. In a conversation with waiters from the Bella Vista Hotel, they tell him that some of the white Americans complained to the hotel management because the hotel served African Americans. He reports that the waiters felt that the white Americans had "tried to bring prejudice to Mexico" and that they "didn't like the Mexicans either although they were visitors and guests in the country" (143–44). Through this example, Motley draws links between U.S. racism as expressed toward African Americans and Mexicans. Motley writes that his conversations with the waiters were "an interesting gauge in race relations . . . giving an insight into what the Mexicans think and feel about the giant at their doorstep" (145).

While Motley directly criticizes the white Americans for their racist and imperialist attitudes toward the Mexicans in whose country they temporarily reside, he employs Mexican antiracism as a counterexample to U.S. racism. In "An American Negro in Cuernavaca," Motley writes that "every Mexican boils with anger every time there's an anti-Negro incident in the United States. A dark-skinned race themselves they vehemently resent the prejudice against Negroes" (145). After citing examples of friendliness and brotherhood shown to him by Mexicans, Motley notes that the racial incidents "all point to but one thing and that is that the United States has, with racial prejudice alone, made a definite enemy of Mexico; has made Mexico color conscious; conscious of its own reflection in the mirror" (146).

In their responses to his draft manuscript of "My House Is Your House," Motley's agent and editor both inferred that his depictions of U.S. racism were too controversial to be included in a book geared toward a predominantly white, middle-class readership. When Motley sent his agent, Mavis McIntosh, the first installment of his manuscript, she responded that his "sections on prejudice should be revised."[20] Motley ignored her comments and submitted the manuscript to Random House without making any revisions to his original material. Although Robert Loomis, his editor at Random House, was initially interested in Motley's idea for "My House Is Your House," he was critical of these sections of the manuscript as well. After Loomis received the first installment, he commented in a letter to

Motley that "This story—your story—was confused somewhat by the incli-
nation of the reader to look at the book as a book about Mexico when in
reality, it is really a book about your own experiences."[21] Loomis continued,

> Of course gradually one begins to see that certainly the main reason that
> Mexico impresses you so much was because of its lack of bigotry towards
> Negroes. I think the reader realizes this before you actually admitted it in the
> book. I know for instance that all Mexicans are not good just as I know that
> all Americans are not bad (we'll make exceptions for Texans if you wish), but
> that is the impression gotten from the book. I don't think this is fair and I
> don't think you'll convince anybody of it either. This impression causes
> some confusion in the reader's mind for while you are praising your new
> environment, you are relentlessly criticizing the people from your former
> environment.[22]

Although the genre of travel writing is frequently autobiographical, what
Motley's editor was inferring is that the book was somehow invalid because
it was about Motley's experiences in Mexico rather than a "book about
Mexico." It appeared to be Motley's specific analyses of U.S. racism in
Mexico (as opposed to a "universalized" portrayal of Mexico) that Loomis
believed would not appeal to white, middle-class American readers. In
addition, it was Motley's representations of U.S. tourists that concerned
Loomis, since this book implicated them in the perpetuation of race preju-
dice. In responding to Loomis's points outlined in the letter, Motley agreed
that some of the passages on American racism in Mexico could be edited
but indicated that he wanted to make sure that the editor would "leave
enough to clearly show how a certain class of American goes to a foreign
country and tries to import its prejudices."[23]

Motley's later chapters focused more specifically on aspects of Mexican
culture rather than on the relations between U.S. tourists and Mexicans.
However, when Motley's editor received these chapters, he again expressed
disapproval because Motley chose to represent aspects of Mexican life that
were not usually examined within conventional U.S. travel narratives of this
period, including the difficult lives of both the working classes and the im-
poverished in Mexico. In response, Motley informed Loomis that he was
"trying to describe the Mexico and Mexicans the tourists never get to see—
the middle and lower classes."[24] In the United States, Motley's writing had
focused on the lives of the working classes, and as Jerome Klinkowitz ar-
gues, he saw himself as a "social researcher, leaving his own middle-class
circumstances, to seek out the deeper truth of life."[25] Motley's focus on the

"other half" of society pleased editors when he wrote novels based on the lives of white, working-class ethnic characters, such as Nick Romano in *Knock on Any Door.* However, Motley's editors did not respond favorably to his inclusion of the poor and working class who labored in the service industry in a book about Mexico. Although Motley wanted to write a book about Mexico that featured the perspectives of working-class Mexicans, Loomis envisioned "My House Is Your House" as a more conventional travel narrative geared toward a white, middle-class readership.

It is not only the subject matter but also the aesthetic form of Motley's book that differentiates it from conventional U.S. travel narratives about Mexico. Mary Louise Pratt identifies three main conventions in her analysis of Victorian discovery rhetoric. One of these, the "monarch-of-all-I-survey" scene, she argues, also appears in contemporary travel accounts, "only now from the balconies of hotels in third world cities."[26] The monarch-of-all-I-survey scene is about "the relation of *mastery* predicated between the seer and the seen," according to Pratt.[27] David Spurr also writes about the appearance of the conventions of colonial discourse contained in travel writing, using Foucault's reading of Bentham's panopticon to describe the position of the Western travel writer.[28] He suggests that "like the supervisor in the panopticon, the writer who engages this view relies for authority on the analytical arrangement of space from a position of visual advantage."[29] Spurr contends that the Western travel writer positions himself or herself at a distance above or at the center of the action and that the "interpretation of the scene reflects the circumspective force of the gaze, while suppressing the answering gaze of the other."[30] Spurr relates Western travel writers' visual surveillance of landscapes to interiors and bodies, arguing that "When it descends from the height of mountain ranges and hotel rooms, the gaze of the Western writer penetrates the interiors of human habitation, and it explores the bodies and faces of people with the same freedom that it brings to the survey of a landscape."[31]

These elements are evident within typical travel books by U.S. writers about Mexico during the 1950s and early 1960s, including Sydney Clark's *All the Best in Mexico* (1953). Clark aestheticizes the landscape, also training his lascivious gaze upon the faces and bodies of women in Mexico. Clark opens his book with the following passage: "If you like pretty girls, especially those who do not know they are pretty, you may see tens of thousands of them in Mexico, for the Indian and the *mestiza* are *naturally* pretty and it

is only the unfortunate exception who is not. The faintly Oriental cast of countenance conspires with the clear-cocoa skin and the petite figure to build remarkable eye appeal."[32] Clark's book contains "standard elements of the imperial trope," according to Pratt's definition, which includes "estheticizing adjectives."[33] Further, his description resembles classic colonial discourse whereby, as Spurr argues, "the eye treats the body as a landscape: it proceeds systematically from part to part . . . finally passing an aesthetic judgment which stressed the body's role as object to be viewed."[34] Clark's depiction of "pretty girls" in his opening serves as a metaphor for Mexico as an innocent, exotic, and compliant body eagerly awaiting conquest, an image that was also depicted in advertising created by both the U.S. and Mexican tourist industries to sell Mexico as a tourist destination during the 1950s and early 1960s.[35] Further, in Clark's book, as in other works of U.S. travel writing, readers are aligned with the perspective of the writer, which is undisrupted by opposing or alternative views and champions its own unencumbered cosmopolitan mobility.[36]

In "My House Is Your House," Motley upsets the monologic, imperial, and exoticizing structure of the conventional travel narrative by borrowing from and incorporating a range of writing styles and techniques. For example, he includes documentary as well as modernist techniques in narrative point of view. He departs from and subverts the standard travel narrative through his use of a variety of experimental techniques, including shifting angles of vision and perspective. This pastiche of stylistic elements works to complicate the univocal, uniperspectival form of the conventional travel narrative in which "we" look at the "exotic" locale and people.[37] Where conventional travel narratives are built upon the vicarious conquest and intimate availability of the "authentic" exotic, Motley's strategy, both formal and political, emphatically de-exoticizes and conveys the recalcitrance of his subject.

Motley's aesthetic challenges to the conventional travel narrative are evident from the beginning of "My House Is Your House." In chapter 1, "South, the Border," Motley depicts his initial impressions of Mexico as a tourist, staying at a hotel that caters to tourists from the United States. Sitting on the veranda of the hotel, Motley observes the dire poverty of many Mexicans, primarily indigenous Mexicans, who pass by. He narrates a scene in which he watches a group of indigenous Mexicans who themselves are looking at the tourists from behind an iron gate. Motley writes from his

perspective, looking at this group, then transitions to the view of the indigenous Mexicans watching the tourists. He describes the indigenous Mexicans as "attracted to the murals. And by the verandah full of people. Women with jewelry. The tables in front of them filled with glasses of tall iced drinks they never saw before or imagined." Following this passage, Motley switches to the perspective of the indigenous Mexicans: "These are rich people. Americans and Mexicans. This I can tell my unborn child. Or this I can hate. This is the life I have never seen before but am now privileged to see through this iron fence. Why are we hungry? Why can they spend in a night what would give us life for a month? Why? Why? Why? And why?" (36). In the passages that follow, Motley continues to alternate between his perspective and that of the indigenous Mexicans who watch the tourists. This technique aligns the reader's perspective not only with that of Motley but also with the indigenous Mexicans who watch the tourists, creating a transnational mode of identification in the reader.

Motley presents a broader perspective of Mexico than do other U.S. travel writers, in part by the way he historicizes social and economic inequalities. In the chapter, "The American Verandah," Motley describes how he and his friends would pass some of their food to beggar children when the manager of the restaurant wasn't watching. After describing the children eating this food, Motley notes the irony of seeing a statue of a leader of the Mexican Revolution "watching them": "Morelos, one of the heroes of the Revolution, who advocated dividing the large *haciendas* among small peasant holdings watches from his huge statue placed on a high plaza next to the *palacio*" (115). Here Motley comments on the limits of the Revolution's goals to provide land and bread to all Mexicans, as beggars, many of whom are children, fill the streets of Cuernavaca. Later, in a section of the book in which Motley relates Mexico to a "beggar and thief" society, he describes the Revolution as a farce, stating that "power and wealth were merely transferred from the hands of the Spaniards, to the generals and the politicos. The people who were to be free and to stand straight on the soil are still reduced to beggary and thievery. The church learned its thievery from the Spaniards, the big politicians learned it from the church" (457–58). Motley's views were influenced by Mexican friends who were critical of the government during what Mexican intellectual Daniel Cosío Villegas described as a "*neoporfiriato*" era.[38] As mentioned in earlier chapters, it was during the administration of Miguel Alemán (1946–1952) that economic

inequalities proliferated in Mexico. Alemán "modernized" Mexico, transforming its economy from one based in agriculture to one based in industry. However, this shift left many agricultural workers unemployed and forced some into poverty. Although Donald Jud argues that "surplus" agricultural workers were absorbed by the service sector located within the tourist industry between 1950 and 1970, Motley's descriptions of beggars in Cuernavaca during the 1950s suggests that this was not entirely the case.[39]

Motley's nuanced critique of Mexican modernization, U.S. neocolonialism, and racialized dispossession could not have been further from the orientalizing boosterism of U.S. travel writing about Mexico during the post–World War II era. Instead of analyzing the adverse effects of modernization on Mexico, travel writers like Kate Simon accented the positive features of Mexican industrialization that made Mexico appear both "safe" and "foreign" to visitors, as Eric Zolov argues. Zolov suggests that travel books on Mexico published in the late 1950s and 1960s, including Kate Simon's *Mexico: People and Pleasures* (1962), highlighted Mexico's "foreignness," balanced with descriptions of Mexico's modernization.[40] In other travel books written during the 1950s, such as *The Standard Guide to Mexico and the Caribbean,* the authors Lawrence and Sylvia Martin uncritically focus on the changes to Mexican fishing villages turned beach resorts, ignoring the impact of the tourist industry on local residents.[41] However, in "My House Is Your House," Motley details the negative impact of the tourist boom on Acapulco during the 1950s and early 1960s. Although he describes its beaches as "undeniably beautiful," he views Acapulco "on the *gringo* circuit" as "actually nothing but a boulevard with the sea attached to it; a Coney Island with *sombreros*" (341). Motley writes that while some in Acapulco benefited from the surge in U.S. tourists to their town, notably those involved in the deep sea fishing business, others were corrupted by the presence of tourists, including young men who learn early how to "pimp off the *gringas*" (347).[42]

Motley attempted to publish this manuscript at a time when the U.S. State Department was encouraging travel writers to learn about the countries they were writing about as well as to present "a desire to share common interests" and "to understand significant differences."[43] Christina Klein argues that travel writers of the 1950s, such as James Michener, constructed "a sentimental, racially tolerant subjectivity in his readers" at the same time that his "anti-racism constituted an integral component of the legitimating ideology of U.S. global expansion."[44] Similar to other white, liberal travel

writers of the 1950s, Michener's analyses of racism can be differentiated from more critical perspectives, as articulated by Motley.

Judging by the dissimilarity between Motley's critical descriptions of U.S. racism in "My House Is Your House" and his earlier works, it can be assumed that Motley's first "official" readers, his agent and editor, were not expecting to read a manuscript that so vehemently indicted U.S. racism and tourism. From examining the correspondence between Motley and Loomis, it appears to have been Motley's criticism of U.S. racism, as well as his unflattering comparison of Americans to Mexicans, that influenced Random House not to publish the manuscript. After the manuscript was rejected by Random House, Motley's other agent, Elizabeth McKee, sent it to additional publishers but was unable to sell it.[45] McKee also had difficulty placing excerpts of the manuscript in magazines, although eventually *Rogue* accepted four chapters that were less "controversial."[46]

DE-EXOTICIZING THE TOURIST IMAGINARY

In 1957, while writing "My House Is Your House," Motley simultaneously started a novel, "Tourist Town," in which he explored the effects of tourism on a small Mexican fishing village. Although Motley could not have anticipated Loomis's initial reaction to "My House Is Your House" or its eventual rejection by Random House, fiction clearly provided him an opportunity that nonfiction disallowed. This is one way to understand why it was that Motley eventually decided to transplant segments from chapters of "My House Is Your House," which focused on U.S. racism in Mexico, into the fictional "Tourist Town." Motley had integrated previously researched material on local history and contemporary social conditions into his literary work before he left the United States. (As mentioned earlier, in writing *Knock on Any Door*, Motley had drawn from research he conducted in a Chicago Italian American neighborhood while working on the Illinois Writers' Project.) However, in the case of "Tourist Town," segments from the "controversial" chapters of "My House Is Your House" and other sections of "Tourist Town" were later excised by Peter Israel, his editor at G. P. Putnam's Sons, in the novel's posthumous publication as *Let Noon Be Fair* in 1966.[47]

While the subject matter of Motley's work changed significantly in Mexico, the formal aspects of his work drew in part from some of his U.S. writings. Scholars have described Motley's first novel, *Knock on Any*

Door, as naturalist, yet *We Fished All Night,* the last book that he wrote in the United States, was more aesthetically diverse and included a multi-protagonist format.[48] Similar to some of the writers whom he befriended in Chicago, Motley wrote novels in Mexico that were, as Stacy Morgan argues, a hybrid product of "documentary impulses and modern literary influences."[49] Motley's fictional work in Mexico, specifically "Tourist Town," developed along the lines of other Cultural Front writers in the United States, whose writing exhibited a "dialectic between fictional invention, autobiographical reflection, and urban fieldwork," as Michael Denning describes.[50] However, unlike in his U.S. writings, in which he utilizes a naturalistic aesthetic, in "Tourist Town," Motley does not emphasize the picturesque.

Similar to his writing in "My House Is Your House," in "Tourist Town," Motley uses a variety of writing styles and techniques, including documentary and modernist techniques in narrative point of view. His experimental techniques include multiple voices and shifting angles of vision and perspective, and the manuscript is organized into short chapters in a fragmentary structure. In "Tourist Town," Motley includes a range of characters whose perspectives are presented within the narrative, including that of Americans and Mexicans. While Motley's original manuscript included these differing views, some of the narrative written from the point of view of African American and Mexican characters was excised by his editor for the publication of *Let Noon Be Fair.* Of the sections that were removed, there was one in which an African American character referred to racism against African Americans by white Americans in Mexico. Other sections either included the voices of Mexicans displaced from the "tourist town" or related the growth of the tourist industry to the rise of poverty in the town. Some other aspects of the manuscript, such as its organization into short chapters, were modified by editors after Motley's death. Motley's original "Tourist Town" manuscript had 186 chapters arranged into eight parts, while the published novel *Let Noon Be Fair* contains 35 chapters assembled into three major parts.[51] Later in the chapter, I analyze the impact of these editorial decisions on the published novel.

"Tourist Town" traces events in the fictional village of Las Casas during a period of thirty years, from a Mexican village to a resort town overrun with tourists from the United States. The incidents and characterizations in the manuscript were based primarily on Motley's experiences in and knowledge of Puerto Vallarta, Cuernavaca, and Acapulco during the 1950s and

1960s.[52] The book contains three sections, which represent three distinct periods in the development of Las Casas. The first part is based on Motley's knowledge of Puerto Vallarta, where he lived for almost a year in the early 1950s before its tourism boom. The second part is drawn largely from Motley's years in Cuernavaca during the 1950s. In fact, some of the material about the tourists came directly from the opening chapters of "My House Is Your House." The third part of the manuscript is based on Acapulco, where Motley visited during its boom years in the early to mid-1960s while finishing the novel.[53] It was in fact Motley's familiarity with these areas that enabled him to write a novel that was critical not only of the role of U.S. tourists but also that of the Mexican elite, including the upper classes and the politically connected, in the development of Pacific coastal resort towns in Mexico.

Motley's experiences in Puerto Vallarta before it was developed, and in Acapulco after its tourism boom, occurred during a shift in Mexico's tourist promotion that emphasized Mexico's beaches rather than its museums. During the 1920s and 1930s, the Mexican government used indigenous and folkloric culture as a means to project a sense of Mexico as a nation to potential tourists in the United States and elsewhere. In order to do so, the state invested money, according to Alex Saragoza, in "archeological excavations, museums, anthropological research, rehabilitation of historical buildings and neighborhoods, arts performance and production, and programs for the maintenance of folklore and popular cultural expression."[54] However, after World War II, the Mexican government started to invest in building roads and highways from Mexico City to the coastal regions around Acapulco and Puerto Vallarta. This redirected Mexican tourist promotion from Mexico City and its museums to the Pacific Coast and its beaches.

The focus of Mexican tourist promotion on Pacific Coast beach resorts not only was influenced by but also benefited Mexican politicians who had invested quite directly in the transformation of Mexican fishing villages like Acapulco into glamorous resort towns. However, much of the development of Acapulco was done illegally. As Stephen Niblo describes, "[O]ne common pattern was for politically powerful people to initiate legal proceedings taking the land of local villages *(ejidos)* for their own property." For example, Niblo states that the *ejido* of Icacos "lost its land to a golf course, a housing subdivision and a company." Not only that, but the Mexican government disobeyed its own laws regarding foreign ownership of coastal property by

allowing J. Paul Getty to acquire the land belonging to the Ejido del Marquez at Puerto Marquez in Acapulco.[55] Getty built two major hotels on this land, the Pierre Marqués and El Presidente, the former of which was subsidized by the Mexican government.[56] Andrew Sackett notes that in order to stay in the hotel during the late 1950s, guests "paid up to $46, fifteen to twenty-five times what Mexican hotel workers earned in a day."[57]

One of the key Mexican politicians involved in transforming Acapulco was President Miguel Alemán, who allocated federal monies to develop the infrastructure of the town. However, the federal organization that was given the funding to create the infrastructure for residential neighborhoods, including municipal services and schools, the Junta Federal de Mejoras Materiales de Acapulco (Acapulco Federal Committee on Material Improvements), spent those funds for "expropriating lands from *ejidos* (communal farms), building scenic highways, improving beaches, planting ornamental shrubs, and paving parking lots for tourists," as Andrew Sackett has argued.[58] Sackett also mentions that only a very small amount of government funding went toward municipal services for those who lived in the residential areas. Meanwhile, at the Pierre Marqués, a hotel subsidized by the Mexican government, "guests weren't subjected to the negative aspects of living in the countryside of a poor tropical country" because "the hotel had its own electricity and water purification plants."[59]

The Mexican government subsidized not only the development of tourism in Acapulco but also transportation networks linking Mexico City to the coastal town. One of the most significant projects of the Alemán administration was the building of a highway between Mexico City and Acapulco. While it had taken eight hours for travelers to journey from Mexico City to Acapulco in 1940, by 1950 it took only six hours.[60] The construction of this highway significantly increased the number of travelers to Acapulco.[61] In tourism promotion material published in the mid-1950s, Acapulco was proclaimed "the ultimate resort destination."[62] Acapulco's year-round population doubled during this period, after the highway from Mexico City was built. By the mid-1950s, there were "eight first-class hotels in addition to an uncounted number of tourist courts, inns, and pensions favored by less affluent visitors, both Mexican and foreign," according to tourism scholars Mary and Sidney Nolan. By 1965, Acapulco had close to 50,000 year-round residents and upwards of 237 hotels.[63]

In "Tourist Town," Motley represents the changes to Las Casas within the context of this redirection of the Mexican tourist industry. The earlier form of tourism of the 1920s and 1930s, with its focus on museums and archeological sites, emphasized an appreciation of Mexican culture, whereas the post–World War II form of tourism, centered on beaches and resorts, positioned Mexico as an anonymous backdrop, with Mexicans portrayed as servants. While Mexican culture was exoticized in tourist literature of the 1920s and 1930s, Mexican tourism of the latter period presented Mexican locales not as spaces of difference but as familiar. Furthermore, in the tourist literature of the 1950s and 1960s, Mexico functioned as a backdrop to a form of tourism that accented pleasure (for white Americans) through being served (by Mexicans).[64] Vacationing in Acapulco and Puerto Vallarta could also be differentiated from beach resorts in the United States because the locations in Mexico had the added benefit of being less expensive. The lower cost was due in large part to the low wages paid Mexican service workers, as noted by Motley in "My House Is Your House."

Motley's examination of the transformations to Las Casas is narrated through a broad range of characters as well as through changes to the town itself. Motley had previously developed a multiprotagonist structure in *We Fished All Night*, featuring three major characters, but "Tourist Town" included more than twenty-five characters. Of the foreigners, there are permanent residents, including U.S. artists and writers, political refugees from Spain and Germany, and seasonal visitors, including tourists. There are also foreign business investors, some of whom are permanent residents, while others either infrequently travel to Las Casas or conduct their affairs in absentia. The Mexican characters include members of the clergy, prostitutes, politicians, fishermen, businessmen, beggars, and shop owners. There are a range of social strata represented in the novel, from the very poor, primarily indigenous Mexicans, to the middle class and the very wealthy.

While Motley primarily holds the U.S. tourists responsible for the changes to Las Casas, he also indicts the town's middle- and upper-class Mexican residents, who both contribute to and benefit from tourism in their town. It is a local resident, Hector Beltran, the richest man in town and owner of its only bank and general store, who buys up all the land that the indigenous Mexicans live on in Las Casas so that he can develop it. (He made his money through buying crops from indigenous Mexicans, whom

he exploits by turning them into sharecroppers.) When he becomes aware that the "Americans are finding us," Beltran, a wealthy indigenous Mexican named Tizoc, and a general extend the boundaries of Las Casas, buying the land at a low price. In one scene, the general shows Beltran and Tizoc how they will accomplish such a plan:

> "[T]his is the direction in which the town will grow and once the road is in"—He indicated with the pistol that part of town in the opposite direction of the beach. "This," he said, pointing, "is the end of the town. Beyond this is *ejidal* land. Now—with your help . . . we can change the boundaries of the town—to here"—pointing with the pistol—"taking in this much territory, comprising about thirty families." . . . "Then it becomes town land, and it can be bought or sold. You see? We settle these peons on the hills, on land that isn't worth anything—or we buy from them for nothing. A few *centavos* a *metro*. Oh, it will all be done legally. This much land can support a country club, a three-hundred-room hotel, a golf course."[65]

In this passage, Motley appears to be basing his characters on politicians and other elites who appropriated *ejidos* in Acapulco, evicting Mexicans who lived and worked on this land.

Motley also creates Mexican characters who are exploited by U.S. tourists and tourism. Drawing from "My House Is Your House," Motley based some of his characters in "Tourist Town" on the lower-middle-class and working-class Mexicans whom he befriended in Cuernavaca. His observations of their lives influenced the characterizations he developed in the manuscript. Motley does not attribute all responsibility for poverty in Las Casas to the growth of the tourism industry, citing as well the role of the Catholic Church and the Mexican government. Furthermore, in an extension of his portrayal of American racism in "My House Is Your House," Motley acknowledges the presence of Mexican racism in "Tourist Town." While he describes little if any prejudice expressed toward African Americans by Mexicans, Motley represents the bias in Mexico against indigenous Mexicans, who were positioned on the lowest rungs of Mexican society.[66] He narrates the "color line" in Mexico through his characterizations of the Espinozas (Spanish), Beltran and Mario (Mexican), and Tizoc (indigenous Mexican).[67]

Motley's American characters range from sympathetic expatriates to "Ugly Americans." The first American to inhabit Las Casas is a writer, Tom Van Pelt, an author from Chicago, who serves as a stand-in for the author. Van Pelt is eventually joined by other Americans, mostly tourists. In the

opening chapter, Motley scathingly describes one of the first female ar-
rivals: "Near the edge of the water a woman stood before a slim-legged
easel with a palette in one hand and a brush in the other. She wore a broad
brimmed straw hat with farmyard animals circling it. It had come from
Acapulco. . . . On her feet were sandals from Cuernavaca out of which, like
teeth bared, highly red-polished toenails protruded, and on her fingers were
large and heavy silver rings from Taxco" (9). In this misogynistic account,
Motley traces the journey of a typical American tourist of the 1950s
through this woman's souvenirs, from purchases of Cuernavacan sandals to
silver rings from Taxco to a straw hat from Acapulco. (There were no direct
flights to Acapulco in the 1950s. Most Mexican tours led Americans
through Cuernavaca and Taxco before they reached Acapulco.)[68] Motley
represents the "visitors" to Las Casas less critically than the tourists, in-
cluding teachers, artists, writers, and retired middle-class couples from the
United States.

Motley relates most of the changes to Las Casas over the course of the
novel to the influx of U.S. tourists and businesses. Within the first few
chapters, the contents of the liquor shelf in the *Candilejas* cantina become
filled with imported whiskeys and martini glasses, "elbowing *caña* and
tequila off the shelf" (78). By the middle of the book, the Little Rose Hotel,
owned by locals, becomes overshadowed by the influx of larger, more stan-
dardized versions, run by foreign investors. The Hotel Tropical, a large
hotel with absentee owners, opens with a huge cocktail party and becomes
the center of American life in Las Casas. At the same point, what was re-
ferred to as the "most modern airport in the republic" was built in Las
Casas (181). Plans were made for newsstands, with both English- and
Spanish-language newspapers for sale, as well as souvenir shops. A golf
course was built, as was a pier, drawing freighters and yachts and displacing
fishermen who instead looked for jobs as "janitors and night watchmen,
waiters and bellhops at the new hotels and restaurants" (250). By the end of
the novel, a bullring is constructed, and France and Italy open consulates.
Promoters advertise Las Casas far and wide; as Motley writes, a "radio pro-
gram was beamed to Mexico City. The town was advertised in newspapers
and magazines throughout the United States and in choice spots in Europe"
(369). During this time, some of the locals resist the commercialization of
their town. Mario, one of the main characters, refuses to sell his beachfront
land to investors who want to build a large hotel on the site.

Although Motley's novel focuses on the transformation of Las Casas from a small fishing village into a tourist hotspot spoiled by commercialization, there was significant disagreement between Motley and his principal editor at Putnam, Peter Israel, as to how to tell that story. Motley in fact encountered difficulty with Peter Israel from the start of their working relationship. The primary conflict between the two men was their disagreement over who were the main characters of the story. In his letters to Israel, Motley wrote that the main subject of the novel was the town of Las Casas itself. Motley's representation of Las Casas as the main protagonist is evident not only in the variety of minor and major characters but also by the fact that, as N. Jill Weyant argues, parts of the landscape become important features in the novel.[69] After Israel received the first 121 pages of the manuscript, he wrote to Motley that while he saw "the town in the local Mexican situation as the set or framework for the book," he envisioned "the debauchers as essential characters, the stuffing, meat of the book."[70] Clearly, Israel wanted the book to focus primarily on the Americans (the debauchers) rather than on the economic effects of U.S. tourism or the lives of the Mexican residents.

In part because in this novel Motley narrates the demise of a Mexican fishing village, the chapters that follow the initial sections that Israel read increasingly explore the influence of the Americans on Las Casas. While Motley did incorporate Israel's feedback, the editor was displeased with Motley's characterizations of the Americans. In a letter that Israel wrote to Motley in April 1963, he noted that the American characters were less developed than the Mexicans and appeared to be interchangeable.[71] In response, Motley asserted, "Don't you think the Americans should appear and then disappear (to go somewhere else) like the monied vagabonds they are?"[72] These more superficial representations served a purpose—they enabled Motley to portray the ephemeral presence of tourists in the town.[73] Motley had described this intent in a letter he wrote to Israel in August 1962: "I think of the debauchers, as season goes into new season, as a new set of characters acting out the same play over and over."[74] Motley contrasted these representations with the more developed characterizations of the permanent residents.

When Motley died of intestinal gangrene at age fifty-two in 1965, Israel had most of Motley's autograph manuscript of "Tourist Town" in his possession. It was only four chapters from completion.[75] While the published book ends where Motley's manuscript left off, Israel made extensive

revisions after Motley's death.[76] Although the story of "Tourist Town" remains to some extent, *Let Noon Be Fair*, the published book, differs in a number of important ways. For one, the structure of the story itself was revised. As mentioned earlier, Motley's original "Tourist Town" had 186 chapters arranged in eight parts, while *Let Noon Be Fair* has 35 chapters arranged into three major parts. Israel cut a number of chapters, including those that told the story of a fictionalized character, Melvin Morrison, an African American novelist and another Motley alias, and the four parts of the novel of which Morrison was the narrator. However, before his death, Motley had informed Israel that it was possible to cut these chapters because they only framed the larger story.[77]

Israel's revisions to the book were based on what he believed would make a popular novel. While Israel had written to Motley that he wanted a "rough, tough-minded angry novel, a no holds barred book," this criterion seems to have only applied to sex, not to racial or economic inequalities, which were important subjects in Motley's manuscript.[78] Douglas Wixson writes that there was significant publishing industry pressure during the 1950s and 1960s for writers to "abandon politicized social realist fiction" as "popular taste gravitated towards brutal realism without the social commentary that writers like Algren, Motley and Conroy nurtured."[79] When Putnam published *Let Noon Be Fair* in 1966, the book was marketed as a novel about the "sensation-seekers [who] flocked to Las Casas, hungry for thrills, in search of sun, sex, profits and escape," a very different angle from the influence of U.S. tourists on Las Casas that Motley had developed in his original manuscript.[80] Still, reviewers of *Let Noon Be Fair*, such as the novelist Nelson Algren, could see Motley's criticisms of U.S. middle-class tourists in the published novel, which Algren related to the antibusiness tradition of Chicago novelists Theodore Dreiser and Richard Wright.[81]

What Dell accented in its marketing of the paperback version of the novel was the interracial relationship between two of the main characters, the Mexican Mario and the American Cathy, who are represented on the cover of the book. Paula Rabinowitz notes that books written during the post–World War II era by white and African American authors that included interracial sex were "marketed as salacious with crossover potential" and "became appropriate for pulp paperbacks."[82] This emphasis is evident in the back cover copy of the paperback that describes the setting of the story as "a sunny paradise on the Mexican shore, where lust and greed were

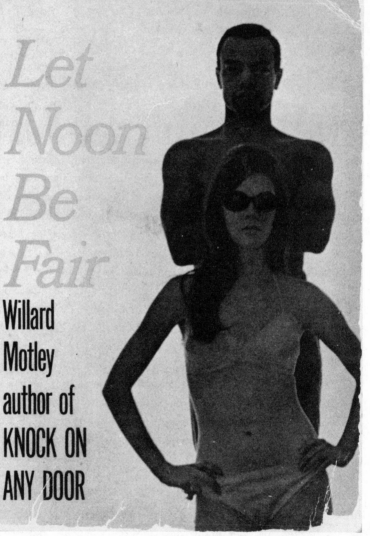

)ELL · 4740 · 95c

The sensational new novel about a sun-bleached
Mexican seaside. "...will shock tame readers."
—ST. LOUIS POST DISPATCH

*Let
Noon
Be
Fair*

Willard
Motley
author of
KNOCK ON
ANY DOOR

Front cover of Willard Motley's *Let Noon Be Fair* (Dell Press, 1966).

private affairs." The marketers of the book represent the demise of Las Casas in a sensationalistic fashion, as tied to its "discovery" by those who "come in search of pleasure . . . a frantic, uninhibited orgy of thrill-seeking, where corruption flourished, desire was flaunted, and private indecency threatened to become public policy."[83] What is intriguing is how Dell's marketing of the paperback version relates the destruction of Las Casas to the degeneracy of the (mostly white) tourists, through their sexual practices (including interracial sex) that are simultaneously selling points for the novel, rather than to the economic effects of the tourism industry, which Motley had detailed in his manuscript.

While the transformation of Las Casas remains in the published novel, Motley's more pointed criticisms about the economic inequalities between American tourists and the majority of Mexicans who live in Las Casas were excised by Israel. Motley's critiques were frequently constructed through pairing contrasting storylines within the same passage. However, when Israel cut down Motley's 186 chapters into 35, he made significant changes to the manuscript by combining references to a certain character or topic within one passage. Not only did this alter how Motley had ordered events but also, because sentences were positioned within a different context, this revised structure dismantled much of Motley's critique.[84] For example, in Motley's "Tourist Town" manuscript, he connects a passage about Julio, a Mexican resident, with one about Bob and Cathy Matthews, two American visitors, juxtaposing Julio's poverty with their carefree lifestyle. Motley writes, "The pump was working again, as the *presidente* had predicted, and Julio could go back to his near poverty. Cathy and Bob Matthews wandered the town, hand-in-hand, falling in love with the town."[85] In the published version, the reference to Julio has been cut and Cathy and Bob's "love" of Las Casas is combined with a passage in which Motley writes about their decision to rent a house and move there: "Cathy and Bob Matthews had fallen completely in love with Las Casas. They found a house. They moved in. It was an old comfortable house of two stories with a wide balcony and cool tile floors, renting for 12 dollars a month" (44). This edit omitted Motley's commentary about the difficulty working-class Mexicans face in obtaining basic services while living in resort towns as well as the stark contrast between the lives of poor Mexican residents and American visitors. Furthermore, by noting the cost of the rental, the editors uncritically emphasized how inexpensive it was for Americans to live in Mexico.

Motley represents poverty in Las Casas as increasing as the tourist in-
dustry grows. However, Israel also edited out sections that contextualized
the transformation of the town, especially those passages that contained an
economic critique of tourism. For example, Israel cut a passage in which
Motley contrasted the growth of the tourism industry with the rising
poverty of Las Casas:

> The season came to full swing. Every hotel was full. On the streets more
> women's slacks and native sandals appeared. A little village of stands, all
> painted baby blue, were erected on Calle Jupiter leading off from the town
> square. Here in these stall-like stands cheap silver bracelets, rings and ear-
> rings were sold.
> Another beggar had appeared on the streets.[86]

Clearly, Israel did not refer back to the letters Motley had written before his
death, in which he mentioned specifically that he wanted "almost constantly
to show poverty living side-by-side with great wealth and waste."[87]

While the presence of beggars is noted in *Let Noon Be Fair*, Motley's
analysis of the relation between tourism and poverty was for the most part
excised by Israel. In "Tourist Town," Motley narrates how the town's elite,
in creating Las Casas as a tourist resort, not only forced residents off their
lands but also pushed the increasing number of beggars off the streets. By
the midpoint of "Tourist Town," beggars not only exist in large numbers in
Las Casas but are forcibly removed from businesses catering to the tourism
trade. For example, a passage spoken by a blind beggar after he is kicked out
of a restaurant was removed by Israel. In this passage, the beggar expressed
"the attitudes of the natives towards the *gringos*":

> They had come as friends.
> We opened our arms and took them in. . . .
> They tried to buy us with their money.
> Our women.
> Our respect.
> *Pinche gringos!*
> Fucking *gringos!*[88]

Here Motley represents the perspective of the displaced residents of Las
Casas, who had originally welcomed the American tourists but over time
became aware of the ways in which their presence changed the dynamics of
the town. However, this segment, articulated from the point of view of a
beggar, was not acceptable to the editor because it did not represent the

perspective of the "debauchers," whom he viewed as the main subjects of the novel.

In his drafts of "Tourist Town," Motley uses prostitution as a metaphor for the Americans' treatment of the people of Las Casas as well as of the town itself. Similarly, the locals' protestation of prostitution in their town functions as an allegory for their resistance to tourism and imperialism more generally. As Las Casas becomes more developed and economic inequalities grow, a group of Mexicans form a protest movement against the U.S. tourists, specifically assailing their use of Mexican prostitutes. This movement is fronted primarily by the sons of middle-class Mexicans in Las Casas. At Maria's, a whorehouse owned by two foreigners, Zimmer and Crowe, these young men march in a picket line carrying placards that read: "Las Casas doesn't need prostitution. Las Casas needs bread," "Go home Yankees. Screw your own women," "Las Casas has become a whorehouse."[89] However, Israel removed these sections presumably because they portrayed the U.S. tourists in a critical manner.

In addition to the passages that examine economic inequalities perpetuated by tourism, Israel also cut sections in which Motley referenced the racism of white Americans against African Americans and Mexicans. Motley's decision to include African American characters in the manuscript enabled him to write about his own experiences in dealing with racist Americans in Mexico. Comparing Motley's manuscript with the published novel, it is evident that Israel removed significant passages of the novel in which Motley described U.S. racism. Not only did Israel exclude the chapters on the African American novelist Melvin Morrison, the original narrator of the story, he also cut parts of the novel that featured other African American characters. One of his largest edits included an eight-chapter segment on Charlie Jackson, who remained the only African American character in the published novel. As a result, Jackson's character was significantly reduced by Israel's editorial decisions.

In part, Jackson serves as another stand-in for Motley: his character has many of the same experiences that Motley described in "My House Is Your House." For example, Jackson's exchanges with some racist Texans were based on Motley's encounters in Cuernavaca. However, the appearance of Willard Motley as a character in the "Tourist Town" manuscript functions as a way to differentiate the treatment of an average African American from that of a celebrity.[90] While Jackson is not asked to a party given by white

Americans in Mexico, "Motley" is treated differently. After a white woman recognizes him, Motley writes the following about himself in the third person: "Motley had arrived. He was a writer. Somehow his color wasn't so noticeable."[91] Here Motley suggests that his status as a best-selling author may have spared him other forms of racist treatment.

However, by including the character of Charlie Jackson in the novel, Motley was able to critique how white Americans imported their racist beliefs towards African Americans to Mexico, which affected how they viewed Mexicans as well. In the manuscript, it is Jackson who makes the other (white) Americans aware of their racist treatment of Mexicans. In the following passage, which Israel edited out of the novel, Jackson reverses the usual missionary model of Anglo-Saxons traveling to far-off places to "civilize" the nonwhite masses: "On the veranda of HOTEL TROPICAL Charlie Jackson says to the white people, laughing, 'I'm here to humanize you. You used to send missionaries to Africa to save the blacks, now I'm here to help you. These Mexicans are people too—they're not just here to wash your clothes.'"[92] It is telling that the only two people to laugh after the statement are Jackson and Tizoc, a person of indigenous heritage, who then asks Jackson to his table to join him in a game of dominoes. Here Motley draws these two characters together—one African American, the other indigenous Mexican—through a shared understanding of U.S. racist and imperialist attitudes.

Israel's editorial decisions had a significant impact on the published version of Motley's manuscript, *Let Noon Be Fair*. On the one hand, these edits dismantled and decontextualized the way that Motley narrated a critique of the effect of U.S. tourists in Mexico during the 1950s and 1960s and omitted the point of view of the town's poorest residents. On the other hand, these editorial changes have limited how scholars have interpreted Motley's writings in Mexico.

THE GIANT AT THEIR DOORSTEP

Motley's decision to make Las Casas the main protagonist of "Tourist Town" provided him a dynamic narrative trope with which to describe the social and economic effects of U.S. tourism in Mexico. Exploring the structural changes to Las Casas offered Motley a means to approach his interests in larger themes of U.S. imperialism and racism, which he had initially examined in "My House Is Your House." While a number of characters stand in for Motley, it is Tom Van Pelt, a white writer from Chicago and

observer of the action, who comes closest to denouncing the American population for the town's demise. In a statement in *Let Noon Be Fair* that bears close resemblance to a passage from "My House Is Your House," Van Pelt remarks:

> The Americans he thought, in their privileged world. The international set, looking for anything to ease the boredom. Our women wear sandals and Mexican jewelry that would weigh a burro down, and slacks. Did you ever see that typical fat-assed *gringa* up-and-down the *malecon,* at the beach, shopping at the supermarket in slacks and hair curlers? And men wearing two and three cameras like burros bringing twin sacks of rocks from the beach for construction? We speak bar Spanish. We know how to ask for a drink. We know how to ask for a woman: *Putas—Casa de putas—Zona Roja—Maria's?* And the silly boy's grin on the fat face below the bald head. . . . "I'll pay you. Just show me where. Savvy?" . . . We are the occupation army, he thought cynically, we make Las Casas tick. It is our goddamn town, the attitude says, and we're going to do as we goddamn please. The Mexicans are just working for us. We are the ex's and the want-to-be's. (292)

Unlike the excerpt from "My House Is Your House," this passage moves from third person to first person, whereby Van Pelt, and by extension Motley, implicates himself for the changes to the town.[93] Here Motley's critique of U.S. tourism is perhaps more permissible because the reciprocities of domestic and international racism are not directly targeted.

In "Tourist Town," Motley indicts himself, through the figure of Tom Van Pelt, demonstrating how "sympathetic" Americans are partially responsible for the commercialization of Las Casas and the effects of that commercialization on the town's poorest residents. Although Motley distinguishes between these sympathetic, permanent residents and the American tourists who traipse in and out of the narrative, he holds all of the Americans, as well as the upper-class Mexicans, accountable for the changes to Las Casas. Toward the end of "Tourist Town," Motley encapsulates some of the effects of the influx of Americans and the growth of the tourism industry on Las Casas, including the development of a poor neighborhood, a section that did not appear in *Let Noon Be Fair.* He writes:

> And now there was definitely a slum area in Las Casas. It started where the hills started to climb in dirt paths. It started along the riverfront and slipped darkly backward where, again the hills began their laborous [sic] climb as if to get away to Mexico City. Over these mountains. Out of here. Somewhere where I won't be used. It started, too, beyond and around, and in front of old town. It started where the beach was of no value because the waves were

dangerous. It started where the soil was eroded. Where there was land with-
out irrigation; land the rich Mexicans and *gringos* didn't want. Land on
stones. Land of cactus. It started in the hearts of men and their families who
saw no future and knew a short past ago, air and sea and land that gave hope,
gave home. It started when they were "discovered."

It started when they were taken over by those from the North, by those
with money. It started when these hands to work had no work to do. It
started small and became big.

It started with Cathy Matthews—god bless her! It started with Tom
Van Pelt—god bless him! It started and continues—goddamn the others![94]

Thus, in addition to his characterizations of Americans exporting racism to
Mexico, Motley's critique of the invasion by Americans of Mexican towns
like Las Casas in "Tourist Town," which displaced local residents, drew at-
tention to the economic effects of U.S. citizens residing in Mexico. This
analysis was not developed by the other American writers who visited Mex-
ico at the time, such as Beat writers William Burroughs and Jack Kerouac.

Unlike Motley and the other U.S. artists and writers who left the United
States during the early Cold War era because of racial discrimination and
political persecution, Beat writers chose to travel to Mexico in the early
1950s as a way of "dropping out" of U.S. consumer–driven society. (Accord-
ing to Drewey Wayne Gunn, Burroughs had gone to Mexico to escape con-
viction as an addict.)[95] Their purpose influenced their perspectives on Mex-
ican culture as well as their relationship to Mexicans. While scholar Eric
Zolov argues that the Beats' "unofficial" tourism provided a "counter-
narrative to the discourse of tourists generally" in the postwar era, he also
comments that they simultaneously "cast a touristic gaze not fundamentally
different from the 'straight' Americans they openly criticized."[96] Zolov sug-
gests that the Beats were "nothing short of imperialist," an argument that
Manuel Luis Martinez makes as well.[97] Aspects of this position are elabo-
rated more directly in their correspondence than in their fiction. In a letter
that Burroughs wrote to Kerouac from Mexico City in 1949, he remarked,
"Be mighty glad to see you down here. You won't make a mistake visiting
Mexico. A fine country with plenty of everything cheap. One of the few
places left where a man can really live like a Prince."[98] In a letter to Allen
Ginsberg from 1951, Burroughs wrote, "Old-style imperialism is done. It
doesn't pay...If you want to give yourself a chance to get rich and live in a
style that the United States has not seen since 1914, 'Go South of the Río

Grande, Young Man.' Almost any business is good down here, since markets are unlimited."[99] While Burroughs and others saw themselves as rejecting U.S. consumer culture, they were uncritical of their privileged position in Mexico. Clearly, a different social optic is at work in the worldview espoused so pointedly by Motley.

Although Motley's reasons for being in Mexico were quite distinct from those of the Beat writers, they shared the experience of being citizens of a "first-world" nation residing in a "third-world" country. Zolov argues that in the relations of U.S. travelers to Mexico in the post–World War II era, "There was no escaping this basic fact of unequal power relations. The flow of persons across the border suggested as much; Mexican *braceros* and illegal immigrants searching for subminimum-wage jobs that, in turn, lowered the cost of goods for middle-class Americans. This further directly subsidized rising levels of consumption in the United States, thus allowing for leisure travel by mainstream tourists and counterculturalists alike back in Mexico."[100] However, while these inequities were ignored by other U.S. writers of the immediate post–World War II era, Motley sought to call attention to these unequal relations of power and, by extension, to the imperialistic relationship of the United States to Mexico, a theme that he narrates in his final novel.

It was Motley's descriptions of U.S. racism and imperialism as contrasted with Mexico's openness toward African Americans that concerned his agent and some book editors. Similar to the work of Richard Wright and other African Americans who lived outside the United States during the early Cold War era, Motley's work became more internationally focused during the 1950s. As Tyler Stovall writes about the work of Richard Wright, "To place America's racial dilemmas in an international political context at the height of the Cold War constituted for many an unforgettable sin."[101] Why would these perspectives be considered so controversial during the early Cold War era? One could argue that it was due to a critical international perspective that connects U.S. racism and imperialism. Set within the context of the struggles over the representation of the global dimensions of U.S. democracy, Motley's scathing indictment of the U.S. color line as ingrained at home and projected abroad was impermissible. Moreover, his narrative emphasis on the combined imposition of U.S. racial attitudes and economic expansion undermined efforts to depict the U.S. presence as an

altruistic, high-minded advance of freedom and democracy. Finally, and perhaps most impermissible of all, to suggest that the leader of the free world might have something to learn from Mexico inverted the hierarchy of leadership and moral authority.

During the early 1960s, while he was writing "Tourist Town," Motley became increasingly interested in the civil rights movement in the United States. Although he did not return to the United States to live, he followed the actions of the movement, noting in a letter to *Time* magazine that when he returned to visit Chicago, he "must go by way of Birmingham or wherever else there is trouble, for I feel that it is time for every man, woman and child of good will to stand up and be counted."[102] However, Motley did not envision the struggle of African Americans in the United States as separate from those who had been discriminated against elsewhere in the world; instead he saw a relationship between these experiences.

In 1963, Motley used his insights on these connections to suggest a campaign in Latin America to put pressure on the U.S. government to improve its treatment of African Americans. In June 1963, Motley wrote a letter to Roy Wilkins, then president of the National Association for the Advancement of Colored People (NAACP), describing his idea. In that letter, Motley proposed to "have huge signed protests from the citizens (or from labor, school groups) from all Latin American countries."[103] Motley explained that he came upon the idea while witnessing Mexicans' reactions to racial conflicts in the United States that they read about in local newspapers. He believed that Mexicans and Latin Americans would be interested in participating because "most Latin Americans don't think they're white and here in Mexico I find a sullen anger against what is happening there [the United States]."[104] (In an essay he wrote the same summer for the *Chicago Sun-Times*, Motley mentioned that the mistreatment of civil rights activists in the Southern Christian Leadership Committee during their desegregation campaign in Birmingham, Alabama, was noticed by people of color around the world, commenting that "Big Brother isn't watching. Asia, Africa, South America is watching. . . . The native Mexican and American Indian are watching with contempt.")[105] In his letter to Wilkins, he reasoned that since the United States was "trying to improve its image in Latin America . . . such a protest from south of the border might make the United States take a second look."[106] Motley's strategy acknowledged the meaning

that criticisms of U.S. racism from Latin America would generate in the international publicity contest between the United States and the Soviet Union for control of "third world" and nonaligned countries during the Cold War.[107]

Motley's articulation of the twin themes of U.S. racism and imperialism in Mexico was guided by a perspective that directly countered the U.S. government's domestic and foreign policies during the early Cold War era. It was at this time that the U.S. government was narrowing and nationalizing race and racial issues into those of civil rights. Kevin Gaines argues that it was "Cold War ideology and politics" that imposed "a narrow domestic civil rights agenda."[108] Like the Ghana expatriates whom Gaines describes, Motley did not limit his "vision of black politics within the domestic realm of Civil Rights": he saw racial inequities in a more global framework.[109] However, Motley's efforts to address racism in the international political realm were limited by this emphasis on civil rights within political organizations in the United States, including the NAACP. If Motley heard back from Wilkins no letter exists in his papers housed in archives at the University of Wisconsin and Northern Illinois University.[110] This strategic intervention, like many of his later writings, would not come to fruition.

Living outside the United States influenced Motley to think in international terms about racial and economic inequalities. Specifically, Motley began to see connections between the experiences of African Americans in the United States and those of working-class and indigenous Mexicans. Motley's criticism of racism in his writings on U.S. tourism and the tourist industry in Mexico during the 1950s and 1960s indicated a change in the direction of his work. While the Mexican context offered Motley different subjects to explore, living in Mexican towns that catered to the U.S. tourist trade also provided him a close-up view of race relations between white Americans, African Americans, and Mexicans. It was white Americans' racist treatment of both African Americans and Mexicans that led Motley to relate U.S. racism and imperialism. Much of Motley's analysis was excised by his editors, a testament to the challenge registered in this critique. However, Motley's original manuscripts demonstrate how African American writers' criticisms of the global dimensions of U.S. racism were being articulated during the early Cold War era, suggesting as well that these criticisms may be more prevalent than previously acknowledged.

6

Exile and After Exile

"American tourists are fools when armed with a camera," complained the U.S. Embassy in Mexico City to the U.S. Department of State on September 25, 1958. It seems that for all the much-touted mutual benefits of the tourist economy, certain U.S. vacationers had carelessly mistaken scenes of political insurgency for photo-album mementos. "American tourists were observed taking pictures in the vicinity of areas where the police were attempting to rout the dissident [labor and student] groups," reported the U.S. Embassy dispatch. The Embassy worried less about these tourists documenting police brutality than about what they interpreted as the tourists' naïve inability to distinguish between quaint travel snapshots and evidence of political turmoil. "If some American tourists become involved," fretted the dispatch's authors, "the mob's vengeance could easily turn on the United States."[1] Indeed, the burgeoning tourist industry held the possibility of too many Americans being in the wrong place at the wrong time. Certainly, the tumultuous labor conflicts of 1957–1958 appeared remarkably inopportune in concert with the rapid growth of tourism.

Tourists were not the only witnesses to the dubious actions of the Mexican state. In his posthumously published memoir, screenwriter John Bright recalled his experience being deported under the uncomprehending gaze of U.S. tourists returning home. At the airport, Bright stood shackled, still in his bedroom slippers, waiting in the rain for the plane to arrive that would forcibly extradite him. "Audience and counterpoint to the obscene scene were the boarding passengers, wearing improbable straw hats and carrying zerapes, on the way back to Peoria or Ypsilanti and such places after an exotic fortnight," writes Bright. "It must have been a jarring experience for them

after the shimmering charm of Acapulco," he surmises. Nevertheless, the tourists rapidly assimilated the scene to the sensationalized tropes to which they were accustomed. As Bright notes in his memoirs, "One woman asked her husband [about Bright] 'do you think that criminal is a murderer, Elmer?' Elmer gave a worldly shrug, 'Probably a dope smuggler. I know the type.'"[2] Indeed, why else would an American be deported from Mexico?

While the U.S. exiles had entered Mexico in three waves, there also followed three principal moments when they left Mexico. The first period occurred during the mid-1950s, when the exiles left as a consequence of the continuing pressure of U.S. governmental agencies on Gobernación, the Ministry of the Interior, which hindered them from securing residency in Mexico. Furthermore, some of these individuals had difficulty finding paid work in Mexico. The methods for confronting obstacles established for the exiles, even when successful, left many physically and emotionally, as well as financially, drained, and some decided to return to the United States within a year or two of relocating to Mexico. They had forsaken political activism in exchange for their residence in Mexico, and a few believed that they could only combat the forces that influenced their decision to leave the United States if they were living there. At the same time, the censure of McCarthy, as well as the Supreme Court decision *Brown v. Board of Education* in 1954, offered a glimmer of hope to those who had left the United States because of anti-Communist repression and/or racism.

Although numerous members of the U.S. exile communities left Mexico by the mid-1950s, others remained, obeying the rules of their habitation, including their complete avoidance of participation in political activity in Mexico. They had learned that engagement in Mexican politics was an impossible dream if they wanted to remain in the country. As Jean Rouverol notes, "an article in the Constitution gave the president the right to deport any foreigner whose presence was considered 'inexpedient.'"[3] This did not mean that they were ignored by agencies of the U.S. government, such as the FBI, which monitored these individuals through wiretapping, routine surveillance, and paid informants throughout the 1950s and beyond.[4] In 1957, a conflict between the U.S. and Mexican governments developed over the plight of two Americans in Mexico, Martha Dodd Stern and Alfred Stern, who were accused of conspiracy to commit espionage. The Mexican government did not deport the Sterns, but did in fact expedite the deportations of other U.S. exiles. The deportations that occurred in late 1957 were

primarily initiated by the FBI working in conjunction with the Dirección Federal de Seguridad (DFS) and Gobernación. Another round of deportations was instigated by the Mexican government during a period of strikes and demonstrations in 1958. In this case, the Mexican government blamed the strikes on the political interference of "outside" organizations and individuals, leading to the expulsion of a number of exiles from Mexico to the United States. These deportations constituted the second wave of U.S. exiles (in this case, forcibly) leaving the country.

By the late 1950s, it became more difficult for many of the U.S. exiles to remain in Mexico than it was for them to return to the United States. At this time, the U.S. government's domestic policies were less focused on anti-Communism, while its foreign policy remained staunchly anti-Communist. In 1960, the U.S. press targeted the U.S. exiles in conjunction with a number of high-profile cases of American citizens, including employees of the National Security Agency (NSA) William H. Martin and Bernon F. Mitchell, who had fled the United States through Mexico for the Soviet bloc. The publicity of these cases made the lives of the exiles in Mexico even more challenging, leading to a third wave of exiles leaving Mexico for the United States, Western Europe, and elsewhere. At this time, political changes were occurring in the United States, such as the *Kent v. Dulles* decision, which resulted in the restoration of their passports in 1958. Furthermore, those who had worked in Hollywood were lured to return by the official breaking of the blacklist in 1960. However, there were still a number of U.S. exiles who remained in Mexico into the 1960s and beyond. Most of these individuals had married Mexicans, started families in Mexico, or become Mexican citizens.

THE FIRST TO RETURN

Generally, the U.S. exiles who decided to return to the United States by the mid-1950s had been unemployed or underemployed in Mexico and had experienced difficulty acclimating to life there. These individuals had not enjoyed living outside the United States because of their inability to engage in either U.S. or Mexican politics. Others left Mexico because they perceived a political turning of the tides in the United States after Joseph McCarthy was censured and the Supreme Court decision on school desegregation was announced in 1954. Of those who left, Audre Lorde, Ring Lardner Jr., and Ian and Alice Hunter resided in Mexico for a brief period, while John Wilson, Dalton Trumbo, and Gordon Kahn lived there for between three and

five years. Most of these individuals encountered major impasses securing employment and acquiring and maintaining residency status in Mexico. A few members of the exile communities left Mexico but did not return to the United States. For example, after spending three years underemployed in Mexico, literary agent Max Lieber decided to return to his native Poland to work in the publishing industry. He was knowledgeable about both American and British literature, and after meeting with members of the Polish consulate in Mexico City, he and his family relocated to Poland in 1955.[5]

Some of the U.S. exiles left Mexico by the mid-1950s after they experienced difficulty renewing their residency permits due to the pressure of U.S. government agencies on the Mexican government. Gordon Kahn, whom the Mexican press had identified as a "Cuernavaca Red," discovered on May 10, 1954, that his papers for Mexican citizenship had been delayed, an action he attributed to his lawyer who, Kahn believed, was purposely working against him.[6] Without these papers, Kahn could not legally earn any money for expenses and legal fees. The Mexican Department of State informed Kahn that he would have to reapply for Mexican citizenship, which he could not afford. Kahn got into a car accident on the way home from visiting his new lawyer and took it as a sign that it was time to leave Mexico.[7]

Others who returned to the United States in the mid-1950s included artist John Wilson. Wilson had become part of a community of artists in Mexico, yet he believed that he needed to be in the United States in order to represent contemporary African American life in his art. Wilson recollected in an interview years later that "this whole dynamic of my wanting to make some statement about what was happening to black people in the United States was something that I felt I had to be there. In other words, I couldn't be a Richard Wright, who created his powerful novels, etc., and felt the horror of living in Jim Crow America and went to Paris where he certainly was totally accepted."[8] However, Wilson also noted that he left because, "in spite of the lack of any overt racism in Mexico," he hadn't been able to procure residency papers that allowed him to work legally in the country.[9]

Of all the groups of U.S. exiles, the blacklisted screenwriters were most interested in returning to the United States in order to secure employment, in their case writing screenplays on the "black market." Screenwriters, including Dalton Trumbo, had found work in the United States, and Trumbo's distance from this source limited his income. Although the letters he wrote

early on during his stay in Mexico suggest that he had initially enjoyed liv-
ing there, by 1953, they clearly indicated otherwise.[10] The Trumbos left
Mexico in February 1954, before their residency permits expired at the end
of March.[11]

Some of the U.S. exiles returned to the United States in the mid-1950s
because of a sense that the political winds were shifting and to engage with
the political forces that had driven them from the United States. Audre
Lorde and her friends "seemed to go crazy with hope for another kind of
America" after the Supreme Court's *Brown v. Board of Education* decision.
Lorde had planned to stay in Mexico for an extended time, but, in her
words, the "court decision . . . felt like a private promise, some message of
vindication particular to me."[12] However, individuals like Jean Rouverol
perceived a contradiction between the successes of Civil Rights legislation
and the House Un-American Activities Committee's (HUAC) continued
hearings into the mid-1950s.[13]

Trumbo's decision to leave Mexico can also be attributed to a combina-
tion of his frustration with his forced abstention from political activity in
the United States and his lack of significant engagement in Mexican life,
culture, and politics. Similar to other U.S. exiles without Mexican citizen-
ship, Trumbo could not be involved in Mexican politics unless he wanted to
risk his residency status. In many ways, Trumbo's return to the United
States was an attempt to engage with the forces that had contributed to his
decision to live in Mexico in the first place. In a letter he wrote to Hugo
Butler after leaving Mexico, Trumbo asserted, "I know that intellectually
life is much more stimulating here than in Mexico, more stimulating for an
American than it can possibly be in any other country; because here is
where the decisions that effect everything are being fought out."[14] Trumbo
left Mexico after McCarthy had been censured, an action that seemed to
promise a change to the ways that U.S. government agencies were pursuing
those accused of association with the Communist Party or "Communist
front" organizations.

Although there was a waning of some government persecution against
those on the Left during the mid-1950s, anti-Communism remained the
ideological engine driving U.S. domestic and foreign policies. Even after
McCarthy had been censured, HUAC remained "infatuated with entertain-
ers and artists" into the mid-1950s, according to Richard Fried.[15] Kenneth
O'Reilly argues that the censure of McCarthy led to "a more pervasive

McCarthyism."[16] He elaborates further that "the condemnation of Senator McCarthy might have signaled a thaw in the domestic Cold War, but the anti-Communist politics favored by the Eisenhower administration, HUAC, and FBI officials remained unchallenged."[17] In 1955, when the HUAC hearings resumed, the committee subpoenaed liberal and left-wing individuals from a broad range of professions to testify. Prosecution against Communists continued; the U.S. exile communities in Mexico were joined by political exiles from Miami's "Little Smith" trials in the mid-1950s.[18]

While some of the exiles were returning home, cultural producers such as Howard Fast decided to leave the United States for Mexico. Fast found that life in Mexico provided a respite from the stresses he encountered in the United States during the 1950s. As he recollected in his memoirs, "It was absolutely marvelous to be in a place where we could live and function like normal human beings, where there was no one waiting across the street to follow us, where a day or a week went by without news of another political jailing, another life ruined, and some new editorial calling for the destruction of Howard Fast." In Mexico, Fast and his family "walked the streets as free people, and those who knew us did not have to pretend not to see us. . . . After ten years of being reviled as a common criminal, here I was sought out and honored and admired."[19] Life in Mexico offered a break from the repressive atmosphere of the United States, yet the Fasts did not remain there as long as they had planned. Although Fast and his wife Bette were treated differently in Mexico, it was not a place where they felt they could create cultural work. The Fasts were in fact "bored to distraction," deciding after many discussions with friends and acquaintances to return to the United States. Their choice to return was a difficult one to make because while they were in Mexico the Communist Control Act was passed in the United States. This Act deemed that those who fit any of its fourteen definitions could be put in prison for up to twenty years.[20]

Gordon Kahn's experience moving back to the United States illustrates some of the difficulties that the U.S. exiles faced when they returned in the mid-1950s. Kahn and his wife Barbara chose to move to New Hampshire, where her father lived, because they thought that HUAC would not locate them there. However, as indicated in Kahn's FBI file, J. Edgar Hoover knew that Kahn had returned to the United States and wrote to the U.S. Embassy in Mexico City asking for his address. While in New Hampshire, the FBI watched over Kahn's home and tapped his phone. In addition, an

acquaintance of the family contacted the Attorney General of New Hampshire, Louis Wyman, who was known to be staunchly anti-Communist. Wyman issued Kahn a subpoena from the New Hampshire Committee to Investigate Subversive Activities, which led to a significant amount of publicity in the local press. Kahn was fortunate in that as he appeared before the New Hampshire Committee, refusing to answer questions, the Supreme Court was reviewing a case on state committees.[21]

For Dalton Trumbo, who returned to Southern California, the harassment he suffered was initiated by negative press. When Trumbo returned to the United States, he continued his black market work. While he was successful in this regard, he and his family were shunned by former coworkers in the film industry as well as by his neighbors. When they returned to Southern California, the Trumbos bought a big house in Highland Park, a working-class neighborhood. Their children were teased at school about their father's political affiliations, and neighbors would taunt the family by throwing garbage and dead animals into their pool and yard. Neighbors also threatened Trumbo in their attempt to force him to move out of the neighborhood, and he was beaten up in front of his house. Trumbo received hate mail as well, in part stemming from the condemning stories written about him in the press.[22]

Even with all this harassment and job-related pressure, the Trumbos became part of a community of "progressives" in Southern California in the mid-1950s. Trumbo socialized primarily with blacklisted filmmakers but also with politically progressive artists and writers. He became good friends with artist Charles White, whom he met in the mid-1950s. White, who had returned to New York from Mexico in the late 1940s, had remarried and moved to California in the mid-1950s for health reasons. Trumbo sold White a lot on his property on which White built a house, and they became neighbors.[23] Trumbo was also active in a variety of political causes when he returned to the United States. While he was most focused on the destruction of the blacklist, he also gave speeches in support of organizations such as the Committee for the Protection of the Foreign-Born and wrote pamphlets, including *The Devil in the Book*, against the Smith Act.[24] Dorothy Healey, who was active in the Communist Party in Southern California, remarked in an interview that during the 1950s, Trumbo "was always available to help," adding, "There was nothing he wouldn't do in a public fight."[25]

The U.S. exiles who remained in Mexico continued to expand the boundaries of their communities in the wake of this exodus. Some of these exiles had already befriended other members of the larger communities of U.S., Central American, and European refugees, and Mexicans. For example, Albert and Margaret Maltz socialized with a Hungarian couple, writer John Penn and his wife, Elizabeth, and Ernesto Amann, an Austrian doctor who had fought with the 15th Battalion of the International Brigade in Spain.[26] George Pepper befriended the Mexican artist Miguel Covarrubias, who shared his interest in pre-Columbian artifacts. The Butlers had become friends with Hans Hoffman, a psychologist from Berkeley, as well as with George and Mary Oppen. Their group of friends had potluck dinner parties and spent Thanksgiving and Christmas together, gathered for Saturday morning baseball games, and shared assorted picnics and trips. In the mid-1950s, some of the U.S. exiles also socialized with new refugees from Central America, specifically from Guatemala.[27]

ANTI-COMMUNISMS

The United States and Mexico each had its own anti-Communist agenda during the early Cold War era, which were distinct, competing, and intertwined. The differences in these agendas had a direct impact on the lives of the U.S. exiles who remained in Mexico past the mid-1950s. While the Mexican government distanced itself from U.S. Cold War foreign policy in the case of Guatemala and later Cuba, some of its domestic policies during the 1950s were distinctly anti-Communist.

One of the most significant concerns of U.S. foreign policymakers during the early 1950s was "neutralism" in Latin America. Part of Secretary of State John Foster Dulles's foreign-policy strategy was to convince Latin American officials that communism was an "internationalist conspiracy, not an indigenous movement."[28] United States government agencies conveyed this strategy through cultural programs, such as those developed by the United States Information Agency (USIA). In March 1953, the Eisenhower administration created NSC 144/1, which contained the administration's response to "neutralism" within Mexico. According to Stephen Rabe, Eisenhower, within his first two months in office, "approved a preliminary statement on 'U.S. objectives and courses of action with respect to Latin

America,'" in which he agreed on "hemispheric solidarity" as essential to
U.S. relations with Latin America in order to "eliminate internal Commu-
nist subversion" from the hemisphere.[29]

Although the Alemán and Ruiz Cortines administrations supported the
United States in many of its Cold War policies, there were limits to their
cooperation. For example, the Ruiz Cortines administration resisted U.S.
efforts to pressure Mexico into taking a stand against Communist subver-
sion when it involved intervening in the affairs of another country. This was
best demonstrated by the position of the Mexican delegation at the 1954
Inter-American Conference in Caracas, Venezuela. At the conference,
Dulles attempted to gather support in the Americas against Guatemala and
its president, Jacobo Arbenz Guzmán, who had worked to democratize the
country as well as to enact legislation that limited the power of the United
Fruit Company, by drawing up the Caracas Declaration, which called for
common action against "international Communist subversion."[30] The Mexi-
can delegation abstained from signing the Caracas Declaration in part be-
cause Mexico had historically refrained from supporting the intervention
of one or more countries into the affairs of another.[31] At the conference,
Mexico's Foreign Minister Luis Padilla Nervo compared the experiences of
Guatemala to the Mexican Revolution, stating: "I remember the time when
Mexico stood alone and we were going through an economic and social re-
form, a revolution, and if at that moment you had called a meeting of the
American States to judge us, probably we would have been found guilty of
some subjection to foreign influences."[32] Padilla Nervo and representatives
from Argentina and Uruguay offered many amendments to weaken the res-
olution, although Dulles was able to successfully challenge almost all of
them, in part because of the support he received from dictators in Latin
America and the Caribbean.[33] Dulles was concerned about Mexico's posi-
tion, which he assumed was related to Communist infiltration into the
Mexican government. The U.S. government retaliated against Mexico's ab-
stention by, in the words of Jorge Castañeda, "using the Mexican right wing
to influence the government, particularly by falsely accusing Foreign minis-
ter Luis Padilla Nervo of Communist sympathies."[34]

Dulles disputed many of the amendments raised by Mexico, Argentina,
and Uruguay, yet the one amendment that was included in the Declaration
indicated that Latin American governments saw no reason to react imme-
diately to events in Guatemala. Faced with hemispheric intransigence on

this issue, as demonstrated in NSC 144/I, the Eisenhower administration opted for covert intervention.[35] U.S. foreign policymakers viewed covert intervention as the only way they could bring down the Arbenz government while maintaining an appearance of noninvolvement. The CIA plotted to overthrow Arbenz with the assistance of a former Guatemalan officer Colonel Carlos Castillo Armas.[36] On June 10, 1954, during the coup, artists in the Taller de Gráfica Popular wrote a letter to President Arbenz expressing their solidarity. Angel Bracho, who wrote the letter on behalf of the collective, stated, "The cause of Guatemala is the cause of all the states of Latin America, weak and exploited. In this hour of adversity, we are sure that the Guatemalans will know how to defend with heroism and intelligence the sovereignty and the freedom of their mother country."[37] The coup was successful, however, forcing many of Arbenz's followers to flee Guatemala to avoid arrest, torture, and/or death. Mexico, which had historically provided asylum to political refugees, allowed exiles from Guatemala to reside in Mexico.[38] Among others, Albert Maltz helped support some of the refugees who settled there.[39] A few refugees had left the United States in the early 1950s, including Gray Bemis, former International Workers Order organizer, and Luisa Moreno, a political activist and union organizer in CIO unions such as the United Cannery, Agricultural, Packing, and Allied Workers of America. Moreno, who was married to Bemis, had been deported by the U.S. Immigration and Naturalization Service (INS) to her native Guatemala in 1950 because of her political affiliations. While in Guatemala, Moreno became involved in various political activities and supported the Arbenz government. After the coup, she went into hiding, eventually making her way to Mexico with her husband.[40]

While Mexico maintained its historic position against intervening in the political affairs of other countries in the case of Guatemala, on the domestic front, the administrations of Ruiz Cortines and López Mateos were decidedly anti-Communist during the mid-1950s. Edward Best suggests that Mexico's diplomatic position "contributed to a revolutionary pretense by which it hoped to maintain its own legitimacy" in order to both "appease opponents and to distract attention from Mexico's internal and international realities."[41] Mexican presidents were also influenced by pressure from the U.S. government. Jurgen Buchenau argues that both Alemán's and Ruiz Cortines's anti-Communism "resulted in part from personal conviction, in part from ceaseless U.S. radio and press propaganda in Mexico, and in part

from the Presidents' desire to accommodate and exploit the shrill tones coming out of Washington."[42]

Although Ruiz Cortines took a stand against the United States in the case of the Caracas Declaration, his actions against American Communists in Mexico suggested an attempt at accommodation. For example, a request in 1955 by the Secretary of Foreign Affairs in Mexico City to the Mexican Embassy in Washington, D.C., for a list of those prominent in the Communist Party of the United States of America (CPUSA) could be taken as an attempt by the Mexican government to appease the United States after the Caracas Declaration. In February 1955, the Secretary of Foreign Affairs in Mexico requested this list "with the purpose of giving instructions so that if they [American Communists] asked to be admitted to Mexico their request would be elevated for consideration by the higher authorities."[43] In August 1955, the Mexican Embassy in Washington sent a list of the names of those in the National Committee of the CPUSA. This list, which had been forwarded by the U.S. State Department to the Embassy's Foreign Affairs Office, included the twelve CPUSA leaders, among them Eugene Dennis, Ben Davis, John Gates, Jack Stachel, Carl Winter, and Claude Lightfoot, who had been indicted during the Smith Act Trials of 1948 and had finished serving their prison terms. Fugitives such as Fred Fine, Gil Green, Henry Winston, and James Jackson were on another list, as were party leaders who had gone underground (Archie Brown) or had been deported (Irving Potash, John Williamson).[44] During the same year, U.S. governmental agencies circulated another list, this one of American Communists in Mexico. By the mid-1950s, the FBI identified these individuals as part of the "American Communist Group in Mexico" (or ACGM), which they defined as "a loosely knit organization of a prominently social nature of persons who are present and/or past members of the Communist Party in the United States and their friends and associates who share a common sympathy for Communism and the Soviet Union."[45] This list made its way to both U.S. and Mexican government agencies and had particularly dire effects on some of the U.S. exiles.

UNDESIRABLE FOREIGNERS

The Mexican government's campaign against "foreign agitators" in Mexico during the late 1950s was related to what Edward Best describes as Mexico's "internal and international realities." The "international realities" reference

the close relations between Mexico and the United States, which led to a rash of deportations in 1957 in the wake of Martha and Alfred Stern's surreptitious exit from Mexico to Czechoslovakia. The "internal realities" allude to the labor conditions in Mexico that contributed to a wave of strikes by electrical workers in 1956; primary-school teachers in 1957; and railway, gas, telephone, and telegraph workers in 1958 and 1959, which "challenged the established model of labor–state relations," according to Barry Carr.[46] However, this campaign was in opposition to Mexico's historic position of sheltering refugees from other nations because it forced out those who had only recently established residence in Mexico, including refugees from Europe, the United States, and Central America.

In 1957, a conflict developed between the U.S. and Mexican governments regarding the plight of the Sterns. Martha Dodd Stern was the daughter of William Dodd, Franklin Delano Roosevelt's ambassador to Germany in the 1930s. Alfred Stern was a millionaire philanthropist. Of the two, Martha had been most actively involved in left-wing politics in the United States. The Sterns moved to Mexico after HUAC issued Martha a subpoena in 1953. In 1957, the Sterns were summoned to appear before a federal grand jury in New York after Boris Morros, a double agent, told the FBI that the Sterns were part of a group who gave defense intelligence materials to the Soviet Union.[47] The Sterns were accused of conspiracy to commit espionage, the same charge for which the Rosenbergs had been convicted and executed.[48] The Sterns decided not to appear before the grand jury but were indicted in absentia, cited for contempt, and given a significant fine. Yet the U.S. Justice Department still wanted to question the Sterns. While U.S. governmental agencies had performed "unofficial extraditions" previously in the case of Morton Sobell, this case was handled differently. U.S. Ambassador to Mexico Francis White contacted a "friend" in the Mexican government, Finance Minister Antonio Carrillo Flores, about the situation. Flores referred him to the head of Gobernación, Angel Carvajal, who sent White to see Fernando Román Lugo, the administrative officer of Gobernación. (In 1957, an anti-Communist investigative unit of Gobernación, headed by Lugo, commenced operation.) White failed to strike a deal with these men, and so he decided to meet with President Ruiz Cortines to discuss the case. In his conversation with Ruiz Cortines, White reminded Ruiz Cortines of a statement he had made in a previous conversation: "That if we want American Communists shipped back to the United States he would be glad

to do so." Further, White noted that "on that basis, President Eisenhower had instructed me to ask President Ruiz Cortines to return these two people to the United States. I said that President Eisenhower did this on the basis of the security of the United States. . . . Ruiz Cortines promised to intervene immediately."[49] However, the Sterns left Mexico for Czechoslovakia with Paraguayan passports before the Mexican government was able to deport them or agencies of the U.S. government organized their "unofficial extradition" from Mexico.

The initial reticence of Mexican officials to take action in the Sterns' case led U.S. government officials to be increasingly concerned about Mexico's commitment to anti-Communism. In response, U.S. government agencies became more involved in publicizing the presence of "American Communists" in Mexico in a reinvigorated mass media campaign directed against these individuals. In July 1957, the U.S. Embassy circulated a list of "American Communists in Mexico" to members of the U.S. press, including writers from *Time* and the *New York Herald Tribune*.[50] In "U.S. Reds Have Haven in Mexico," published in the *New York Herald Tribune* on August 30, 1957, journalist Bert Quint describes almost all of the individuals who were included on the Embassy's list of American Communists in Mexico, including Alfred Stern and Martha Dodd Stern, Frederick Vanderbilt Field and Anita Boyer Field, Maurice Halperin, and Albert Maltz.[51] After the article was published, Edith Halperin, the wife of Maurice Halperin, a former Boston University professor of Latin American studies, was dismissed from her position as a teacher at the American School in Mexico City.[52]

Some of the more conservative Mexican newspapers also challenged Ruiz Cortines's decision not to use his executive powers to deport foreigners. In an August 1957 editorial on "Extranjeros Indeseables" (Undesirable Foreigners) that appeared in *Excélsior,* the editors advised the President to use Article 33 of the Constitution in which "the Executive Branch of the Union shall have the exclusive power to make them leave the national territory, immediately and without the need of a previous judgment [court case], of ALL foreigners whose presence is determined to be inconvenient." Here the editors tried to pressure the President to use Article 33 not only for foreigners whose residency papers were not in order but for "those whose presence is deemed undesirable, whether or not they have proof [immigration papers in order]."[53]

While U.S. government agencies had avoided an unofficial extradition in the case of the Sterns, afterwards, the FBI became more involved in arranging unofficial extraditions of American Communists while working in conjunction with Mexican governmental agencies, including Gobernación and the DFS.[54] The first of their attempts involved three Americans, Enos Wicher, Max Shlafrock, and Sam Novick. Both Shlafrock and Novick were deported from Mexico in December 1957. Wicher, who owned a chicken farm with Shlafrock, had worked as a researcher at Columbia University before moving to Mexico City.[55] Sam Novick had been the secretary of the Electronics Manufacturers Association, which was connected to the United Electrical, Radio and Machine Workers of America, and he had appeared before HUAC in 1949.[56] Shlafrock, a contractor and target of Miami's Little Smith trials lived in Mexico for two years until he was deported on a technicality, as he did not have either the *inmigrado* or *capitalista* visa status required of U.S. citizens who ran businesses in Mexico. After Shlafrock was deported, he sent the following "statement" to Albert Maltz, describing the events that transpired that day: "On Wednesday, December 18, 1957 at 9:15 a.m., two men stopped me on Calle Fresnos and insisted that I go with them to Gobernación. . . . Senor Romero took out my file. . . . He asked me if there was a political Communist party in the U.S. and I said I suppose there was; was I member of it—I refused to discuss it. He asked if I participated in Mexican politics and I answered, 'no.'"[57] This interrogation turned out to be a prelude to a more unexpected turn of events: "At about 10:00 p.m., we were told that we were being deported right away. . . . After that, everyone, including the inspectors, began gathering up their things for the trip—the inspectors were as unprepared for the trip as we were. . . ." Shlafrock drove with the Mexican immigration officials to Laredo, Texas, a town close to the U.S.–Mexican border. When they arrived, they found the American inspectors as unaware of their arrival as the Mexican inspectors had been of their departure. Eventually, the American inspectors "leaned" on Shlafrock for "information," and he admitted to, in his words, "having been deported from Mexico for having violated Mexican immigration laws by investing money I had no right to invest." A couple of days later, still being detained by DFS agents, he read an article in a Mexican newspaper that accused both him and Novick of being the most dangerous Communist spies in the world.[58]

However, Shlafrock and Novick were allowed back into Mexico due to the efforts of friends in Mexico City. The U.S. exiles, including Albert Maltz and Maurice Halperin, organized to prevent Shlafrock and Novick from being (permanently) deported by contacting lawyers in Texas, ex-president Lázaro Cárdenas, as well as a Mexico City attorney, who, according to Diana Anhalt, started the process for obtaining an *amparo,* a writ that could be used to prevent arrest.[59] When Shlafrock and Novick met with the judge, the lawyer told the DFS agents that their case should be handled by immigration officers in Nuevo Laredo, although Shlafrock and Novick were later allowed to return to Mexico City, where they had to "register" three times a day at a government office. Although their "sentence" had been handed down by a Mexican judge, they continued to be surveyed by U.S. government agents. In his statement, Shlafrock noted that in Mexico, "We were constantly being followed—if we walked, we were followed by walking 'tails,' if we rode, we were followed by a car. The only thing I couldn't understand was why we were being followed in Mexico by a car with Texas license plates."[60]

The detentions, deportations, and negative press directed toward American Communists—organized by U.S. governmental agencies in collaboration with Mexican governmental agencies—offered Ruiz Cortines potential scapegoats for a wave of strikes that began in 1956 and continued through the end of his term in 1958.[61] The problems that led to these strikes had surfaced before the administration of Ruiz Cortines, during the "counterreform" of the administrations of Manuel Avila Camacho (1940–1946) and Miguel Alemán (1946–1952). Barry Carr argues that this counterreform involved legal and institutional changes and an increase in foreign investment that "modified the pattern of social relations in production."[62]

The strikes were also related to the growth of independent unions that occurred during Ruiz Cortines's administration. Presidential administrations of the 1940s, including those of Avila Camacho and Alemán, had hampered the more radical leadership of Mexican unions. This process started with Avila Camacho, who replaced Vicente Lombardo Toledano, the left-wing leader of the Confederación de Trabajadores de México (Confederation of Mexican Workers, or CTM) with the conservative Fidel Velázquez.[63] John Sherman argues that "Alemán and Velázquez divided labor by imposing on its unions compliant new leaders in the process that became known

as *charrismo* (drawn from *charro* or cowboy, the term evolved from the cowboy-like, cavalier attitude of these new chieftains towards the rank-and-file)."[64] Velázquez did not advocate pay increases for union members, nor did he suggest that his members strike as a means to force negotiation. Like Avila Camacho, Alemán also tried to control the labor movement, with help from American labor officials. Norman Caulfield points out that the "U.S. labor movement's participation in consolidating the Mexican charro system" was central to the Mexican government's repression toward independent unions during some of the 1950s.[65]

However, some independent unions did develop in the mid-1950s during the administration of Ruiz Cortines. Independent factions grew within a number of unions, including the Teachers' Revolutionary Movement, which formed out of the National Education Workers' Union. In 1958, the Teachers' Revolutionary Movement called for a 40 percent wage increase and retirement benefits, demands that they made during a demonstration in April that turned violent because of police repression.[66] As a result, the teachers went on strike, receiving support from electricians and railroad workers. On September 6, 1958, the Movement coordinated another demonstration to force the Mexican government to recognize the union's elected officials.[67] During this demonstration, the police arrested over two hundred participants. These arrests reflected the concern of the Mexican and the U.S. governments over the formation of independent unions in Mexico.[68] U.S. officials in Mexico were wary of the influence of the Communist Party in trade unions and viewed the leaders of the teachers' union and the railroad workers' union as Communist agitators.[69]

In an effort to distract from the conditions that led to the strikes and demonstrations in 1958, Mexican authorities held Mexican Communists and foreign refugees from the United States, Spain, Germany, Cuba, and Guatemala responsible for instigating these "disturbances" and ordered their arrest and deportation. The wave of arrests and deportations started after the demonstration organized by the Teacher's Revolutionary Movement. In arresting and deporting the U.S. exiles, Mexican officials accused them of violating residency laws by masterminding these strikes. Jean Rouverol notes in her memoirs that she and other U.S. exiles "had leaned over backward to avoid involvement in Mexican politics, and few of us even had enough mastery of Spanish to hold a philosophical discussion with our

Mexican peers on any subject—let alone do any serious rabble-rousing among them."[70] The objective of the raids, arrests, and the expulsion of these Americans, in the words of *New York Times* reporter Paul Kennedy, was to "seal off" what President Ruiz Cortines had identified as a "fountainhead of agitation."[71] Agents from Gobernación had visited the homes of a number of U.S. exiles, including the Maltzes and the Hoffmans, who were out of town at the time. Other U.S. exiles who had been brought in for questioning left Mexico City as soon as they were released to avoid more questioning and possible deportation.[72] Some who were informed about this investigation by other members of the exile community left Mexico City as well.[73]

Those whose last names were at the beginning of the alphabet were arrested first, including Elizabeth Catlett and John Bright. Catlett was jailed and then released days later due to her husband's Mexican citizenship, while Bright was deported. Late in the evening on a Saturday night in early September 1958, Catlett was at home with her children when she heard a knock at the door. She opened the door to find a man who "smelled of *tequila.*" At first, she thought he was a tourist, but he informed her that he was from Gobernación and had come to see her residency papers. She told him that she would get her papers and tried to close the door, which was letting in a draft. He then stuck his foot in the door to prevent her from closing it. They argued for a while, and then he told her that she was coming with him. He grabbed her arm and whirled her around, putting his arm around her neck, jerking her out of the house. Along with two other Gobernación agents, he lifted her up off the ground and carried her down the stairs to a car. When Catlett got inside the car, she found herself surrounded by four men. While they drove around, the men told her that the government was going to deport her. They eventually brought her to a house not far from her own home. Once they arrived, Catlett saw that they checked her name off a list that had come from the U.S. Embassy. She was left at the house while the men went after others on the list. There she was held with other foreigners who had been arrested, including two Cuban women and one German woman.[74] Catlett's family tried to get her out of jail on Saturday, when she was arrested, but she ended up staying there for a few days. Eventually, the Mexican Secretary of Education, who was an admirer of her artwork and collected her prints, obtained her release.[75] The day after she returned from jail, she called a number of Americans whose names she had seen on

the list.[76] Most of them had left the area, having been alerted to the arrests by other U.S. exiles or by Mexican friends with government contacts.

Gobernación agents came to John Bright's house the same night as Catlett's arrest, also asking to see his residency papers. Although Bright had *inmigrado* status at this time, these agents took him to a detention jail for foreigners whom the government planned to deport. While he was in jail, he witnessed what he later referred to as "a mass roundup of leftists." According to Bright, "most were Latinos, Spaniards, Cubans and South Americans, judging by their accents as they shouted defiance and radical slogans."[77] He also saw former Hollywood scenario director and producer Alan Lane Lewis, who had been taken from his home while babysitting his kids.[78] While in jail, Bright learned about the arbitrariness of the roundup of leftists, indicating that those brought in might or might not have any involvement in political activity in Mexico.

While a few members of the U.S. exile community were arrested during this raid on "foreign agitators," most were from Spain or Central America. Bright notes in his memoirs that of all the foreigners captured during this raid, the Spaniards presented the biggest problem to the Mexican government. As he put it, "Cardenismo still prevailed in foreign policy; Franco's Spain was not recognized by Mexico, which had opened its arms to the refugee antifascists. So deportation was legally difficult and politically importune. The new administration could do nothing with the Spanish leftists but jail them." If deported, Bright could be subpoenaed by HUAC and possibly jailed (as was the case for the Hollywood Ten), but he knew that for these other prisoners, "in some instances deportation was tantamount to a death sentence—those shipped back to Batista, Cuba, Guatemala and other dictatorships, condemnations numbering in the hundreds."[79]

Although Bright's friends and family fought for his release, they were no match for the high-ranking Mexican politicians pushing for his deportation. On the sixth day of Bright's imprisonment, a friend visited with a note from the former ambassador to Mexico, William O'Dwyer, who was Bright's lawyer. The note indicated that O'Dwyer was filing an *amparo*, which would release him from jail the next day. Someone in Gobernación had most likely been tipped off about the *amparo* because at midnight agents released Bright from jail, drove him to the airport, and put him on a plane headed for the United States. While at the airport, he had to sign a

document indicating that his was a "voluntary deportation," an act that he performed at gunpoint. Bright noted that his three-hour flight to San Antonio was pleasant, as he was joined (ironically) by a few members of the Mexico City symphony orchestra "headed to Washington to do a 'good neighbor' performance for Eisenhower." Bright had met their manager previously through Diego Rivera, and Bright told this man what had happened to him. The manager of the orchestra shared Bright's story with other orchestra members, most of whom were refugees from European fascism and sympathetic to Bright's situation, giving him money and drinks and playing chamber music for him during the flight.[80]

Bright's reception in the United States again reveals the involvement of Mexican rather than U.S. governmental agencies in his deportation. His main concern about landing in San Antonio, Texas, was how he would get through U.S. immigration without citizenship papers. However, the immigration official at the airport did not call the FBI when Bright arrived without papers but instead tested his knowledge of American popular culture as evidence of his citizenship. When Bright saw this man in a coffee shop a couple of hours later, he was looking at a front-page headline in a local paper that accused Bright of being a "Hollywood Red" who had been deported from Mexico. Nevertheless, the immigration official did not inform the FBI or police, enabling Bright time to get a friend in Los Angeles to wire money for a plane ticket. The only follow-up to his deportation was an interview with a *Time* magazine reporter and a brief visit from the FBI while he was in Los Angeles. Meanwhile, an acquaintance of Bright's who lived in Mexico, writer Anita Brenner, located his record at Gobernación in order to find out what the charges were against him. She discovered that someone had accused Bright of funneling money from the Czechoslovakian Embassy to the Mexican Communist Party.[81]

Individuals in Mexico who responded to the arrests and deportations were primarily those active in the Mexican Communist Party, including David Alfaro Siqueiros. In an article published in *Excélsior* on September 12, 1958, the (anonymous) author mentions that members of the Mexican Communist Party were protesting against the government's violation of the individual rights of foreign residents who had been apprehended, incarcerated, and deported surreptitiously out of Mexico. The article notes that the protesters emphasized the contradiction between the Mexican government's expulsion of political refugees and Mexico's "tradition" of sheltering them.[82]

While the previous deportations (Shlafrock and Novick) had been initiated by agencies of the U.S. government, this round appeared to be instigated by agencies of the Mexican government. (Although clearly the Mexican government was responding to pressure from the U.S. government, had received a list of alleged American Communists from the U.S. Embassy in Mexico City, and utilized the FBI-trained DFS.) There is no evidence in declassified U.S. government documents on the deportations that would indicate the involvement of the U.S. Embassy in Mexico City or the State Department. A letter from Ambassador Hill in Mexico City to the Secretary of State was typical of the declassified communication from the U.S. Embassy to the State Department. Hill stated that Ruiz Cortines was so angered by the demonstration of the Teachers' Revolutionary Movement that he "issued instruction arrest and deport alien Communists, including American." Hill made note of those Americans who had been arrested, asserting that they all had "previous record of Communist affiliation." The list included John Bright, Alan Lewis, and Bernard Blasenheim. He mentioned that Catlett had been arrested but was released because her husband was "reportedly Mexican citizen." Hill also noted that the relatives of those who had been deported had contacted the Embassy, including Alan Lewis's wife, who informed them that her husband had been arrested on September 6th for no reason and that he had been deported to the United States with Bernard Blasenheim.[83]

Communication between the U.S. State Department and the U.S. Embassy in Mexico City indicates that the State Department also did not have information on the deportations before their occurrence. A staff member of the State Department wrote to the U.S. Embassy on September 11, 1958, after a meeting between Mr. Blanchard, the State Department's officer in charge of Mexican affairs, and Ms. Lewis, who represented Congressman Francis Walter, the chair of the HUAC. During their meeting, Ms. Lewis brought these deportations to the attention of the State Department by requesting a report on Americans who had been deported to the United States. As the author of the communication stated, "Her interest is on behalf of Congressman Walter, Chairman of the House Committee on Un-American Activities, who has expressed the intention to subpoena the persons involved promptly upon their arrival in the United States to appear before the committee."[84] In responding to the Secretary of State, the Mexico City Embassy reported that "subjects involved [were] unquestionably American citizens and

so far Embassy knows it is not U.S. policy to refuse a citizen admittance to country."[85] This letter indicated that once deported from Mexico, U.S. citizens could enter the United States, implying that HUAC could subpoena these individuals.

Although the U.S. Embassy in Mexico City did not inform the Secretary of State about the source of their information on the deportations, from reading additional correspondence between the U.S. Embassy and the State Department, it appears that their facts were gleaned from Mexican newspapers, including *Claridades, Excélsior,* and *Novedades.* For example, a letter from the U.S. Embassy to the Secretary of State dated September 13, 1958, on the subject of "Mexican action against alleged foreign agitators" stated, "Press reports that Fernando Román Lugo . . . state Gobernación acting with energy against foreign agitators and affirm to Mexico not now and will not be in future springboard for Communism in Americas. Expulsion of American citizens Bernard Blasenheim, Albert Alan Lewis, John Milton Bright, and Max Shlafrock confirmed."[86] Another reason not to assume the involvement of the U.S. Embassy in Mexico City in the arrest and deportation of these individuals was the concern that Embassy staff expressed for the way in which Gobernación was soliciting information about the "alleged foreign agitators." In the same letter, an Embassy staff member wrote that newspaper reports, which "were probably of Gobernación origin," asked Mexican citizens to come forward with the names of possible suspects. An Embassy official indicated in the letter that "reliable sources" had determined that "lists of suspects are being solicited by agents of Gobernación, one such agent on being advised no such list available commenting 'any old list will do.'"[87] The Embassy's concern may have stemmed from the possibility that Gobernación agents were referencing out-of-date lists of American Communists that had been given to them by Embassy officials years earlier, which if erroneous could cause problems for the Embassy.

The inaccuracy of the list and the charges brought against "foreign agitators" was both accepted and challenged within the U.S. press. The arrests and deportations of U.S. exiles were reported in *U.S. News & World Report,* the *Los Angeles Times,* and the *Los Angeles Mirror News,* among other U.S. newspapers. The *Los Angeles Times* featured an article entitled "Mexican Crackdown Bags Rich Americans" in which U.S. exiles were represented as having funded the strikes:

Many known Communists, including prominent and wealthy North Americans with headquarters here, are being deported by the government to crackdown following a wave of strikes and disorders. The Ministry of the Interior said it had proved the Communist agitators had masterminded the riots and had taken "money and technical assistance" to teachers, students, telegraphers, and railway workers. . . . Newspapers said the crackdown was ordered after the "underground intervention of undesirable foreigners" was discovered. The national headquarters of the Communist Party here was raided recently and documents seized.[88]

However, an article in the *New York Times* commented on the inaccuracies of these accusations. In the article, Paul Kennedy wrote that many of those arrested were quickly released when it was determined that they had not been directly connected with the "recent disturbances."[89]

It was particularly the listing of their names and the articles published in the Mexican press that concerned the U.S. exiles. Following the deportation of John Bright and others, the Mexican press continued to print the names of those included on the list of alleged American Communists, with reporters speculating about future arrests and deportations.[90] An article in *Últimas Noticias de Excélsior* entitled "Ninguno debe quedar en el país" ("No one shall remain in the country") included the names of "Elizabeth Catlett de Mora, Charles M. Smolikoss (Small), Albert Mantz [Maltz], Samuel Brooks, Asa Zatz, Linin Moerbeck (USSR), and Paul Higgins." These individuals were identified as "part of the group of North Americans, who, with other European and North American Communist agitators, were in charge of the infiltration and other activities of agents working for the Kremlin."[91] In addition, George and Mary Oppen and artist Philip Stein were included as part of a "Group of Progressive North Americans" in another article printed in the same publication.[92]

The public listing of their names created much anxiety for the U.S. exiles who remained in Mexico. Many believed it fostered an element of suspicion around them—as individuals and as a group—that could affect their residency status and lead to deportation and subpoenas from courts and/or congressional committees in the United States. Albert Maltz, who was in California when the agents from Gobernación came to his house, wrote a letter of complaint to that agency. He challenged the articles published in the Mexican press about him that stated that he "(and other North Americans) were conducting political agitation in Mexico"; that he was a "fugitive from the United States"; that he "(and others) were responsible for the student riots

and events of September 6, 1958"; and that he "was scheduled by Gober-
nación to be deported."[93] In the letter, Maltz explained that these stories were
inaccurate in a number of respects. In countering the accusation that he and
others were responsible for the student riots and events of September 6,
1958, he wrote:

> In asserting that I have been conducting political agitation in Mexico, the
> newspapers offered no single piece of evidence. The reason for this is that
> none exists. I hereby assert that I do not know, and have had no political con-
> tact whatsoever with any of the leaders or any members of the student organi-
> zations or trade unions involved in the events of August and September
> 1958. I have given no financial aid to them, I never have attended any of
> their meetings, public or private. Furthermore, since I respect the laws of the
> country which has extended its hospitality to me, I have not participated in
> the political life of Mexico in any way in the years of my residence here.[94]

Maltz mentioned that he wished to stay in Mexico but offered that he
would gladly leave voluntarily rather than be forced out like the other de-
portees. In this letter to Gobernación, Maltz tried to gain support from the
Mexican government by highlighting its sense of justice. Maltz wrote, "I do
not feel I merit an early morning police visit, or instant, forcible deporta-
tion. It seems to me that the honor of Mexico, and simple justice, are both
abused if officials arbitrarily deport a resident without judicial process."[95]
Maltz stayed out of Mexico until December 1958, when President López
Mateos was inaugurated, since he was friends with cinematographer Gabriel
Figueroa (Mateos), a cousin of the president-elect.[96]

Although the interests of the U.S. and Mexican governments coincided
in the arrests and deportations of some of the U.S. exiles in 1958, following
this period agencies of the Mexican government, including Secretaría de
Relaciones Exteriores (Foreign Relations) communicated that they did not
want U.S. assistance or interference in dealing with American Communists
in Mexico. During a visit to Mexico City in February 1959, Milton Eisen-
hower, the younger brother of President Eisenhower, spoke with the Secre-
tary of Foreign Relations, Luis Padilla Nervo, along with the Mexican am-
bassador to Washington, Manuel Tello, about "North American Communists
or Communist sympathizers who reside in Mexico" and about American
journalists who wrote about them. Padilla Nervo, who had been accused of
Communist sympathies by right-wing members of the Mexican govern-
ment because of pressures exerted by the U.S. government in the wake of

the Caracas Declaration, indicated that the Mexican government did not need U.S. assistance, as Mexico did not support the intervention of one country (the United States) into the affairs of another (Mexico).[97]

Furthermore, some Mexican government officials did not believe that the U.S. exiles were a threat to their country. After the meeting with Milton Eisenhower, Padilla Nervo and staff from the Mexican Embassy in Washington issued a statement to President López Mateos about the U.S. exiles in which they asserted not only that they did not "know or investigate their ideology" but that the Mexican government had "received letters from institutions in which their economic and moral solvency was guaranteed." Furthermore, Padilla Nervo and the Mexican Embassy staff indicated that most of these individuals had not caused problems in Mexico. However, they noted that "in the cases in which they have infringed on Mexican laws they have been properly sanctioned," stating that some had been expelled from Mexico. They also mentioned that the Secretary of Foreign Affairs in Mexico City had once asked the Mexican ambassador to the United States for a list of Communists and Communist sympathizers from the U.S. State Department "with the purpose of giving instructions so that if they asked to be admitted to Mexico their request would be elevated for consideration by higher authorities."[98] These statements suggested that Mexican officials did not view the U.S. exiles as a potential threat to their government, as opposed to the CPUSA leaders whose names they requested in 1955, but affirmed that they would punish foreigners whom they believed had broken Mexican law. The first paragraph of the statement also demonstrated Mexico's criteria for accepting refugees, which was related to their "economic and moral solvency" rather than their ideology. This tough stance against the U.S. government revealed López Mateos's more assertive foreign policy for Mexico, which included his support of Cuba after the Revolution, in opposition to the United States.[99]

LEAVING MEXICO AND NOT LEAVING

In the late 1950s and early 1960s, many of the U.S. exiles left Mexico, including the Butlers, the Oppens, and Julian Zimet. Indeed, the U.S. exile community in Mexico City diminished considerably during this period. Jean Rouverol describes in her memoirs that "More and more of our friends were moving away—some to Cuernavaca or Valle de Bravo, others back to the States." She later reflected that they "may have begun to sense that an

era was coming to a close, that it was time to move on."[100] The Oppens and Julian Zimet returned to the United States, while the Butlers moved to Italy where Hugo wrote the screenplay "Sodom and Gomorrah" for producer Robert Aldrich. The "official" breaking of the blacklist occurred in 1960, when Otto Preminger openly hired Dalton Trumbo to write the screenplay for *Exodus*. As a result, some of the Hollywood exiles, such as Albert Maltz, returned to Los Angeles to write screenplays in the early 1960s. Others, such as Elizabeth Catlett, remained in Mexico for many years, either becoming Mexican citizens or settling there as permanent residents.

The exodus of the U.S. exiles from Mexico starting in the late 1950s was based on numerous factors related to changes in U.S. (and Mexican) foreign and domestic policies regarding Communism. During the late 1950s, when many of the exiles in Mexico returned to the United States, the powers of investigative panels such as HUAC had been challenged by the Supreme Court.[101] Richard Fried argues that by 1960, the focus of U.S. policies had been redirected toward the USSR and away from "Red infiltration" in U.S. governmental agencies and American life more broadly.[102] This redirection of U.S. domestic policies meant that the United States appeared to be a more hospitable place for these individuals than did Mexico. In addition, the Supreme Court decision *Kent v. Dulles* ruled against the State Department's withholding of passports for political reasons in June 1958, enabling these individuals to receive passports and thus to travel.

While their left-wing friends in the United States experienced a thawing of repressive domestic policies toward Communists and "fellow travelers," the U.S. press associated the exiles who remained in Mexico with a "Red Underground Railroad" in Mexico that sheltered "spies" traveling to Communist countries, including Cuba and the Soviet Union. Although their evidence was negligible, these accusations led to both harassment and firings of those working at American-owned businesses or at American-run schools in Mexico, which in turn made many of the U.S. exiles feel uncomfortable about remaining in Mexico.

What enabled the U.S. exiles, including the Butlers, to leave Mexico was the reinstatement of their passports in 1958. Most of the U.S. exiles in Mexico who had applied for passports in the early 1950s had been turned down, for reasons cited earlier. All of this changed in 1958 when the Supreme Court voted 5 to 4 in *Kent v. Dulles* to reverse the right of the State Department to refuse passports on political grounds.[103] Screenwriter

Julian Zimet remembers, "Suddenly it was easy for me to travel again."[104] For some, a passport meant freedom to travel outside Mexico, for others it signified the possibility of returning to the United States. For the Oppens, who had applied for U.S. passports less than a year after arriving in Mexico in March 1951, the receipt of their passports symbolized the end of McCarthyite harassment of U.S. citizens, as it guaranteed their right to travel. As Mary Oppen wrote in her autobiography, "A passport meant that our rights as citizens were again being respected . . . to us a passport meant we were free to leave the United States legally . . . to live with all the rights that citizenship presumably guarantees under our Constitution—our basic rights of citizenship which had been grievously violated."[105] Other Supreme Court decisions of the late 1950s also ruled against anti-Communist legislation. In 1957, for example, the Supreme Court discredited the Smith Act in *Yates v. United States* that reversed the convictions of fourteen Communist leaders.[106] However, as Richard Fried argues, "Even as the Supreme Court buttressed the rights of radicals, the FBI stepped up its subterranean activities against them—perhaps in part because of the growing obstacles to prosecution."[107]

U.S. governmental agencies such as the State Department found other ways to control the movement of the U.S. exiles after the *Kent v. Dulles* decision, through collaboration with U.S. embassies and consulates in Mexico, the FBI, the CIA, and the INS. This movement toward alternative strategies started immediately following the Supreme Court decision when the State Department held a meeting with staff at twelve consulates in Mexico. Journalist Paul Kennedy wrote in his article on the briefing that State Department personnel communicated to consulate staff that due to the Supreme Court decision, "there appears to be no way to deny passports to documented U.S. citizens here or in any part of the world where the nation's passports are valid."[108] In the article, he mentioned some of the individuals who were part of the "colony" of congressional committee evaders, including Maltz, Halperin, and Field, noting that "their travel has been restricted largely to Mexico itself" and that they "have been under continuing surveillance here by the Mexican foreign office and secret police." Kennedy noted that with U.S. passports, however, the U.S. exiles in Mexico "would be in a position to travel in any part of the world not expressly forbidden in the passport itself, and to demand United States Embassy or consular protection."[109]

As a result of the collaboration between the State Department, U.S. embassies and consulates in Mexico, the FBI, the CIA, and the INS, U.S. exiles who remained in Mexico into the late 1950s requested and received their passports but had difficulty flying to or through the United States. Albert Maltz documented for his lawyer, Ben Margolis, the harassment he experienced flying through the United States to Paris in February and August of 1959, as he had hoped to bring a case against the INS. In August 1959, Maltz was detained in Los Angeles on his way to and from Paris by U.S. government officials. Margolis acknowledged in a letter of response to Maltz that indeed his civil rights were being violated and that he would have a good case against the INS, but it would be too expensive to file in court. Maltz instead tried to publicize the issue in the press; in 1959, he wrote a letter to journalist I. F. Stone asking him to mention it in his weekly *News Letters*.[110]

The State Department developed a different strategy with naturalized U.S. citizens in Mexico by attempting to revoke their citizenship. In November 1958, Hugo Butler, a naturalized U.S. citizen originally from Canada, flew to New York to visit his son, who was a student at Columbia University and was hospitalized with pneumonia. During Butler's trip, there was frequent communication between J. Edgar Hoover, the director of the FBI; the State Department; the Subversive Activities Control Board's field offices in New York, Washington, D.C., and Los Angeles; the CIA; and the INS.[111] While in New York, Butler tried to secure his passport through his lawyer, Leonard Boudin, so that he could travel to Europe to work on a film. However, in a communication between the FBI and the Subversive Activities Control Board (SACB), SACB mentioned that the Passport Office had raised the "question of possible expatriation," in Butler's case, "because of foreign residence." The Passport Office reported that Butler had lost his original "naturalization" certificate in 1946, and although he had applied to the Los Angeles office for a new one, the office denied his passport application in April 1958 because he had failed to report for the interview. A letter from the Washington Field Office of the SACB to the FBI stated that unless Butler "could present evidence showing that the cause of his residence in Mexico came within any of the exemptions of the Immigration and Nationality Act, he must be considered to have lost nationality of the United States." The letter described a debate between the Passport Office and the U.S. Embassy in Mexico City with Boudin regarding

whether Butler had resided abroad longer than the "statutory period of time prescribed under Section 352 (a) (2) of the Immigration and Nationality Act of 1952." Boudin had argued that Butler's case came within Section 354 (1) of the Act, which included exemptions for nationals residing abroad.[112] Hugo Butler succeeded in obtaining a new passport on December 16, 1958. However, even after he received his passport, SACB continued its correspondence with the FBI on Butler's case, as demonstrated in a memo written in January 1959 in which a SACB staff member wrote that "[the] Immigration and Naturalization Service has alerted its border offices and would attempt to intercept subject's projected return to the United States in view of their position that subject has lost his American citizenship by reason of continued residence abroad beyond the statutory period."[113]

As the Supreme Court dismantled much of the infrastructure of the domestic "Red Scare," curtailing prosecution against those accused of Communist Party membership during the late 1950s, U.S. foreign policymakers focused on the actions of the Soviet Union as well as changes in the leadership in Cuba. In Latin America, U.S. foreign policymakers were disturbed by Mexico's support of Cuba after the Revolution in 1959, as Mexico again refused to support U.S. foreign-policy decisions at the 1960 OAS conference. That same year, Mexico invited the Cuban president Osvaldo Dorticós to Mexico. The Eisenhower administration had been concerned about López Mateos since he entered office in 1958, representing himself "on the extreme left of the Constitution."[114] However, according to Seth Fein, López Mateos was able "to compensate for rightist politics at home and its [Mexican government's] increasingly close economic relations with its northern neighbor" by supporting Cuba at the same time that he strategically communicated to the United States that Mexico's position toward Cuba derived from its traditional position of nonintervention, rather than support for Communism per se.[115]

While the domestic Red Scare had dissipated to some extent by 1960, U.S. policymakers (and, by extension, the U.S. press) mounted another mass media campaign against the U.S. exiles, this time accusing them of helping Americans flee the United States through Mexico to Communist-run countries, including Cuba. Around the time of the 1960 OAS conference, the U.S. press targeted the U.S. exiles as central to what they called an "Underground Railway" or "Underground Railroad" that directed American Communists from Mexico to Cuba and the Soviet Union.[116] In these articles,

the U.S. media accused the exiles of being "sheltered" by the Mexican government. For example, a series on the subject in *U.S. News & World Report* appears to have been a response to the movement of U.S. exiles and other American citizens through Mexico to Communist-run countries, as it highlighted the recent defections of two Americans, William H. Martin and Bernon F. Mitchell. Both of these individuals had worked at the National Security Agency and had apparently fled to Cuba from Mexico City in June 1960. The U.S. press linked the defections of these individuals to the U.S. exiles, including the Sterns and Maurice Halperin, who had left Mexico for Communist-run countries in the late 1950s fearing that they were about to be deported or extradited back to the United States. In one of the *U.S. News & World Report* articles, Francis Walter, chairman of HUAC (1955–1960), was quoted as referring to Maurice Halperin as a "defector" and "a leader of the American Communist colony in Mexico" in a statement he made to Congress.[117] Walter also mentioned the names of those he believed to be part of the so-called American Communist colony in Mexico, including "Frederick Vanderbilt Field, Hugo D. Butler, George Pepper, Mr. and Mrs. David Drucker, Albert Multz [Maltz], Bart and Edna Van der Shelling [Van der Schelling], Max and Nina [Minna] Lieber, Mr. and Mrs. Phil Stein."[118] While the author of the article took a hostile stance against Cuba, accusing the island nation of "harboring" U.S. Communists, criticism was also directed specifically at the U.S. exiles in Mexico whom the author represented as a link for U.S. defectors between the United States and Soviet bloc nations.

This campaign was also prompted by the *Kent v. Dulles* decision, which enabled the U.S. exiles to receive passports and thus travel outside Mexico. Another article in the *U.S. News & World Report* series highlighted the effects of the Supreme Court decision that allowed so-called American Communists to receive passports. The author of the article criticized the inability of the State Department to deny passports to U.S. citizens on the grounds of their political beliefs, suggesting that the Supreme Court decision "is a 'boon' for American Communists in Mexico."[119] The author advocated increased U.S. involvement in extraditing Communist and left-wing refugees from Mexico to the United States, arguing that the "Red Underground Railway" and other activities of the American Communists in Mexico were beyond the reach of U.S. law. The author asserted that "Mexico has long been considered a choice shelter for American Communists. It is close

enough to the United States to permit easy contact with friends back home. At the same time, it is safe from the reach of the U.S. government. Mexico's broad tradition of political asylum guarantees American Communists sanctuary so long as they obey this country's law."[120] According to the author, a foreigner in Mexico "can get favorable consideration in the courts . . . if he says the charges against him are politically inspired."[121] The author incorrectly stated that American Communists were beyond the jurisdiction of the U.S. government once they arrived in Mexico, a point that could be disproved by the deportations of Morton Sobell and Gus Hall, among others.

The irony of these articles is that the U.S. exiles were accused of being "American Communists" at a time when most of them were not members of the Communist Party. While many of the U.S. exiles never were members of the Communist Party, or had dropped out by the mid-1940s before settling in Mexico, a few remained supportive of the Soviet Union into the 1950s. However, Nikita Khrushchev's 1956 speech to the 20th Party Congress acknowledging the atrocities of the Stalin era made individuals such as Albert Maltz, Hugo Butler, Jean Rouverol, and George and Mary Oppen question their beliefs in Communism and the Soviet Union.[122] In *Cold War Exile*, a book about the life of Maurice Halperin, Don Kirshner notes that Khrushchev's speech challenged those whose membership in or alliance with the Communist Party was the basis for their understanding of world politics. According to Kirshner, "in Mexico it [the speech] was debated endlessly. A hard-core of true believers simply refused to accept it. There had never been such a speech, they insisted. It was all a plot, an act of CIA disinformation."[123] Rouverol remembers that they and many of their friends believed it to be (at least at first) a "Cold War invention." She recollected in her memoirs that since "Khrushchev had made such a confession, that meant that the situation was being corrected, didn't it?"[124] Of the U.S. exiles, Albert Maltz was one of the most committed Communists, and he especially had difficulty accepting Khrushchev's revelation about Stalin.[125] Maltz mentioned in an interview with Joel Gardner that after Khrushchev's speech, he reread classic works of Marxist literature "to understand how this could have happened."[126] While few of the U.S. exiles believed that they had wasted time while involved in the Communist Party, most eventually came to believe Khrushchev.[127]

By 1960, the Mexican government had no reason to target these individuals, and the Mexican press did not report on the accusations articulated

in the U.S. press. As such, the repercussions of these articles in the U.S. press directly affected only the U.S. exiles and their families who worked at American-owned businesses or attended American schools in Mexico. As a result of being mentioned in these articles, Frederick Vanderbilt Field was pressured to resign from the board of the American School, which also fired some of the teachers whose names were mentioned in the articles.[128] Furthermore, Hugo Butler and Jean Rouverol's daughter Mary was taunted by the children of U.S. Embassy officials at the American School. Rouverol was furious that an article with such false information could be published; in her view, to be accused of such inflammatory crimes: "After ten years of minding our own business, of struggling to make a living and a reasonably happy life for our children—to be accused of such nonsense was really more than we could bear."[129] This series of articles contributed to the Butlers' decision to leave Mexico. In her memoirs, Rouverol wrote that she feared Hugo would miss Mexico the most, because in her view, "it was he who had been most nearly assimilated. He loved everything Mexican, the food, the music, the bullfights, the countryside; it had been almost a passion with him."[130] Although he had experienced difficulties in Mexico as a foreigner, Butler had been able to keep his film career going. In a conversation years later in Hollywood with an acquaintance who was (presumably unknown to Butler) an informant for the FBI, Butler remarked that "the authorities had actually done him a favor," that he had acquired screen credits and financial success during his years on the blacklist.[131]

While most of the U.S. exiles eventually returned to the United States, others remained in Mexico, making it their permanent home, with some becoming Mexican citizens. The individuals who stayed in Mexico included Elizabeth Catlett, who became a Mexican citizen, and Willard Motley and George Pepper, who lived in Mexico until the end of their lives. Catlett's decision to become a Mexican citizen occurred in response to her arrest in 1958 and to subsequent difficulties that she experienced in the early 1960s when the American Embassy in Mexico City refused to grant her a visa (because the staff believed that the Taller de Gráfica Popular was a "front" for the Communist Party) to travel to the United States to see her mother, who had been hospitalized. A friend offered Catlett her voter-registration card to help her get into the United States, as Catlett believed that this could be the last time she would see her mother alive. However, Catlett's husband, Francisco Mora, persuaded her not to go because he

sensed that she was deliberately being provoked. A few days later, Catlett's sister called from Washington, D.C., to let her know that an agent from the INS had come to the hospital looking for her. Catlett was later informed that the INS agent had also gone to the homes of both her sister and her aunt. Fortunately, Catlett's mother survived her illness and soon after decided to join her daughter in Mexico.[132] After this episode, Catlett applied for Mexican citizenship; she became a citizen of Mexico in 1962.

The early 1960s were in fact a relatively peaceful period for American leftists in Mexico. The Mexican government's treatment of them shifted as it instead focused on containing dissident labor leaders by jailing them for extensive periods, thereby squashing independent unions. However, the difficulty for the U.S. exiles who remained in Mexico, especially those who had become Mexican citizens, was in entering the United States, as I discuss in the conclusion.[133]

Conclusion

I have argued that the work of the Cold War exiles constitutes a form of critical transnationalism that challenged the official versions of U.S. national culture from the mid-1940s to the mid-1960s. This development in their work was a direct consequence of their repression and dislocation by the U.S. government and the multiple communities of cultural producers established in Mexico. Members of the Cold War culture of political exile in Mexico produced film, visual artwork, and fictional and nonfictional writing that developed in numerous locations and drew upon multiple cultural traditions. These works were positioned both aesthetically and ideologically against the dominant post–World War II cultures of the United States and Mexico.

Oppositional networks forged in Mexico City, both personal and institutional, enabled these individuals to create their work. For the artists, the institutions that nurtured these associations included the Taller de Gráfica Popular and La Esmeralda, while the filmmakers formed their own informal networks of foreigners who could not work in the state-funded Mexican film industry. It was in these circumstances that the U.S. exiles developed a critical transnationalist perspective in the form and/or content of their work directed against U.S. nationalism, imperialism, and the global permutations of racism.

As many scholars of the Cold War have argued, agencies of the U.S. government placed culture in a significant role in the global battle for the hearts and minds of individuals in Western Europe, Africa, and elsewhere. U.S. governmental agencies, including the State Department and the CIA, promoted artistic and musical forms such as abstract expressionism and jazz

music in order to portray the United States to the so-called third world as a champion of "individual liberty" (as against Soviet totalitarianism). Individuals who had been blacklisted because of their political beliefs thus experienced the constraints placed on freedom of thought and freedom of association during the early Cold War era.

The work of the U.S. exiles substantially criticized, through both form and content, dominant U.S. cultural production of the early Cold War era. Elizabeth Catlett's artwork, including *The Negro Woman* series (1946–1947) and the Taller de Gráfica Popular's series *Against Discrimination in the United States* (1953–1954) that she conceived, champions African Americans, both famous and unknown, for their courage and resistance to U.S. racism. John Wilson's 1952 mural *The Incident*, with its portrayal of a lynching, condemns racial violence in the United States. All of these politically engaged figurative works challenged the U.S. government's promotion of abstract expressionism abroad. In *A Long Way from Home*, Gordon Kahn critiques the relations of U.S. imperialism and condemns the Korean War as profit driven. In contrast to the State Department film *And Now, Miguel* that emphasized assimilation for Mexican Americans through participation in the military, Kahn's story features a Mexican American draft dodger and is assertively anti-assimilationist. Butler's collaboration with Buñuel on *The Adventures of Robinson Crusoe* critiqued the European civilizing mission and foregrounded the colonial encounter as a precursor to the contemporary imperialism of Hollywood narrative cinema. While *!Torero!* ran counter to the romanticized and exoticized representation of bullfighting within the U.S. and Mxican film industries, Butler's screenplay of *Los pequeños gigantes* undermined the notion of America as a "democratic" nation in its representation of U.S. racism against Mexicans and Mexican Americans and repressive U.S.–Mexico border politics.[1] Willard Motley's "My House Is Your House" and "Tourist Town" focused on U.S. tourism as a malign extension of U.S. racism and imperialism. Motley's aesthetic strategies, including experiments in shifting perspectives in narration, challenge the possessive exoticism of the conventional travel narrative. Although much of his critique was excised by his editors, Motley's original manuscripts demonstrate how African American writers articulated links between U.S. racism at home and abroad during the early Cold War era.

Their context in Mexico led the U.S. exiles to have an increased awareness of the global impact of the United States during the Cold War and

contributed to their opposition to U.S. imperialism. Their broader oppositional mode was evident in much of their work—from Butler's screenplay of *Los pequeños gigantes* to Kahn's critique of the processes and practices of U.S. imperialism in *A Long Way from Home* to Motley's "My House Is Your House" and "Tourist Town" in which he used U.S. tourism as a trope for U.S. racism and imperialism in Mexico.

The cultural work of the U.S. exiles drew on influences from the United States, Mexico, and elsewhere, and it inspired oppositional art movements in both the United States and Mexico. Specifically, the U.S. exiles' critical perspectives and aesthetic strategies influenced younger generations of artists and filmmakers in both countries. (However, this was not the case for the writers whose work was censored completely or was published posthumously.) The aesthetic and ideological challenge to dominant Hollywood and Mexican film registered in the independent film practices of Hugo Butler and others influenced a group of emerging film critics and filmmakers in Mexico who were also excluded from the Mexican film industry. These filmmakers and critics established Nuevo Cine (New Cinema) in Mexico. African American artists who visited or remained in Mexico had a significant influence on artists in the Black Arts Movement during the 1960s and 1970s. In particular, Elizabeth Catlett's focus on the importance of African Americans creating public art in a collective context for other African Americans and for people of color throughout the world was significant for artists in the Black Arts Movement. Indeed, she came to be viewed by many as the "foremother of the Black Arts Movement."[2]

The cultural politics of the Cold War in the United States was predicated in part upon the excision and suppression of critical perspectives. The Cold War culture of political exile in Mexico, however, attests to the survival of forms of cultural opposition during the late 1940s and 1950s. Living in Mexico enabled some to produce critical work, although the avenues of distribution for their work were sometimes blocked. Michael Denning notes that during the Cold War, plebeian writers were silenced by "ordinary labor, by the literary marketplace, by the blacklist and by exile."[3] For writers such as Willard Motley and Gordon Kahn, the constraints of the literary marketplace were significant. Motley's narrative associations between U.S. domestic and international racism in works directed toward the U.S. commercial publishing industry resulted in either the censorship or complete reworking of his manuscripts. Since his critical writings on racism and imperialism

either were not published or were omitted in published works by his editors, these perspectives were not available to those involved in the Black Arts Movement. It was writers in the Black Arts Movement who provided the context for the return of the work of other African American artists and writers who left the United States during the early Cold War era, such as Richard Wright, whose books were reprinted starting in the mid-1960s.[4]

Unlike Motley's work, Gordon Kahn's novel *A Long Way from Home* was later "reclaimed" and published in a series on Mexican American literature in the 1980s.[5] In his introduction, the literary critic Santiago Daydí-Tolson argues that the novel is an important precursor to those written by Mexican Americans in the late 1960s during the height of the Chicano movement in the United States. He states that "*A Long Way from Home*...provides an ideologically determined view of the Mexican-American situation which, with its rebellious and explicit criticism of the American system and its positive view of old Mexican traditions and values, prefigures the cultural, political, and social developments that would lead a decade later to the growing consciousness of a Chicano culture and to the political developments of the Chicano movement with its creation of the visionary image of Aztlán."[6] As Daydí-Tolson suggests, the reclamation of *A Long Way from Home* in the late 1980s was influenced by the Chicano movement of the 1960s, which as Laura Pulido argues, "sought to validate *mestizaje* and affirm Chicanas/os' indigenous roots."[7] However, while Daydí-Tolson asserts that Gilberto chooses to remain in Mexico because it is the "land of his ancestors," I argue that Gil's decision to renounce his U.S. citizenship and to become a Mexican citizen has more to do with his seeing the parameters that frame U.S. Cold War ideology.

While Kahn's and Motley's writings were censored or reworked in order to be published, numerous films written by Hollywood exiles were distributed in the United States and Mexico during the 1950s and 1960s. There were also some Hollywood exiles, especially Dalton Trumbo, who played crucial roles in breaking the blacklist and found themselves to be part of what Michael Denning refers to as a "revival of the Popular Front in Hollywood" during the 1960s and 1970s.[8] This revival started not long after director Otto Preminger decided in 1960 to give Trumbo an onscreen credit for *Exodus* (1960), opening the door for other Hollywood exiles to both gain employment in the United States and receive credit for their work.[9] The reintroduction of the Hollywood exiles into the film industry was the

result of a number of factors, including significant changes within the studio system. By the 1960s, independent producers could put together films using personnel from throughout the industry rather than from just one studio. According to Michael Ryan and Doug Kellner, "The demise of the studio system gave filmmakers more control over their product . . . and this development helped facilitate the production of more socially critical and innovative films."[10] As a result of their politics and extensive screenwriting experience, a number of the Hollywood exiles were enlisted to work on film projects during this period.

The return of the U.S. exiles to the Hollywood film industry was also related to broader political changes during the 1960s and 1970s. The social movements of the period—the civil rights, antiwar, black power, gay liberation, and feminist movements—noticeably impacted the kind of films that were produced in Hollywood. This "short-term shift" to the Left within the Hollywood film industry provided a receptive context for the reentry of blacklisted screenwriters such as Trumbo, who sold at least twelve screenplays between 1960 and 1973. Other screenwriters who had chosen exile in Mexico, including Ring Lardner Jr. and Albert Maltz, also wrote scripts for films produced in Hollywood during the 1960s and 1970s.[11]

The work of the U.S. exiles who did not return to the United States also had significant consequences. Hollywood exiles who remained in Mexico in the late 1950s and beyond, such as Hugo Butler and George Pepper, played an important role in the making of an independent film movement in Mexico.[12] As I argue in this book, the filmmaking practices of the Hollywood exiles in Mexico expanded beyond the normative boundaries of classical Hollywood and Mexican narrative cinema.[13] Filmmakers working independently from the mainstream Mexican film industry during the 1950s, including Butler, Pepper, Luis Buñuel, Manuel Barbachano Ponce, Carlos Velo, Giovanni Korporaal, and Benito Alazraki, as well as Spanish exile Luis Alcoriza (who collaborated with Buñuel on the screenplay for *Los olvidados*), provided a countermodel for independent film production and were thus crucial to the development of Nuevo Cine.[14]

In 1960, a group of young, leftist Mexican film critics, scholars, and emerging filmmakers who had been kept out of the state-sponsored film industry formed El Grupo Nuevo Cine (The New Cinema Group).[15] This group rejected the conventions of "Golden Age" Mexican cinema, which they argued was modeled both structurally and aesthetically on classical Holly-

wood narrative cinema. Seth Fein argues that they connected "an indictment of Hollywood cultural and economic hegemony and the Cold War imperialism of the United States to the dominant Mexican filmmaking class."[16] However, unlike independent film movements of the 1950s and early 1960s in Europe and the United States, such as the French New Wave, which were influenced by *Cahiers du Cinéma*'s concept of *la politique des auteurs,* or "auteur theory," Nuevo Cine and other "third cinema" movements were less concerned with the single artistic vision of one particular author. Julianne Burton contends that independent filmmakers and critics in Latin America and in other parts of the so-called third world translated *la politica de los autores* differently, instead viewing it as a "practical strategic position (simultaneously a 'policy' and a 'politics') from which to combat the actual or putative norm of a hierarchical studio-based production system in which the director was relegated to subordinate managerial status."[17] Thus, rather than championing a hyper-individualist cinema of artistic expression, these filmmakers were staging a critical response to the predominant industrial model.

In their writings, members of Nuevo Cine did not just critique the influence of Hollywood but also analyzed local film production within the context of Mexico's political and economic dependence on the United States. One of the founders of Nuevo Cine, Manuel Michel, described the problems of Mexican cinema in his 1965 article "Mexican Cinema: A Panoramic View" as "explained by the complexity of the problems of an underdeveloped economy, and the struggle of a national bourgeoisie engaged in industrialization and concerned with veiling cultural problems."[18] In their writings and manifestos, film critics and filmmakers involved in the Nuevo Cine movement situated dominant Mexican cinema within the broader context of the Mexican economy. Scott Baugh argues that the manifestos of Nuevo Cine went beyond film criticism to "critique the official discourse of modernization and development that dominate studies of Mexico and the Latin America global region more generally."[19]

For filmmakers and critics involved with the Nuevo Cine movement, independent film production challenged how Mexican cinema figured into broader economic relations between Mexico and its powerful neighbor to the north. They developed their own film manifesto, *En el balcón vacío* (On the Empty Balcony) (1961), under the direction of Jomí García Ascot.[20] They also briefly published their own film journal, *Nuevo Cine* (April 1961– August 1962), and organized a film society, Instituto Frances de América

Latina (IFAL). In pursuing creative and economic autonomy, they drew upon existing cinematic models as well as earlier efforts to highlight the insidious preponderance of the United States throughout the hemisphere.

During the time in which Hugo Butler and other independent filmmakers in Mexico contributed to the development of this new cinema movement in the early 1960s, the Black Arts Movement was taking shape in the United States. This movement was directly indebted to Elizabeth Catlett as well as to other African American artists who had returned to the United States from Mexico in the late 1940s and 1950s, including Margaret Taylor Goss Burroughs and Charles White. Burroughs in particular was part of a network of African American artists who had been politically active during the 1930s and 1940s and who formed the foundation for the Black Arts Movement.[21] As James Smethurst asserts, "Once the Cold War receded a bit, this network would be crucial to the establishment of new Left-led African American institutions, especially discussion groups, educational associations, workshops and arts organizations, prefiguring, influencing and often becoming those of the Black Arts Movement."[22] Among her numerous political commitments, Burroughs was on the board of *Freedomways*, founded in the early 1960s. This culturally focused journal, which published the work of African American writers and artists, including Elizabeth Catlett and Charles White, brought together the Popular Front generation with younger artists and writers in the burgeoning Black Arts Movement. According to Smethurst, *Freedomways* provided "an internationalist perspective, a strong emphasis on the arts, and a deep sense of the history of black radicalism as it both reported and theorized black liberation movements at home and abroad."[23] Catlett's global perspective, in which she linked the concerns of African Americans in the United States with people of color in Latin America, Africa, and Asia, fit well with those of the *Freedomways* editors. Her global perspective likely influenced the editors of *Freedomways* to include her speech to the National Conference of Negro Artists in 1961 in the first issue of the publication. Catlett's career provides an especially powerful example of the effect some of the U.S. exiles had on social movements and progressive artists during the 1960s and 1970s.

Catlett's 1961 speech to the National Conference of Negro Artists and its subsequent publication in *Freedomways* had a significant impact on artists who became part of the Black Arts Movement. Explicitly noting how the Taller de Gráfica Popular's recuperation of traditional graphics and emphasis

on public distribution had influenced her, Catlett called upon her audience to prioritize African American history and culture. She encouraged them to create representations of African American life and to make public art in a collective context addressed to other African Americans as well as to people of color throughout the world. Catlett's speech inspired African American artists, including Romare Bearden, who later observed that her speech "resulted in the formation of groups, such as Spiral in New York," an intergenerational African American artists' group that Bearden founded.[24] Bearden and Harry Henderson also note that as a consequence of her address, "all-black exhibitions swept across the country. Instead of accepting a shut-out by galleries and museums the all-black exhibitions brilliantly demonstrated the talent of black artists in all parts of the country, awakening millions of Americans to their existence for the first time."[25]

The significance of Catlett's speech had to do not only with her focus on African American art production and distribution but also with how she situated the role of African Americans within the context of the historic events of decolonization underway in Africa and elsewhere. In her speech, Catlett drew parallels between the experiences of African Americans in the United States and people of color throughout the world: "The Negro people of the United States, the people of Latin America, of Africa and of Asia are determined that, at a time when we are seeking the means to conquer space with other planets as our destination, second-class nations and second-class citizens shall no longer exist on this planet. There can be only one way of living in our world—in full equality, of nations and of men."[26] Catlett saw the plight of African Americans in the United States as related to those in newly independent nations in Africa as well as to people of color in Asia and Latin America. Although her speech was well received, Catlett's attendance at this meeting was to be the last time she traveled from Mexico before being barred from entering the United States because of her affiliation with the Taller de Gráfica Popular, which the State Department considered a front for the Communist Party.[27]

Catlett not only influenced the development of the Black Arts Movement, she also became a part of the movement herself. Her involvement in the Black Arts Movement should be seen within the context of changes in the Mexican art world, which during the early 1960s began to prioritize abstraction, and her eventual departure from the Taller de Gráfica Popular due to disputes within the collective. The move toward abstraction in the

Mexican art world was the product of the U.S. promotion of abstract expressionism globally. By the late 1950s, the Mexican art establishment had developed a cosmopolitan orientation in which abstraction figured prominently. Shifra Goldman and Eva Cockcroft have both described how by the Second Inter-American Painting and Printmaking Biennial in 1960, which was dominated by abstract painters, the ideological transformation of Mexican art from an emphasis on nationalist- and indigenous-centered work to a cosmopolitan focus had been clearly established.[28] A dispute regarding the Taller de Gráfica Popular's participation in the Biennial split the collective. Because of the Mexican government's jailing of David Alfaro Siqueiros, Catlett and others felt that the Taller de Gráfica Popular should not exhibit their work at the state-supported Biennial. Those who did participate in the Biennial, including two Taller founders, Leopoldo Méndez and Pablo O'Higgins, decided at this time to leave the collective. Elizabeth Catlett and her husband, Francisco Mora, remained members of the Taller de Gráfica Popular with Catlett occupying a position of leadership into the mid-1960s. However, Catlett and Mora left the Taller de Gráfica Popular in 1964 after another member of the collective, Luis Arenal, brought President López Mateos to their studio to ask for funding from the Mexican government without consulting members of the group. López Mateos, a president who "wanted to be known for his support of the arts" had jailed Siqueiros in 1960 for the crime of "social dissolution" (in actuality, his support of the railroad unions during their strike of 1959) and outlawed public support for the artist during his imprisonment.[29] While Catlett's involvement with the Taller de Gráfica Popular had been a source of inspiration for many years, when she left the collective in the mid-1960s she felt that there was not a group of artists in Mexico with whom she could work. It was at this point that she increasingly addressed her artwork to African Americans in the United States.

Catlett's relationship to the Black Arts Movement was limited because of her continued residence in Mexico, yet her artwork of the 1960s predominantly addressed issues concerning the Black Arts and Black Power movements in the United States. Most of Catlett's visual artwork of the late 1960s and early 1970s focused on political topics that were important to the Black Power Movement, including her prints *Malcolm X Speaks for Us* (1968–1969), *Freedom for Angela Davis* (1969–1970), and *Homage to the*

Panthers (1970). Catlett created the poster *Freedom for Angela Davis* while she organized the Comité Mexicano Provisional de Solidaridad con Angela Davis in Mexico City, a group that protested Angela Davis's imprisonment.[30] Her other prints of this period, *Negro es Bello* (1968), *Black Is Beautiful* (1970), and *Homage to My Young Black Sisters* (1969), appealed to artists in the Black Arts Movement, who were attracted to her aesthetic style and her political vision.

Catlett brought a distinctly transnational perspective to the Black Arts Movement. While much of her artwork of the 1960s focuses on African American subject matter, she linked this work to her representations of Latin Americans in particular. For example, Catlett's artwork of the late 1960s addressed both the violence of the U.S. state against the people of Latin America and police violence against African Americans in the United States. These images, including her print *The Torture of Mothers* (1970), depicted U.S., Mexican, and Latin American contexts. Melanie Herzog notes in her book on Catlett that "she knew at first hand mothers in Mexico whose children had been felled by the military forces confronting student protesters in Mexico City in 1968. Her own sons had been part of these mass demonstrations. She knew mothers of young black men in the United States, who lived in fear that their sons would be next. And she knew of mothers in Latin America, whose children were 'disappeared' by government forces supported by the United States."[31] In this sense, Catlett went beyond focusing solely on the concerns of African Americans in the United States to a broader analysis that examined the U.S. and Latin American governments' violence against people of color and political dissidents.

During her first two decades living in Mexico, Catlett had exhibited her work infrequently in the United States. In addition to her solo show at the Barnett-Aden Gallery in 1947–1948, her work was included at the Atlanta University Annual Exhibition, in 1946, 1956, and 1966.[32] However, starting in the early 1970s, her work was shown in numerous exhibitions in the United States. The first art show in the United States in which her work appeared during this period was "Dimension of Black," held in 1970. This exhibition and an article published in *Ebony* on Catlett in 1970 significantly increased awareness of her artwork among the broader African American public, something that had been lacking for many of the years that she had lived in Mexico.[33]

The enthusiastic reception of Catlett's work in the United States by African American artists and intellectuals in the 1960s and African Americans more broadly by the early 1970s meant that she was frequently asked to speak at conferences and to attend openings of her exhibitions. However, after becoming a Mexican citizen in 1962, Catlett was continually denied a visa to enter the United States. The U.S. government's persistent refusal to give her a visa in the 1960s and early 1970s was based on the provision of the Immigration and Nationality Act of 1952 that prohibited those the government perceived as "Communist" from entering the country. In 1970, Catlett had been invited to present a speech at the Conference on the Functional Aspects of Black Art (CONFABA 70) at Northwestern University as an "elder of distinction." When the U.S. government once again denied her a visa, she decided to deliver her presentation by phone from Mexico, a situation similar to the one that Paul Robeson experienced in the early 1950s.[34] In her speech, Catlett commented on the reasons the U.S. government refused to grant her a visa:

> Unfortunately for me, I was refused on the grounds that, as a foreigner, there was a possibility that I would interfere in social or political problems, and thus I constituted a threat to the well-being of the United States. To the degree and in the proportion that the United States constitutes a threat to black people, to that degree and more, do I hope to have earned that honor. For I have been, and am currently, and always hope to be a Black Revolutionary Artist and all that it implies![35]

Catlett also drew a parallel between the experiences of African Americans and colonized peoples, asserting that African Americans "suffer the fate of colonial peoples in the realm of culture. First, the colonizers destroy the culture of the people, then they deny the contribution of those colonized, who participate in their culture."[36] Catlett's statement reflects as much her own circumstances as the broader circumstances of African American history and culture.

Although Catlett's artwork was exhibited widely in the United States during the early 1970s, she continued to experience difficulties physically entering the country. In addition to the State Department's denying her a visa to attend CONFABA 70, Catlett had trouble attaining a visa that she needed to attend her first solo show in the United States since 1948 at the Studio Museum of Harlem in 1971. The director of the Studio Museum worked tirelessly to secure her a visa and was finally successful when he

represented her visit to the U.S. State Department as a kind of "cultural exchange."[37] However, once in the United States, Catlett could not travel freely. According to Melanie Herzog, "she was ordered to travel by the most direct route and to provide authorities with her complete itinerary."[38] Despite these difficulties, the show was a major success for Catlett and was later referred to as "one of the benchmarks in recent Afro-American history."[39]

The consequences of the Cold War culture of political exile persisted long beyond the relatively brief period commonly associated with the most egregious of Cold War initiatives. Even after public support dissipated for overtly repressive policies, individuals who had been blacklisted and/or barred from entering the United States continued to be targeted by these policies.[40] The political climate of the early twenty-first century "War on Terror" only further underscores the mutability and resilience of Cold War precedents, especially with regard to policing the boundaries between belonging and not belonging to the U.S. nation-state. Examining the U.S. government's double standards toward its citizens and noncitizens in the current context, legal scholar David Cole notes how often laws used against foreign nationals are subsequently turned against U.S. citizens. Nativist measures against Communists established during the 1919–1920 Red Scare were used to police and punish dissident citizens during the early Cold War era in the name of national security.[41] The Immigration and Nationality Act of 1952, which authorized the deportation of foreigners affiliated with politically subversive organizations such as the Communist Party, was not repealed until 1990. Cole observes that even as Congress rescinded these laws, "it substituted provisions making foreign nationals deportable for engaging in terrorist activities. The Immigration and Naturalization Service immediately interpreted this new law, however, to make noncitizens deportable not merely for engaging in or supporting terrorist *activity*, but for providing any material support to a terrorist *organization*, without regard to the purpose or effect of the support." Much of the language in the Act was transferred into the U.S. Patriot Act, including deportation for those associated with certain political organizations.[42]

I have emphasized how U.S. Cold War policies against cultural producers who were committed to social justice did not end their challenge to U.S. hegemony more broadly and in fact produced new cultural forms of resistance. This book is an effort to understand the specific dimensions of these innovative new forms of cultural production that emerged from the

experiences of U.S. exiles in Mexico between the mid-1940s and the mid-1960s. During the early Cold War era, agencies of the U.S. government targeted Left cultural producers and others whom they believed influenced public opinion. The government's draconian policies led some of these individuals to flee the United States. I have focused on the ways in which the cultural work of the U.S. exiles in Mexico critically engaged both the global policies of the United States and the domestic consequences of the Cold War, and I contend that the form and content of their work underwent a significant transformation as a result of their circumstances in Mexico and conditions of exile. From this context, these artists, writers, and filmmakers developed a critical transnationalist perspective articulated to various degrees through the form and content of their work. I argue that the cultural practices and aesthetic forms they developed were specific to the early Cold War era. Their cultural work addressed the particular consequences of American nationalist and exceptionalist ideologies by focusing on forms of political exclusion and racialization that were advanced through these policies and everyday ideologies. Their work not only provides a vital counterpoint to the authoritarian cultural and political norms of the United States during the early Cold War but also demonstrates the resilience of oppositional cultural production in response to protracted state repression.

Acknowledgments

Many individuals and institutions helped me in the process of researching and writing this book. This project started as a doctoral dissertation in the American Studies Program at Yale University. At Yale, I wish to express my sincere thanks to Michael Denning for his cogent criticism, support, and extensive work with me. Special thanks also go to Jean-Christophe Agnew, Hazel Carby, and Robert Johnston, each of whom provided thoughtful and encouraging responses to my work. Matt Jacobson also offered insightful comments as well as helpful suggestions about the next step. A number of my graduate school colleagues, including Catherine Gudis, Andrew Sackett, and Michelle Stephens, provided feedback on the manuscript and intellectual support. I am especially indebted to Joseph Entin, who read and commented on portions of the manuscript at a key moment in its development. I also thank the following scholars who contributed their expertise: Diana Anhalt, Jurgen Buchenau, Barry Carr, Peter Carroll, David Caute, Larry Ceplair, Seth Fein, Gil Joseph, Patrick McGilligan, Ellen Schrecker, Maurice Tenorio-Trillo, Alan Wald, George Yúdice, and Eric Zolov.

Comments by George Lipsitz and anonymous readers at the University of Minnesota Press, as well as the input of scholars at regional, national, and international conferences, helped me to refine my arguments. In particular, I acknowledge George Yúdice, Kevin Gaines, Claire F. Fox, and Marlon Ross, who responded to papers I presented at American Studies Association conferences. I benefited tremendously from the comments of Sandhya Shukla, Heidi Tinsman, and Nicholas Bloom, who included excerpts of this book in their edited collections. At the University of New Mexico, I thank

my colleagues Alex Lubin, Carmen Nocentelli, and Sam Truett for their comments on parts of this manuscript, as well as Susan Dever, Robert Fleming, and Carl Mora for their help with sources. I also express my appreciation to my research assistants Beth Swift, Tita Berger, Asako Nubuoko, and most notably Annette Rodriguez and Caitlin Barry, who helped tremendously in the final stages. Thanks also go to Jeremy Lehnen and José Luis Santana for their assistance with copyediting the Spanish text. Richard Morrison and Adam Brunner of the University of Minnesota Press have been a pleasure to work with; I thank Richard in particular for his encouragement and interest in this project.

Without the proficiency of archivists and librarians, research on this project would not have been possible. Special thanks go to Beth Silvergleit and Russ Davidson of the Center for Southwest Research at Zimmerman Library, University of New Mexico; Polly Armstrong, Special Collections, Greene Library, Stanford University; Camille Billops, Hatch-Billops Archive; Lynne Thomas, Rare Books and Special Collections, Northern Illinois University; Heidi Dodson, Amistad Research Center at Tulane University; Madeline Matz, Motion Picture and Broadcasting Division, Library of Congress; Milton Gustafson, National Archives, College Park, Maryland; Dee Grimsrud and Dorinda Hartman, Wisconsin Center for Film and Television Research, State Historical Society of Wisconsin Manuscripts and Archives; Peter Filardo, Tamiment Archives, Bobst Library, New York University; Carol Bowers, American Heritage Center, University of Wyoming; Charles Silver, Film Study Center, Museum of Modern Art; and Rogelio Agrasánchez Jr. and Xóchitl Fernández of Agrasánchez Film Archives. In Mexico, I thank Roberto Morín at the Secretaría de Relaciones Exteriores, Archivo Histórico who assisted me while I was conducting research in Mexico City. I also acknowledge the efforts of the Interlibrary Loan staff at Zimmerman Library, University of New Mexico, most notably Randy Moorhead, for helping me locate and retrieve much needed materials.

I wish to recognize the artists, writers, and filmmakers whose work this book examines at length. I am grateful to them and their families, including Jean Rouverol, Mary Butler, Elizabeth Catlett, Tony Kahn, Crawford Kilian, Christopher Trumbo, and Julian Zimet, who shared their experiences in Mexico with me. I am indebted to Elizabeth Catlett, Jean Rouverol (for Hugo Butler), and John Wilson, who gave me permission to publish their

artwork and photographs. I thank Jane Yeomans for allowing me to use her photograph on the cover.

I have been fortunate to receive financial assistance to research and write this manuscript. At the University of New Mexico, the Research Allocation Committee and the Feminist Research Institute awarded me research grants that facilitated my completion of the book. I also thank the Dean's Office of the College of Arts and Sciences at the University of New Mexico for a faculty research leave that enabled me to finish the manuscript, as well as for subvention funds to cover the costs of image rights and indexing. At Yale University, I was the fortunate recipient of the John F. Enders Research and Dissertation Fellowships and the John Perry Miller Research Grant, which funded my research in Mexico City; Washington, D.C.; Madison, Wisconsin; and DeKalb, Illinois. I am grateful for a Graduate Student Fellowship from the Beinecke Rare Book and Manuscript Library, which supported my initial research.

On a more personal note, I acknowledge my past and present colleagues in the American Studies Department at the University of New Mexico for their encouragement of this project: Beth Bailey, Amy Brandzel, Amanda Cobb, Laura Gómez, Laura Hall, Jake Kosek, Alex Lubin, Gabriel Meléndez, Vera Norwood, Sandy Rodrigue, Michael Trujillo, Gerald Vizenor, and Jane Young. I express my appreciation to friends and family who cheered me on while I was researching and writing, including Enrique Aguilar, Michael Alexander, Aliyah Baruchin, Sophie Bell, Rosemary Cosgrove, Joseph Entin, Malcolm Goldstein, Marin Goldstein, Cathy Gudis, Blaine Keesee, Alex Ku, Stephanie and Stuart Lipkowitz, Tara McGann, Carol Marcy, Carmen Nocentelli, Julia Talbot, Sam Truett, Jane Yeomans, and Cynthia Young. I would like to recognize my parents, Carol and Sanford Schreiber, and my sister, Madeline Schreiber, for their many levels of support over the years.

This book is dedicated to my daughter, Alia, who earlier on asked me if she "had to write a book too" and now writes and illustrates her own, and to my husband, Alyosha Goldstein, for his invaluable comments and endless support. I couldn't have done it without you.

Notes

Throughout the notes and in the text, all translations are mine unless otherwise indicated.

Introduction

1. Writers Richard Wright, Chester Himes, and James Baldwin; visual artist Ed Clark; film director John Berry; and screenwriter Michael Wilson, among numerous others, went to live in France. Actor Sam Wanamaker, screenwriters Donald Ogden Stewart and Carl Foreman, and film director Joseph Losey went to England, where writers C. L. R. James and Cedric Belfrage were deported in the 1950s. Cartoonist Ollie Harrington went to Paris and then to East Germany, film director Jules Dassin moved from Paris to Greece, and countless others migrated to Madrid, Barcelona, Rome, and elsewhere. In addition, numerous émigrés to the United States left in the late 1940s and early 1950s, including actor Charlie Chaplin, composer Hans Eisler, director Luis Buñuel, playwright Bertolt Brecht, and writer Thomas Mann. See John Russell Taylor, *Strangers in Paradise: The Hollywood Émigrés* (New York: Holt, Rinehart and Winston, 1983), and David Caute, *The Great Fear: The Anti-Communist Purge under Truman and Eisenhower* (New York: Simon and Schuster, 1978). In this book I focus primarily on the U.S. exiles who produced cultural work while living in Mexico.

2. Two books have been written about these communities. Diana Anhalt, the daughter of U.S. Communists who moved to Mexico, wrote a book about the broader U.S. exile communities in Mexico, *A Gathering of Fugitives: American Political Expatriates in Mexico, 1948–1965* (Santa Maria, Calif.: Archer Books, 2001). Jean Rouverol's memoir, *Refugees from Hollywood: A Journal of the Blacklist Years* (Albuquerque: University of New Mexico Press, 2000), focuses extensively on the lives of U.S. exiles, specifically the Hollywood exiles, in Mexico.

3. Jerome Klinkowitz, ed., *The Diaries of Willard Motley* (Ames: Iowa State University Press, 1979), xix.

4. It is difficult to determine the exact number of Cold War exiles in Mexico who were artists, writers, or filmmakers. According to Diana Anhalt, during the late

1940s and the early 1950s, there were around sixty families living in the U.S. exile community in Mexico, primarily in Mexico City and Cuernavaca. (However, not all of these individuals were writers, artists, or filmmakers.) However, Anhalt notes in *A Gathering of Fugitives* that "Although I have identified more than 60 such families I am reluctant to give more precise numbers because it is impossible to determine unequivocally who went to Mexico for political reasons. Sometimes, the individuals themselves are uncertain; a few concealed their motivations from each other; others established no relationships with known political expatriates or lived outside Mexico City, making them more difficult to identify" (89n46). Karl Schmitt identified around 150 U.S. Communists in Mexico during the early 1950s. Schmitt, *Communism in Mexico: A Study in Political Frustration* (Austin: University of Texas Press, 1965), 217–18.

5. Letter from Margaret Taylor Goss Burroughs to Bill Mullen in Bill Mullen, *Popular Fronts: Chicago and African American Cultural Politics, 1935–1946* (Urbana: University of Illinois Press, 1999), 102n51. While Burroughs and others used the term *progressive,* I use the terms *left* or *left-wing* to describe individuals who were members of the Communist Party, those whom I think were members of the Communist Party, and those who had supported the Communist Party but didn't join.

6. Scholarly works about the U.S. government's linking of antiracist organizations and the Communist Party during the Cold War include Gerald Horne's *Black and Red: W. E. B. Du Bois and the Afro-American Response to the Cold War, 1944–1963* (Albany: State University of New York Press, 1986), as well as his *Black Liberation/Red Scare: Ben Davis and the Communist Party* (Newark: University of Delaware Press, 1994) and Kenneth O'Reilly's *Black Americans: The FBI Files* (New York: Carroll & Graf Publishers, 1994).

7. See Peter Carroll, *The Odyssey of the Abraham Lincoln Brigade: Americans in the Spanish Civil War* (Stanford, Calif.: Stanford University Press, 1994), 287.

8. This was particularly difficult for the Communist Party, which had to register as a Communist-action organization, effectively identifying its members as holding allegiance to a foreign power. Caute, *The Great Fear,* 163–71.

9. Ellen Schrecker, *Many Are the Crimes: McCarthyism in America* (Boston: Little, Brown, 1998), 208.

10. Cedric Belfrage, *The American Inquisition, 1945–1960: A Profile of the "McCarthy Era"* (New York: Thunder's Mouth Press, 1989). A recently declassified letter from FBI director J. Edgar Hoover to Sidney S. Souers, the first director of Central Intelligence, dated July 7, 1950, indicates that Hoover proposed not only to detain the 12,000 individuals listed on the security index but also to suspend the Writ of Habeas Corpus. See letter from J. Edgar Hoover to President's Special Consultant (Sidney S. Souers), July 7, 1950, in *The Intelligence Community, 1950–1955,* ed. Douglas Keane and Michael Warner (Washington, D.C.: U.S. Government Printing Office, 2007), 18–20. It is likely that a significant percentage of the Cold War exiles were listed on the security index. Of those whose FBI records I have in my possession, both George Oppen and Hugo Butler were tagged as secu-

rity risks and labeled as both COMSAB, Communists with potential for sabotage, and DETCOM, which indicated the government's plan to detain these individuals (see chapter 6).

11. While the designation "American" is not limited to individuals who live in the United States but can refer to residents throughout the Americas, for stylistic reasons I use *American* interchangeably with U.S. citizen in some parts of the text.

12. Although it was later deemed unconstitutional, the Internal Security Act of 1950 made it illegal for members of "Communist Action Groups" to apply for passports. Caute, *The Great Fear*, 254.

13. Dean Acheson, as quoted in James Fleming, "Passport Refusals for Political Reasons: Constitutional Issues and Judicial Review," *Yale Law Journal* 61, no. 2 (February 1952): 173.

14. Others chose not to go to Canada because of the espionage trials that took place in the mid-1940s. Anhalt, *A Gathering of Fugitives*, 35.

15. Melani McAlister, *Epic Encounters: Culture, Media, and U.S. Interests in the Middle East, 1945–2000* (Berkeley: University of California Press, 2001), 46. See also Ernest May, ed., *American Cold War Strategy: Interpreting NSC 68* (Boston: Bedford Books of St. Martin's Press, 1993), 130–51.

16. Eric Zolov, "Discovering a Land 'Mysterious and Obvious': The Renarrativizing of Postrevolutionary Mexico," in *Fragments of a Golden Age: The Politics of Culture in Mexico since 1940*, ed. Gilbert M. Joseph, Anne Rubenstein, and Eric Zolov (Durham, N.C.: Duke University Press, 2001), 248. For a broader perspective on the Cold War in Latin America, see Greg Grandin, *The Last Colonial Massacre: Latin America in the Cold War* (Chicago: University of Chicago Press, 2000), and Gilbert M. Joseph and Daniela Spenser, eds., *In from the Cold: Latin America's New Encounters with the Cold War* (Durham, N.C.: Duke University Press, 2008).

17. This "counterreform" is described in Stephen R. Niblo, *Mexico in the 1940s: Modernity, Politics and Corruption* (Wilmington, Del.: Scholarly Resources Press, 1999); Barry Carr, *Marxism and Communism in Twentieth-Century Mexico* (Lincoln: University of Nebraska Press, 1992); and Alan Riding, *Distant Neighbors: A Portrait of the Mexicans* (New York: Vintage Books, 1986), among other sources.

18. The strikes in Mexico of the mid- to late 1950s are examined in W. Dirk Raat, *Mexico and the United States: Ambivalent Vistas* (Athens: University of Georgia Press, 1992); Norman Caulfield, *Mexican Workers and the State: From the Porfiriato to NAFTA* (Fort Worth: Texas Christian University Press, 1998); Peter Smith, "Mexico since 1946: Dynamics of an Authoritarian Regime," in *Mexico since Independence*, ed. Leslie Bethel (Cambridge: Cambridge University Press, 1991); and Kevin Middlebrook, *The Paradox of Revolution: Labor, the State, and Authoritarianism in Mexico* (Baltimore: Johns Hopkins University Press, 1995).

19. George Lipsitz, *American Studies in a Moment of Danger* (Minneapolis: University of Minnesota Press, 2001), 17.

20. While I am using this phrase to specifically describe the position of the Cold War exiles, Nicholas De Genova articulates the necessity for a "critical transnational

perspective" in reference to his study "to dislodge some of the dominant spatial ide-
ologies that undergird a prevalent common sense about the naturalized difference
between the United States and Mexico, as well as between the United States and
Latin America more generally." De Genova, *Working the Boundaries: Race, Space,
and "Illegality" in Mexican Chicago* (Durham, N.C.: Duke University Press, 2005), 95.

21. These nationalist aesthetic parameters include the U.S. Cold War state's
political uses of abstract expressionism during the early Cold War period. See Serge
Guilbaut, *How New York Stole the Idea of Modern Art: Abstract Expressionism, Free-
dom and the Cold War* (Chicago: University of Chicago Press, 1983); Erica Doss,
"The Art of Cultural Politics: From Regionalism to Abstract Expressionism," in
Recasting America: Culture and Politics in the Age of Cold War, ed. Lary May (Chicago:
University of Chicago Press, 1989); Max Kozloff, "American Painting during the
Cold War," *Artforum* 11, no. 9 (May 1973): 43–54; and Eva Cockcroft, "Abstract
Expressionism: Weapon of the Cold War," *Artforum* 12, no. 10 (June 1974): 39–41.
As May explains, the U.S. state was also aligned with the Hollywood film industry
during the early Cold War era. May, "Movie Star Politics: Hollywood and the Mak-
ing of Cold War Americanism," in *The Big Tomorrow: Hollywood and the Politics of
the American Way* (Chicago: University of Chicago Press, 2000). See also Francis
Stoner Saunders, *The Cultural Cold War: The CIA and the World of Arts and Letters*
(New York: W.W. Norton, 1999).

22. John Fousek argues that the Cold War was influenced by an ideology of
American nationalist globalism that referred back to American exceptionalist ideas
of "America's national mission and destiny." *To Lead the Free World: American Nation-
alism and the Cultural Roots of the Cold War* (Chapel Hill: University of North Caro-
lina Press, 2000), 187.

23. Gordon Kahn's *A Long Way from Home* and Hugo Butler's film *Los pequeños
gigantes* (1958) along with *Salt of the Earth* (1953), written, produced, and directed
by blacklisted screenwriters, share a critical perspective on Mexican American life in
the United States and narrate economic inequalities between Mexicans and U.S.
citizens. These films can be contrasted with those produced by the USIA, such as
And Now, Miguel (1953), as well as Hollywood films that focus on Mexican culture,
including *Viva Zapata!* (1952). (See chapters 3 and 4.) See also my analysis of
Willard Motley's nonfictional "My House Is Your House" and his novel "Tourist
Town," published as *Let Noon Be Fair* (1966), in chapter 5.

24. I agree with scholar Amy Kaminsky that *voluntary exile* is an "oxymoron
that masks the cruelly limited choices imposed on the subject." See Kaminsky, *After
Exile: Writing the Latin American Diaspora* (Minneapolis: University of Minnesota
Press, 1999), 9.

25. According to Mae Ngai, the Walter-McCarran Act "provided for the de-
naturalization of naturalized citizens if within 10 years of naturalization one was
cited for contempt for refusing to testify about subversive activity." Mae Ngai, *Im-
possible Subjects: Illegal Aliens and the Making of Modern America* (Princeton, N.J.:
Princeton University Press, 2004), 239.

26. As mentioned in chapter 1, while most of the African American artists and writers who left the United States had experienced some kind of harassment because of their association with the Communist Party or in organizations that attorney Tom Clark deemed "subversive," others left because of the racist environment of the United States in the immediate post–World War II era.

27. In the film industry, screenwriters did encounter some "black market" work, whereby they wrote scripts under pseudonyms. In their interpretations of this work, film historians Ceplair and Englund argue that "Considerations of political/social content in a script . . . became unheard of luxuries for men and women blacklisted because of their political views. Ninety-nine percent of the material that one encountered on the black market did not, in any case, 'lend itself' to making 'statements.'" Larry Ceplair and Stephen Englund, *The Inquisition in Hollywood: Politics in the Film Community, 1930–1960* (Berkeley: University of California Press, 1983), 406–7.

28. Draft of letter from Dalton Trumbo to John Bright, c. 1958. Dalton Trumbo Collection, Wisconsin Center for Film and Theater Research, State Historical Society of Wisconsin Archives and Manuscripts, Madison, Wisconsin. (This collection is hereafter cited as DTC, WCFTR.)

29. John Bright, "Letter to Friends," May 28, 1957, 4. DTC, WCFTR.

30. See chapter 6. Others who saw their lives in Mexico as temporary included poet George Oppen and his wife Mary Oppen. Mary noted in her memoirs that "We were in exile in a country we had chosen only because we could enter Mexico without a passport when a passport was refused us. . . . We were not expatriates by choice, and we were unrelenting in withholding ourselves from becoming exiles forever. We wanted more than anything to return home to the United States." *Meaning a Life: An Autobiography* (Santa Barbara, Calif.: Black Sparrow Press, 1978), 200.

31. Another screenwriter who frequently worked in the Mexican film industry was John Bright, who wrote scripts for Mexican film productions starting at the time he arrived in the early 1950s, through the help of his friend Pedro Armendáriz, one of Mexico's most famous movie stars. Two of the screenplays he wrote were based on the novels of German exile B. Traven, including *La rebelión de los colgados (The Rebellion of the Hanged)* (1954), about a worker's revolt during the early part of the Mexican Revolution and *Canasta de cuentos mexicanos (A Basket of Mexican Stories)* (1955), based on Traven's short stories. The director of *La rebelión de los colgados* was Alfredo Crevanna, a refugee from the pre-Hitler Universum Film AG who had worked with director Fritz Lang; the producer of the film was Holocaust refugee José Cohen; and the cinematographer was Gabriel Figueroa. See John Bright, *Worms in the Winecup: A Memoir* (Lanham, Md.: Scarecrow Press, 2002). Before he was deported in 1958, Bright developed a film project, as he described it, "organized on a broad collective basis of numerous artists," which had "the full support of the unions." (John Bright, "Letter to Dalton Trumbo," September 22, 1957, 2. DTC, WCTFR.) Other Hollywood exiles who wrote for films produced in Mexico include Albert Maltz, who wrote the screenplay for *Flor de Mayo (Beyond All*

Limits) (1957), and Hugo Butler, who worked on a screen adaptation for *La escondida* (The Hidden One) (1955).

32. Stacy Morgan has asserted that muralism, a cultural form associated with the Works Progress Administration (WPA) of the 1930s, was not in "a state of dormancy" during the 1940s and 1950s until the emergence of the Black Art and Chicano movements of the 1960s. *Rethinking Social Realism: African American Art and Literature, 1930–1953* (Athens: University of Georgia Press, 2004), 71.

33. Romare Bearden and Harry Henderson, *A History of African American Artists from 1792 to the Present* (New York: Pantheon Books, 1993), 419.

34. Most of the scholarship on U.S. culture of the early Cold War era focuses on dominant culture, including Stephen J. Whitfield's *The Culture of the Cold War* (Baltimore: Johns Hopkins University Press, 1991).

35. Melani McAlister, "Can This Nation Be Saved?" *American Literary History* 15, no. 2 (Summer 2003): 423.

36. Ibid. McAlister here is referring to Paul Gilroy's *The Black Atlantic: Modernity and Double Consciousness* (Cambridge, Mass.: Harvard University Press, 1993); George Lipsitz's *Dangerous Crossroads: Popular Music, Postmodernism, and the Politics of Place* (London, New York: Verso, 1994); Lisa Lowe's *Immigrant Acts: On Asian American Cultural Politics* (Durham, N.C.: Duke University Press, 1996); and José David Saldívar's *Border Matters: Remapping American Culture Studies* (Berkeley: University of California Press, 1997).

37. See José Limón, *American Encounters: Greater Mexico, the United States, and the Erotics of Culture* (Boston: Beacon Press, 1998); Claire F. Fox, *The Fence and the River: Culture and Politics at the U.S.–Mexico Border* (Minneapolis: University of Minnesota Press, 1999); Eric Zolov, *Refried Elvis: The Rise of the Mexican Counterculture* (Berkeley: University of California Press, 1999); and Seth Fein, *Transnational Projections: The United States in the Golden Age of Mexican Cinema* (Durham, N.C.: Duke University Press, forthcoming). See also the edited collections *Imagining Our America: Toward a Transnational Frame*, ed. Sandhya Shukla and Heidi Tinsman (Durham, N.C.: Duke University Press, 2007), and *Hemispheric American Studies*, ed. Caroline F. Levander and Robert S. Levine (New Brunswick, N.J.: Rutgers University Press, 2008).

38. Michael Denning, *The Cultural Front: The Laboring of American Culture in the 20th Century* (London: Verso, 1996).

39. See Morgan, *Rethinking Social Realism;* and James Edward Smethurst, *The Black Arts Movement: Literary Nationalism in the 1960s and 1970s* (Chapel Hill: University of North Carolina Press, 2005).

40. Stacy Morgan examines the work of Charles White, John Wilson, and Willard Motley, among others, in *Rethinking Social Realism.* Bill Mullen mentions the work of Willard Motley, Margaret Taylor Goss Burroughs, Elizabeth Catlett, and Charles White in *Popular Fronts.* Alan Wald analyzes Gordon Kahn's novel *A Long Way from Home* (1989) in *Writing from the Left: New Essays on Radical Culture and Politics* (London: Verso, 1994).

41. Some of the scholars who have written about this exodus include Brian Neve, *Film and Politics in America: A Social Tradition* (New York: Routledge, 1992); and Paul Buhle and Dave Wagner, *Hide in Plain Sight: The Hollywood Blacklistees in Film and Television, 1950–2002* (New York: Palgrave, 2003). These authors describe many of the films produced by blacklisted Hollywood screenwriters and directors who left the United States for France, England, and other parts of Western Europe, but few if any works of blacklisted screenwriters in Mexico.

42. See Gilroy, *The Black Atlantic;* Tyler Stovall, *Paris Noir: African Americans in the City of Light* (Boston: Houghton Mifflin, 1996); Kevin Gaines, *American Africans in Ghana: Black Expatriates and the Civil Rights Era* (Chapel Hill: University of North Carolina Press, 2006); and Wendy W. Walters, *At Home in Diaspora: Black International Writing* (Minneapolis: University of Minnesota Press, 2005).

43. Paul Gilroy argues that once in France, African American writer Richard Wright started to envision "links between the struggles against racial subordination inside America and wider, global dimensions of political antagonisms." (Gilroy, *The Black Atlantic,* 154.) Gaines describes how individuals who went to Ghana in the late 1950s and early 1960s, including Julian Mayfield, "risked official censure by articulating a vision of global democracy as a critical alternative to a U.S. liberalism unwilling to interrogate the racism that belied its universalist claims and aspirations" (Gaines, *American Africans in Ghana,* 7). Gaines also asserts that "Cold War rivalry with the Soviet Union heightened the significance of racial discrimination against African Americans. The all-too-frequent incidence of antiblack brutality throughout the postwar era imperiled U.S. attempts to secure the allegiance of this global majority of nonwhite nations. Thus, for African Americans to criticize U.S. racism from abroad was certain to provoke an irate response from U.S. officialdom" (Ibid., 12).

44. This scholarship includes writings on the exchange between African American and Mexican artists during the 1920s as described in Lizzetta LeFalle-Collins and Shifra M. Goldman, *In the Spirit of Resistance: African American Modernists and the Mexican Muralist School* (New York: American Federation of Arts, 1996); and Adriana Williams, *Covarrubias* (Austin: University of Texas Press, 1994). Gerald Horne has written more recently about the involvement of African Americans in political struggles in Mexico, specifically the Mexican Revolution, in *Black and Brown: African Americans and the Mexican Revolution, 1910–1920* (New York: New York University Press, 2005).

1. Routes Elsewhere

1. Julian Zimet, letter to Patrick McGilligan and Paul Buhle, published in *Tender Comrades: A Backstory of the Hollywood Blacklist* (New York: St. Martin's Press, 1997), 726.

2. Elizabeth Catlett, interview with author, Cuernavaca, Mexico, June 8, 1999.

3. Mary Dudziak writes about how violence against African Americans increased in the postwar era, noting that "In the years following World War II, a wave

of violence swept the South as African American veterans returned home. Lynchings and beatings of African Americans, sometimes involving local law enforcement officials, were covered in the media in this country and abroad." According to Dudziak, "The violence spawned protests and demands that the federal government take steps to alleviate that brutality and other forms of racial injustice." Mary Dudziak, *Cold War Civil Rights: Race and the Image of American Democracy* (Princeton, N.J.: Princeton University Press, 2000), 23.

4. However, government support for African American artists was limited. Willard Motley described in an article that many African American artists worked full time in other careers, leaving only the evenings for their art. Willard F. Motley, "Negro Art in Chicago," *Opportunity* 18 (January 1940): 19–22, 28.

5. Lisa Farrington, *Creating Their Own Image: The History of African American Women Artists* (New York: Oxford University Press, 2005), 97.

6. This was an investigation of the Federal Theater Project. Bruce Bustard, *A New Deal for the Arts* (Washington, D.C.: National Archives and Records Administration and University of Washington Press, 1997), 123.

7. Individuals with progressive political views who worked for the WPA were affected by this bill. For example, Gwendolyn Bennett, who served as a director of the WPA-funded Harlem Community Arts Center, was fired for her political views at this time. Melanie Anne Herzog, *Elizabeth Catlett: An American Artist in Mexico* (Seattle: University of Washington Press, 2000), 143.

8. Bustard, *A New Deal for the Arts,* 123, 126.

9. Patricia Hills, *Social Concern and Urban Realism: American Painting of the 1930s* (Boston: Boston University Press, 1983), 41.

10. Mullen, *Popular Fronts,* 191.

11. Charles White, interview with Betty Lochrie Hoag, March 9, 1965. Archives of American Art, Smithsonian Institution, Washington, D.C., 22.

12. Ibid.

13. Farrington, *Creating Their Own Image,* 96.

14. Ibid., 117.

15. Lizzetta LeFalle-Collins, "African American Modernists and the Mexican Muralist School," in LeFalle-Collins and Goldman, *In the Spirit of Resistance,* 64.

16. However, a number of politically progressive gallery owners, both white and African American, welcomed African Americans to exhibit their work during the 1940s. In New York, the ACA (American Contemporary Art) Gallery and the Downtown Gallery showed the work of African American artists, as did the Barnett-Aden Gallery, the first private gallery of African American art in Washington, D.C.

17. Morgan, *Rethinking Social Realism,* 21.

18. The Rosenwald Foundation gave money specifically to African American organizations, artists, and writers.

19. See Tyler Stovall, "Life on the Left Bank," in Stovall, *Paris Noir.*

20. Other African American artists who traveled to Mexico during this period included Sargent Johnson, John Biggers, and Harold Winslow.

21. Mullen, *Popular Fronts,* 191.

22. Elizabeth Catlett, interview with author, Cuernavaca, Mexico, June 8, 1999.

23. Margaret Taylor Goss Burroughs, interview with Anna M. Tyler, November 11, December 5, 1988, Archives of American Art, Smithsonian Institution, Washington, D.C., 59. Here she is referring to how, because of Truman's anti-Communist executive orders, both government and private employers could fire employees on the basis of their supposed "political disloyalty."

24. Other U.S. artists who were working at the Taller de Gráfica Popular at this time included Mariana Yampolsky, Robert Mallary, Albert Steiner, and Harold Winslow. Visitors included Marshall Goodman, Max Kahn, Jules Heller, and Mitch and Eleanor Coen. Elizabeth Catlett, interview with author, Cuernavaca, Mexico, June 8, 1999.

25. LeFalle-Collins, "African American Modernists," 43.

26. John Woodrow Wilson, interview with Robert Brown, August 9, 1994, Archives of American Art, Smithsonian Institute, Washington, D.C., 60–61.

27. Ibid., 343.

28. Howard Fast, *Being Red* (Boston: Houghton Mifflin, 1990), 332.

29. It is important to note that HUAC had first gone to Hollywood to investigate "Communist subversion" in 1939. Martin Dies, then chairman of the committee, had informed studio executives in Hollywood of the employees whom he believed had political allegiances to the Communist Party. At that time, the studio executives said that there was nothing that they could do because these employees were under contract. Dies conducted a series of closed hearings in 1940 and gave Hollywood "a clean bill of health," as he apparently was not able to find evidence to support claims of Communist infiltration. See Neil Gabler, *An Empire of Their Own: How the Jews Invented Hollywood* (New York: Crown Publishers, 1988), 354.

30. Ibid., 366.

31. Victor Navasky, *Naming Names* (New York: Penguin, 1991), 174.

32. Thom Anderson, "The Time of the Toad," *20th Film Festival Rotterdam Program* (1990), 19.

33. Some of the Hollywood exiles were also married to artists and writers. Albert Maltz's wife Margaret Larkin was a folklorist, playwright, and novelist. In the 1920s, she recorded the songs and stories of Ella May Wiggins, a union activist who was shot during a strike in Gastonia, North Carolina, in 1929. Larkin also wrote a play and edited a collection of cowboy songs in the early 1930s. Asa Zatz was married to dancer Waldeen (nee Falkenstein) who had left the United States for Mexico in the 1940s to work with contemporary dance groups.

34. Bright's former wife, Josefina Fierro, was living in Mexico City after leaving the United States in the late 1940s to escape political persecution for her involvement in the National Congress of Spanish-Speaking Peoples in Los Angeles. Mario

Garcia, *Memories of Chicano History: The Life and Narrative of Bert Corona* (Berkeley: University of California Press, 1994), 116.

35. Bercovici initially fled to Mexico and later, once he received a passport, to Italy. Leonardo Bercovici, interview with Paul Buhle, in McGilligan and Buhle, *Tender Comrades,* 30.

36. Tony Kahn, *Blacklisted,* Public Radio International, 1996.

37. Anhalt, *A Gathering of Fugitives,* 60.

38. Helen Manfull, ed., *Additional Dialogue: The Letters of Dalton Trumbo, 1942–1962* (New York: M. Evans, 1970), 286n33.

39. Rouverol, *Refugees from Hollywood,* 9, 11.

40. HUAC had issued a subpoena to Butler on April 11, 1951 (Hugo Butler's FBI file #100-HQ-321017).

41. I have preserved quotations as they originally appeared, including the exiles' mistakes in Spanish. The correct word is *mordida,* meaning "little bite," which is a bribe, here referring to bribery of Mexican immigrant officials. *Inmigrante* is a level of residency status more desirable than that of "tourist," what most Americans received after arriving in Mexico. Dalton Trumbo, letter to Gordon Kahn, August 8, 1951, in Manfull, *Additional Dialogue,* 227.

42. Dalton Trumbo, letter to Hugo Butler, July 16, 1951. DTC, WCFTR.

43. Rouverol, *Refugees from Hollywood,* 6.

44. Dalton Trumbo, letter to Hugo Butler, August 6, 1951, in Manfull, *Additional Dialogue,* 224.

45. Dalton Trumbo, letter to Hugo Butler, June 25, 1951, Ibid., 217. Apparently, Trumbo's visa status in Mexico was a matter of concern to him. In the same letter, Trumbo questioned Butler about the possibility of transferring $40,000 to a Mexican bank upon entering Mexico in order to receive *"capitalisto" [capitalista]* status. According to Trumbo biographer Bruce Cook, that would have made it easier to secure an *inmigrante* visa in Mexico. Both Trumbo and Butler initially settled for *turista* status, although it meant they were temporary residents in Mexico. Bruce Cook, *Dalton Trumbo* (New York: Charles Scribners' Sons, 1977), 228.

46. Rouverol, *Refugees From Hollywood,* 17.

47. Ibid., 25.

48. Surprisingly, Rossen then returned to the United States to appear before HUAC in June 1951. Alan Casty, *The Films of Robert Rossen* (New York: Museum of Modern Art, 1969), 29.

49. The project was turned down because, in Zimet's words, "Luther ended up betraying the peasantry." Julian Zimet, correspondence with author, August 1998.

50. Zimet, letter in McGilligan and Buhle, *Tender Comrades,* 726.

51. Dalton Trumbo, letter to Hy and Rheata Kraft, May 4, 1952, in Manfull, *Additional Dialogue,* 230.

52. Among others, Angus Cameron, an editor at Little, Brown, was blacklisted from mainstream publishing houses. Cameron later started a press with Albert

Kahn. Cameron & Kahn published numerous texts by left-wing writers during the 1950s that mainstream presses would not, including John Wexley's *The Judgment of Julius and Ethel Rosenberg* (New York: Cameron & Kahn, 1955).

53. Fast, *Being Red*, 331.

54. The Joint Anti-Fascist Refugee Committee was included on the attorney general's list of "subversive" organizations.

55. Natalie Robbins, *Alien Ink: The FBI's War on Freedom of Expression* (New York: W. Morrow, 1992), 240.

56. Fast, *Being Red*, 329–31.

57. Rachel Blau DuPlessis, ed., *The Selected Letters of George Oppen* (Durham, N.C.: Duke University Press, 1990), xvi.

58. Oppen, *Meaning a Life*, 194. George Oppen had applied for a passport to go to France and was denied. DuPlessis, *The Selected Letters of George Oppen*, 367n.

59. Anhalt, *A Gathering of Fugitives*, 223. Once in Mexico, he met Diego Rivera, David Alfaro Siqueiros, and Leopoldo Méndez and worked on writing a book about Mexican mural painting and muralists. See Charles Humboldt papers, Manuscripts and Archives, Sterling Memorial Library, Yale University. (This collection is hereafter cited as CHC, YMA.)

60. Rob Kroes, *Photographic Memories: Private Pictures, Public Images, and American History* (Hanover, N.H.: Dartmouth College Press, 2007), 136. While in Mexico, Timberman worked as a still photographer on the set of *La rebelión de los colgados*, a film based on B. Traven's novel. Rouverol, *Refugees from Hollywood*, 117.

61. Some African American writers went to Paris during the post–World War II period, including Richard Wright, James Baldwin, and Chester Himes. See Stovall, *Paris Noir*.

62. For example, on May 3, 1950, Motley spoke about culture and the H-bombs at a talk on "Humanity vs. the H-bombs," sponsored by the Chicago Council of the Arts, Sciences and Professions. Willard Motley Collection, Rare Books and Special Collections, Northern Illinois University. (This collection is hereafter cited as WMC, NIU.)

63. "The Return of Willard Motley," *Ebony* XIII (December 1958): 88.

64. Willard Motley, *We Fished All Night* (New York: Appleton-Century-Crofts, 1951), 450.

65. The Harlem Writers Guild was both a literary group and an association that promoted political activism. Sharon Howard, "Harlem Writer's Guild," in *Encyclopedia of African American Culture and History*, Vol. 3, ed. Jack Salzman, David Smith, and Cornel West (New York: Macmillan Library Reference, 1996), 1219–20.

66. In this passage, she uses pseudonyms for her friends Joan and Al Sandler and Ruth Baharas. Audre Lorde, *Zami: A New Spelling of My Name* (Trumansburg, N.Y.: The Crossing Press, 1982), 149.

67. Alexis De Veaux, *Warrior Poet: A Biography of Audre Lorde* (New York: W.W. Norton, 2004), 42.

230 . . . Notes to Chapter 1

68. Alan Riding characterizes modern Mexico by its "massive industrialization, chaotic urbanization, high economic growth rates, emergence of a big-spending middle-class and neglect of social problems." *Distant Neighbors,* 80.

69. Carr, *Marxism and Communism,* 145.

70. Colin M. McLachlan and William H. Beezley, *El Gran Pueblo: A History of Greater Mexico,* 3rd ed. (Upper Saddle River, N.J.: Prentice Hall, 2004), 393.

71. Carr, *Marxism and Communism,* 145.

72. U.S. Embassy, Mexico City, to Department of State, April 19, 1948, Records of Foreign Service Posts of the Department of State, U.S. Embassy, Mexico City, General Records, 1941–1949, Box 70. National Archive Record Group 84 (hereafter cited as NARG 84), File: 800C "Communism."

73. Department of State to U.S. Embassy, Mexico City, October 14, 1950, State Department Central Files, National Archive Record Group 59 (hereafter cited as NARG 59). The full content of this communication was not available, as passport materials are closed for seventy-five years after a person's death.

74. U.S. Embassy, Mexico City, to Secretary of State, December 28, 1950, State Department Central Files, NARG 59, 712.001/12–2850.

75. Diana Anhalt notes that the Mexican government would view these "unofficial extraditions" as problematic if they knew that agencies of the U.S. government were involved, because then the United States would be interfering in Mexico's legal processes. *A Gathering of Fugitives,* 144.

76. "The Rosenberg Case," *Columbia Law Review* (February 1954): 233n57.

77. Albert Maltz, letter to Herbert Biberman, October 29, 1951. Albert Maltz Collection, Wisconsin Center for Film and Theater Research, State Historical Society of Wisconsin Archives and Manuscripts. (This collection is hereafter cited as AMC, WCFTR.)

78. Gil Green, *Cold War Fugitive: A Personal Story of the McCarthy Years* (New York: Internatioinal Publishers, 1984), 99.

79. Carr, *Marxism and Communism,* 191. According to Joseph Starobin, the Communist underground had three different categories: "One category was known as the 'deep freeze.' It consisted of the men who had evaded jail and who were now to go into prolonged hiding.... The second category was known as the 'deep, deep freeze.' It consisted of trusted cadres who had not necessarily been prominent but who were viewed as the ultimate source of leadership and responsibility in case all other levels of leadership had been discovered and arrested. Many of these had been sent abroad—to Mexico, Europe, and Canada. The third category was known as the 'O.B.U.,' the 'operative but unavailable' leadership, consisting of cadres who moved about the country, often disguised." Joseph Starobin, *American Communism in Crisis, 1943–1957* (Cambridge, Mass.: Harvard University Press, 1972), 221.

80. Green, *Cold War Fugitive,* 100.

81. Ibid.

82. Pamphlet edited by the Comisión Organizadora del Comité de Defensa de

Los Derechos Humanos (Organizing Commission for the Defense Committee of Human Rights), *En defensa de la soberanía de México* (México, D.F.: s.e., s.f., October 1951).

83. Albert Maltz, letter to Herbert Biberman, October 29, 1951. AMC, WCFTR.

84. Oppen, *Meaning a Life*, 194–95.

85. Cook, *Dalton Trumbo*, 228.

86. Albert Maltz, letter to Herbert Biberman, October 29, 1951. AMC, WCFTR.

87. Ibid.

88. Ibid.

89. In a revised edition of *Terry's Guide to Mexico*, Norman explained that "In Mexico resident status is either provisional *(inmigrante)* or permanent *(inmigrado)*. After going through the hoops of provisional residence which must be renewed annually for five years, one's status becomes permanent. During the five-year *inmigrante* period gainful activity is limited to a job or work authorized by the Minister of Interior. . . . When residence becomes permanent (after five years) you are permitted to engage in almost any legitimate employment or business." James Norman, *Terry's Guide to Mexico* (New York: Doubleday, 1965), 28.

90. Ibid., 59.

91. For example, Butler renewed his tourist visa every six months from the time of his arrival through July 7, 1953, when he was granted *inmigrante* status. He then had to apply to Gobernación every year to have his visa renewed. Six years later, on July 28, 1959, Butler qualified for *inmigrado* status (Immigration and Naturalization Service interview with Hugo Butler, January 19, 1959, from Hugo Butler's FBI file #100-HQ-321017).

92. Denaturalization proceedings could be enacted against naturalized U.S. citizens, like Gordon Kahn, born in Hungary, and Hugo Butler, born in Canada, if deported from Mexico. (See chapter 3.)

93. According to Article 33 of the Mexican Constitution, in addition to their abstention from political activity in Mexico, noncitizens could not be employed as manual laborers, work in bars, invest in a media enterprise, or own property within a certain number of meters from the coast. If they disobeyed this law, the president could deport them without a hearing. Frederick Vanderbilt Field, *From Right to Left: An Autobiography* (Westport, Conn.: Lawrence Hill, 1983), 293.

94. Not only political activity but also writing about controversial topics in local newspapers could affect a U.S. citizen's immigration status in Mexico. Eudora Garrett, a friend of Audre Lorde, was an American journalist who wrote a critical article about the Morton Sobell case for a Mexican newspaper, which resulted in her visa being changed from *inmigrado* to *inmigrante*. This "demotion" meant that while she could still work in Mexico, she could not own property. She told Lorde that this was "one way of getting uppity Americans to keep their mouths shut." Lorde, *Zami*, 163.

95. Cook, *Dalton Trumbo*, 228.

96. Most of the African American artists and writers who relocated to Mexico came from Northern cities, including Chicago, Boston, and New York, where public spaces were not segregated to the same degree as in the South.

97. John Woodrow Wilson, interview with Robert Brown, August 9, 1994, 345–46.

98. Ibid., 346.

99. Willard Motley, "The States Again," in "My House Is Your House," 4. WMC, NIU.

100. Ibid.

101. De Veaux, *Warrior Poet*, 49. (From Audre Lorde's unpublished journal, undated entry 1954, 2. Audre Lorde papers, Special Collections, Spelman College Archives, Atlanta, Georgia.)

102. Lorde, *Zami*, 158.

103. John Bright, interview with Bruce Cook, in Cook, *Dalton Trumbo*, 226.

104. Diana Anhalt, correspondence with author, August 6, 1998.

105. Bob Heller had been hired to produce a Spanish-language version of *Howdy Doody* for Mexican television.

106. Dalton Trumbo, letter to Hugo Butler, July 16, 1951, in Manfull, *Additional Dialogue*, 218.

107. Albert Maltz, letter to Herbert Biberman, May 3, 1951. AMC, WCFTR.

108. Albert Maltz, letter to "Friends," September 17, 1951. AMC, WCFTR.

109. John Woodrow Wilson, interview with Brown, 346.

110. Margaret Taylor Goss Burroughs, interview with Anna M. Tyler, November 11, December 5, 1988, 60.

111. Julian Zimet, correspondence with author, August 1998.

112. Oppen, *Meaning a Life*, 195.

113. Rouverol, *Refugees from Hollywood*, 33.

114. Oppen, *Meaning a Life*, 196. Bernard Gordon and the Oppens were good friends of Julian Zimet. The Gordons stayed with the Oppens from September through December of 1950 and left Mexico shortly afterward. Bernard Gordon, correspondence with author, August 1998.

115. Anhalt, *A Gathering of Fugitives*, 73.

116. An example of this would be the series of articles on Communists in Cuernavaca published in *Excélsior*. (See chapter 3.)

117. Garcia, *Memories of Chicano History*, 178. An examination of Butler's FBI file indicates that they were well aware that Diego Rivera was Butler's neighbor (Hugo Butler's FBI file #100-HQ-321017).

118. According to Zimet, Bob Allen put himself at risk by sheltering him, because the Associated Press was frequently pressured by the State Department and the U.S. Embassy in Mexico City. Zimet, letter in McGilligan and Buhle, *Tender Comrades*, 726.

119. Ibid., 730.

120. DuPlessis, *The Selected Letters of George Oppen,* xvi.

121. Zimet, letter in McGilligan and Buhle, *Tender Comrades,* 74.

122. Rouverol, *Refugees from Hollywood,* 45–47.

123. Anhalt, *A Gathering of Fugitives,* 91–93.

2. The Politics of Form

1. Hills, *Social Concern and Urban Realism,* 14.

2. Mauricio Tenorio-Trillo, "The Cosmopolitan Mexican Summer: 1920–1949," *Latin American Research Review* 32, no. 3 (1997): 224.

3. See James Oles, *South of the Border: Mexico in the American Imagination, 1914–1947* (Washington, D.C.: Smithsonian Institution Press, 1993).

4. Denning, *The Cultural Front,* 12–13.

5. Other examples include the Workers Film and Photo League, known as the Film and Photo League after 1933, which was part of a cultural movement sponsored by the Communist International. Russell Campbell, *Cinema Strikes Back: Radical Filmmaking in the United States, 1930–1942* (Ann Arbor: University of Michigan Press, 1982), 29.

6. Hills, *Social Concern and Urban Realism,* 15.

7. Quoted in Laurence E. Schmekebier, *Modern Mexican Art* (Minneapolis: University of Minnesota Press, 1939), 31.

8. Miguel Covarrubias, "Modern Art," in *Twenty Centuries of Mexican Art,* ed. Museum of Modern Art (New York: The Museum of Modern Art, 1940), 138.

9. Shifra Goldman, "Mexican Muralism: Its Influence in Latin America and the United States," in *Dimensions of the Americas: Art and Social Change in Latin America and the United States* (Chicago: University of Chicago Press, 1994), 103.

10. Ibid.

11. Raquel Tibol, foreword, LeFalle-Collins and Goldman, *In the Spirit of Resistance,* 12.

12. Octavio Paz, "Social Realism in Mexico: The Murals of Rivera, Orozco and Siqueiros," *Artscanada* 36 (December 1979–January 1980): 56.

13. David Shapiro, "Social Realism Reconsidered," in *Social Realism: Art as a Weapon,* ed. David Shapiro (New York: Frederick Unger, 1973), 28n1.

14. Ibid.

15. As Miguel Covarrubias describes, "Rivera, who had labored in Paris through a three-year period as [a] cubist, returned to Mexico by way of Italy, where he saw the great frescoes, the Byzantine mural mosaics, and the Etruscan relics that recalled to him the plastic strength of ancient Mexican art." Covarrubias, "Modern Art," 138.

16. Shifra Goldman, "The Mexican School, Its African Legacy, and the 'Second Wave' in the United States," in LeFalle-Collins and Goldman, *In the Spirit of Resistance,* 70.

17. Siqueiros was a delegate for the Liga de Escritores y Artistas Revolucionarios (League of Revolutionary Writers and Artists) to the First American Artists Congress.

18. Milton Brown, "Social Art in America, 1930–1945," in *Social Art in America, 1930–1945* (New York: ACA Galleries, 1981), 10.

19. Even before federal programs such as the PWAP and the WPA were established, the College of Art Association began a relief program called the Emergency Work Bureau (EWB) in New York, which was at one point financed by the Temporary Emergency Relief Administration, a New York State agency (Hills, *Social Concern and Realism,* 10). Artists working within the EWB formed the Artists Union in 1933, which took up the role of bargaining agent for the artists and published the journal *Art Front* with the Artists Committee of Action. In later years, the Artists Union protested cutbacks to the WPA, which stopped hiring artists in 1936, as well as layoffs in 1936, 1937, and 1938.

20. Ibid. (Other art-sponsored projects were organized under the Treasury Department.)

21. Ibid., 11.

22. Other agencies included the Federal Security Administration (FSA), which operated between 1937 and 1943.

23. However, segregated African American arts centers operated in New York, Illinois, Florida, North Carolina, Louisiana, and elsewhere.

24. The Harlem Artist's Guild was set up in order to address racial discrimination in the WPA.

25. Bearden and Henderson, *A History of African American Artists,* 239. Sources include *Art Digest* 13 (April 15, 1939): 15; *Opportunity* 14 (April 1936): 114; and *The Crisis* 46 (March 1939): 79–80.

26. Bearden and Henderson, *A History of African American Artists,* 236.

27. LeFalle-Collins, "African American Modernists," 30.

28. The work of José Clemente Orozco, for example, was included in the famous 1933 John Reed Club show in New York, titled "The Social Viewpoint in Art." This show also featured the work of Stuart Davis, Ben Shahn, Käthe Kollwitz, and Thomas Hart Benton. Denning, *The Cultural Front,* 65.

29. Charles Alston, interview with Harlan Phillips, September 28, 1965. Transcripts in Charles Alston papers, Smithsonian Institution, Archives of American Art, Washington, D.C., 4.

30. Ibid., 14.

31. Mullen, *Popular Fronts,* 77. Mullen mentions that Charles White worked with artists Edward Millman, Edgar Britton, and Mitchell Siporin, all of whom had traveled to Mexico to work with *los tres grandes.*

32. Alison Cameron, "Buenos Vecinos: African American Printmaking and the Taller de Gráfica Popular," *Print Quarterly* XVI, no. 4 (1999): 358.

33. Bearden and Henderson, *A History of African American Artists,* 408.

34. Morgan, *Rethinking Social Realism*, 63.

35. In this chapter, I focus on the influence of Mexican artists on Catlett's early print work. However, Elizabeth Catlett also studied at the National School of Painting and Sculpture with Mexican sculptors including Francisco Zúñiga, who taught her about pre-Hispanic artmaking techniques.

36. Herzog, *Elizabeth Catlett*, 53.

37. Mullen, *Popular Fronts*, 93.

38. See Alain Locke, "Chicago's New Southside Art Center," *Magazine of Art* 34 (August–September 1941).

39. Mullen, *Popular Fronts*.

40. Samella Lewis, *The Art of Elizabeth Catlett* (Los Angeles: Museum of African Art, 1984), 159.

41. Camille Billops, interview with Elizabeth Catlett, October 1, 1989. *Artists and Influence* 10 (1991): 20.

42. In addition, they met Langston Hughes, Paul Robeson, and Dorothy and Kenneth Spencer. While in Harlem, Catlett also became chairperson of the Russian War Relief in Harlem, a role that caused difficulty for her when she tried to get a visa to travel to the United States in the 1960s.

43. Herzog, *Elizabeth Catlett*, 56.

44. In New York, Catlett was also involved with the Arts Committee of the National Negro Congress, one of the largest Popular Front organizations active in Harlem during the 1930s and 1940s, and taught ceramics at the Marxist-based Jefferson School of Social Science. (Ibid., 36.)

45. Bearden and Henderson, *A History of African American Artists*, 422.

46. Gwendolyn Bennett had previously run the Harlem Artists Guild and the Harlem Community Arts Center.

47. Lewis, *The Art of Elizabeth Catlett*, 19.

48. Elizabeth Catlett, "Responding to Cultural Hunger," in *Reimagining America: The Arts of Social Change*, ed. Mark O'Brien and Craig Little (Philadelphia: New Society Publishers, 1990).

49. Letter from Mrs. William C. Haywood, acting director for fellowships, Julius Rosenwald Fund, to Elizabeth Catlett. April 25, 1945. Papers of Charles White, Archives of American Art, Smithsonian Institution, Washington, D.C.

50. Camille Billops, Interview with Elizabeth Catlett, 21.

51. Catlett, "Responding to Cultural Hunger," 246.

52. Herzog, *Elizabeth Catlett*, 70.

53. Helga Prignitz, *El Taller de Gráfica Popular en México, 1937–1977* (México: Instituto Nacional de Bellas Artes, 1992), 55.

54. In the 1930s, Siqueiros, Orozco, and many other Mexican artists became associated with LEAR. Visual artists who were members of LEAR were involved in mural projects sponsored by the Mexican government. They also organized international artists' conferences and sent members to conferences held elsewhere.

55. Deborah Caplow, *Leopoldo Méndez: Revolutionary Art and the Mexican Print* (Austin: University of Texas Press, 2007), 94. This position, in which the organization took a confrontational stance against the Mexican government, changed significantly after the emergence of the Popular Front.

56. Covarrubias, "Modern Art," 138.

57. See Caplow, *Leopoldo Méndez.*

58. Ibid., 98–99.

59. Ibid., 99.

60. Elizabeth Catlett, interview with author, Cuernavaca, Mexico, June 1999.

61. Elizabeth Catlett, quoted in Samella Lewis, "Elizabeth Catlett," in *Elizabeth Catlett: Works on Paper, 1944–1992,* ed. Jeanne Zeidler (Hampton, Va.: Hampton University Museum, 1993), 9.

62. Goldman, "The Mexican School," 58.

63. This focus on international issues was in part related to the presence of exiles from Germany and Spain in the Taller de Gráfica Popular. One of these exiles was Hannes Meyer, who had been involved with the Bauhaus in Germany.

64. Dawn Ades, "The Mexican Mural Movement," in *Art in Latin America: the Modern Era, 1820–1980* (New Haven: Yale University Press, 1989), 188.

65. Susan Richards, "Imagining the Political: El Taller de Gráfica Popular in Mexico, 1937–1949" (Ph.D. dissertation, University of New Mexico, 2001), viii.

66. Floyd Coleman, *A Courtyard Apart: The Art of Elizabeth Catlett and Francisco Mora* (Biloxi: Mississippi Museum of Art, 1990), 13.

67. See El Taller de Gráfica Popular, *Estampas de la Revolución Mexicana* (México: La Estampa Mexicana, 1947).

68. Ibid., 152. Hannes Meyer further elaborated on this statement in an essay he wrote and edited for *T.G.P. México: El Taller de Gráfica Popular: Doce años de obra artística colectiva* in 1949: "The question of the TGP's future is in practice identical with that of the Mexican nation and of the revolutionary forces within. An art that is true to the life of the people is inseparably bound to their destiny. Mexico, along with the other Latin American countries, is exposed to economic and cultural invasion from their 'good neighbors' to the north. [Eighty percent] of Mexico's trade is with the United States. This is a threat to the Mexican national economy on all fronts, to industry, education, and art—to the entire achievement of the Mexican Revolution, in short." "The Workshop of Popular Graphic Art in Mexico," in *T.G.P. México: El Taller de Gráfica Popular: Doce años de obra artística colectiva / The Workshop for Popular Graphic Art: A Record of Twelve Years of Collective Work,* ed. Hannes Meyer (México: La Estampa Mexicana, 1949), xxii.

69. James M. Wechsler, "Propaganda Grafica: Printmaking and the Radical Left in Mexico, 1920–50," in *Mexico and Modern Printmaking: A Revolution in the Graphic Arts, 1920–1950,* ed. John Ittman (New Haven, Conn.: Yale University Press, 2006), 75.

70. Herzog, *Elizabeth Catlett,* 58–59.

71. Elizabeth Catlett, interview with author, June 1999.

72. Herzog, *Elizabeth Catlett*, 60.

73. Ibid., 59. (From "Paintings, Sculpture and Prints of the Negro Woman," in the possession of Elizabeth Catlett.)

74. The Barnett-Aden Gallery was the first private gallery of African American art in Washington, D.C. It was founded in 1943 by Alonzo Aden and James Herring, who opened the gallery to provide a space for all artists, especially African American artists, to show their work.

75. Herzog, *Elizabeth Catlett*, 70.

76. By the time of publication, Catlett had become a full member of the Taller de Gráfica Popular. Herzog, *Elizabeth Catlett*, 70. See also *T.G.P. México*.

77. Interview with John Woodrow Wilson by Robert F. Brown, August 9, 1994. (Archives of American Art, Smithsonian Institution, Washington, D.C.), 301.

78. Ibid., 319.

79. Soon after arriving, Wilson met U.S. exile Philip Stein, Siqueiros's assistant, who was experimenting with "fast-working" materials, such as paint used for automobiles and vinylite, a plastic, for use in outdoor murals.

80. Interview with John Woodrow Wilson by Robert F. Brown, 340.

81. Ades, "The Mexican Mural Movement," 170.

82. In his interview with Robert Brown, Wilson mentions when asked that he was "interested in some other social philosophy or direction" because "clearly capitalism or whatever I was living in wasn't working for me, it wasn't working for black people" (336).

83. John Wilson, "Biography" (1990), Papers of John Wilson, Reel 4876, Archives of American Art, Smithsonian Institution, Washington, D.C.

84. Interview with John Woodrow Wilson by Robert F. Brown, 342–43.

85. Ibid., 342.

86. The National Association for the Advancement of Colored People (NAACP) and the International Labor Defense (ILD) were involved in extensive antilynching campaigns during the 1930s. Although these organizations had proposed numerous bills to Congress and the Senate, federal antilynching legislation was not enacted owing to the intransigence of white politicians in the South. Marlene Park, "Lynching and Anti-Lynching: Art and Politics in the 1930s," *Prospects* 18 (1993): 311–65.

87. Drawing on the work of Kenneth Burke, Denning notes that "the arts of the 'cultural front' are better characterized as a 'proletarian grotesque' than as any kind of social realism." Denning, *The Cultural Front*, 123.

88. Ibid.

89. The Mexican government had established a law for the Protection of National Monuments. See Philip Stein, *The Mexican Murals* (México: Editur, 1991). Siqueiros had also created a mural of a lynching earlier in his career, which suggests his interest in representations of racial violence in the United States.

90. Catlett picked Tubman, and although there is some confusion in the scholarship on the Taller de Gráfica Popular, Burroughs, not Wilson, produced the image of Sojourner Truth. See Herzog, *Elizabeth Catlett*, 203nn60–61.

91. Because of their association with the Communist Party or so-called Communist "front" organizations, Du Bois and Robeson's passports were revoked by the State Department so that they could not travel outside the United States. See Horne, *Black and Red.*

92. "Veinte años de vida del Taller de Gráfica Popular" ("20 Years of the Taller de Gráfica Popular"), *Artes de México* 3, no. 18 (1957).

93. Elizabeth Catlett, "The Negro People and American Art," *Freedomways* (Spring 1961): 76.

94. David Shapiro and Cecile Shapiro, "Abstract Expressionism: The Politics of Apolitical Painting," *Prospects: An Annual of American Cultural Studies* 3 (1977): 183.

95. Ibid., 203.

96. As opposed to the work of African American artists, it is interesting to note that the State Department promoted the music of African American jazz musicians as both "universal" and uniquely American. See Penny von Eschen, *Satchmo Blows Up the World: Jazz Ambassadors Play the Cold War* (Cambridge, Mass.: Harvard University Press, 2004).

97. Saunders, *The Cultural Cold War,* 254.

98. See note 21 of the introduction for a list of studies that focus on U.S. governmental agencies' use of abstract expressionism during the early Cold War period.

99. Shapiro and Shapiro, "Abstract Expressionism," 206. David and Cecile Shapiro write that the CIA took the job away from the United States Information Agency (USIA), which when it sponsored art exhibitions abroad would not include nonrepresentational art forms, as some Congressmen considered that work to be "communistic." See also Francis Stonor Saunders, "Yanqui Doodles," in *The Cultural Cold War.*

100. Cockcroft, "Abstract Expressionism," 40.

101. The connection of abstraction with a "free" society was first made by Clement Greenberg in his essay "Avant-garde and Kitsch," originally published in *Partisan Review* in the fall of 1939. It was later published in Clement Greenberg, *Art and Culture: Critical Essays* (Boston: Beacon Press, 1961).

102. Bearden and Henderson, *A History of African American Artists,* 414. Clothier has also suggested that White's work was "profoundly at odds with much of the art of its time, yet profoundly consonant with a history of a particular people at a particular time." Peter Clothier, "Story of White's Art," *Freedomways* 20, no. 3 (1980): 141.

103. Morgan, *Rethinking Social Realism,* 24.

104. Ibid., 303.

105. The USIA also limited the dissemination of their work abroad: it would not exhibit the work of "avowed Communists, persons convicted of crimes involving a threat to the security of the United States, or persons who publicly refused to answer questions of congressional committees regarding connection with the Commu-

nist movement." William Hauptman, "The Suppression of Art in the McCarthy Decade," *Artforum* (October 1973): 49.

106. Other artists who exhibited their work at the gallery included William Gropper, Jack Levine, Moses and Raphael Soyer, Philip Evergood, Anton Refregier, and Robert Gwathmey.

107. He had been represented by Boris Mirski's gallery in Boston. Lois Tarlow, "John Wilson" *Art New England* 19, no. 5 (August/September 1998): 21–23.

108. Margaret Taylor Goss Burroughs, lecture at the opening of "Highlights from the Atlanta University Collection of Afro-American Art," at the High Museum of Art in 1973, as quoted from Winifred Stoelting, "The Atlanta Years: A Biographical Sketch," in *Hale Woodruff: 50 Years of His Art* (New York: Studio Museum in Harlem, 1979), 24.

109. Eva Cockcroft, "The United States and Socially Concerned Latin American Art: 1920–1970," in *The Latin American Spirit: Art and Artists in the United States, 1920–1970*, ed. Luis B. Cancel (New York: H. N. Abrams and the Bronx Museum of the Arts, 1988), 202.

110. Quoted in John Pittman, "He Was an Implacable Critic of His Own Creations," *Freedomways* 20, no. 3 (1980): 191.

111. John Wilson started making prints at Blackburn's studio in the late 1950s after working as an illustrator for the Packinghouse Workers Union in Chicago. Interview with Wilson by Brown, 365–67.

112. Cameron, "Buenos Vecinos," 364.

113. During the 1950s, the CNA also started a publication, *Freedom*, which later became *Freedomways*.

114. Benjamin Horowitz, "Images of Dignity," in Charles White and Benjamin Horowitz, *Images of Dignity: The Drawings of Charles White* (Los Angeles: Ward Ritchie Press, 1967), 24.

115. Richard J. Powell, *Black Art: A Cultural History* (London: Thames and Hudson Ltd., 2002), 117. Stacy Morgan, in *Rethinking Social Realism*, details Charles White's other activities once he returned to the United States, including his involvement as a contributing editor for *New Masses* and later *Masses and Mainstream*, as well as publishing his work in *Freedom* and *The Daily Worker* (23).

116. Mullen, *Popular Fronts*, 192.

117. As a response to her rejection from the South Side Community Art Center, Burroughs helped found the Ebony Museum, later the DuSable Museum of African American history. (Ibid.)

118. Burroughs, interview with Anna M. Tyler, November 11, December 5, 1988, 64.

119. Ibid., 67.

120. Her speech, "The Negro People and American Art," was also available for a broader audience when it was published in the first issue of *Freedomways* in the spring of 1961.

121. Catlett, "The Negro People and American Art," 79.

122. Ibid., 78.

123. Pittman, "He Was an Implacable Critic," 191.

124. Saunders, *The Cultural Cold War*, 291.

3. Allegories of Exile

1. Chris Trumbo, interview with Bruce Cook, *Dalton Trumbo*, 234.

2. Barbara Foley, *Radical Representations: Politics and Form in U.S. Proletarian Fiction 1929–1941* (Durham, N.C.: Duke University Press, 1993), 327.

3. See introduction. According to Gordon Kahn's son Tony Kahn, his father was aware that if he was deported, he could be denaturalized. Tony Kahn, *Blacklisted*, Public Radio International, 1996.

4. While the Smith Act of 1940 declared that immigrants with U.S. citizenship could be deported if they had been found to be members of organizations that advocated the violent overthrow of the United States, it was not until 1950, with the passage of the Internal Security Act, that the U.S. government viewed the Communist Party as this type of organization. Caute, *The Great Fear*, 226–27.

5. U.S. Embassy, Mexico City, to the Secretaría de Relaciones Exteriores, April 16, 1951. In a letter of response dated April 20, 1951, Manuel Tello of the Secretaría de Relaciones Exteriores stated that Kahn had not applied for Mexican citizenship. Diana Anhalt received these letters under a Freedom of Information Act request to the FBI. These letters were included in Gordon Kahn's FBI file. (I would like to thank Diana Anhalt for sharing this letter with me.)

6. Norma Barzman, "Upheaval in Hollywood," in *The Un-Canadians: True Stories of the Blacklist Era*, ed. Len Scher (Toronto: Lester Publishers, 1992), 267.

7. Denning, *The Cultural Front*, 7.

8. Ibid., 130.

9. Fousek, *To Lead the Free World*, 187.

10. Seth Fein, "From Collaboration to Containment: Hollywood and the International Political Economy of Mexican Cinema after the Second World War," in *Mexico's Cinema: A Century of Film and Filmmakers*, ed. Joanne Hersfield and David Maciel (Wilmington, Del.: Scholarly Resources, 1999), 126.

11. Oppen, *Meaning a Life*, 194.

12. Ibid., 200.

13. Ibid., 199. DuPlessis, *The Selected Letters of George Oppen*, xvii. Although George Oppen had worked as a carpenter in the United States, he could not legally receive a salary because of his residency status and thus could not work as a manual laborer in Mexico. Instead, he set up a furniture workshop with a Mexican partner, Carlos Ayala.

14. Ian Hunter, interview with Bruce Cook, in Cook, *Dalton Trumbo*, 232.

15. Albert Maltz, letter to Herbert Biberman, May 3, 1951, 3. AMC, WCFTR.

16. In a letter to Hy Kraft, Trumbo wrote, "I was a fool for coming down here. The line of supply to my living source is so tenuous that when I do work the

people who owe me for it mistake my absence for my death, and simply do not pay without the strongest kind of pressure being exerted." Dalton Trumbo, letter to Hy Kraft, April 6, 1953, in Manfull, *Additional Dialogue*, 268.

17. Dalton Trumbo, letter to Michael Wilson, November 15, 1953, in Manfull, *Additional Dialogue*, 278.

18. Crawford Kilian, "Growing Up Blacklisted" (unpublished), 13.

19. John Woodrow Wilson, interview with Robert Brown (Washington, D.C.: Archives of American Art, Smithsonian Institution, August 9, 1994), 350.

20. Willard Motley, "My House Is Your House" (unpublished), 145. WMC, NIU. Langston Hughes, whose father lived in Mexico, had a slightly different opinion. He wrote in 1940 that *gringo* is a "term that carries with it distrust and hatred." Hughes, *The Big Sea: An Autobiography* (New York: Hill and Wang, 1940), 40.

21. See Robert Cromie, "New Motley Novel Near Completion," *Chicago Tribune*, "Books Today" section, October 18, 1964, 10.

22. Lorde, *Zami*, 154, 156.

23. Elizabeth Catlett, interview with author, June 8, 1999, Cuernavaca, Mexico.

24. Motley, "My House Is Your House," 147. WMC, NIU.

25. Wilson, interview with Brown, 351.

26. Robert Fleming, *Willard Motley* (Boston: G.K. Hall, 1973), 135. However, scholars such as Marco Polo Hernández Cuevas have more recently argued that people of African ancestry in Mexico have been, since colonial times, positioned even further down the racial hierarchy than have "*indios*" (indigenous Mexicans). Hernández Cuevas, *African Mexicans and the Discourse of the Modern Nation* (Lanham, Md.: University Press of America, 2003), 75, 81.

27. Motley, "My House Is Your House," 430. WMC, NIU.

28. While the U.S. Embassy in Mexico City had been monitoring the Communist Party in Mexico since the late 1940s, it was not until the 1950s that it started a formal "anti-Communist campaign."

29. William O'Dwyer to the Department of State, January 18, 1951. State Department Central Files, 1950–1954. NARG 59, 712.001/1851. The letter also referred to a memorandum dated January 4, 1951, entitled "Need to Inject Elements of Reality into Latin American Comprehension of the Communist Menace."

30. "Cuernavaca convertida en nido de rojos prófugos de EEUU" (Cuernavaca Converted into a Nest of Red Refugees from the United States), *Excélsior*, October 8, 1951, 1.

31. Albert Maltz, letter to Herbert Biberman, October 29, 1951. AMC, WCFTR.

32. Anhalt, *A Gathering of Fugitives*, 102, 107. There is also evidence that both the U.S. Embassy and the State Department exerted pressure on U.S. journalists in Mexico. Bob Allen, who worked as an Associated Press correspondent in Mexico, informed Julian Zimet that he and other AP correspondents were "subject to pressures from the American Embassy in Mexico City, as well as the State Department." Julian Zimet, letter in McGilligan and Buhle, *Tender Comrades*, 54. If one

did not submit to these pressures, the U.S. Embassy might try to coerce Mexican governmental agencies to retaliate.

33. Motley, "My House Is Your House," 158. WMC, NIU.

34. Ibid., 161–62.

35. Ibid., 167.

36. Franklin C. Gowen, counselor of the U.S. Embassy, Mexico City, for the ambassador, letter to the Department of State, October 10, 1951, 1. Records of the Foreign Service Posts of the Department of State, Files of U.S. Embassy, Mexico City. NARG 84, 711.001/10–1051.

37. Ibid. (The translation of the article from Spanish was conducted by a U.S. Embassy employee.)

38. According to Maltz, Motley was drinking one night with friends at a hotel bar when the Texan demanded that the manager make Motley leave because he was African American. The hotel manager refused, and that night Motley and his friends shouted statements like "Down with Texas, down with the United States, Viva Stalin, Viva the Soviet Union" from the verandah of the hotel. Albert Maltz never met Motley but described his behavior during the 1951 hotel incident as "irresponsible bohemianism." (Maltz, letter to Biberman, October 29, 1951, 3. AMC, WCFTR.) This event became misconstrued in one of the *Excélsior* articles, which was later reframed for an American audience by Richard English in "Mexico Clamps Down on Stalin" (*Saturday Evening Post,* August 30, 1952, 16–17, 41–44). English's version of the incident purposely omits Motley's role, focusing instead on the Hollywood exiles, none of whom was actually present at the hotel. Motley also describes this incident in his unpublished nonfictional book about Mexico, "My House Is Your House." However, according to Motley, the Texan who Maltz indicated had spoken to the manager about Motley's presence at the hotel had actually ignored Motley while being introduced to him. When Motley returned to his table, his friend Bill provokingly shouted "Viva Russia" because an "unofficial" spy for the FBI, whom Motley and his friends referred to as "Porky," had joined the crowd on the verandah of the Bella Vista hotel. (Motley had learned that "Porky," a self-appointed FBI agent, went to the U.S. Embassy every week with a report on the "Communists of Cuernavaca.") Motley, "My House Is Your House," 166. WMC, NIU.

39. The U.S. expatriates and European émigrés who lived in Cuernavaca were apparently surprised when the U.S. exiles arrived. In a barely fictionalized version of her life in Cuernavaca during the 1950s, author Martha Gellhorn wrote, "The trouble was that no one in Tule had ever heard of American refugees; the residents were uncertain how to act. The European residents thought this rather a joke on the American residents; where they came from dictators and invading army's produced refugees." Martha Gellhorn, *The Lowest Trees Have Tops* (New York: Dodd, Mead, 1967), 19.

40. Others listed included Gordon Kahn, Willard Motley, Ross Evans, Charles McCabe, Martha Gellhorn, Ernest Ammans, Pilar Ammans, Bob Cutters, John Szekelys (alias "Pen"), Bob Williams, Kitty Williams, Margaret McKittrick, Dr. Frank

Baumbach, and Leda Baumbach. "Cuernavaca convertida en nido de rojos prófugos de EEUU," 13.

41. Franklin C. Gowen, counselor of the U.S. Embassy, Mexico City, for the ambassador, letter to the Department of State, October 10, 1951, 1. Records of the Foreign Service Posts of the Department of State, Files of U.S. Embassy, Mexico City. NARG 84, 711.001/10–1051.

42. U.S. Embassy, Mexico City, to U.S. State Department, January 2, 1952. Records of Foreign Service Posts of the Department of State, Files of U.S. Embassy, Mexico City, 1950–1954, Classified, Box 4. NARG 84, 712.001/1–252.

43. Franklin C. Gowen, counselor of U.S. Embassy, Mexico City, for the ambassador, to U.S. State Department, February 7, 1952. Records of Foreign Service Posts of the Department of State, Files of U.S. Embassy, Mexico City, 1950–1954, Classified, Box 4. NARG 84, 712.001/1–252.

44. Maltz, letter to Biberman, October 29, 1951, 2. AMC, WCFTR.

45. "Cuernavaca convertida en nido de rojos prófugos de EEUU," 1.

46. Willard Motley went to the U.S. Embassy, where he was told "that's the way things are done in Mexican newspapers"—in other words, "There were deals under the table with money involved and you had people written up in a good or bad light by paying for it" (Motley, "My House Is Your House," 164–65, WMC, NIU). Albert Maltz had written a letter in response to English's article "Mexico Clamps Down on Stalin," but it was not printed. Maltz then sent the letter to *The Nation*, which did publish it.

47. In response to the appearance of his name in the *Excélsior* articles, Gordon Kahn was concerned that he and his family might be deported and went to see their attorney to sue the newspaper. It was Dalton Trumbo's lawyer who had suggested that he have a party to invite certain Mexican politicians as a way to establish relationships with these officials. Jean Rouverol, who attended the party with other Hollywood exiles, remembers that Trumbo hired a mariachi band and that there was dancing. She recollects that the Mexican politicians brought their mistresses to the party and danced with the wives of the blacklisted screenwriters. Jean Rouverol, interview with Bruce Cook, in Cook, *Dalton Trumbo*, 229.

48. Albert Maltz, letter to Herbert Biberman, October 29, 1951. AMC, WCFTR.

49. Joel Gardner, *Citizen Writer in Retrospect: Oral History of Albert Maltz* (completed under the auspices of the Oral History Program of the University of California, Los Angeles, 1983), 843–44.

50. Ibid., 846–47. After five years, Maltz requested the visa status of an *inmigrado*, which allowed him to work in Mexico and to own property. Maltz was not the only U.S. exile to receive assistance from Mexican governmental agencies or sympathetic Mexican citizens who attempted to reverse interventions by U.S. governmental agencies. During the early 1950s, Donald Jackson, a committee member of HUAC, came to Mexico City and held a conference with the mayor, which resulted in the censorship of the Butlers' mail. This occurred at a time when the

Butlers had depleted their savings to such an extent that they had to send letters to family and friends asking for loans in exchange for a percentage of Hugo Butler's interest in the film *The Adventures of Robinson Crusoe*. When they had not received any responses a few weeks after mailing the letters, Jean Rouverol called her mother, who she discovered had sent a number of checks about two weeks earlier. Jean was friendly with her mailman and asked if he knew what happened to their mail, to which he responded that it was being inspected and censored for political reasons. Her mailman was sympathetic and made arrangements for her to meet his supervisor at the post office to discuss the matter. The supervisor told her that he would investigate her case, and within an hour the mailman returned with their letters, in Jean's view because "this was Mexico and not the United States," and thus "no effort was made to hide the government's interference; all the letters had simply been waylaid and left on a shelf somewhere . . . contents included." Rouverol, *Refugees from Hollywood*, 67.

51. Ceplair and Englund, *The Inquisition in Hollywood*, 404.

52. Ibid.

53. John Howard Lawson, as quoted in Navasky, *Naming Names*, 390.

54. Rouverol, *Refugees from Hollywood*, 34.

55. Seth Fein, "Motion Pictures, 1930–1960," in *Encyclopedia of Mexico: History, Society and Culture*, ed. Michael S. Werner (Chicago: Fitzroy-Dearborn Publishers, 1997), 969.

56. The Banco Cinematográfico was established in 1942; however, the Mexican state reorganized it into the Banco Nacional Cinematográfico. Fein, "From Collaboration to Containment," 146.

57. John King, *Magical Reels: A History of Cinema in Latin America* (New York: Verso, 1990), 129.

58. This "cinematic crosscurrent" had a significant impact on Mexican cinema, as I discuss later in the book. Ernesto Acevedo-Muñoz has written about how Buñuel was instrumental to the shift from the "classical" style of Emilio Fernández and Gabriel Figueroa to the New Cinema movement in Mexico in the early 1960s. Ernesto Acevedo-Muñoz, *Buñuel and Mexico: The Crisis of National Cinema* (Berkeley: University of California Press, 2003), 76.

59. Rouverol, *Refugees from Hollywood*, 47.

60. Luis Buñuel, *My Last Sigh* (New York: Alfred A. Knopf, 1983), 107.

61. Joanne Hersfield, *Mexican Cinema/Mexican Woman, 1940–1950* (Tucson: University of Arizona Press, 1996), 122.

62. Baxter notes that Buñuel once wrote that he had a "revulsion for conventional capitalist cinema." John Baxter, *Buñuel* (New York: Carroll & Graf, 1998), 132. As opposed to the political project of this type of filmmaking, Buñuel wrote that if he could, he would direct films that "apart from entertaining the audience would convey to them the absolute certainty that they DO NOT LIVE IN THE BEST OF ALL POSSIBLE WORLDS." He continued, "and in doing this I believe that my

intentions would be highly constructive. Movies today, including the so-called neo-realist, are dedicated to a task contrary to this. How is it possible to hope for an improvement in the audience—and consequently in the producers—when every day we are told in these films, even in the most insipid comedies, that our social institutions, our concepts of country, religion, love etc., etc., power, while perhaps imperfect, UNIQUE AND NECESSARY? The true 'opium of the audience' is conformity; and the entire, gigantic film world is dedicated to the propagation of this comfortable feeling, wrapped though it is at times in the insidious disguise of art." Robert Hughes, ed., *Film Book 1: The Audience and the Filmmaker* (New York, Grove Press, 1959) 41.

63. Acevedo-Muñoz, *Buñuel and Mexico*, 58. Buñuel's distance from the aesthetics of documentary realism is apparent in *Land without Bread*, a film that differs substantially from that of documentary filmmaker Joris Ivens, who directed *The Spanish Earth* (1937).

64. The attack on Buñuel was part of a larger campaign by Hollywood studios against OCIAA films being produced at MoMA. According to John Baxter, the Hollywood studios viewed MoMA as competition (Baxter, *Buñuel*, 184).

65. As his biographer John Baxter notes, "until the 1970s, when he [Buñuel] hired an immigration lawyer to clear his name, he would be subjected to interrogation and surveillance every time he entered the U.S." (ibid., 187).

66. Ibid., 184.

67. While in California, Buñuel socialized with other European émigrés, including René Clair, Man Ray, Erich von Stroheim, and various Spanish exiles. Buñuel and Man Ray even wrote a treatment for a film entitled "The Sewers of Los Angeles" about people who lived in a huge garbage dump outside the city (ibid., 191).

68. As mentioned in the introduction, after World War II, foreign artists, notably those on the Left, were frequently linked with subversive activities, and some, like Bertolt Brecht, Hans Eisler, and Charlie Chaplin, were forced or pressured to leave the United States during this period. This general view was what encouraged Luis Buñuel to relocate to Mexico. Taylor, *Strangers in Paradise*, 243.

69. John Steinbeck, who had seen Dancigers's work on *The Pearl* (1946), suggested that he be hired to co-produce *Viva Zapata!*, which was originally scheduled to be shot in Mexico. However, when the legal department at Twentieth-Century Fox did some research on Dancigers and discovered his Communist Party background, they rejected Steinbeck's suggestion. Baxter, *Buñuel*, 199.

70. While he was visiting Mexico, Buñuel had dinner with Mexican writer Fernando Benítez, who was the secretary to the Interior Minister. Benítez told Buñuel that he could help him obtain residency papers. Benítez later introduced him to the Interior Minister, Héctor Pérez Martínez, who was sympathetic toward Spaniards, as well as a writer. Martínez told Buñuel, "Return to the United States and we will issue an order to the Consulate so that you can come and live in this country." José

de la Colina and Tomás Pérez Turrent, *Objects of Desire: Conversations with Luis Buñuel* (New York: Marsilio Publishers, 1992), 46. In 1948, Buñuel applied for Mexican citizenship.

71. Baxter, *Buñuel*, 199.

72. Ibid., 205.

73. Acevedo-Muñoz, *Buñuel and Mexico*, 67.

74. The U.S. government had denied Figueroa a visa to enter the country after he had been offered a three-year contract by John Ford, presumably because he was friends with blacklisted screenwriters in Hollywood. Years later, when John Huston wanted to hire him in the early 1980s, the U.S. government again denied him entry into the United States. Julia Preston, obituary for Gabriel Figueroa Mateos, *New York Times*, April 29, 1998, Section B, 9.

75. Buñuel had wanted to place irrational elements, such as a one-hundred-piece symphony orchestra in a vacant lot, which would have been seen, in Buñuel's words, "in the blink of an eye and only have been noticed by one spectator in a hundred, who would have been left in doubt, thinking it might only have been an illusion." He commented further that these elements were "an attempt not to follow the story line to the letter, to achieve a 'photographic' reality" (de la Colina and Turrent, *Objects of Desire*, 63).

76. Ibid., 61.

77. Baxter, *Buñuel*, 207.

78. According to Jeannette Pepper Bello, there were one hundred investors in *The Adventures of Robinson Crusoe*, 80 percent of whom were musicians. Jean Rouverol, correspondence with author, July 24, 1998.

79. Buñuel, *My Last Sigh*, 191.

80. While there were two versions of the film, one in English and one in Spanish, I analyze the English language version.

81. Martin Green, *Dreams of Adventure, Deeds of Empire* (New York: Basic Books, 1979), 5.

82. Brett McInelly, "Expanding Empires, Expanding Selves: Colonialism, The Novel and *Robinson Crusoe*," *Studies in the Novel* 35, no. 1 (Spring 2003): 5.

83. In the novel, Crusoe derives pleasure from exile, in his "mastering" of his island environment, which is lessened only by the idea of an Other's (savage/cannibal) presence: "I was now in my twenty-third year of residence in this island, and was so naturalized to the place, and to the manner of living, that could I have but enjoyed the certainty that no savages would come to the place to disturb me, I could have been content to have capitulated for spending the rest of my time there, even to the last moment, till I had laid me down and dy'd." Daniel Defoe, *Robinson Crusoe* (New York: Penguin Books, 1965), 185.

84. Peter Hulme, *Colonial Encounters: Europe and the Native Caribbean, 1492–1797* (London: Methuen, 1986), 200.

85. de la Colina and Turrent, *Objects of Desire*, 92.

86. McInelly has written about Defoe's Friday in this way (McInelly, "Expanding Empires," 16).

87. Víctor Fuentes, *Buñuel en México: Iluminaciones sobre una pantalla pobre* (Teruel and Zaragoza: Instituto de Estudios Turolenses and Gobierno de Aragón, 1993), 93. I would like to thank Annette Rodriguez for her help with the translation of this passage.

88. Marvin D'Lugo, "Hybrid Culture and Acoustic Imagination: The Case of *Robinson Crusoe*" in *Luis Buñuel: New Readings,* ed. Peter William Evans and Isabel Santaolalla (London: British Film Institute, 2004), 91.

89. David Bordwell and Kristin Thompson, *Film Art: An Introduction,* 5th ed. (New York: McGraw-Hill Companies, 1997), 109.

90. David James, *Allegories of Cinema: American Film in the 1960s* (Princeton, N.J.: Princeton University Press, 1993), 23.

91. Bordwell and Thompson, *Film Art,* 11.

92. Buñuel, *My Last Sigh,* 132.

93. Ana M. López, "Crossing Nations and Genres," in *Visible Nations: Latin America Cinema and Video,* ed. Chon A. Noriega (Minneapolis: University of Minnesota Press, 2000), 34.

94. In an interview conducted by Tony Richardson for *Sight and Sound,* Buñuel noted that *The Adventures of Robinson Crusoe* was not in any way a Hollywood film (Tony Richardson, "The Films of Luis Buñuel," *Sight and Sound,* January 1954, 130). Acevedo-Muñoz argues that some of Buñuel's films made in Mexico, including *The Adventures of Robinson Crusoe,* were distinctly "non-Mexican" (Acevedo-Muñoz, *Buñuel and Mexico,* 13).

95. Hamid Naficy, "Between Rocks and Hard Places: The Interstitial Mode of Production in Exilic Cinema," in *Home, Exile, Homelands: Film, Media, and the Politics of Place,* ed. Hamid Naficy (New York: Routledge, 1999), 134.

96. Marsha Kinder, *Blood Cinema: The Reconstruction of National Identity in Spain* (Berkeley: University of California Press, 1993), 287.

97. D'Lugo, "Hybrid Culture and Acoustic Imagination," 93. Here D'Lugo is also referring to the work of M. de la Vega Hurtado, "The American Buñuel: *The Young One* and the Politics of Exile," *Nuevo Texto Crítico,* 21/22, 1998, 237; and Fuentes, *Buñuel en México,* 93.

98. Fuentes, *Buñuel en México,* 92.

99. Kahn was part of the original Hollywood 19 who had been subpoenaed to appear before HUAC in 1947.

100. Alan Wald attributes Kahn's decision to narrate his experience of exile through that of a Mexican American draft dodger as stemming from the context of the Cold War years when many left-wing writers were "looking to people of color as symbols of resistance," and as such they "created non-white characters as the major spokespersons to explain and dramatize the themes of counter-hegemonic culture." Wald, *Writing from the Left,* 153. Furthermore, Wald notes that Kahn wrote the

novel during "the peculiar 'moment' of the witch-hunt era in which leftists who did not bail out through naming names and bathetic confessions found their ability to pursue their literary careers as widely as possible, even as whites, blocked—blocked by a stigma. This stigma, vastly intensified from what it was in the 1930s and 1940s, was their being targeted for demonization and for unofficial as well as official black-listing through the ideology of 'anticommunism,' which in the form characteristic of the McCarthy era has marked similarities to racism, anti-Semitism, and homophobia" (Ibid., 160).

101. Tony Kahn, *Blacklisted*, Public Radio International, 1996.

102. G. D. Keller, preface to Gordon Kahn, *A Long Way from Home* (Tempe, Ariz.: Bilingual Press, 1989).

103. Carl R. Shirley, "*Pocho:* Bildungsroman of a Chicano," *Revista Chicano-Riqueña*, VII, 2, Spring 1979, 63.

104. Ramón Ruiz, "On the Meaning of *Pocho*," in José Antonio Villarreal, *Pocho* (New York: Anchor Books, 1970), xi.

105. Santiago Daydí-Tolson, "Gordon Kahn's *A Long Way from Home:* A Wishful Journey," in *A Long Way from Home*, 6–7.

106. See Garcia, *Memories of Chicano History;* Mario T. Garcia, *Mexican-Americans: Leadership, Ideology, and Identity, 1930–1960* (New Haven: Yale University Press, 1989); George J. Sánchez, *Becoming Mexican-American: Ethnicity, Culture and Identity in Chicano Los Angeles* (New York: Oxford University Press, 1998); and Curtis Marez, *Drug Wars: The Political Economy of Narcotics* (Minneapolis: University of Minnesota Press, 2004).

107. This political activity influenced Cultural Front filmmakers to produce both novels and films about Mexican Americans in the 1940s and 1950s. These include Joseph Losey's *The Lawless* (1949), Herbert Biberman and Paul Jarrico's *Salt of the Earth* (1954), and Orson Welles's *Touch of Evil* (1957). Blacklisted screenwriter Phil Stevenson, who published under the name of Lars Lawrence, wrote a series of novels, including *Morning, Noon and Night* (1954), *Out of the Dust* (1956), *Old Father Antic* (1961), and *The Hoax* (1961), which focused on the lives of Mexican American miners.

108. Before her involvement in El Congreso, Fierro had run the Motion Picture Democratic Committee (MPDC), which elected progressives to state and national office, and later the MDC, supported by the MPDC and the Mexican consul.

109. During the summer of 1942, there was a backlash against Mexican migrants in Los Angeles in the form of a reported "crime wave," at which time a Mexican American man, José Díaz, was killed in Los Angeles, and seventeen young men, most of whom were Mexican American, were arrested. The ensuing legal battle was referred to as the "Sleepy Lagoon" case, the name for a reservoir where one of the men had been beaten up by rival gang members.

110. From Albert Camarillo's interview with Josefina Fierro, 1995, Reel 5. Special Collections, Greene Library, Stanford University. Stacy Morgan argues that

"agitation for racial justice was one of the prominent causes for persecution of progressive cultural producers by HUAC." *Rethinking Social Realism,* 22.

111. Denning, *The Cultural Front,* 7.

112. Ibid., 130.

113. Bordwell and Thompson, *Film Art,* 479.

114. The introduction to chapter 11 includes the point of view of Bishop.

115. For a good overview of modernism's aesthetic innovations, see Peter Nicholls's *Modernisms: A Literary Guide* (Berkeley: University of California Press, 1995).

116. The parallel between Kahn's story and that of the main character has been noted by other scholars. Alan Wald suggests that "Kahn's escape to Mexico to avoid a subpoena to 'name names' may have struck him as analogous to the situation of a Chicano fleeing across the border to escape a summons to extend U.S. hegemony to Korea." Wald, *Writing from the Left,* 160.

117. Kahn, *A Long Way From Home,* 48 (hereafter cited in text with page numbers).

118. Barbara Foley explains that in the work of proletarian novelists mentor characters "elucidate arguments and ideas that can not necessarily be inferred from the story." Foley, *Radical Representations,* 332.

119. Ibid., 327.

120. *Paz* (Peace) was a periodical in Mexico during the 1950s. It appears from this segment of the novel that Kahn is referring to a specific issue. In addition to quoting political leaders, this issue of *Paz* contains the cultural work of Mexicans and others who were against the war. Gil glances at woodcuts by Taller members "Zalce, Chávez-Morado, Leopoldo Méndez and Pablo O'Higgins," and reads an article on Diego Rivera, noting to himself that "maybe this had something to do with peace also." Kahn, *A Long Way from Home,* 427.

121. Alan McPherson, *Intimate Ties, Bitter Struggles: The United States and Latin America since 1945* (Washington, D.C.: Potomac Books, 2006), 24.

122. Mae Ngai argues that the Bracero Program was "supposed to be a solution to illegal immigration, but in fact it generated more illegal immigration." *Impossible Subjects,* 147.

123. See Von Eschen, *Satchmo Blows Up the World,* as well as sources on abstract expressionism mentioned in note 21 of the introduction.

124. Seth Fein, "Transcultured Anti-Communism: Cold War Hollywood in Postwar Mexico," in Noreiga, *Visible Nations,* 93.

125. Fein writes specifically about transnational film productions created by U.S. and Mexican governmental agencies working in conjunction with U.S. and Mexican film industries during the early Cold War era, which served the cultural agendas of both the U.S. and Mexican governments. While Fein argues that co-produced films like *The Fugitive* (1947) exhibited immediately following World War II displayed more subtle messages regarding Communism, he suggests that after

the Korean War started, U.S.–Mexican coproductions like *Dicen que soy comunista* contained more direct "messages" regarding anti-Communism. Fein mentions that during World War II, RKO collaborated more than any other studio with the U.S. government's film propaganda in Latin America. Fein, "Transcultured Anti-Communism," 84.

126. Ibid., 100.

127. Ibid. In his dissertation, Fein notes that "some might find Galindo's knowing (or unknowing participation in this State Department project) equally inexplicable given the conventional view of the filmmaker, based on works such as *Espaldas mojadas* (1953)." Fein suggests that "this is not really as much of a paradox," because "Galindo's leftism was circumscribed within the nationalism defined by the Mexican state." Seth Fein, "Hollywood and United States–Mexico Relations in the Golden Age of Mexican Cinema" (Ph.D. dissertation, University of Texas, 1996), 659–60, n35. See chapter 4 for a brief discussion of *Espaldas mojadas*.

128. These films were screened by USIS officials based at U.S. embassies in Latin America. Fein explains that "The State Department's International Motion Picture Division (IMP) produced the films, which were administered abroad by the United States Information Service (USIS) officials based in the U.S. embassies. These functions were streamlined under the management of the United States Information Agency (USIA) formed in 1953, which represented the institutionalization of propaganda promotion as a Cold War weapon." Seth Fein, "Everyday Forms of Transnational Collaboration: Film Propaganda in Cold War Mexico," in *Close Encounters of Empire: Writing the Cultural History of U.S.–Latin American Relations*, ed. Gilbert M. Joseph, Catherine C. LeGrand, and Ricardo D. Salvatore (Durham, N.C.: Duke University Press, 1998), 406.

129. Joseph Krumgold, *And Now, Miguel* (Binghamton, N.Y.: Vail-Ballou Press, 1953).

130. Laura Pulido, *Black, Brown, Yellow and Left: Radical Activism in Los Angeles* (Berkeley: University of California Press, 2006), 114.

131. Saunders, *The Cultural Cold War*, 291. According to Gabriel Meléndez, *And Now, Miguel* was kept in USIS libraries in Latin America and elsewhere. Meléndez, "Who Are the 'Salt of the Earth'? Competing Images of Mexican-Americans in *Salt of the Earth* and *And Now, Miguel*," in *Expressing New Mexico: Nuevomexicano Creativity, Ritual and Memory*, ed. Phillip B. González (Tucson: University of Arizona Press, 2007), 132.

132. Saunders notes that the State Department's Motion Picture Service had consulted with Hollywood film director Cecil B. DeMille, who suggested that they insert their messages rather than focusing entire plots on anti-Communist themes. Saunders, *The Cultural Cold War*, 288.

133. Krumgold, *And Now, Miguel*, 193, 204.

134. Fousek, *To Lead the Free World*, 187.

135. Ibid.

136. The Chávez family was also portrayed by John Collier Jr. as part of the Farm Security Administration's photography project directed by Roy Stryker. Russell Lee, *Far from Main Street: Three Photographers in Depression-Era New Mexico, Russell Lee, John Collier Jr., and Jack Delano* (Santa Fe: Museum of New Mexico Press, 1994), 12.

4. Audience and Affect

1. Rouverol, *Refugees from Hollywood*, 75–76.
2. Willard Motley, "Moment of Truth," WMC, NIU.
3. Perhaps the one similarity between the two films is that they both tell dramatic stories. Trumbo's film focuses on the rare event of the *indulto*, when the bull is pardoned for its bravery, whereas Butler tells his story through one of the most significant moments in the career of bullfighter Luis Procuna.
4. Rouverol, *Refugees from Hollywood*, 34; Dalton Trumbo, letter to Hy Kraft, May 31, 1952, in Manfull, *Additional Dialogue*, 231; Zimet, letter in McGilligan and Buhle, *Tender Comrades*, 729.
5. DuPlessis, *The Selected Letters of George Oppen*, 67.
6. Trumbo, letter to Hy Kraft, May 31, 1952, in Manfull, *Additional Dialogue*, 231.
7. Rouverol, *Refugees from Hollywood*, 50.
8. Alice Hunter, interview with Bruce Cook, in Cook, *Dalton Trumbo*, 233.
9. Rouverol, *Refugees from Hollywood*, 35–36.
10. Ibid., 75.
11. Cook, *Dalton Trumbo*, 231.
12. Rouverol, *Refugees from Hollywood*, 75.
13. At the time, Trumbo was in fact suing MGM in his attempt to force them to abide by the stipulations of his contract. Cook, *Dalton Trumbo*, 193.
14. Hugo Butler did some writing on both *The Prowler* and *He Ran All the Way*.
15. Cook, *Dalton Trumbo*, 223.
16. Dalton Trumbo, letter to Herbert Biberman, August 12, 1951. DTC, WCFTR.
17. Dalton Trumbo, letter to Frank King, King Brothers Productions, February 25, 1959. DTC, WCFTR.
18. Cook, *Dalton Trumbo*, 231. As noted above, Dalton Trumbo did not speak or read Spanish.
19. Film scholar Laura Podalsky writes that the "determining influence behind the celebration of indigenous culture and landscape typical of Emilio Fernández and Gabriel Figueroa (which became emblematic of the national film industry and Mexican national identity) can be traced through Paul Strand's *Redes* (1934) to Eisenstein and Tissé." Laura Podalsky, "Patterns of the Primitive: Sergei Eisenstein's *¡Qué viva México!*" in *Mediating Two Worlds: Cinematic Encounters in the Americas*, ed. John King, Ana M. López, and Manuel Alvarado (London: British Film Institute

Publishing, 1993), 28.

20. Fein, "From Collaboration to Containment," 124.

21. Carlos Monsiváis, "Mythologies," in *Mexican Cinema*, ed. Paulo Antonio Paranaguá, trans. Ana M. López (London: British Film Institute Publishing and IMCINE in association with Consejo Nacional Para la Cultura y las Artes de México, 1995), 123.

22. The influence of Hollywood training on Mexican filmmakers has been well established in the scholarship of Mexican cinema. One of the starting places for these connections are the actors and production team involved in the film *Santa* (1931), many of whom, including the Russian cinematographer Alex Phillips, had previously worked in Hollywood. Carl Mora, *Mexican Cinema: Reflections of a Society, 1896–1988* (Berkeley: University of California Press, 1982 rev. ed.), 35.

23. Fein, "From Collaboration to Containment," 123.

24. The segments of the film include "Skull" (on Mexicans and death), four aspects of Mexican life and history—"Sandunga" (about a wedding in Tehuantepec), "Maguey" (about class struggle set during the Porfirian era), "Fiesta" (about a bullfight in Mérida), "Soldadera" (about the Revolution of 1910)—and an epilogue. Although *¡Qué viva México!* was never finished, sections of the film were later released as *Thunder over Mexico* (1933). King, *Magical Reels*, 43.

25. Podalsky, "Patterns of the Primitive," 27.

26. King, *Magical Reels*, 44.

27. Eduardo de la Vega Alfaro, "Origins, Development and Crisis of Sound Cinema, 1924–1964," in Paranaguá, *Mexican Cinema*, 79.

28. While Strand was mostly known for his still photography, he had also been an experimental filmmaker and a freelance newsreel cameraman. Following his work in *Redes*, he became involved in Nykino, the experimental film group that later became Frontier Films, and helped produce the Farm Security Administration film *The Plow That Broke the Plains*, directed by Pare Lorentz. Campbell, *Cinema Strikes Back*, 124, 145.

29. Denning, *The Cultural Front*, 251.

30. From Sidney Meyer's article "Redes," *New Theater*, November 1936, 21.

31. Mora, *Mexican Cinema*, 42.

32. Charles Ramírez Berg, "The Cinematic Invention of Mexico: The Poetics and Politics of the Fernández–Figueroa Style," in *The Mexican Cinema Project*, ed. Chon Noriega and Stephen Ricci (Los Angeles: UCLA Film and Television Archive, 1994), 19.

33. Fein, "From Collaboration to Containment," 123.

34. Ibid., 124.

35. "My Friend Bonito" was based on the short story "Bonito the Bull" by Robert Flaherty, about the friendship between a *mestizo* boy and a bull. Novelist John Fante had written the screenplay along with Norman Foster, who later became the film's codirector. Charles Higham, *The Films of Orson Welles* (Berkeley: University of California Press, 1970), 84.

36. Emilio García Riera, *Historia documental del cine mexicano, 1958–1960* (Guadalajara: Universidad de Guadalajara: Gobierno de Guadalajara: Consejo Nacional para la Cinematografía, Instituto Mexicano de Cinematografía, 1992–1997), 144. I would like to thank Annette Rodriguez for translating this quote.

37. When one of the producers suggested that a dream sequence be inserted, Trumbo responded, "This picture is very simple, and deals with very real things, and will best be done if it is done in simple realism." Dalton Trumbo, letter to King Brothers Productions, in Manfull, *Additional Dialogue*, 271.

38. In 1942, Nelson Rockefeller, of the Office of the Coordinator of Inter-American Affairs (OCIAA), contacted Welles to serve as a "Good Will Ambassador" to Latin America. The OCIAA was developed by Nelson Rockefeller in 1940 to strengthen hemispheric solidarity and trade between the United States and Latin America. According to Catherine Benamou, the "tightening of hemispheric defense against the Axis powers," was "matched . . . by a highly publicized campaign of cultural reciprocity," which included film production. *It's All True* was produced under the auspices of the OCIAA's Motion Picture Division (MPD), run by John "Jock" Whitney. Catherine L. Benamou, *Orson Welles's Transcultural Cinema and Historical/Textual Reconstruction of the Suspended Film, It's All True, 1941–1993* (Ph.D. dissertation, Department of Cinema Studies, New York University, September 1997), 35–36.

39. JADC, *Monthly Film Bulletin* 25, no. 290 (March 1958): 31.

40. *Variety*, September 19, 1956.

41. Reviews appeared in *Motion Picture Herald* 204, no. 13 (September 29, 1956): 91; *Variety*, September 19, 1956; and *Monthly Film Bulletin* 25, no. 290 (March 1958): 31.

42. JADC, *Monthly Film Bulletin* 25, 31.

43. *Motion Picture Herald* 204, number 13 (September 29, 1956): 91, and *Variety*, September 19, 1956.

44. Although the direction of the cinematography was not within Trumbo's purview, the cinematographer's decisions were an outcome of the film's production within the Hollywood film industry.

45. Roger Bartra, *The Cage of Melancholy* (New Brunswick, N.J.: Rutgers University Press, 1992), 164. See also Seth Fein, "Myths of Cultural Imperialism and Nationalism in Golden Age Mexican Cinema," in *Fragments of a Golden Age: The Politics of Culture in Mexico since 1940*, ed. Gilbert M. Joseph, Anne Rubenstein, and Eric Zolov (Durham, N.C.: Duke University Press, 2001), 185.

46. See Fein, "From Collaboration to Containment," 124; and Susan Dever, *Celluloid Nationalism and Other Melodramas: From Post-Revolutionary Mexico to Fin De Siglo Mexamérica* (Albany: State University of New York Press, 2003), 25.

47. Dalton Trumbo, "Blacklist = Black Market," *The Nation*, May 4, 1957, 386–87.

48. Higham, *The Films of Orson Welles*, 94.

49. Garćia Riera, *Historia documental del cine mexicano, 1958–1960*, 144.

50. José García defined bullfighting as an "urban entrepreneurial activity that developed simultaneously in large, industrializing cities" in Mexico. José García, "Bullfighting," in *Encyclopedia of Mexico: History, Society and Culture,* ed. Michael S. Werner (Chicago: Fitzroy Dearborn Publishers, 1997), 167.

51. Charles Ramírez Berg, *Cinema of Solitude: A Critical Study of Mexican Film, 1967–1983* (Austin: University of Texas Press, 1992), 46.

52. Nelson Carro, "Film-makers," in Paranaguá, *Mexican Cinema,* 271.

53. See Manuel Michel, "Mexican Cinema: A Panoramic View," *Film Quarterly* 18, no. 4 (Summer 1965): 51 (trans. Neal Oxenhandler); and Emilio García Riera, "The Eternal Rebellion of Luis Buñuel," *Film Culture* 21 (1960): 42–60. In this article, García mentions that Ponce, "surrounded by a good team, has given to Mexican film three of its most important works during the past six years: *Raíces, ¡Torero!,* and *Nazarín*" (43).

54. Smith, "Mexico since 1946," 326.

55. The structure of the film is similar to Eisenstein's *¡Qué viva México!* in that it consists of a group of stories, was shot in distinct regions of Mexico on location, and uses nonprofessional actors. The four stories include "Las vacas" (The cows), "Nuestra señora," "El tuerto" (One-eyed), and "La Potranca" (The filly).

56. Jorge Ayala Blanco, *La aventura del cine mexicano,* 2nd ed. (México City: Ediciones era, 1979), 263.

57. According to Seth Fein, the USIA identified EMA as a procommunist newsreel, which received support from the Mexican government. Fein, "New Empires into Old: Making Mexican Newsreels the Cold War Way," *Diplomatic History* 28, no. 5 (November 2004): 742.

58. Velo later worked on the film *Nazarin* (1958), which was directed by Buñuel and produced by Ponce.

59. Francisco Pina, "Carlos Velo realizador de 'Torero,' Odia las corridas de toros," *Mexico en la cultura* (*Novedades* supplement), June 2, 1957, 1.

60. Jean Rouverol mentions that "Hugo did some of the directing himself; and soon found himself traveling to bull ranches all over central Mexico with the crew, either watching Vela [Velo] or shooting footage himself of *tientas,* mock bull fights where young bulls are caped to test their courage." Rouverol, *Refugees from Hollywood,* 79.

61. Giovanni Korporaal directed the film *El brazo fuerte* (The Strong Arm) in 1958.

62. Denning, *The Cultural Front,* 154.

63. Eric Hobsbawm, *The Jazz Scene* (New York: Pantheon, 1993), 170, 172. I would like to thank Michael Denning for informing me about this source.

64. Hugo Butler, "Suit of Lights," Hugo Butler Collection (Unprocessed), American Heritage Center, University of Wyoming, Laramie, Wyoming. (This collection is hereafter cited as HBC, AHC.)

65. In this regard, *¡Torero!* did resemble one film produced by blacklisted Hollywood filmmakers, *Salt of the Earth* (1953) directed by Herbert Biberman and writ-

ten by Michael Wilson. Similar to *¡Torero!*, *Salt of the Earth* was also made outside the Hollywood studio system, was shot on location, and included nonprofessional actors in its production. However, unlike *¡Torero!*, *Salt of the Earth* is structured like a conventional Hollywood narrative film.

66. In a statement of intent authored soon after they formed, members of The Group commented that "the official cinema all over the world is running out of breath. It is morally corrupt, aesthetically obsolete, thematically superficial, temperamentally boring." Quoted in P. Adams Sitney, *Film Culture Reader* (New York: Prager, 1970), 70. Film scholar David E. James describes the New American Cinema group as inventing "an extra-industrial and, in fact, an anti-industrial use of the medium." James, *Allegories of Cinema*, 87.

67. In *Bullfight*, Sokolow performs "Homage to a Bullfighter"; the bullfighting footage was shot by Peter Buckley, a friend of Ernest Hemingway. Lauren Rabinovitz, *Points of Resistance: Women, Power and Politics in the New York Avant-Garde Cinema, 1943–1971* (Urbana: University of Illinois Press), 98. Following *Bullfight*, Clarke went from making experimental dance films to creating independent feature-length films, such as *The Connection* (1961), another example of what was considered a "new form"—a docudrama or dramatic documentary.

68. *Brave Bulls* resembles boxing films like *Body and Soul* (director Robert Rossen, 1947) and *Champion* (director Mark Robson, 1949), which draw parallels between boxing and capitalism. In these films, the fighters become obsessed with money, which they eventually are destroyed by *(Champion)* or ultimately reject *(Body and Soul)*. According to film scholar Brian Neve, boxing, in the work of Cultural Front screenwriters and playwrights like Clifford Odets, "was the metaphor for a system of capitalist competition that divided men from others and from themselves." Neve, *Film and Politics in America*, 12.

69. Tomás Pérez Turrent, in an interview with Catherine Benamou, noted how Mexican filmmakers had uncritically represented bullfighting as a career that enabled class mobility. Benamou, *Orson Welles's Transcultural Cinema*, 360n.

70. Hugo Butler, "Sequences and Footage per edition of August 15, 1955 of the Motion Picture 'Suit of Lights,'" 5. HBC, AHC.

71. Pina, "Carlos Velo realizador de 'Torero,'" 5. I would like to thank Annette Rodriguez for translating this article.

72. Teshome H. Gabriel, "Towards a Critical Theory of Third World Films," in *Questions of Third Cinema*, ed. Jim Pines and Paul Willeman (London: BFI Publishing, 1989), 38.

73. See reviews by Bosley Crowther in the *New York Times*, May 22, 1957, 29; and Robert Hatch in *The Nation* 184, no. 22 (June 1, 1957): 486. Part of this perception was probably reaffirmed by the film's exhibition in art-house theaters. Unlike *The Brave One*, which had widespread distribution in the United States, *¡Torero!* received limited distribution and was shown only in U.S. art-house theaters in major metropolitan areas when it was released in the mid-1950s.

74. Hatch review, *The Nation,* 486.

75. Since he had been blacklisted, Hugo Butler used the pseudonym Hugo Mozo so the film could be shown in the United States; *mozo* is the Spanish word for houseboy or butler, which disguised his identity as someone of "Anglo-Saxon" ancestry.

76. Jean Rouverol, interview with Paul Buhle and Dave Wagner in McGilligan and Buhle, *Tender Comrades,* 171. The classification of *¡Torero!* as a documentary also served to erase Hugo Butler's involvement in the film's production as the screenwriter, for the screenplay is viewed as a "nonelement" within documentary film production. Realism, in Bill Nichols words, "hinges on the presence of the filmmaker or authoring agency as an absence." Bill Nichols, *Representing Reality: Issues and Concepts in Documentary* (Bloomington: Indiana University Press, 1991), 43. In the production of documentary film, there is usually an attempt to capture the "real" in order to mobilize some kind of "truth." As such, there is generally a claim to limit intervention by their makers so that elements such as direction and screenwriting are minimized.

77. Emilio García Riera, *Historia documental del cine mexicano, 1955–1957* (Guadalajara: Universidad de Guadalajara: Gobierno de Guadalajara: Consejo Nacional para la Cinematografía, Instituto Mexicano de Cinematografía, 1992–1997), 135.

78. Filmmakers who were part of this movement included Spanish exile Luis Alcoriza and Giovanni Korporaal.

79. Other screenplays written by the Hollywood exiles for films on Mexican subject matter produced within the Hollywood film industry during the mid-1950s include Julian Zimet's *The Naked Dawn* (1956) and "Beach Boys" (1958), a screenplay he wrote with Bernard Gordon.

80. Other screenplays written by the Hollywood exiles for films produced within the Mexican film industry during the mid-1950s include Albert Maltz's *Flor de mayo* (1957) and John Bright's *La rebelión de los colgados* (1954), based on a novel by B. Traven, and *Canasta de cuentos mexicanos* (1955) from Traven's short stories.

81. Seth Fein, "Motion Pictures: 1930–1960," *Encyclopedia of Mexico,* 970.

82. More recent analyses of the film include Paul Vanderwood's essays "An American Cold Warrior: *Viva Zapata!*" in *American History/American Film: Interpreting the Hollywood Image,* ed. John O'Connor and Mark Jackson (New York: Continuum, 1998), 183–201; and "The Image of Mexican Heroes in American Films," *Film Historia* 3 (1992), 221–44.

83. John Howard Lawson, *Film in the Battle of Ideas* (New York: Masses & Mainstream, 1953), 41.

84. Ibid., 42–43.

85. Lester Cole, *Hollywood Red* (Palo Alto, Calif.: Ramparts Press, 1981), 259–60, 352.

86. Cook, *Dalton Trumbo,* 242.

87. Manfull, *Additional Dialogue,* 301.

88. Dalton Trumbo in Cook, *Dalton Trumbo*, 260. See also Trumbo, "Blacklist = Black Market," 386–87.

89. Other attempts to break the blacklist, especially through legal actions, had not been successful. For example, lawsuits filed by blacklisted film workers, such as *Wilson v. Loews*, demanded financial remuneration for the losses and damages that the industry inflicted upon them. However, screenwriter Michael Wilson and the other plaintiffs lost their cases in the district courts, courts of appeal, and supreme courts. (Manfull, *Additional Dialogue*, 424). Trumbo commented in a 1958 letter to Charles Humboldt that "of all the groups who have fought through this period, the Hollywood blacklistees are the only ones who have never had even a qualified victory before the courts. They have, on the contrary, had sixteen straight defeats. There is no legal recourse left open to them, and they number over 200 careers." In this same letter, Trumbo wrote that "after 10 years of litigation and expense and loss of career, the Hollywood blacklistees still have fewer civil rights than an open official of the Communist Party." Dalton Trumbo, letter to Charles Humboldt, May 21, 1958. CHC, YMA.

90. Dalton Trumbo, letter to William Faulkner, January 27, 1957, in Manfull, *Additional Dialogue*, 382.

91. Ibid., 383. The other writers to whom he sent letters were John Steinbeck, Ernest Hemingway, William Saroyan, A. B. Guthrie, Tennessee Williams, and Thornton Wilder.

92. Dalton Trumbo, letter to Edward Lewis, May 31, 1958, in Manfull, *Additional Dialogue*, 427. While Trumbo's letter overstated the position of blacklisted Hollywood screenwriters in Mexico, by the time he wrote the letter, many of the exiles had secured *inmigrante* status, allowing them to work legally in Mexico.

93. In his letter to Edward Lewis, Trumbo wrote, "The industry has for three long years been in a state of economic crisis. Its public relations throughout the world are a matter of first importance to it. Hollywood cannot exist without its world market. The films which it sends out to the world are, or ought to be, ambassadors of American goodwill toward the world. Yet its own blacklisting casts doubt upon its good intentions. Its necessary dealings with European producers and studios are greatly complicated by the blacklist. It is constantly plagued abroad by the embarrassing question of whether American democracy is for all or just for some." Dalton Trumbo, letter to Edward Lewis, May 31, 1958, in Manfull, *Additional Dialogue*, 429.

Trumbo made similar points in "Blacklist = Black Market," in which he describes the Hollywood blacklist as part of a larger blacklist: "barring its victims from work at home and denying them passage abroad—which mocks our government in all its relations with civilized powers that neither tolerate nor understand such repression" (385).

94. Trumbo noted further that "it is hoped that such information will be of value to European intellectuals who wish to preserve in their own countries the tra-

dition of cultural independence that in America has been suppressed." Dalton Trumbo, letter to President Dwight D. Eisenhower, January 24, 1957, DTC, WCFTR. In an attachment to the letter, he mentioned that he planned to publish articles in *The New Statesman and Nation* and *Le Monde*.

95. Dalton Trumbo, letter to Special Counsel to the President, Gerald D. Morgan, February 12, 1957, in Manfull, *Additional Dialogue*, 385.

96. Cook, *Dalton Trumbo*, 264.

97. According to Larry Ceplair and Stephen Englund, the Academy of Motion Picture Arts and Sciences had not previously allowed Fifth Amendment witnesses to receive Academy Awards. Ceplair and Englund, *The Inquisition in Hollywood*, 419.

98. Cook, *Dalton Trumbo*, 277.

99. There are many similarities between *Los pequeños gigantes* and *¡Torero!*, as Butler developed their stories from the experiences of his subjects, with voiceover narration told from the perspective of a main character. These films also contain reenacted scenes and stock footage from newsreels, and focus on a form of Mexican popular culture.

100. García, "Bullfighting," 167.

101. Blacklisted Hollywood screenwriter Edward Huebsch received a credit for the screenplay as well, under the pseudonym Eduardo Bueno.

102. Hugo Butler, *Los pequeños gigantes*. Final English script. HBC, AHC.

103. Juan Ramón García, *Operation Wetback: The Mass Deportation of Mexican Undocumented Workers in 1954* (Westport, Conn.: Greenwood Press, 1980).

104. McAllen, Texas, had its own detention camp during the mass deportation drive of Operation Wetback. García, *Operation Wetback*, 217.

105. The number of undocumented border crossers was high in this area of South Texas, as farmers in the area had a history of hiring "illegal" Mexican workers, according to Mae M. Ngai, largely because Mexico had excluded Texas from the Bracero Program due to racial segregation in the state. When Texas was removed from the Bracero Program's "blacklist" in 1949, farmers continued to hire unauthorized workers. Further, as Ngai notes, "Illegal migration continued even as the Bracero Program stabilized in the late 1950s." Ngai, *Impossible Subjects*, 147, 152, 157.

106. Butler, *Los pequeños gigantes*. Final English script, 22. HBC, AHC.

107. Ibid., 29.

108. Fein, "Hollywood and United States–Mexico Relations," 741.

109. Mora, *Mexican Cinema*, 44.

110. Fein, "Hollywood and United States–Mexico Relations," 743.

111. Rouverol, *Refugees from Hollywood*, 155.

112. Butler, *Los pequeños gigantes*. Final English script, 29. HBC, AHC.

113. Ibid., 33.

114. Ibid., 36.

115. Ibid., 47.

116. García Riera, *Historia documental del cine mexicano, 1958–1960*, 182. García

Riera notes further that "Butler did not want to make the subject too obvious, but the solidarity of the black caretaker of a North American park with the Mexicans or the examination of the predominant attitude of the white Texans gave a clear idea of his intentions." I would like to thank Annette Rodriguez for help with this translation.

117. Rouverol, *Refugees from Hollywood*, 157.

118. Fein, "New Empires into Old," 712.

119. Ibid. Stephen Rabe argues that the USIA's programs were "geared towards informing Latin Americans of the dangers of Soviet communism." Stephen Rabe, *Eisenhower and Latin America: The Foreign Policy of Anticommunism* (Chapel Hill: University of North Carolina Press, 1988), 33.

120. Fein, "New Empires into Old," 718. The producer of the newsreel, Robert Tomkins, had made anti-Communist films in Mexico while running Estudios Churubusco in the early 1950s. Seth Fein, *"Dicen que soy comunista:* Nationalist Anti-Communism in Mexican Cinema of the 1950s," *Nuevo Texto Crítico* 11, no. 21/22 (1998): 159.

121. The USIA found ways around Mexico's laws regarding the sovereignty of their mass media (foreigners could not legally own media enterprises in Mexico) through a *prestanombre*, a Mexican serving as a business front. (Fein, "New Empire into Old," 745.) Butler had his own "front," as he used the Spanish translation of his last name ("Mozo") as a pseudonym so that his films could be shown in the United States. The irony is that the USIA and Butler both used fronts, with different relationships to the Mexican state. The further irony is that by blacklisting them, the United States drove screenwriters into the black market, forcing them to use fronts, adopting a similar strategy of masquerade.

122. Fein, *"Dicen que soy comunista,"* 155.

123. Fein has argued that "this conformed to the logic of Mexican foreign policy in the late 1950s and early 1960s, which ostentatiously touted its international independence from the United States to compensate for its rightist policies at home and its increasingly close economic relations with its northern neighbor." Fein, "New Empires into Old," 737.

124. García Riera, *Historia documental del cine mexicano, 1958–1960,* 185.

125. From "Prologue: A Marginal Cinema" by Manuel Michel, originally published in *Revista de Bellas Artes,* no. 3 (1965), as quoted in Sergio García, "Toward a Fourth Cinema," *Wide-Angle* 21, no. 3 (1999): 75.

126. Giovanni Korporaal's *El brazo fuerte* (1958) critiqued *caciquismo,* a system whereby a local boss exerts power over the rural poor.

127. See Niblo, *Mexico in the 1940s.*

128. Fox, *The Fence and the River,* 99. Fox is referencing both Charles Hale's article on Daniel Cosío Villegas and Cosío's essay "Sobre la libertad de prensa," *Labor periodística: Real e imaginaria* (Mexico City: Era, 1972), 313–25.

129. Daniel Cosío Villegas, "Mexico's Crisis," in *American Extremes/Extremos de América,* trans. Américo Paredes (Austin: University of Texas Press, 1964), 3.

Villegas had originally published "Mexico's Crisis" in *Cuadernos Americanos,* Año VI, 2, March 1947, Vol. XXXII.

130. Charles Hale, "The Liberal Impulse: Daniel Cosío Villegas and the *Historia moderna de México,*" in *Hispanic American Historical Review,* 54.3 (August 1974): 482.

131. Galindo's exceptions to this statement included only "banned" films, such as his own *Espaldas mojadas,* as well as *El brazo fuerte* (1958) and *Rosa Blanca* (White Rose) (1961). Alejandro Galindo, *El cine mexicano: Un personal punto de vista,* 2nd ed. (Mexico City: EDAMEX, 1986) 146.

132. Fox, *The Fence and the River,* 114–15. Fox is drawing from Galindo's memoir *El cine mexicano,* 146–50.

133. Berg, "The Cinematic Invention of Mexico," 13.

134. Carlos Monsiváis notes that starting during the administration of Manuel Avila Camacho, "the bourgeoisie abandoned their fear of socialism and allowed itself to be convinced by Emilio Fernández, in other words, the Revolution has become an extension of postcards." Monsiváis, "Se fue el remolino y nos adecentó: la nostalgia en el cine," in *Siempre* (Mexico City) no. 1625 (August 15, 1984): 6–7, as quoted in Julia Tuñón, "Emilio Fernández, A Look Behind the Bars," in *Mexican Cinema,* ed. Paranaguá, 183.

5. Unpacking Leisure

1. See Alex Saragoza, "The Selling of Mexico: Tourism and the State, 1920–1952," in *Fragments of a Golden Age: The Politics of Culture in Mexico since 1940,* ed. Gilbert Joseph, Anne Rubenstein, and Eric Zolov (Durham, N.C.: Duke University Press, 2001); and Zolov, "Discovering a Land."

2. These cultural works include John Bright's screenplay, based on some of B. Traven's short stories, that was made into the film *Canasta de cuentos mexicanos (Basket of Mexican Stories)* in 1955; "The Beach Boys" screenplay written by Julien Zimet and Bernard Gordon; and a screenplay by Hugo Butler written in the late 1950s, in which he sets a Chekov novel in Acapulco.

3. Klinkowitz, *The Diaries of Willard Motley,* xvi.

4. Willard Motley, "An American Negro in Cuernavaca," from the unpublished "My House Is Your House," 147–48. WMC, NIU.

5. Here I am referring to his professional writing as an adult. Motley had in fact started publishing a newspaper column when he was thirteen. Mullen, *Popular Fronts,* 135.

6. Morgan, *Rethinking Social Realism,* 256–57.

7. See Morgan, *Rethinking Social Realism,* 258; and Klinkowitz, *The Diaries of Willard Motley,* 165.

8. Morgan, *Rethinking Social Realism,* 245.

9. Ibid., 12.

10. Willard Motley, "A Kilo of Tortillas, A Güaje of Pulque," *Rogue* IX, no. 4 (August 1964): 46–48, 57.

11. Mary Nolan and Sidney Nolan, "The Evolution of Tourism in 20th-century Mexico," *Journal of the West* 27 (October 1988): 17.

12. Zolov, "Discovering a Land," 34.

13. Alex Saragoza, "Tourism," in *Encyclopedia of Mexico: History, Society and Culture*, ed. Michael S. Werner (Chicago: Fitzroy-Dearborn Publishers, 1997), 1414.

14. Christina Klein, *Cold War Orientalism: Asia in the Middlebrow Imagination, 1945–1961* (Berkeley: University of California Press, 2003), 103.

15. Ibid., 104.

16. David Spurr, *Rhetoric of Empire: Colonial Discourse in Journalism, Travel Writing and Imperial Administration* (Durham, N.C.: Duke University Press, 1996), 9.

17. Willard Motley, "My House Is Your House" (unpublished manuscript) WMC, NIU, 32 (hereafter cited in text with page numbers).

18. Klein, *Cold War Orientalism*, 110.

19. Cromie, "New Motley Novel Near Completion," 10.

20. Mavis McIntosh, letter to Willard Motley, May 5, 1960. Willard Motley Papers, Special Collections, Memorial Library, University of Wisconsin, Madison. (This collection is hereafter cited as WMC, UW, Madison.)

21. Robert Loomis, letter to Willard Motley, May 23, 1960. WMC, UW, Madison.

22. Ibid.

23. Ibid.

24. Willard Motley, letter to Robert Loomis, February 1, 1961. WMC, UW, Madison.

25. Klinkowitz, *The Diaries of Willard Motley*, ix.

26. Mary Louise Pratt, *Imperial Eyes: Travel Writing and Transculturation* (London and New York: Routledge, 1992), 216.

27. Ibid., 204.

28. See Michel Foucault, *Discipline and Punish: The Birth of the Prison*, trans. Alan Sheridan (New York: Vintage, 1977).

29. Spurr, *Rhetoric of Empire*, 16.

30. Ibid., 16–17.

31. Ibid., 19.

32. Sydney Clarke, *All the Best in Mexico* (New York: Dodd, Mead, 1953), 39.

33. Pratt, *Imperial Eyes*, 209.

34. Spurr, *Rhetoric of Empire*, 23.

35. Although he does not write about them directly, Alex Saragoza does include advertisements in his essay "The Selling of Mexico" that contain images of women. While he argues that "It is beyond the scope of this essay to discuss the centrality of female figures to the promotion of tourism in Mexico," he contends that "clearly the sexualized images of tourist activities and the like were crucial to the overall strategy of selling Mexico." Saragoza, "The Selling of Mexico," 115.

36. For example, Saldívar analyzes Barbara Lowry's travel writing on Tijuana for the *New York Times*, noting, "Readers hardly get a sense of the limitation of her

universalized panoramic view." Saldívar, *Border Matters,* 134.

37. I am indebted to Joseph Entin for his insights on the formal qualities of Motley's work.

38. In "My House Is Your House," Motley describes the experiences of his friend Chuy who attacked a corrupt politician misusing government funds. Chuy and some colleagues in a literary club publication had revealed that the governor of his state and another "distinguished" man were cheating the poor. After the publication of this article, they were picked up by the secret police and brought to the governor's office. Motley describes the irony of the situation: "The governor had been in the revolution. He pulled out his shirt tails and showed them his belly—and he had a couple of scars: 'I got these for being a man and not a sonofabitch like all of you.' He then gave them their choice between being kicked out of the state or going to the penitentiary" (366). WMC, NIU.

39. G. Donald Jud, "Tourism and Economic Growth in Mexico since 1950," *Inter-American Economic Affairs* 28, 1 (Summer 1974), 30–31. Jud contends that there was an increase in demand for labor within the Mexican tourist industry between 1950 and 1970. While Jud touts many of the benefits of tourism within Mexico, he mentions few of its negative influences. However, he does assert that most of the positive social effects of tourism "accrue to the tourists," and he states that "there are often very negative social effects that are engendered by tourism" (40). Dina Berger argues that few scholars have written about the impact of tourism on Mexico compared to the number of scholars who have written about the impact of industrialization. Berger, *The Development of Mexico's Tourism Industry: Pyramids by Day Martinis by Night* (New York: Palgrave MacMillan, 2006), 118.

40. Zolov, "Discovering a Land," 246.

41. This is a point that Andrew Sackett makes in "The Two Faces of Acapulco during the Golden Age" in *The Mexico Reader: History, Culture, Politics,* ed. Gilbert M. Joseph and Timothy J. Henderson (Durham, N.C.: Duke University Press, 2002), 504. Sackett draws from a section of *The Standard Guide to Mexico and the Caribbean* that focuses on Acapulco. The authors describe the changes to Acapulco, writing that "Boulevards curve where thatched huts once stood among the coco palms. Residential suburbs spread deeper and farther into what was jungle. The juke box sings where late the crocodile basked." Lawrence Martin and Sylvia Martin, *The Standard Guide to Mexico and the Caribbean* (New York: Funk and Wagnalls, 1958–1959 edition), 209.

42. The sentiments are shared by individuals who were interviewed by Francisco R. Escudero. In "Efectos del turismo en nuestra cultura" (Effects of tourism on our culture), the epilogue of Escudero's book, he interviews a young man who had grown up in Acapulco. Reflecting on the impact of foreign tourism, the interviewee notes that "our way of dressing; our way of speaking; our way of eating; our commerce; our entertainment . . . and our identity as Mexicans changed with the arrival of tourism." Francisco R. Escudero, *Origen y evolución del turismo en Acapulco* (Universidad Americana de Acapulco and H. Ayuntamiento Constitucional de Aca-

pulco, 1988), 310.

43. Klein, *Cold War Orientalism*, 111, from a State Department pamphlet quoted in Frances J. Cooligan, "Americans Abroad," *Department of State Bulletin*, May 3, 1954, 664.

44. Ibid.

45. Robert Loomis, letter to Willard Motley, July 13, 1961. WMC, UW, Madison.

46. Motley, "A Kilo of Tortillas," 46–48, 57; "Give the Gentleman What He Wants," *Rogue* IX, no. 4 (October 1964): 14–16, 75; "Christmas in Mexico," *Rogue* IX, no. 5 (December 1964): 27–28, 74; "Death Leaves a Candle," *Rogue* X, no. 4 (August 1965): 19–22, 79. Jack Conroy, in "Motley and the Novel That Never Got Written" (*Chicago Daily News*, Panorama section, February 26, 1966, 7) wrote that Motley also published another chapter about the burial of a Mexican baby in John Edgar Webb's *The Outsider* (Spring 1963).

47. Motley's decision to integrate aspects of "My House Is Your House" into "Tourist Town" may also have been related to his financial status. After "My House Is Your House" was rejected by publishers and his advance was withdrawn from Random House, Motley felt significant financial pressure to write another book. He still owed money on a house that he bought in Puerto Vallarta for $2,000 in the early 1950s, and it is evident from reading his diaries that he had so little money that he frequently went without eating. (See Willard Motley's diaries between November 6, 1961, and February 19, 1965. WMC, NIU.) According to his contract with Putnam, Motley would receive a check each time he turned in a predetermined portion of the manuscript. Thus, there was a strong financial incentive to finish the novel as quickly as possible.

48. Morgan, *Rethinking Social Realism*, 254.

49. Ibid.

50. Denning, *The Cultural Front*, 228.

51. See Willard Motley's "Tourist Town" manuscript (WMC, NIU) and Willard Motley, *Let Noon Be Fair* (New York: Putnam, 1966).

52. Cromie, "New Motley Novel Near Completion."

53. Willard Motley, letter to Peter Israel, August 6, 1962. WMC, UW, Madison.

54. Saragoza, "Tourism," 1415.

55. Niblo, *Mexico in the 1940s*, 275.

56. Sackett, "The Two Faces of Acapulco," 505.

57. Ibid.

58. Ibid., 504.

59. Ibid., 505–6.

60. Ibid., 503.

61. Saragoza, "Tourism," 1415.

62. Nolan and Nolan, "The Evolution of Tourism in 20th-century Mexico," 17.

63. Ibid., 18, 21.

64. See Martin and Martin, *Standard Guide to Mexico*; and Clarke, *All the Best*

264... Notes to Chapter 5

in Mexico.

65. Willard Motley, *Let Noon Be Fair* (New York: Dell, 1966), 39 (hereafter cited in text with page numbers).

66. Fleming, *Willard Motley*, 135.

67. These racial hierarchies were not explored in the work of white exiles in Mexico, who generally viewed the country as free from racism. For example, black-listed Hollywood screenwriter John Wexley wrote that "there was no color line drawn between the whitest descendent of Cortez or the darkest '*vanquero*' riding down from the mountains wrapped in the same poncho as his Aztec ancestors." Wexley, *The Judgment of Julius and Ethel Rosenberg*, 149.

68. Stanton Delaplane and Robert DeRoos describe the "standard tour" as "Cuernavaca for lunch, Taxco overnight, Acapulco and return. Five days for $57" in *Delaplane in Mexico* (1960), an excerpt of which appears in *The Reader's Companion to Mexico*, ed. Alan Ryan (New York: Harcourt Brace, 1995), 189.

69. N. Jill Weyant, "Lyrical Experimentation in Willard Motley's Mexican Novel: *Let Noon Be Fair*," *Negro American Literature Forum* 10 (1976): 96.

70. Peter Israel, letter to Willard Motley, August 2, 1962, 2. WMC, UW, Madison.

71. Peter Israel, letter to Willard Motley, April 19, 1963. WMC, UW, Madison.

72. Willard Motley to Peter Israel, April 25, 1963. WMC, UW, Madison.

73. This was the effect on many readers, including Nelson Algren, who wrote in a review that the Americans tended to blend in with each other, in contrast to the Mexicans. Nelson Algren, "The Trouble at Gringo Gulch," *Bookweek*, March 6, 1966, 5, 15.

74. Willard Motley to Peter Israel, August 6, 1962, WMC, UW, Madison.

75. William Nelles, "From 'Tourist Town' to *Let Noon Be Fair:* The Posthumous Revision of Motley's Last Novel," *Analytical and Enumerative Bibliography* 2, no. 2 (1988): 61–62.

76. Motley wrote the autograph manuscript for "Tourist Town" between November 2, 1962, and February 18, 1965. The manuscript of 1,822 pages is organized into 186 chapters. According to Abbott and Van Mol, "since Motley's agent and editor received parts of the novel as the autograph draft was completed, the second draft was being typed as the first was being written." Craig Abbott and Kay Van Mol, "The Willard Motley papers at Northern Illinois University," *Resources for American Literary Study* 7, no. 1 (Spring 1977): 7.

77. Willard Motley, letter to Peter Israel, January 3, 1965. WMC, UW, Madison.

78. Peter Israel to Willard Motley, August 23, 1962. WMC, UW, Madison.

79. Douglas Wixson, *The Worker-writer in America: Jack Conroy and the Tradition of Midwestern Literary Radicalism, 1898–1990* (Urbana: University of Illinois Press, 1994), 459.

80. Motley, *Let Noon Be Fair* (Putnam, 1966), front flap.

81. Algren, "The Trouble at Gringo Gulch," 15.

82. Paula Rabinowitz, "Pulping Ann Petry: The Case of 'Country Place,'" in

Revising the Blueprint: Ann Petry and the Literary Left, ed. Alex Lubin (Jackson: University of Mississippi Press, 2007), 59.

83. Willard Motley, *Let Noon Be Fair* (New York: Dell, 1966), back cover.

84. For more detail on editorial changes to the novel, see Nelles, "From 'Tourist Town' to *Let Noon Be Fair*," 63–64.

85. Motley, "Tourist Town," final typescript, 70. WMC, NIU.

86. Motley, "Tourist Town," second draft, Chapter 58, 12. WMC, NIU.

87. Willard Motley to Peter Israel, August 6, 1962, WMC, UW, Madison.

88. Motley, "Tourist Town," second draft, chapter 78, 10. WMC, NIU.

89. Motley, "Tourist Town," final typescript, 1096. WMC, NIU.

90. Israel edited out the Motley character from the final version of his manuscript. (Willard Motley, "Tourist Town," final typescript, 614, 750–52. WMC, NIU).

91. Motley, "Tourist Town," final typescript, 750. WMC, NIU.

92. Ibid., 756.

93. Weyant has also made this point in her essay "Lyrical Experimentation in Willard Motley's Mexican Novel," 98.

94. Motley, "Tourist Town," final typescript, 788–89. WMC, NIU.

95. Drewey Wayne Gunn, "The Beat Trail to Mexico," in *Adventures into Mexico: American Tourism beyond the Border,* ed. Nicholas Bloom (Lanham, Md.: Rowman and Littlefield, 2006), 80.

96. Zolov, "Discovering a Land," 254.

97. Ibid., 253; and Manuel Luis Martinez, "'With Imperious Eye': Kerouac, Burroughs, and Ginsberg on the Road to South America," *Aztlán* 23, no. 1 (Spring 1998): 41.

98. William S. Burroughs, letter to Jack Kerouac, in *The Letters of William S. Burroughs,* ed. Oliver Harris (New York: Penguin, 1994), 56, quoted in Martinez, "With Imperious Eye," 36.

99. William S. Burroughs, letter to Allen Ginsberg, in *Letters of William S. Burroughs,* 78, quoted in Martinez, "With Imperious Eye," 51.

100. Zolov, "Discovering a Land," 265.

101. Stovall, *Paris Noir,* 221.

102. Willard Motley, "Stand Up and Be Counted," *Time* LXXXI 23 (June 7, 1963): 11. Motley was writing in response to a feature on James Baldwin published in *Time* LXXXI, 20 (May 17, 1963): 26–27. Motley wrote this letter while the Southern Christian Leadership Conference mounted an antisegregation campaign in Birmingham, Alabama.

103. Willard Motley, letter to Roy Wilkins, June 10, 1963. WMC, UW, Madison.

104. Ibid.

105. Willard Motley, "Let No Man Write Epitaph of Hate for His Chicago," *Chicago Sunday Sun-Times* (August 11, 1963): Section 2, 2.

106. Motley, letter to Wilkins, June 10, 1963. WMC, UW, Madison.

107. As Thomas Borstelmann argues, "The Soviet government and its allies . . . delighted in publicizing news of American racial discrimination and persecution."

Borstelmann, *The Cold War and the Color Line: American Race Relations in the Global Arena* (Cambridge, Mass.: Harvard University Press, 2001), 75.

108. Kevin Gaines, "From Black Power to Civil Rights: Julian Mayfield and African American Expatriates in Nkrumah's Ghana, 1957–1966," in *Cold War Constructions: The Political Culture of United States Imperialism, 1945–1966*, ed. Christian Appy (Amherst: University of Massachusetts Press, 2000), 258.

109. Ibid., 259.

110. Mildred Bond, the administrative assistant of the NAACP, noted in a letter to Motley dated July 2, 1963, that Roy Wilkins had received the letter and planned to respond (Mildred Bond, letter to Willard Motley, July 2, 1963. WMC, UW, Madison).

6. Exile and After Exile

1. U.S. Embassy, Mexico City, dispatch on "Labor and Student Disturbances in Mexico City during the Week of August 25, 1958," to the Department of State, September 25, 1958. Records of Foreign Service Posts of the Department of State, Files of U.S. Embassy, Mexico City, 1955–59, Central Decimal File. NARG 59, Box 2951. College Park, Maryland. (Freedom of Information Act request, received by author on April 10, 2003).

2. Bright, *Worms in the Winecup*, 237.

3. Rouverol, *Refugees from Hollywood*, 88–89.

4. There is evidence of frequent correspondence between the FBI and other governmental offices, including the U.S. Embassy's legal attaché in Mexico City and the Department of State, Office of Security, in the FBI files of U.S. exiles, including those of Hugo Butler and George Oppen. Although these exiles lived outside the United States, their files grew significantly during this period. Even Oppen's six-month residence checks, at the U.S.–Mexico border, were documented in his FBI file (George Oppen's FBI file #100–422032). The FBI labeled both Butler and his fellow exile Oppen as security risks. A memo from the SACB to the FBI dated December 15, 1953, identified Oppen as a member of the Communist Party with potential for sabotage and thus labeled him as COMSAB and DETCOM, which implied that he could be a leader in the party. (As mentioned earlier, the "DET" in DETCOM alluded to the plans of the U.S. government to detain or incarcerate Communists or so-called "fellow travelers.") Peter Steinberg, *The Great "Red Menace": United States Prosecution of American Communists, 1947–1952* (Westport, Conn.: Greenwood Press, 1984), 182–83. Meanwhile, the SACB had sent a memo to the FBI with the exact same information about Hugo Butler on December 24, 1953 (Hugo Butler's FBI file #100-HQ-321017). Both Butler and Oppen were removed from this labeling in June 1955, and both were eventually taken off the SACB security index (Hugo Butler's FBI file #100-HQ-321017 and George Oppen's FBI file #100-HQ-422032). In addition, Butler's files indicate that the INS was attempting to begin denaturalization proceedings against him starting in 1951, with follow-up investigations through the mid-1950s. Butler, who was Cana-

dian, had become a U.S. citizen in August 1941 (memos from INS to FBI, December 1951; from FBI to Department of State, March 24, 1952; and from INS to FBI, March 5, 1954. Hugo Butler's FBI file #100-HQ-321017).

5. Albert Maltz, interview with Joel Gardner, *Citizen Writer in Retrospect,* 875.

6. Kahn had also experienced problems with his Mexican business partner, who assisted him with his finances and embezzled Kahn's savings. Kahn had taken legal action against this man, who subsequently retaliated by having Kahn's files and papers that permitted him to live in Mexico misplaced in the office of Gobernación. Without those documents, Kahn could be deported from Mexico, and once in the United States, he could be subpoenaed to appear before HUAC. However, a friend who also had political connections in Mexico was eventually able to locate Kahn's residency papers. Tony Kahn, *Blacklisted,* Public Radio International, 1996.

7. Kahn, *Blacklisted.* Some who remained in Mexico also experienced harassment from U.S. and Mexican governmental agencies. Albert Maltz had problems renewing his residency visa at Gobernación, while the U.S. Embassy demanded that Elizabeth Catlett sign an affidavit that included the names of all the Communists she knew in Mexico. In 1954, Albert Maltz, whom both the U.S. and Mexican press had identified as a "leader" of the "Cuernavaca Reds," discovered that his residency papers were missing from Gobernación at the time of his annual review. Soon after this occurred, he wrote the following to Dalton Trumbo, explaining his view of the situation: "Somebody—my attorney thinks it could be the Greek embassy—got someone in Gobernación to make off with our red books [passports] and complete file. Since October, when we came up for the annual revision, we have been without papers. A new file has been reconstructed, and new books issued—but we haven't seen them yet. These little games are plays." Albert Maltz, letter to Dalton Trumbo, April 27, 1954. AMC, WCFTR. Because of her past affiliation with the Carver School in Harlem and her involvement in the Taller de Gráfica Popular in Mexico City, Elizabeth Catlett was investigated by the U.S. Embassy. In 1955, the U.S. Embassy had requested that she come to its offices to sign an affidavit in which she was supposed to include the names of all the Communists she knew in Mexico. When she arrived at the embassy, she asked if signing an affidavit was a requirement for all U.S. citizens. An embassy official told her that it was, and so Catlett, testing the official, asked whether her three young sons, all U.S. citizens, would have to sign an affidavit. The embassy official told her that her oldest child, Francisco, who was eight, could write a statement for himself and his younger brothers. Catlett, who had no intention of writing the affidavit, told him that when she did write it, she would send it to him, and left the office. Elizabeth Catlett, interview with author, Cuernavaca, Mexico, June 8, 1999.

8. Interview with John Woodrow Wilson by Robert F. Brown, August 9, 1994. (Archives of American Art, Smithsonian Institution, Washington, D.C.), 361.

9. Ibid., 360, 362.

10. Trumbo noted his impressions about Mexico in a letter to Hy Kraft: "Cleo and ours appear to thrive. Never having lived in a foreign city, I find this experience

interesting, stimulating and restful; and, as I indicated in my other letter, Cleo loves it." (Dalton Trumbo, letter to Hy Kraft, May 31, 1952, in Manfull, *Additional Dialogue*, 231). This initial feeling about life in Mexico was shared by other Hollywood exiles, including Gordon Kahn (Kahn, *Blacklisted*).

11. Gustavo Diaz Ordaz, Gobernación, letter to Dalton Trumbo, June 17, 1953. DTC, WCFTR.

12. Lorde, *Zami*, 172.

13. Rouverol, *Refugees from Hollywood*, 129.

14. Dalton Trumbo, letter to Hugo Butler, 1954. DTC, WCFTR. In the letter. Trumbo also describes the reversals of policies toward Communists in the courts and the censuring of Joseph McCarthy.

15. Richard M. Fried, *Nightmare in Red: The McCarthy Era in Perspective* (New York: Oxford University Press 1990), 173.

16. Kenneth O'Reilly, *Hoover and the Un-Americans: The FBI, HUAC and the Red Menace* (Philadelphia: Temple University Press, 1983), 194.

17. Ibid., 197.

18. During the early 1950s, the state attorney for Dade (Miami) County prosecuted individuals who were accused of being members of the Communist Party. After having been jailed for months before the Supreme Court of Florida supported their rights to cite the Fifth Amendment, many left the state, with some individuals relocating to Mexico. Belfrage, *The American Inquisition*, 221–22.

19. Fast, *Being Red*, 333–34.

20. Ibid., 334.

21. Kahn, *Blacklisted*.

22. Cook, *Dalton Trumbo*, 246–47.

23. Ibid., 247–48.

24. Trumbo gave a speech on behalf of the Committee for the Protection of the Foreign-Born on April 14, 1956, in San Francisco. *The Devil in the Book* was published by the California Emergency Defense Committee in May 1956. DTC, WCFTR.

25. Cook, *Dalton Trumbo*, 257.

26. Maltz interview with Gardner, *Citizen Writer in Retrospect*, 945.

27. Rouverol, *Refugees from Hollywood*, 128.

28. Rabe, *Eisenhower and Latin America*, 31.

29. NSC 144/I, March 18, 1953, FRUS, 1952–1954, 4:6–10, as quoted in Ibid., 26.

30. Jesús Hernández, "Mexico and U.S. Policy towards Central America" in *The Difficult Triangle: Mexico, Central America and the United States*, ed. H. Rodrigo Jauberth, Gilberto Castañeda, Jesús Hernández, and Pedro Vuskovic (Boulder, Colo.: Westview Press, 1992), 29. See also Josefina Zoraida Vázquez and Lorenzo Meyer, *The United States and Mexico* (Chicago: University of Chicago Press, 1985), 169.

31. See Schmidt, *Communism in Mexico*, 193; and Luis Quintella, "Controls and Foreign Policies in Latin American Countries," in *Controls and Foreign Rela-*

tions in Modern Nations, ed. Philip W. Buck and Martin B. Travis (New York: W.W. Norton, 1957), 226–27.

32. Rabe, *Eisenhower and Latin America,* 52.

33. Ibid.

34. Jorge Castañeda, "Mexican Foreign Policy," in *Limits to Friendship: The United States and Mexico* by Jorge G. Castañeda and Robert A. Pastor (New York: Vintage Books, 1989), 172. Ruiz Cortines also asked for the resignation of Narciso Bassols in 1954. (Bassols was both a Marxist and a founder of the Partido Popular.)

35. Rabe, *Eisenhower and Latin America,* 26.

36. Walter LaFeber, *Inevitable Revolutions: The United States in Central America* (New York: W.W. Norton, 1984), 159.

37. Letter to Mr. Jacobo Arbenz, President of the Republic of Guatemala, June 10, 1954, from Angel Bracho, President, on behalf of the Taller de Gráfica Popular. Taller de Gráfica Popular Records, 1937–1960, Center for Southwest Research, Zimmerman Library, University of New Mexico. I would like to thank Annette Rodriguez for translating this document.

38. Hernández, "Mexico and U.S. Policy towards Central America," 29.

39. Maltz, interview with Gardner, *Citizen Writer in Retrospect,* 865.

40. Vicki Ruiz, "Luisa Moreno: A Fighter for Social Justice," [unknown source] 3, 16. Luisa Moreno Papers, Special Collections, Greene Library, Stanford University.

41. Edward Best, "Mexican Foreign Policy and Central America from the Mexican Revolution" (Ph.D. dissertation, University of Oxford, 1980), 5–6.

42. Jurgen Buchenau, "Foreign Policy: 1946–96," in *Encyclopedia of Mexico: History, Society and Culture,* ed. Michael S. Werner (Chicago: Fitzroy-Dearborn Publishers, 1997), 511.

43. "Memorandum para información del Señor Presidente de la Republica" ("Memorandum for the information of the President of the Republic") February 19, 1959. File: "Extranjeros Undeseables," Secretaría de Relaciónes Exteriores, Archivo Histórico (hereafter cited as SRE), Mexico City, Mexico.

44. Mexican Embassy in Washington, D.C., to Secretary of Foreign Affairs, Mexico, August 1955. File: "Extranjeros Undeseables." SRE.

45. This description of the ACGM is found in David Drucker's FBI file #105–1276157 in an FBI communication dated April 29, 1955, 4. I would like to thank Diana Anhalt for sharing this information with me.

46. In addition to fighting for improvements in wages, these workers had other goals, which included the democratization of labor unions. Carr, *Marxism and Communism,* 188.

47. See Katrina Vanden Heuvel, "Grand Delusions," *Vanity Fair* 54, no. 7 (September 1991).

48. Anhalt, *A Gathering of Fugitives,* 147.

49. "Ambassador's conversation with President Ruiz Cortines regarding Stern case," June 10, 1957, State Department Document #F790009-2071, #F790009-2072.

NARG 59, Box 2816. I would like to thank Diane Anhalt for sharing this information with me.

50. "American Communists in Mexico," July 1957. Records of Foreign Service Posts of the Department of State, Files of U.S. Embassy, Mexico City, 1956–58, Classified, Box 4. NARG 84, College Park, Maryland. File: "Communists in Mexico," 350.21. Evidence that the U.S. Embassy passed on a list of names of alleged American Communists in Mexico to members of the U.S. press can be found in a telegram from the U.S. Embassy to the Secretary of State. After the *New York Herald Tribune* article was published, in which writer Bert Quint asserted that one of the leaders of the group was Sterling Dickinson, the director of an art school in San Miguel de Allende, Dickinson contacted the embassy, requesting an investigation. Raymond Leddy, a U.S. Embassy official, wrote in a telegram to the Secretary of State that another embassy official had given the list to Quint but that this list did not include Dickinson's name. (U.S. Embassy, Mexico City, to the Secretary of State, September 7, 1957. Records of Foreign Service Posts of the Department of State, Files of U.S. Embassy, Mexico City, 1956–58, Classified, Box 4. NARG 84. File: "Communists in Mexico," 350.21.) Dickinson met with Ambassador Hill about the incident on September 9, with the ambassador informing him that "a careful inquiry had established that no information concerning him had been given to any newspaper representative by the American Embassy." (U.S. Embassy, Mexico City, to the Secretary of State, September 10, 1957. Records of Foreign Service Posts of the Department of State, Files of U.S. Embassy, Mexico City, 1956–58, Classified, Box 4. NARG 84. File: "Communists in Mexico," 350.21.) Dickinson had asked the Ambassador to make a public statement regarding the information in the article, but the Ambassador refused to make a commitment to do so. In another article, the author describes Dickinson's home as the center of the colony where he "keeps open house for Communists and fellow travelers" ("Red Haven," *Time,* September 9, 1957, 46).

51. Bert Quint, "U.S. Reds Have Haven in Mexico," *New York Herald Tribune,* August 30, 1957, 1–2. Frederick Vanderbilt Field was a grandson of Cornelius Vanderbilt. Field was called to testify before HUAC in the early 1950s, and after citing the Fifth Amendment, was given a jail sentence. Maurice Halperin had been chairman of the Department of Latin–U.S. Regional Studies at Boston University. He, along with other U.S. exiles such as Albert Maltz, Charles Humboldt, and Frederick Vanderbilt Field, invested in an ice cream business in Mexico together.

52. U.S. Embassy, Mexico City, to the Secretary of State, September 7, 1957. Records of Foreign Service Posts of the Department of State, Files of U.S. Embassy, Mexico City, 1956–58, Classified, Box 4. NARG 84. File: "Communists in Mexico," 350.21. See also Albert Maltz, letter to Charles Humboldt, November 22, 1957. CHC, YMA.

53. "Extranjeros Indeseables," *Excélsior,* August 26, 1957, 6A. Stephen Rabe describes *Excélsior* as a conservative newspaper (*Eisenhower and Latin America,* 330).

I would like to thank Annette Rodriguez for translating this article.

54. Diana Anhalt believes the FBI was behind the detentions and the deportations of these individuals, as had been the case with Gus Hall and other CPUSA leaders who had been brought to the United States by Mexican agents, thus avoiding a legal extradition. Anhalt, *A Gathering of Fugitives*, 166.

55. Ibid.

56. Ibid.

57. Max Shlafrock "Statement." AMC, WCFTR.

58. However, other articles published in Mexican newspapers were more sympathetic to Shlafrock and Novick. After Shlafrock and Novick were deported, an article entitled "Violación a los derechos humanos en el caso de Shlafrock y Novick" (Violation of Human Rights in the Case of Shlafrock and Novick) appeared in the Mexican news magazine *Claridades* on December 29, 1957.

59. Anhalt, *A Gathering of Fugitives*, 171–72. Their legal case, handled in part by Maurice Halperin, was supported with funds from other U.S. exiles. In a letter to Charles Humboldt, Albert Maltz wrote that he could not, at that time, make a financial contribution to the journal *Mainstream*, as "The Novick-Shlafrock deportation case not only was exceedingly costly to us and to others, but we laid out a considerable sum in advance that has not yet been returned." Albert Maltz, letter to Charles Humboldt, February 11, 1958. CHC, YMA.

60. Max Shlafrock, "Statement." AMC, WCFTR. According to U.S. Embassy documents, Novick and Shlafrock were in fact being monitored by the U.S. Embassy. In a letter written by U.S. Embassy official Winston M. Scott to Raymond Leddy, he noted that a "usually reliable source" reported that Novick and Shlafrock would leave Mexico by April 1, 1958. Scott remarked that they had submitted a request to leave Mexico, although their lawyer "would continue to attempt to revise this document after their departure, apparently with a view to their eventual legal return to Mexico." Winston M. Scott to Raymond G. Leddy, Political Counselor, April 9, 1958. Records of Foreign Service Posts of the Department of State, Files of U.S. Embassy, Mexico City, 1956–58, Classified, Box 4. NARG 84. File: "Communists in Mexico," 350.21.

61. This was suggested in an editorial published in *The Nation*. See Field, *From Right to Left*, 290.

62. Carr, *Marxism and Communism*, 188.

63. Raat, *Mexico and the United States*, 153.

64. John Sherman, "The Mexican 'Miracle' and Its Collapse," in *The Oxford History of Mexico*, ed. Michael C. Meyer and William H. Beezley (New York: Oxford University Press, 2000), 583.

65. Caulfield notes further that "During the years of the Cold War, when the U.S. labor movement fell in line with the American government's anti-Communist foreign policy, the help that American unionists gave the Mexican government and the CTM bureaucrats was crucial. Using ORIT [Organización Regional Intra-

Americana de Trabajadores] resources and dollars, the CTM and the Mexican government eradicated militant and independent forces in organizations that opposed state policy. As economic ties between the U.S. and Mexico increased and industrialization accelerated, a disciplined labor movement devoid of militant and independent elements became essential." Caulfield, *Mexican Workers and the State,* 120.

66. Ibid., 109.

67. Ibid.

68. Ibid.

69. U.S. Embassy, Mexico City, dispatch on "Labor and Student Disturbances in Mexico City during the Week of August 25, 1958," to the Department of State, September 25, 1958, included in a report "Composite Memorandum of Conversations with Confidential Embassy Sources on September 13, 14, 1958." State Department Central Files, 1955–1959, NARG 59, Box 2951. College Park, Maryland.

70. Rouverol, *Refugees from Hollywood,* 185.

71. Paul Kennedy, "Mexican Arrests Curb Alien Reds," *New York Times,* September 11, 1958, 32.

72. Rouverol, *Refugees from Hollywood,* 104. The U.S. Embassy was aware of the effects of the raids on the U.S. exile population. In a letter dated September 13, 1958, from the U.S. Embassy to the Department of State days after the arrests and deportations, an official noted, "Some foreigners reported leaving country voluntarily fearing apprehension or involvement until situation acquires more normalcy." State Department Central Files, 1955–1959, NARG 59, College Park, Maryland.

73. Don S. Kirschner, *Cold War Exile: The Unclosed Case of Maurice Halperin* (Columbia: University of Missouri Press, 1995), 163–64.

74. Elizabeth Catlett, interview with author, Cuernavaca, Mexico, June 8, 1999.

75. Catlett did not indicate who the Secretary of Education was at this time. Catlett, interview with author, Cuernavaca, Mexico, June 8, 1999.

76. Catlett, interview with author, Cuernavaca, Mexico, June 8, 1999.

77. Bright, *Worms in the Wine Cup,* 234.

78. Alan Lewis had been misidentified as Lewis Allen, which was the reason he was picked up early on in the raid.

79. Bright, *Worms in the Wine Cup,* 234.

80. Ibid.

81. Ibid., 243–44.

82. "Protestan los Comunistas por el encarcelamiento de once personas," *Excélsior,* September 12, 1958, 3.

83. From U.S. Embassy in Mexico City to Secretary of State, September 10, 1958. State Department Central Files, 1955–1959, NARG 59, Box 2951. College Park, Maryland.

84. Department of State to the U.S. Embassy, Mexico City, September 11, 1958. Records of Foreign Service Posts of the Department of State, Files of U.S. Embassy. Mexico City. 1956–58, Classified, Box 4. NARG 84. File: "Communists in Mexico," 350.21.

85. U.S. Embassy, Mexico City, to Department of State, September 13, 1958. State Department Central Files, 1955–1959. NARG 59. College Park, Maryland.

86. Ibid.

87. Ibid.

88. "Mexican Crackdown Bags Rich Americans," *Los Angeles Times*, September 11, 1958.

89. Kennedy, "Mexican Arrests Curb Alien Reds," 32.

90. Articles appeared in *Últimas Noticias de Excélsior* on September 10, 11, and 27, 1958; in *Excélsior* on September 11 and October 1, 2, and 3, 1958, and in *Novedades* on September 9, 1958.

91. Manuel Camin, "Ninguno debe quedar en el país," *Últimas Noticias de Excélsior*, September 10, 1958.

92. Raúl Rodríguez, "Extranjeros y fondos alientan el Comunismo," *Últimas Noticias de Excélsior*, September 11, 1958.

93. Albert Maltz, letter to Gobernación [no date]. AMC, WCFTR.

94. Ibid. In the previous draft of the letter, Maltz was more openly hostile toward the U.S. Embassy. He wrote that he was referred to as a "foreign agitator" in the newspaper not because of anything he had done in Mexico but because of his political activities in the United States. Albert Maltz, draft letter to Gobernación [no date]. AMC, WCFTR.

95. With his statement, Maltz included letters from two Mexican citizens, one of whom he "lived and worked with for five intensive weeks during the production of a film about Mexico," as proof of his loyalty to Mexico. Albert Maltz, letter to Gobernación [no date]. AMC, WCFTR.

96. Maltz, interview with Gardner, *Citizen Writer in Retrospect*, 907–8.

97. "Memorandum para información del Senor Presidente de la Republica" ("Memorandum for the information of the President of the Republic"), February 19, 1959. File: "Extranjeros Indeseables," SRE.

98. Ibid.

99. In contrast to his nationalist foreign policies, López Mateos was assertive in trying to control the Left in Mexico, especially those within dissident labor unions. Fein argues that it was in fact the PRI's "own reliance on anti-Communism in the late 1950s to suppress domestic opposition by imprisoning labor leaders as foreign directed subversives," that "demanded that it perform its Cold War sovereignty through independence from Washington's foreign policies." Fein, "New Empires into Old," 734. In the late 1950s, railway unionists in the Sindicato de Trabajadores Ferrocarrileros de la República Mexicana (STFRM) who had helped establish the dissident union Confederación Única de Trabajadores (CUT) went on strike to protest a decrease in their wages during the 1950s. The strike began as a series of stoppages that led to a general strike. After dissident union leader Demetrio Vallejo was elected into office, he demanded wage increases, threatening that the union would strike again. When Vallejo proposed a strike before Easter in 1959, the government decided that it was illegal and jailed Vallejo and thousands of other union

members, as well as their supporters, including artist David Alfaro Siqueiros, who was imprisoned in 1960. Smith, "Mexico since 1946," 350.

100. Rouverol, *Refugees from Hollywood,* 244–45.

101. After HUAC cited union leader John Watkins for contempt in 1957, the "Warren" Court (Earl Warren became Chief Justice in 1953) argued that "Congressional power to investigate was not boundless" that they had to serve a legislative function. (Fried, *Nightmare in Red,* 185). However, the FBI, which frequently worked in collaboration with HUAC, responded to this and other legislative decisions by creating COINTELPRO, a series of counterintelligence programs. O'Reilly, *Hoover and the Un-Americans,* 198.

102. Fried, *Nightmare in Red,* 194. According to Kenneth O'Reilly, "It was not an inevitable or necessary outgrowth of the Cold War that mistrust of the Soviets abroad would be projected onto native Communists and other dissidents at home." O'Reilly, *Hoover and the Un-Americans,* 169.

103. The artist Rockwell Kent, on whom the case was based, had refused to sign an anti-Communist affidavit that was required for his passport application. Griffin Fariello, *Red Scare: Memories of the American Inquisition* (New York: W.W. Norton, 1995), 265. As Susan Buck-Morss has argued, the Supreme Court "established that, while the Department of State had the right to deny passports, it could not do so arbitrarily, in violation of due process of law; nor could anti-U.S. political beliefs (as opposed to anti-U.S. criminal practices) be considered sufficient grounds for denial." Buck-Morss, "Passports," *Documents* 1, no. 3 (Spring 1993): 75n38. See also *Freedom to Travel: Report of the Special Committee to Study Passport Procedures of the Association of the Bar of the City of New York* (New York: Dodd, Mead, 1958).

104. Julian Zimet, letter in McGillian and Buhle, *Tender Comrades,* 747.

105. Oppen, *Meaning a Life,* 202.

106. Fried, *Nightmare in Red,* 185.

107. Ibid., 189.

108. Paul Kennedy, "Passport Ruling Sifted in Mexico," *New York Times,* June 29, 1958, 26.

109. Ibid.

110. There was no response from Stone in Maltz's files. Albert Maltz, letter to Ben Margolis, August 5, 1959; Ben Margolis, letter to Albert Maltz, August 27, 1959, October 30, 1959. Albert Maltz, letter to I. F. Stone, September 6, 1959. AMC, WCFTR.

111. As mentioned earlier, the SACB had been established as part of the McCarran Act, otherwise known as the Internal Security Act of 1950. SACB consisted of five members appointed by the President, who required that all left-wing organizations should register. According to Belfrage, this would involve "disclosing its membership and financial affairs and labeling itself subversive on all its printed matter." Belfrage, *The American Inquisition,* xii.

112. SAC, Washington Field Office to Director, FBI, and SAC Los Angeles and New York, November 10, 1958. Hugo Butler's FBI file #100-HQ-321017 (Freedom of Information Act request, received by author on August 22, 2002).

113. U.S. Embassy, Mexico City, memo dated January 15, 1959, from SAC to the FBI, in Hugo Butler's FBI file #100-HQ-321017.

114. Smith, "Mexico since 1946," 353.

115. Fein, "New Empires into Old," 737.

116. "The 'Underground Railroad'—To Russia," *U.S. News & World Report*, September 19, 1960, 10. "Underground Railway for Reds Begins at U.S. Border," *U.S. News & World Report*, November 7, 1960, 82–84.

117. "The 'Underground Railroad'—To Russia," 33.

118. The information supplied to the writer was out of date, as Maxim Lieber had left Mexico for Poland in 1955. "The 'Underground Railroad'—To Russia," 10.

119. Ibid.

120. "Underground Railway for Reds," 82.

121. Ibid., 83.

122. Anhalt, *A Gathering of Fugitives*, 203–4.

123. Kirschner, *Cold War Exile*, 162.

124. Rouverol, *Refugees from Hollywood*, 128.

125. Kirschner mentions Maltz as an example of how far someone would go in support of the Communist Party. Maltz had gone through a humiliating experience after he wrote an article, "What Do We Ask of Writers?" for the *New Masses* in February 12, 1946, arguing that writers should have the freedom to express their thoughts rather than have their work be dictated by the Communist Party. Maltz was intensely criticized for this perspective in the *New Masses* and elsewhere (Kirschner, *Cold War Exile*, 160). Eventually, Maltz wrote a follow-up article, "Moving Forward," in which he "recanted". (*New Masses*, April 9, 1946, 8–10, 21).

126. Maltz, interview with Gardner, *Citizen Writer in Retrospect*, 879.

127. Rouverol, *Refugees from Hollywood*, 127–28.

128. Field, *From Right to Left*, 290–91.

129. Rouverol, *Refugees from Hollywood*, 252.

130. Ibid., 256.

131. From SACB of Los Angeles to the Director of the FBI, June 24, 1964, in Hugo Butler's FBI file #100-HQ-321017.

132. Catlett, interview with author, Cuernavaca, Mexico, June 8, 1999.

133. While the Mexican government's repression against U.S. exiles in Mexico diminished considerably in the 1960s, U.S. surveillance of the exiles continued into the 1960s, as former CIA agent Philip Agee describes: "The (Mexico City) station also collects information about Communists from the U.S. living in Mexico. Many of them arrived during the McCarthy period and have subsequently become citizens. Information about them is mainly of interest to the FBI which calls them the American Communist Group in Mexico City (ACGMC). Information collected about

them includes data obtained through the LIENVOY." (LIENVOY was the joint CIA–Mexican Security Service telephone-tapping operation.) Philip Agee, *Inside the Company: CIA Diary* (New York: Bantam Books, 1975), 542.

Conclusion

1. In contrast to *Los pequeños gigantes*, the USIA-sponsored Mexican newsreel initiative "Project Pedro" used footage of the winning Mexican Little League team's meeting with Eisenhower to convey good relations between the United States and Mexico. Fein, "New Empires into Old," 712.

2. Herzog, *Elizabeth Catlett*, 159.

3. Denning, *The Cultural Front*, 228.

4. Harper & Row Publishers reprinted *Uncle Tom's Children* and *The Outsider* in 1965, *Native Son* and *Black Boy* in 1966, *American Hunger* in 1979, *Long Dream* in 1987, and *White Man, Listen!* and *Black Power* in 1995. However, Mullen argues that Richard Wright and other African American writers were reclaimed by the Black Arts Movement "absent their leftist pasts." Mullen, *Popular Fronts*, 187.

5. Kahn's novel was published in 1989 as part of the "Clásicas Chicanos/ Chicano Classics" series produced by Bilingual Press/Editorial Bilingüe.

6. Daydí-Tolson, "Gordon Kahn's *A Long Way from Home*: A Wishful Journey," 2.

7. Pulido, *Black, Brown, Yellow and Left*, 114.

8. Denning, *The Cultural Front*, 470.

9. However, it is important to note that most of the Hollywood exiles did not secure work in the Hollywood film industry until the late 1960s, if at all. Ceplair and Englund contend that only 10 percent of those blacklisted within the Hollywood film industry ever returned to work. Ceplair and Englund, *The Inquisition in Hollywood*, 419.

10. Michael Ryan and Doug Kellner, *Camera Politica: The Politics and Ideology of Contemporary Hollywood Film* (Bloomington: Indiana University Press, 1988), 6.

11. Screenplays written by Hollywood screenwriters who chose exile in Mexico include antiwar films such as the Oscar-winning *M.A.S.H.* (1970; screenplay, Ring Lardner Jr.) and *Johnny Got His Gun* (1971; screenplay, Dalton Trumbo) as well as *Custer of the West* (1967; screenplay, Julian Zimet and Bernard Gordon); and *Two Mules for Sister Sara* (1969; screenplay, Albert Maltz).

12. In addition to writing the screenplays for *The Adventures of Robinson Crusoe*, *¡Torero!*, and *Los pequeños gigantes*, Hugo Butler wrote the screenplay of *The Young One* (1960), which was directed by Luis Buñuel and produced by George Pepper.

13. This work can be distinguished from that of blacklisted Hollywood filmmakers who went to Europe where the aesthetic and narrative conventions of classical Hollywood cinema continued to serve as a primary influence on their work. In England, Joseph Losey directed numerous dramatic films, such as *Time without Pity* (1957), written by Hollywood exile Ben Barzman, within the British film industry.

In France, blacklisted filmmakers Jules Dassin and John Berry wrote and directed thrillers; Dassin directed *Rififi* (1955); and Berry directed *Ça Va Barder* (1955). Dassin also directed the drama *Celui qui doit mourir (He Who Must Die)* (1957), a literary adaptation of *The Greek Passion* by Nikos Kazantzakis, an Italian–French co-production, as well as *Never on Sunday* (1960), within the Greek film industry.

14. Manuel Michel, one of the founders of Nuevo Cine, has described the importance of Luis Buñuel as well as the filmmakers involved in the production of *Raíces* and *¡Torero!* on independent film production in Mexico. Michel, "Mexican Cinema." See also García Riera, *Historia documental del cine mexicano, 1955–1957*, 135.

15. Berg, *Cinema of Solitude*, 46.

16. Fein, "Motion Pictures: 1930–1960," 970.

17. Julianne Burton, "Marginal Cinemas and Mainstream Critical Theory," *Screen* 13, no. 3 (1985): 3.

18. Michel, "Mexican Cinema," 47.

19. Scott Baugh, "Developing History/Historicizing Development in Mexican Nuevo Cine Manifestoes around 'La Crisis,'" *Film & History* 34, no. 2 (2004): 26.

20. The script, written by Emilio García Riera, focused on the traumatic experiences of Ascot's wife, who left Spain during the Spanish Civil War. Mora, *Mexican Cinema*, 107.

21. James Smethurst argues that "In an odd way, Cold War repression promoted the grass-roots African American cultural infrastructure of Chicago—and elsewhere." Smethurst, *The Black Arts Movement*, 193.

22. Ibid.

23. Ibid., 124.

24. Other members of the group included Hale Woodruff, who had gone to Mexico in the 1930s and founded the Atlanta University Annual in the 1940s; Charles Alston, who had painted murals as part of the WPA; Norman Lewis, an abstract expressionist; as well as younger artists. Bearden and Henderson, *A History of African American Artists*, 400.

25. Ibid., 419.

26. Catlett, "The Negro People and American Art," 74.

27. See Schmidt, *Communism in Mexico*.

28. See Shifra Goldman, *Contemporary Mexican Painting in Times of Change* (Albuquerque: University of New Mexico Press, 1981); and Cockcroft, "The United States and Socially Concerned Latin American Art," 184, 207.

29. Goldman, *Contemporary Mexican Painting*, 39. Siqueiros was released in 1964 because López Mateos did not want his imprisonment of this famous artist to mar his legacy.

30. Herzog, *Elizabeth Catlett*, 136.

31. Ibid., 140.

32. Elizabeth Catlett, interview with author, Cuernavaca, Mexico, June 8, 1999.

33. Marc Crawford, "My Art Speaks for Both My Peoples," *Ebony* 25, no. 3

(January 1970). Following "Dimensions of Black," exhibitions of Elizabeth Catlett's work were held at Howard University, the Museum of the National Center for Afro-American Artists and the Atlanta Center for Black Art in 1972, Jackson State College and Fisk University in 1973, Southern University in 1974, and Scripps College in 1975, and in Europe. Lynne Kenny, "Chronology," in *Elizabeth Catlett's Sculpture: A Fifty-Year Retrospective* (Neuberger Museum of Art, Purchase College, State University of New York, 1998).

34. This experience resembled the U.S. government's policing of Paul Robeson's movements during the 1950s, but while he was contained in the United States under what he argued was a kind of "domestic house arrest and confinement," Catlett, now a Mexican citizen, was not allowed to enter the country. Similar to Catlett, however, when Robeson was denied entry into Canada to give a concert in Vancouver, British Columbia, in 1952, he gave his speech "through the device of a long-distance telephone hookup relayed to the public address system." Martin Bauml Duberman, *Paul Robeson: A Biography* (New York: Ballantine Books, 1989), 399–400.

35. "CONFABA," Elizabeth Catlett papers, Amistad Research Center at Tulane University, New Orleans.

36. Ibid.

37. Herzog, *Elizabeth Catlett*, 150. The Studio Museum's director Edward S. Spriggs and writer Elton C. Fax started the process of acquiring a visa for Catlett in 1970. In his foreword to an exhibition catalogue for the show at the Studio Museum, Elton Fax wrote that at the time there was, in his words, "still some question whether the United States government will issue her a visitor's visa to attend the opening of this exhibition." Elton C. Fax, "Foreword," in *Elizabeth Catlett: Prints and Sculpture* (New York: Studio Museum in Harlem, 1971).

38. Melanie Herzog's information about the stipulations of Elizabeth Catlett's visa was based on her interview with Clifton Johnson, former director of the Amistad Research Center at Tulane University. Herzog, *Elizabeth Catlett*, 150.

39. Richard J. Powell, "Face to Face: Elizabeth Catlett's Graphic Work," in *Elizabeth Catlett's Works on Paper, 1944–1992*, ed. Jeanne Zeidler (Hampton, Va.: Hampton University Museum, 1993), 49.

40. While the U.S. exiles in Mexico had difficulty traveling to or through the United States during the late 1950s and early 1960s, individuals who either had never been American citizens or had become Mexican citizens experienced the most obstacles entering the United States. In addition to former U.S. citizens Elizabeth Catlett and composer Conlon Nancarrow, who both became Mexican citizens, Luis Buñuel, Gabriel Figueroa, and Cedric Belfrage (a British journalist who had been deported from the United States during the 1950s) had trouble acquiring visas that they needed in order to enter the United States from Mexico in the 1970s and 1980s. Belfrage, who moved to Mexico in the early 1960s, had applied for a visa to travel to the United States for a tour promoting his book *The American Inquisition 1945–1960*. The U.S. State Department granted him a one-month visa to visit the

United States in 1973, which gave him time to tour the East Coast, although it ruled out a visit to the West Coast. He was informed by a "Mr. Karp" at the U.S. Embassy in Mexico City that if he did not abide by his itinerary approved by the embassy, his visa would be rescinded and he would be deported ("U.S. Embassy Round One, January 27, 1973," "U.S. Embassy Round Two, January 30, 1973," U.S. Embassy Round Three, February 6, 1973," and "Editorial by Cedric Belfrage about trip," May 31, 1973. Cedric Belfrage papers, Tamiment Library/Robert F. Wagner Labor Archives, Elmer Holmes Bobst Library, New York University).

41. David Cole, *Enemy Aliens: Double Standards and Constitutional Freedoms in the War on Terrorism* (New York: The New Press, 2003), 29.

42. Cole, *Enemy Aliens*, 60. Also see Cynthia Brown, ed., *Lost Liberties: Ashcroft and the Assault on Personal Freedom* (New York: The New Press, 2003); and Rachel Meeropol, ed., *America's Disappeared: Secret Imprisonment, Detainees, and the "War on Terror"* (New York: Seven Stories Press, 2005).

Index

abstract expressionism: as limiting exhibition space for representational art, xvi, 35, 51, 54; in Mexico, xix, 209–10; U.S. government's promotion of, xiii, xv, 51–53, 96–97, 202–3, 210

ACA (American Contemporary Art) Gallery (New York City), 53, 55, 226n16

Acevedo-Muñoz, Ernesto, 74, 244n58, 247n94

ACGM ("American Communist Group in Mexico"), 180, 275n133

Acheson, Dean, xi

Ades, Dawn, 46

Adventures of Robinson Crusoe, The (film), xvii, xxii–xxiii, 74, 77, 80, 99–100, 118, 203; as allegory of exile, 58, 59–60, 62, 71–73, 75–83, 97

African Americans, 55; antiracist themes in works by exiles among, xiv, xv, xvi, xviii, xxii, xxiv, 3, 27–28, 33–34, 37, 41–44, 47–50, 56–57, 137–45, 152, 163–64, 167–69, 203, 204, 210–11; artists among, as U.S. political exiles in Mexico, ix–x, xiv–xv, xx–xxii, 3, 5–6, 22–23, 38, 52; blacklist's effects on artists among, xvi, xviii; exhibitions of works by, 44, 53, 55, 209, 211–13,

226n16; exiled artists among, as influence on Black Arts Movement, xviii–xix, xxv, 204, 205, 208–11, 276n4; exiled, relations with Mexicans, 3, 22, 56, 63–65, 144–45, 200; funding for artists among, 3–6, 32–35, 37, 46, 47, 55, 226n4; history of, portrayed in exiles' work, xiv, xviii, xxii, 27, 34, 35, 37, 41–44, 47–50, 54, 56, 57, 203, 208–11; lack of Mexican racism against, 3, 6, 13, 64, 65, 143, 146, 167, 173; marginalization of, within art world, 5, 32, 35, 52–53, 238n96, 238n105; reasons for going into political exile in Mexico, x, xvii, xxi–xxii, 1–3, 5, 12–13, 27, 37–38, 46, 223n26; as representatives of U.S. government abroad, 57, 96–98, 238n96; return from exile, 172, 173, 205; U.S. racism directed toward, xiv, xvii, xxi, 1–3, 6, 19–20, 32, 58–59, 137–40, 142, 143–45, 152, 163–64, 169, 223n26; work of, as influencing views of the United States from Mexico, xviii–xix, xxii, xxv, 28, 29, 204, 208, 209–13. *See also* civil rights movement; racism (U.S.); segregation; *names of specific African American exiles*

Hulme, Peter, 79
Humboldt, Charles (Clarence
 Weinstock), 12, 229n59, 257n89,
 270n51, 271n59
Hunter, Alice, 8, 11, 63, 172
Hunter, Ian McLellan, 8, 11, 63,
 107, 172
Hurtado, M. de la Vega, 247n97

Illinois Federal Art Project, 34, 36
Illinois Writers' Project, 141
"imagined community," xiii
Immigration and Nationality Act of
 1952 (McCarran-Walter Act), xv,
 212, 213
Immigration and Naturalization Ser-
 vice (INS): denaturalization proceed-
 ings, 60–61, 96, 222n25, 231n92,
 267n4; monitoring of U.S. exiles,
 195–97, 201. See also deportation
imperialism (U.S.): antiracism seen as
 integral component of, 150–51; Beat
 writers and, 166–67; Mexican artists'
 critique of, 41; Mexican opposition
 to, 15, 92–94, 130, 133, 178, 179,
 192–93; as part of conventional
 travel narratives, 147, 148, 261n35;
 U.S. political exiles' critique of, xii,
 xiii, xiv–xvi, xxiv, 59, 62, 71–72, 76–
 84, 99, 124, 137–40, 147–50, 164–
 67, 202–4, 207, 214, 249n116. See
 also Korean War; racism (U.S.);
 "resident imperialists"; tourism
Incident, The (Wilson), xviii, xxii, 47–
 48, 203
independent film production (Mexico):
 Buñuel's involvement in, 71–83, 206,
 244n58, 244n62; Butler's artisanal
 mode of production in, 103, 115, 118–
 19, 122, 136, 206; Butler's exposure to,
 71, 115; Butler's films as influence on
 Nuevo Cine's, xviii, xxv, 103, 104,
 115, 123, 204, 206–8; Hollywood

filmmakers involved in, xvii, xviii,
 xxii, xxv, 25, 59, 70–83, 102–4, 106–7,
 114, 115, 122–23, 128, 136, 204, 206–
 8. See also names of specific directors,
 influences, producers, screenwriters,
 techniques, and titles of films
independent film production (United
 States), 106, 118–19, 206. See also
 names of specific directors, influences,
 producers, screenwriters, techniques, and
 titles of films
Index of American Design, 32
Indians. See indigenous peoples
indigenous peoples: conditions for, in
 Mexico, 86, 116, 135; descriptions
 of Mexican, in travel guides, 148,
 261n35; filmmakers' stereotypical
 depiction of, 108–13, 116, 123, 135–
 36; Mexican artists' interest in tradi-
 tions of, 30–31, 34, 210; Mexican
 racism against, xxi, 31, 65, 80–81, 95,
 134, 156; in Mexican Revolution,
 124; Motley's use of perspectives of,
 xxiv, 138, 149, 152, 155–56, 162–64.
 See also Mexicans
industrialization (in Mexico), xii, 14–
 15, 41, 63, 86, 95, 113, 116, 149–50,
 207, 230n68, 271n65
inmigrado residency status (Mexico),
 18, 183, 187, 231n91, 243n50
inmigrante residency status (Mexico), 9,
 10, 18, 19, 69–70, 228n41, 231n91,
 257n92
In Phyllis Wheatley I proved intellectual
 equality in the midst of slavery
 (Catlett), 42, 43
INS. See Immigration and
 Naturalization Service
In Sojourner Truth I fought for the
 rights of women as well as Negroes
 (Catlett), 42
Inter-American Conference (1954,
 Caracas, Venezuela), 178, 180, 193

exiles' selection of, xi, xvi–xvii, xxi,
1–6, 9, 46, 70, 101–2, 175; residency
difficulties of U.S. exiles in, xxiv, 1, 9,
16–19, 24, 60–61, 70, 96, 123, 171,
173, 182, 183, 185–86, 191, 267n6;
strikes in, xii, xxiv, 172, 181, 184–85,
190–92, 210; U.S. political exiles'
arrest and deportation from, xii, xvii,
xxiv, 15–18, 66, 67–68, 170–72, 181–
92, 199, 271n54; U.S. political exiles
in, ix–xi, 20–26, 126, 219n4; work of
exiles in, as influencing views of the
United States, xviii–xix, xxii, xxv, 28,
29, 204, 208, 209–13. *See also* exiles;
Mexican government; Mexican
Revolution; press; Taller de Gráfica
Popular; tourism; *names of specific
cities, individuals, and presidents*
Meyer, Hannes, 40
Miami's "Little Smith" trials, 175, 183
Michel, Manuel, 115–16, 134, 207
migration. *See* exiles; refugees
Military Defense Assistance Act
(1951), 93–94
modernization. *See* industrialization;
urbanization
Monsiváis, Carlos, 108, 260n134
Mora, Carl, 110, 131
Mora, Francisco (Pancho), 22, 56, 65,
186, 189, 200–201, 210
Moreno, Luisa, 85, 179
Morgan, Stacy, xx, 35, 52, 141, 152,
224n32, 239n115, 248n110
Motion Picture Alliance for the
Preservation of American Ideals, 7
Motley, Willard: anti-imperialist
themes, xvi, xxiv, 137, 139–40, 147–
50, 164–67, 169, 203, 204; antiracist
themes, xiv, xvi, xxiv, 20, 65, 137–45,
152, 163–64, 167–69, 203, 204; bull-
fighting as theme, 102, 142; censor-
ship and heavy editing of works, xiv,
xxiv, 137, 138, 140, 145–47, 151,

152, 158–59, 161–64, 169, 203, 204–
5; death, 158; as permanent resident
in Mexico, xvii, 65, 200; reasons for
leaving the United States, 12–13,
144, 166; relations with Mexicans,
65, 144–45, 149, 156; relations with
other U.S. exiles in Mexico, 3, 24, 65,
66–68; techniques used in works by,
xvi, xxiv, 138, 140–42, 148–49, 152,
162–63, 203. *See also specific works*
Mullen, Bill, xx, 4, 5, 13, 36, 276n4
muralism: Mexican government's sup-
port for, 31, 32, 235n54; as Mexican
influence on U.S. African American
artists, xix, xxi–xxii, 1, 6, 27, 29–38;
themes in Mexican, 31, 34, 46; in the
United States, 32, 224n32; by U.S.
exiles in Mexico, 47–48. *See also*
public art; social realism; *names of
specific muralists and murals*
"My Friend Bonito" (*It's All True*
segment), 110–11, 119
"My House Is Your House" (Motley),
64, 67, 137–51; anti-imperialism in,
204; censorship of, xiv, 140, 145–47,
151; narrative strategies in, 140, 148–
49; parts of, in "Tourist Town," 151,
153, 156; on racism, xiv, xxiv, 20, 65,
137, 140–41, 144–46, 164, 203

Naficy, Hamid, 82
Nancarrow, Conlon, 11, 23, 25,
278n40
National Association for the Advance-
ment of Colored People (NAACP),
168, 169, 237n86
National Conference of Negro Artists,
xv, xix, 50–51, 55–57, 208–9
National Education Workers' Union
(Mexico), 185
nationalism: anti-Communism as
patriotic form of U.S., 62, 96, 97;
in Mexican filmmaking, 97, 108;

Rebecca M. Schreiber is assistant professor of American studies at the University of New Mexico.